D1094261

Citing China

Critical Interventions
Sheldon H. Lu, general editor

CRITICAL INTERVENTIONS

Citing China
Politics, Postmodernism, and World Cinema

Gina Marchetti

University of Hawai'i Press
Honolulu

23 22 21 20 19 18 6 5 4 3 2 1

Critical Interventions

Sheldon H. Lu, general editor

Critical Interventions consists of innovative, cutting-edge works with a focus on Asia or the presence of Asia in other continents and regions. Series titles explore a wide range of issues and topics in the modern and contemporary periods, especially those dealing with literature, cinema, art, theater, media, cultural theory, and intellectual history as well as subjects that cross disciplinary boundaries. The series encourages scholarship that combines solid research with an imaginative approach, theoretical sophistication, and stylistic lucidity.

Library of Congress Cataloging-in-Publication Data
Names: Marchetti, Gina, author.
Title: Citing China : politics, postmodernism, and world cinema / Gina
 Marchetti.
Description: Honolulu : University of Hawai'i Press, [2018] | Includes
 bibliographical references and index.
Identifiers: LCCN 2017032672 | ISBN 9780824866570 (cloth alk. paper)
Subjects: LCSH: China—In motion pictures. | Orientalism. | Motion pictures
 and transnationalism. | Motion pictures and globalization.
Classification: LCC PN1995.9.C47 M37 2018 | DDC 791.430951—dc23
LC record available at https://lccn.loc.gov/2017032672

Cover photo: Bicycle dreams in Patrick Tam's *After This Our Exile* (2006).

*I dedicate this book to the memory of
my dear colleague Esther M. K. Cheung,
a giant in the field of Hong Kong cultural
studies, an influential public intellectual, and
an inspired teacher. She left us all too soon.*

Contents

Acknowledgments

The material included in this book represents several years of research into the cinematic conversations that have developed in recent years between Chinese-language film and European as well as Hollywood motion pictures. I am exceedingly grateful for the generous support of the following funding bodies for making the research for this book possible: GRF award, 2011–2014, Research Grants Council, Hong Kong (General Research Fund 750111); HKU Fellowship Award, 2012; GRF Incentive Award, 2009–2010 and 2010–2011, University Research Committee, University of Hong Kong; Research Grant, 2008–2010, Hsu Long-sing Research Fund, University of Hong Kong; Research Grant, 2007–2009, Seed Funding Program for Basic Research, University of Hong Kong.

I would also like to express my gratitude to all the conference organizers and hosts who enabled me to present my research during the writing of this book, as well as the editors of previously published materials. Conferences and institutions where I had the privilege of presenting some of the ideas in this book include the Busan Cinema Forum, University of Hong Kong, Universita Ca'Foscari in Venice, the XXVI FILLM International Congress, Hong Kong Baptist University, Lingnan University, and National Chiao Tong University.

Another version of material from chapter 3 appears as "Bicycle Thieves and Pickpockets in the 'Desert of the Real': Transnational Chinese Cinema, Postmodernism, and the Transcendental Style," in *East Asian Cinema*, ed. Vivian Lee (London: Palgrave Macmillan, 2011), pp. 61–86. Portions of chapter 4 on Evans Chan appear as "Brecht in Hong Kong: Evans Chan's *The Life and Times of Wu Zhongxian*," in *Postcolonialism, Diaspora, and Alternative Histories: The Cinema of Evans Chan*, ed. Tony Williams (Hong Kong: Hong Kong University Press, 2015), pp. 81–100. Small portions of chapter 5 on *Irma Vep*, in substantially different form, appear in "From Fu Manchu to *M. Butterfly* and *Irma Vep*: Cinematic Incarnations of the Chinese Villain," in *Bad: Infamy, Darkness, Evil and Slime on Screen*, ed. Murray Pomerance (Albany: State University of New York Press, 2004), pp. 186–199. The concluding section of chapter 7 appears as "Clara Law's

Red Earth: The Hong Kong International Film Festival and the Cultural Politics of the Sponsored Short," in *Chinese Film Festivals: Sites of Translation,* ed. Chris Berry and Luke Robinson (New York: Palgrave Macmillan, 2017), 259–277. My thanks to Palgrave Macmillan and the Hong Kong University Press for permission to reprint portions of chapters 3, 4, and 7.

I am particularly grateful for the excellent advice given to me by my colleagues during the course of this research. Special thanks go to Staci Ford, Esther C. M. Yau, Aaron Han Joon Magnan-Park, Mirana Szeto, Winnie Yee, Fiona Law, Jason Ho, Giorgio Biancorosso, Tim Gruenewald, Tan See-Kam, Chuck Kleinhans, Julia Lesage, Sebastian Veg, Elena Pollacchi, Dina Iordanova, Tim Bergfelder, Leon Hunt, Paul Bowman, Song Hwee Lim, Evans Chan, Tony Williams, Murray Pomerance, Vivian Lee, David Desser, Frances Gateward, Zhang Yingjin, Feng Pin-chia, Patricia Zimmermann, and Christine Holmlund. Many thanks to the research assistants who worked diligently on this project over the years, including Fanny Chan, Natalie Wong, Derek Lam, Kasey (Man Man) Wong, and Iris Eu. I would also like to acknowledge the kind assistance of the editorial team at the University of Hawai'i Press, including Pamela Kelley, Cheryl Loe, Bojana Ristich, and "Critical Interventions" series editor Sheldon Lu, a leader in the field who genuinely understands the importance of citing China in film and cultural studies.

My husband, Cao Dongqing, and son, Luca Cao, gave me enormous support and showed extraordinary patience as we traveled to film museums, archives, and festivals to gather materials.

I am also indebted to the late Esther Cheung, my chair and colleague in the Department of Comparative Literature, University of Hong Kong. Our conversations about Chinese cinema inspired me to think in new ways about the topic, and as a small gesture of gratitude, I dedicate this book to her memory.

Citing China

Introduction

Hot Air and High Hopes in World Cinema

Citing China: Politics, Postmodernism, and World Cinema explores the role film plays in creating a common ground for the exchange of political and aesthetic ideas between China and the rest of the world. The depiction of "China" on contemporary world screens serves as a site, sight, and citation—a place, an image, and a reference point—for an ongoing critique of global politics and film aesthetics. This book discusses how films about China and from the Chinese-speaking world use self-reflexive techniques with a high degree of intertextuality in order to carve out a transnational space of cinematic solidarity and dissent. Cinematic quotations, then, operate as part of a postmodern cultural marketplace. However, more important, they link current films to past political movements and unresolved social issues that continue to fuel screen fantasies about China in the twenty-first century.

Since the chronicles of the voyage of Marco Polo appeared in Europe, philosophers, historians, theologians, artists, and writers of various sorts have regularly cited "China" as a point of difference constituting a dramatic shift in the constitution of the Western "self" as "modern." The meaning of "China" has metamorphosed over time, as has the idea of "modernity." Just as modernism, at least in part, was predicated on the encounter between the West and its "others," so too has postmodernism been built around intellectual and aesthetic encounters with the non-West—and with China in particular.

It seems apposite, therefore, that Fredric Jameson should cite "China" in his seminal essay, "Postmodernism and Consumer Society,"[1] which defines the current era and which Gayatri Spivak cites as part of her "critique of postcolonial reason."[2] As an example of the postmodern aesthetic, Jameson includes Bob Perelman's poem, "China," which he reads as a schizophrenic meditation on the People's Republic of China (PRC) and an obliquely political work with apparently celebratory references to the "third" way of the Chinese Communist Party (CCP). However, after this hermeneutic detour, Jameson reveals the poem really has nothing to do with the PRC or the CCP at all. It provides an example of "fake

realism"—"art about other art, images of other images."[3] The poem consists of captions Perelman devised for photographs from a book that the poet came across on a trip to Chinatown. Just as the PRC defines the "modern" for Western Marxists such as Jameson, it also delineates the "postmodern"—the realm of the copy, the desultory remark, the surface of the image, and the counterfeit. Jameson mentions Andy Warhol in the same essay, and, clearly, the artist's obsessively reproduced and reprocessed images of Chairman Mao operate in a similar way—evoking modern China as a radical project and treating it as an empty image, part of a postmodern consumer society of the spectacle (as Guy Debord might say).

Jameson's essay came out in the anthology *The Anti-Aesthetic: Essays in Postmodern Culture* in 1983, and he went to the PRC to give a series of lectures in 1985. Tang Xiaobing translated some of his writings on postmodernism into Chinese in 1987, and Jameson's perspective on postmodern culture has been enormously influential in China since that time. As Jameson cited "China" to develop his ideas about postmodernity, Chinese intellectuals absorbed Jameson on the postmodern. "China," then, circulates as a site (the PRC), a sight (Warhol's reproductions of Mao's image), and a citation (Perelman's poem) within Jameson's essay, as well as within the development of a notion of "postmodernity" in China.

This book examines the circulation of "China" as a marker of modernity/postmodernity in contemporary film culture by looking at the ways in which global filmmakers cite "China" on screen. Filmmakers from the PRC, Taiwan, Hong Kong, and throughout the Chinese diaspora engage ideologically and aesthetically with world cinema, which has embraced Chinese-language cinema, seeing in it references to Euro-American motion picture traditions. Film scholars, in fact, recently have begun to examine the transnational exchanges across media industries and their cross-cultural trajectories involving Chinese motion pictures.[4] Plumbing the depth and surveying the reach of these enormously complex relations remains outside the scope of this particular study. Rather, the objective here is to look at a corpus of films made between 1997 and 2010 involving China that directly cite the political history of this cinematic encounter. These films participate in a network of citations that can be traced back historically to the silent era and, in the late twentieth and early twenty-first centuries, testify to their ability to be in conversation with the established canon of world cinema. Within a critical interrogation of film aesthetics, building on what Sergei Eisenstein, Vsevolod Pudovkin, Bertolt Brecht, and Jean-Luc Godard, among others, have taken from Chinese politics and art, filmmakers inside and outside the Chinese-speaking world continue to serve as subversive voices within commercial cinema, as renegades within film culture or as interlocutors of a different sensibility that offsets the cinematic status quo.

Citing China looks at key figures in international film who take an active interest in Chinese aesthetics, translate it into practice, and have an impact on the way in which "China" is depicted in global cinema today. They draw on previous encounters filmmakers had with China, reference these earlier efforts, and use these cinematic credentials to reflect on their current contributions to world cinema. While some are in an avowedly Marxist tradition (Brecht, Eisenstein, Godard), others take a different route (transcendentalism, various traditions of critical realism, feminism, interrogations of the politics of race and colonialism, among others). Their films highlight political issues, but they also participate in cinematic experimentation to varying degrees. *Citing China* focuses, then, on cinematic encounters that cross various aesthetic boundaries—from popular entertainment with a political punch (e.g., the legacy of Bruce Lee) to international art cinema and the emergence of the so-called "festival film." Connections exist on a continuum, and this book focuses on that part of the spectrum that produces cultural, aesthetic, and political critique across the China-West divide. Whether these filmmakers are attempting to build solidarity based on a shared spiritualism, anti-capitalism, feminism, or other form of political engagement, the implications of these encounters continue to metamorphose as the world in which they blossom and circulate changes.

As Jameson leaves open the question of the potential of postmodern aesthetics for political critique at the end of his essay, the issue remains salient here. While some films seem to bleed aesthetic innovation of any political punch, others build on a legacy of direct action. With political and aesthetic common ground varying widely, the context in which a particular strand is taken up, explored, exploited, or ignored becomes significant as specific narrative devices, character types, cinematic techniques, performance styles, or screen icons come into play intertextually. Ideas bounce back and forth between Chinese film cultures and the rest of the world over the broad expanse of film history, and the links become confused, convoluted, and often involve misunderstandings, misquotations, redirections, arguments, and counterpoints.

In "Remapping Taipei," Jameson comments on the echoes of European modernist cinema (primarily the work of Michelangelo Antonioni) in Edward Yang's *The Terrorizers* (1986); he discusses the film's "archaic modernity," which he sees as containing elements that strike a "regressive note."[5] However, as Jameson rightly observes, the film operates between "modernism" and "postmodernism," between "subjectivity and textuality...without having to commit itself to either as some definitive reading, or as some definitive formal and stylistic category."[6] It can be added that Yang self-consciously cites Antonioni not only to somehow fit within an art film tradition dominated by European modernists, but also to link his critical examination of postmodern Taipei to Antonioni's

critique of the Western petite bourgeoisie in the 1960s and 1970s. Yang conjures up a past aesthetic stance in order to make a statement—albeit indirectly—about the political moment in Taiwan before the lifting of martial law in 1987. Postmodern pastiche allows for this play of signification, and an outmoded modernism obliquely comes to the service of a cogent social critique.

Yang references *Blow-Up* (1966) to question the fundamental nature of perception and human connections through the device of a photographer who captures the object of his gaze in fragments. Of course *Blow-Up* can be interpreted as a fable about artists and intellectuals fundamentally out of touch with the working classes (whom the photographer, Thomas, played by David Hemmings, impersonates in order to get a story about mine workers) and youth (whose ability to "see" a world that does not yet exist flummoxes Thomas). While Antonioni blows up an image until it empties of meaning, with the human form disintegrating before the technology of the camera, Yang tacks up pieces of a human figure—a portrait of the biracial "White Chick"—whose fragmented identity cannot add up to a unified whole (figure 1.1). Yang's "copy" of *Blow-Up*, too, does not quite cohere into a comprehensible totality; the fissures characteristic of the postmodern keep the film's political critique at a remove and allow it to circulate as a film sponsored by (and presumably representing the "modernity" of) the Nationalist Party (Guomindang or Kuomintang/KMT). Comparing the fragmented image in *The Terrorizers* to the images in *Blow-Up*, Jameson notes, "Here

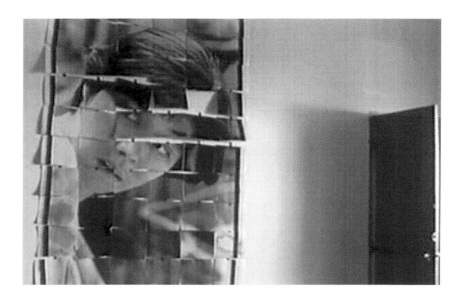

Figure 1.1. Shu-an (Wang An) in The Terrorizers; dir. Edward Yang, 1986.

the wind that blows through the great trees in Antonioni's park only mildly lifts and ruffles the segments of the portrait. Photography's prestige here is to be equal to the simulacrum and more interesting than the reality, but otherwise little more than a way of killing time."[7] As E. H. Gombrich argues in *Art and Illusion,* and Harold Bloom contends in *The Anxiety of Influence,* artists and writers always remain enthralled by the works of the past.[8] Likely, when Jameson claims that postmodernism has killed the "new," he simply recognizes a fact that had been known for quite some time. Modernism may celebrate the "new" with narratives of progress, enlightenment, and liberation, but postmodernism revels in the copy, the recycled fragment, and the fake.

Jameson, then, may recognize that Yang's aesthetic is "derivative," but he cannot dismiss Yang's achievement and the importance of his intervention in not only Taiwanese and Sinophone film circles, but in world cinema as well.[9] The postmodern moment has freed Yang of any "anxiety of influence," and he adeptly uses an idiom that should be—but is not—alien to him in order to circulate freely on world screens with a film that speaks to a political moment in Taiwan but has global implications. The biracial, female, anti-heroine of Yang's film puts a hybrid stamp on the disintegrating identities of an earlier era. Just as Antonioni's films about the insularity of a particular class spoke specifically to the momentous upheavals of the late 1960s without taking a direct political stand, Yang's *The Terrorizers* addresses the relationship between a vacuous global media culture and the oppressiveness of life in Taipei.

A tacit acceptance of the impossibility of the "new" within postmodernism has, indirectly, lessened the stigma placed on art that modernist aesthetics condemned as "derivative" and insufficiently "individualistic." With the dissolution of the "individual" at the heart of discourse, quotation, citation, appropriation, piracy, pastiche, imitation, adaptation, and all variations that comprise the cinematic "knock-offs" of contemporary film culture become part and parcel of the postmodern moment. The colonial "mimicry" condemned as lack of original inspiration by former colonizers becomes in the postcolonial present the creolized, hybridized, polyglot communication of global culture that Yang's "White Chick" represents. Ella Shohat and Robert Stam describe this as cinematic "cannibalism" and "jujitsu" as Third World filmmakers ingest and overthrow the Euro-American status quo.[10]

Of course, Edward Yang's encounter with Antonioni begs a comparison with the Italian auteur's controversial exploration of China in *Chung Kuo Cina* (China, 1972). Antonioni's vision of the "modern" Chinese state as "backward" created a furor that continues to reverberate in world film circles to this day. In fact, the link between Antonioni as an aesthetic force in world cinema, the invitation for him to make a film in China, his decision to accept, and the resulting "look" of that film

may, indeed, be a key part of the story of Yang's *The Terrorizers.* Yang cites an aesthetic that incorporates a history that involves China and, inevitably, provides another layer to the palimpsest that pushes *The Terrorizers* into the realm of the postmodern. Although *Blow-Up* and the vacuity of the lives of its characters gesture toward Antonioni's work before *Chung Kuo,* the fact that the director is notorious for his China film—that few may have seen but many more in film circles would certainly know about—needs to be a part of how Yang's film functions in relation to Western modernist cinema.[11] Yang draws close to Antonioni, as the Italian auteur was attracted to China as a political sight.

Just as Jameson's encounter with "China" and Edward Yang's *The Terrorizers* shaped his thinking about modernism and postmodernism, Roland Barthes's encounter with China during his trip in 1974 also became a commentary on Antonioni's *Chung Kuo.* As the number of references to the film in his notebooks, collected as *Travels in China,* indicate, Barthes "saw" the place through the Italian director's lens as well as his own written articulation.[12] Barthes muses: "Reading through my notes to make an index, I realize that if I were to publish them as they are, it would be exactly a piece of Antonioni. But what else can I do?"[13] Antonioni's film provides a way of seeing China for Barthes, and even when encountering acerbic condemnation of the film by his hosts, he cannot escape the director's vision.

When PRC filmmaker Jia Zhangke revisits the filming of *Chung Kuo* in *I Wish I Knew* (2010), it serves as part of an exploration of Shanghai (the city of Edward Yang's birth) through cinema and popular culture from another perspective.[14] In this case, Jia looks at Antonioni gazing at Shanghai by juxtaposing his own similar use of the camera as observer. He punctuates his film with images of a trip by boat along the Huangpu River, echoing Antonioni's sail along the same waterway. While the wind and hand-powered Chinese junks no longer sail, refuse ships transporting garbage still ply the river. Antonioni's vision of China—including showing Shanghai's "dirty laundry," literally hung out to dry on one of the ships—became a bone of contention, and Jia sets out to examine not just Shanghai, but also the world's vision of "China" in the cinema.[15]

Chung Kuo and *I Wish I Knew* both feature the famous Huxinting Teahouse in front of the Yu Garden in Shanghai's old district and focus on the faces of pedestrians in the crowds. However, unlike Antonioni, Jia begins with an image of a woman using a small digital camera to photograph the scene as the filmmaker captures her image as she takes her shot. Jia's film highlights the process of image making and self-consciously cites other motion pictures to frame his views. In addition to revisiting Antonioni's observational style in *I Wish I Knew,* Jia also intercuts his footage in the Huxinting with Antonioni's images of the teahouse. Whereas Antonioni includes anonymous patrons enjoying their tea and focuses

on some of the details of the tea service—including pots, cups, a bawling child, a cat, and the general ambiance—the Sixth Generation Chinese filmmaker instead provides an interview. Jia replaces part of Antonioni's soundtrack with a voice-over of Zhu Qiansheng, involved with the Shanghai portion of the Italian documentary. Zhu complains that Antonioni shot a lot of inappropriate footage that made China look "backward." Perhaps replicating the tension between Zhu's and Antonioni's perspectives, Jia cuts away to two old men cooling themselves with fans featuring calligraphy that could be construed as "backward" (i.e., Shanghai has an aging population and no air-conditioning) or "picturesque" and "positive" (i.e., Shanghai has a contented population of senior citizens who still appreciate the traditional arts).

Jia Zhangke films Zhu framed by one of the open windows in the teahouse (figure 1.2). Boxed in and hanging out in profile, Zhu continues his story. He notes that the critique of *Chung Kuo* was really an indirect attack on Zhou Enlai, who had invited the Italian director to make the film, by those jockeying for power in Mao's inner circles. This does, indeed, ring true since Joris Ivens filmed virtually identical scenes of acrobatics and acupuncture in *How Yukong Moved the Mountains* (1976) without any of the same opprobrium.[16] In fact, after the denunciation of the film, Zhu suffered by being paraded through all of Antonioni's Shanghai locations for public criticism. In the interview, Zhu sums up the irony of the situation by exclaiming that to this day he remains uncertain about the particulars of the attack since he has not seen the film. The consequences of mutual misperceptions can be grave as well as baffling.

When compared with Yang's references to Antonioni's works, Jia's encounter with the Italian director breaks down into even finer fragments since Antonioni's vision becomes simply a piece of the larger tapestry of filmmakers who

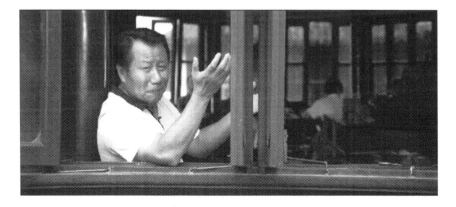

Figure 1.2. Zhu Qiansheng in I Wish I Knew; dir. Jia Zhangke, 2010.

have encountered Shanghai, including Fei Mu, Xie Jin, Hou Hsiao-hsien, and Wong Kar-Wai, among many others. Jia gazes back at Antonioni as one among many—including himself—who have observed the former semi-colonial city as a very visible meeting point of "East and West" in its extraterritoriality.

In the case of Chinese-language cinema, the Yang-Jia-Antonioni connection is far from unique. Chinese filmmakers engage in exchanges with an established cohort of global auteurs who have drawn on Chinese aesthetics and subject matter. Modernism was never a one-way street, and the foundations of what we see today as cinematic modernism—montage, the alienation effect, counter-cinema —are rooted in conversations with Asian aesthetics (from calligraphy and Chinese opera to Mao's "On Contradiction"). These filmmakers take up the foreign interest in China (and/or "things Chinese") started by Brecht, Godard, Antonioni, and Bertolucci, as well as Hollywood directors, but they also use these visions of "China" to engage with other aesthetic issues involving representation, film style, and ideology that speak differently within a Chinese context and in the postmodern moment. In fact, filmmakers and scholars have noted how Robert Bresson, Yasujirō Ozu, Martin Scorsese, Vittorio De Sica, and Alfred Hitchcock, among many other film luminaries, speak to contemporary Chinese directors. The ways in which Chinese cinema talks back to world film—the depiction of China, its history and people—vary tremendously, however. Completing the cycle, filmmakers outside of China reenter the mix and exploit themes and techniques developed in Chinese-language cinema.

Many of these films about China also share an aesthetic common ground within postmodern film culture. As a consequence, they display the basic characteristics outlined by Fredric Jameson on postmodernism, including pastiche; schizophrenia; a disregard for entrenched personal, public, cultural, aesthetic, and other boundaries; an elimination of the "new"; a disregard for temporal causality and a free mining of fragments of past styles; an abandonment of teleology and faith in "progress," enlightenment, and/or emancipation; and an ambivalent attitude (at best) toward political change. Taking global consumerism as a given and the dominance of the marketplace as a fact, these films circulate and communicate differently than the films that they quote, paraphrase, mimic, plagiarize, or otherwise cite.

Whether mediated, translated, glossed, imagined and imaginary, quoted out of context or even misquoted, or purposely or unintentionally misrepresented or misinterpreted, meaning still circulates and intertextual citations continue. Chinese artists encounter the traces of Chinese aesthetics through the work of Euro-American filmmakers, and Western filmmakers see their own progenitors through the lens of Chinese film. In *At Full Speed: Hong Kong Cinema in a Borderless World,* Esther C. M. Yau sees a double standard in operation in

world cinema: "A refusal to act 'authentically' and to comply with Orientalist assumptions has to take into account the double standard that modernism maintains when it comes to 'authenticity': when Europe's artists reference the non-West, this gesture adds value to their work and their originality; but, when non-Western artists reference Europe and the United States, their work is deemed derivative and inauthentic."[17] Aware of this double standard, I am not looking exclusively, or even primarily, at the problem of the colonized mind and China's so-called cultural "debt" to Western modernity. Filmmakers share mutual concerns and artistic problems and engage in a collective quest for aesthetic solutions in order to communicate with one another, as well as to their audiences.

Rey Chow has examined Chinese encounters with Western forms and concepts as a search for affirmation inside and outside the Chinese-speaking world, while they are compelled, in the same instance, to resist cultural imperialism, Westernization, and the loss of a distinct identity.[18] In *Woman and Chinese Modernity: The Politics of Reading between West and East,* for example, Chow observes, "What is missing from the preoccupation with tradition and authentic originariness as such is the experience of modern Chinese people who have had to live their lives with the knowledge that it is precisely the notion of a still-intact tradition to which they cannot cling—the experience precisely of being impure, 'Westernized' Chinese and the bearing of *that* experience on their ways of 'seeing' China."[19] Euro-American hegemony within the so-called global "marketplace of ideas," of course, makes this a "no win" situation. For Chinese filmmakers, acceptance in the West may mean survival as artists in the PRC, Taiwan, Hong Kong, or elsewhere, while the alienation from their Chinese "roots" begs charges of elitism or inauthenticity.

If the "anxiety" haunting Chinese filmmakers involves the question of influence and authenticity, a parallel feeling taints the Euro-American side of the encounter. As Western filmmakers cite China, they also inevitably become part of—and need to come to grips with—an Orientalist tradition that predates the advent of the motion picture. The spectacle of "China" produces an "underground self" for many filmmakers and can lead to a regime of "knowledge" and visual representation that builds Western modernity on the back of Chinese "primitivism." Around the same time Jameson went to China to lecture on postmodernism, Bernardo Bertolucci gained access to Beijing's Forbidden City to produce *The Last Emperor* (1987). With its classical delineation of period detail and casting of stalwarts of the historical biopic such as Peter O'Toole, *The Last Emperor* seems to represent what Jameson calls the postmodern "nostalgia film." According to Jameson, "by reinventing the feel and shape of characteristic art objects of an older period…, [the nostalgia film] seeks to reawaken a sense of the past associated with those objects."[20] Jameson continues:

Cultural production has been driven back inside the mind, within the mo-
nadic subject; it can no longer look directly out of its eyes at the real world for
the referent but must, as in Plato's cave, trace its mental images of the world
on its confining walls. If there is any realism left here, it is a "realism" which
springs from the shock of grasping that confinement and of realizing that, for
whatever peculiar reasons, we seem condemned to seek the historical past
through our own pop images and stereotypes about that past, which itself
remains forever out of reach.[21]

Bertolucci, who made direct reference to Plato's cave in his film about Italian fas-
cism, *The Conformist* (1970), seems well aware of this, and the link among visual
illusion, self-delusion, and fascism becomes an important motif in *The Last Em-
peror* as well.

After years of existing as a "shadow" ruler (concretized by Bertolucci's depic-
tion of the young emperor playing with his eunuchs, silhouetted against sheets of
cloth), Pu Yi (John Lone) has an epiphany when he sees his own image as emperor
of Manchukuo intercut with pictures of the Nanjing Massacre, Pearl Harbor, and
Emperor Hirohito in a newsreel screened in a Chinese prison. Living through this
history, having memories of the events, even being an agent involved does not
have the same impact as seeing an image on the screen. Likewise, as a nostalgia
film, *The Last Emperor* recycles the Orientalist splendors of past cinema, shadows
of newsreel memories, and screen representations of China as a spectacular object
known from Hollywood. Bertolucci acknowledges this directly at the film's con-
clusion. Pu Yi's discovery of his beloved cricket underneath his throne, still magi-
cally alive since his childhood, breaks with any realist claims to historical accu-
racy or authenticity. *The Last Emperor* provides and profits from spectacle,
entertaining world audiences by offering a glimpse at the "forbidden" power, sex,
drugs, and decadence associated with the "mysterious East."

However, this reading recognizes only one side of the coin. *The Last Em-
peror* also can be read as a somewhat ambivalent narrative of redemption
through communism. Pu Yi does, under the tutelage of his jailor, see the full
scope and nature of not only the crime of collaboration with the Japanese, but
also the hubris of clinging to an illusion of imperial power when the Chinese
Empire has become defunct. Bertolucci owes a debt to Hollywood Orientalism,
but he also cites Western Marxist practices reminiscent of Brecht and nods to
Chinese "revolutionary romanticism" in this story of improbable transforma-
tions, as Pu Yi's story allegorizes the construction of the PRC. Pu Yi famously
changes from "emperor" to "citizen," and, in his so doing, the film provides a
model of transformation—aided by the projection of the newsreel within the
film—that serves as a model for the conversion of the spectator as well (although

tempered again by references to the excesses of the Great Proletarian Cultural Revolution, 1966–1976).

Chinese aesthetics, then, provides the background against which the inadequacies of Europe and America can be measured. Some of these engagements are clearly politically motivated, while others have built on a broad interest in how Western "universal" ways of seeing the world meet a brick wall when Chinese visual, dramatic, and narrative schema come into play and offer a very different aesthetic path. At the time, Bertolucci's cinematic approach spoke volumes to younger filmmakers such as Chen Kaige, who had a bit part in the film, and Ning Ying, who served as assistant director on *The Last Emperor*. Chris Berry, for one, likely referring to films such as *Farewell My Concubine* (1993), laments, "Chen Kaige's lapse into the production of *chinoiserie*…out-Bertoluccis Bertolucci."[22] However, the fascination with Bertolucci may go beyond a self-Orientalizing impulse in an effort to find a place within film culture outside of Asia. Bertolucci's postmodern balance of politics and spectacle, nostalgic consumer-friendly Orientalism with the cunning depiction of the vicissitudes of Communist Party policies, and the transformative power of socialist thought became as important a part of the visual lexicon of a generation of PRC filmmakers as Jameson's concept of "postmodernism" did for a broader cross-section of intellectuals and artists. *The Last Emperor,* then, provides some common ground for political and aesthetic exchange.

Like Antonioni, Bertolucci functions as a cinematic sounding board for filmmakers intent on exploring China on global screens. In addition to Chen Kaige's *Farewell My Concubine* (mentioned above), citations of Bertolucci films punctuate Ang Lee's *Lust, Caution* (2007), which overlaps in the principal time period covered and in its exploration of the politics of collaboration during the Japanese Occupation.[23] Ann Hui's *The Golden Era* (2014) also contains elements of spectacle reminiscent of Bertolucci's portrayal of the Republican era in China, while Feng Xiaogang's *Big Shot's Funeral* (*Dawan,* 2001) directly cites Bertolucci's *The Last Emperor*.[24] In fact, the story concerns a famous director, Ron Tyler (Donald Sutherland), in Beijing to remake Bertolucci's epic. The plot, however, more closely follows that of another film about an aging Western auteur who attempts to remake a classic film with a Chinese lead, Olivier Assayas's *Irma Vep* (1996), which will be discussed in greater detail in chapter 5. Both films feature directors associated with the cinematic past who try to refresh their careers by turning to China. They fall short in their ambitions, collapse, and need to be replaced for the films to continue in risibly compromised forms.

With the symbolic "death" of the Western auteur, global cinema and Chinese filmmakers take a different turn away from the modern into the realm of the postmodern. Whether it is the scratched surface of Maggie Cheung's face

citing Stan Brakhage at the end of *Irma Vep* or the funereal product placements and garish billboards of *Big Shot's Funeral,* the spectacle replaces the gravity of the modernist past. Critique of the culture industry, the society of the spectacle, and the commodification of the cinema lingers but without the "authority" of the Euro-American auteur to shore it up. A coherent political vision becomes elusive, and films slip between satire and commercial complicity, anger and Orientalism, and the underground and the marketplace. As Jameson points out, postmodernism represents the cultural form of late capitalism, and David Harvey posits the PRC's post-Mao Reform Era as a model for neoliberalism. In this era of global capitalism, then, *Irma Vep* and *Big Shot's Funeral* visualize the circulation of "China" as an object, self-reflexively comment on the transnational conditions that allow for these visual flows, and gesture toward a critique of the vacuity of the consumerist societies they engender.

Citing China deals with work by filmmakers comfortable with the contradictions of postmodern culture. Feng Xiaogang's alter ego Yo Yo (Ge You), who moves from documentary practitioner, originally hired to do a "making of" tribute to Tyler's film, to entertainment entrepreneur in *Big Shot's Funeral,* provides a comic case in point.[25] These transnational filmmakers cross borders—intellectual and aesthetic. They actively engage with ideas outside their own native linguistic, national, social, and cultural domains. Often multilingual and cross-culturally competent, they feel compelled to work across cinematic divides for a wide range of reasons. They use the medium of the motion picture to engage critically with the society at large and, specifically, China's position within global film culture. Thinking through the concept of "China" and attempting a way of "seeing" things Chinese link them.

Renowned Chinese auteurs, such as Jia Zhangke, Chen Kaige, Ang Lee, Ann Hui, Tsai Ming-liang, and Hou Hsiao-hsien, may, in fact, have quite a lot in common with Feng's fictional Yo Yo. Their work bridges Asia and the West, and they navigate not only culturally alien environments, but also the vicissitudes of the film marketplace and the varying tastes of its cultural mavens. Their films must circulate buffeted by accusations of being derivative, lacking in original genius, and flawed by self-Orientalism, as well as an even more constraining inability to connect with world cinema and its established aesthetic expectations if they fail to conform to what an authentic "Chinese" film should be. In Hou Hsiao-hsien's *Café Lumière* (2003) and *Flight of the Red Balloon* (2007), for example, the various ways these films negotiate a space between Chinese-language filmmaking in Taiwan and the legacy of global art cinema become readily apparent.[26] Hou stepped out of what could be said to be his "comfort zone" by agreeing to make these films outside of Taiwan—using languages he does not speak. In this regard, they are case studies in how ethnic Chinese filmmakers travel within the orbit of world

cinema without being assimilated and the politics that define their place in post-modern culture.

The title of *Café Lumière*, of course, conjures up the origins of the motion picture through the invocation of the "Lumière" name and its continuing connection to not only French light and shadows, but also cinema's global dimension since the first encounters with the cinema in many countries came through the intrepid wanderings of Lumière cinematographers. In this case, Hou links French and Japanese cinema imaginatively through the title of the film. The compositions self-consciously conjure up Ozu (the film, in fact, was commissioned to celebrate the one hundredth anniversary of Ozu's birth). As the production context parallels the film's narrative, Hou positions himself (and, by extension, Taiwanese and/or Chinese cinema) as the bastard fetus in the womb of Yoko (Yo Hitoto), who returns—knocked up—from a research trip to Taiwan to trace the career of transnational composer Jiang Wen-Ye. Yoko's friend, Hajime (Tadanobu Asano), a sound recording artist, helps her, and, ironically, Hou looks at the city through the eyes of Ozu and listens to Japan through the ears of Jiang without understanding the language. Taiwanese composer Jiang functioned as Japanese during the colonial period, but he moved to mainland China after the war and lived through the ups and downs of Mao's China and into the post-Mao era (he died in 1983). Jiang's music, much like Hou's film, draws on European modernism as part of a Taiwanese aesthetic sensibility located between Japan and the PRC. By the time Hou made *Café Lumière*, of course, he had himself become an international cinematic "institution"—perhaps as widely known, at least in film festival circuits, as the Lumière Brothers and Ozu. Asian filmmakers pay homage to Hou in their films (e.g., Jia Zhangke and Hirozaku Kore-eda, among many others), and Hou responds by repositioning his work in a changing global frame.

This transnational repositioning can be seen very clearly in *Flight of the Red Balloon*. Another commissioned work, Hou made this film to mark the twentieth anniversary of the *Musée d'Orsay* in Paris. To this end, the sponsor required that at least part of the film be set in the museum, and Hou chose to incorporate a school field trip to view Félix Vallotton's painting, "Le ballon." The painting finds its cinematic parallel in Albert Lamorisse's *The Red Balloon* (1956). Just as Hou finds his eyes through Ozu and the Lumière Brothers and his ears through Jiang in Tokyo in *Café Lumière*, he looks at Paris through the perspective of Lamorisse, who, in his turn, conjured up the working-class milieu of Dimitri Kirsanoff's *Menilmontant* (1924), through the charm of a boy's relationship with a balloon. André Bazin famously calls the Lamorisse film "an imaginary documentary,"[27] praising it for eschewing montage in favor of the long take, and much the same could be said of the aesthetic Hou brings to his version. The ethnic Chinese director, then, brings fresh but infantilized eyes to European classics. Hou's film draws on the childlike vision

of Lamorisse's original, but it expands to include an adult perspective on child-hood as well, an addition that places Hou in the place of the appreciative connois-seur of French visual culture. The position of Song Fang, the young, ethnic Chinese filmmaker, as an *au pair* in Paris, in fact, parallels Hou's role as a caretaker of world film culture. PRC-born Song Fang essentially plays herself as an aspiring young Chinese filmmaker honing her craft in Europe (figure 1.3).[28]

Hou's connection to Taiwan surfaces through the inclusion of Ah Zhong, a Nanguan glove puppetmaster who lectures on the art of traditional Chinese pup-petry in France. Li Chuan-can (second son of Li Tien-lu, who was the puppeteer in Hou's *The Puppetmaster* [1993]), essentially plays himself.[29] By including Tai-wanese puppets, Hou self-consciously draws attention to his oeuvre. Song trans-lates for Ah Zhong and a French admirer of Chinese puppetry, Suzanne (Juliette Binoche), who also employs her as an *au pair* for her son. In the exchange, which takes place on a train (conjuring up Ozu and a common visual obsession), two visions of contemporary Chinese cinema surface. The established craft associ-ated with Hou finds its parallel in Ah Zhong, with Taiwan functioning as a cus-todian of traditional Chinese culture through the puppets. The mainland Song's rising red balloon—concretized by the DV (digital video) film she works on us-ing her computer, citing and superseding the French original—points Hou in a different direction. Song's presence, indeed, further clarifies Hou's position. He hovers between China and the West, the postmodern moment and the tradi-tional past, between the younger generation of mainland Chinese filmmakers and the graying artists of Taiwan New Cinema.

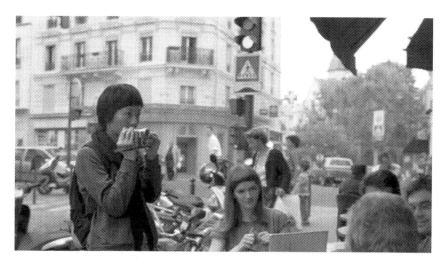

Figure 1.3. Song Fang (as herself) in *The Flight of the Red Balloon*; dir. Hou Hsiao-hsien, 2007.

Flight of the Red Balloon clearly bulges with intertextual references to Post-Impressionist painting (Félix Vallotton), postwar French (Lamorisse) and Japanese (Ozu) cinema, the French New Wave, Taiwan New Cinema, Hou's oeuvre, China's new independent filmmakers (Song Fang), and Juliette Binoche's transnational acting career. These references bounce off each other, manufacturing and obscuring potential interpretations, creating a palimpsest that occludes the original sources while juxtaposing citations that may provide new associations and significations. If we move from its original commission by the Musée d'Orsay through its screening at festivals such as Cannes and Locarno, it seems clear that the film operates as much as a "production" or performance as a text. Rather than our looking for "meaning" through textual exegesis, it therefore makes sense to search for the film's "politics" in its commissioned production, festival circulation, and exhibition. The intertextual web that Hou creates in *Flight of the Red Balloon* allows for such a search. A reminder of the film's provenance is embedded in virtually every shot—from the titular homage to Lamorisse's classic to the sponsor's payoff through the school trip to the museum. However, the film also performs its role as an international art film—a meeting place of the cosmopolitan actress Binoche with the Asian auteur Hou. It recognizes the global worth of French culture as reflected in or refracted through Taiwan New Cinema.

The citations match potential screening locations—museums (d'Orsay), festivals (Cannes, where *The Red Balloon* won the Palme d'Or in 1956), classrooms (the school group's discussion of the Vallotton painting, the educational seminar for puppeteers), and avant-garde performance venues (the puppet theater). These intertextual references also provide a specific way of seeing/reading the film for programmers, publicists, and curators—as art ("Le ballon"), as film (*The Red Balloon*), as performance (Binoche), and as part of Hou's oeuvre (*The Puppetmaster*). It confirms the importance of the past (Post-Impressionism, classic French cinema, Taiwanese puppetry) and points to the future (digital cinema) while confirming Hou's importance in the present. In other words, it serves as a fitting complement to Hou's recognition by the cinéastes in the film festival circuit. It pays tribute to European precedents, acknowledges the emergence of the new (mainland China and digital cinema through Song), and finds a perfect niche as "world cinema." The European festival has opened its home to Asian cinema just as Suzanne (Binoche) has opened her apartment to the *au pair* Song. Servant, companion, filmmaker, artist, and translator, Song, a mainland Chinese film student, floats somewhere above as well as below her two employers (Suzanne onscreen and Hou offscreen). Ostensibly hired to babysit Suzanne's son Simon, she also needs to take care of Suzanne as translator and likely of Hou, who speaks no French. Compared to the garrulous Suzanne, Song is quite silent, more at home in the speechless world of Lamorisse's *The Red Balloon* than in the plotline involving

Suzanne's complicated domestic life. Hou drifts above it all—mimicking the long takes and long shots of classic French cinema, channeling Ozu's trains and box-like interiors, basking in the glory of traditional Chinese puppet theater, and also giving in to his actresses—to Binoche's talent for improvisation and Song's for playing herself, mediating between the French and Chinese languages and aesthetic sensibilities.

Although Hou is no stranger to female-centered narratives (as *Café Lumière* certainly shows) and he has collaborated successfully throughout the preponderance of his career with female screenwriter Chu T'ien-wen, *Flight of the Red Balloon* places him at the mercy of his two principal actresses in ways unprecedented in his career. They perform in a film he cannot completely comprehend. The parallels to the Taiwanese puppetmaster are telling. The puppeteer can only hope the French interpretation of the Chinese stories of white-haired witches, young scholars, and dragons makes some sense across the linguistic, cultural, and historical divides, just as Hou surely must hope for the best as he gives up a certain control over meaning to Binoche, Song, and his French sponsors.

It is apposite that *Flight of the Red Balloon* should be based on a children's film classic since at several points it addresses the viewer as a child. At a certain level, in fact, Hou's film serves as a primer on how to appreciate it, and it can be approached as a pedagogical exercise. The film provides various models for its student viewers. Suzanne studies Chinese puppetry, Song learns filmmaking, Simon practices painting, and the audience is tutored in cross-cultural art appreciation. The commission also follows a certain logic. It seems reasonable to get a fresh vantage point on French culture enshrined in national museums and film archives through non-Western eyes so that cultivated, cosmopolitan viewers appreciate anew the Musée d'Orsay, Lamorisse, and Binoche through Hou's eyes. Hou instructs Asian audiences as well. He champions the young PRC filmmaker Song and acclimatizes her to the world beyond the Beijing Film Academy. Following Simon and the balloon through the streets of Paris, she seems quite far from the more acerbic views of contemporary urban life in the films of Jia Zhangke, for example. Hou softens Chinese cinema and brings it into the orbit of global cinema through French film aesthetics and his own cinematic sensibility.

Hou, in fact, seems to take some of the bite out of the original as he highlights the magic of filmmaking, the bittersweet qualities of childhood, and the adult perspective on growing up. A great deal of the power of Lamorisse's film comes from its links to the working-class district of Montmartre and its resonance with the Nazi occupation. Prefiguring François Truffaut's *The 400 Blows* (*Les quatre cents coups,* 1959), it takes up youthful frustration with authority at a much more profound and visceral level.[30] The closed doors of the school and church, the cool disdain or disregard of the adult figures, the isolation of the boy,

and the violent demise of the balloon at the hands of a mob of bullies seem to speak to France's Fascist past—to occupation and collaboration—and the balloon to resistance, freedom, and hope. The fact that the balloon finds its rebirth in numbers is quite different from Hou's more abstract and formal appreciation of the balloon framed by the museum's modernist ceiling beams as part of a circle of crimson in contrast to the strong, dark, perpendicular lines. Hou's red balloon stands more for the cinema than for the political past or present—a nostalgic nod to a French classic, an evocation of national cultural greatness, a passing swipe at the PRC as perpetually in need of tuition in order to "catch up" with the West, as a fragile red orb filled with hot air (and quite far from the "red sun" that inspired an older generation of French Maoists). Lamorisse's working-class neighborhood is gentrified, and Suzanne's incessant banter about trying to evict the bohemians squatting in her rental property bring the source into the bourgeois world of established artists, educated *au pairs,* and upscale domiciles. Freed of its earlier proletarian, anti-Fascist political connotations, *The Red Balloon* flies free to serve in another capacity in Hou's tribute.

In taking up the children's film as its primary reference, Hou's film infantilizes the spectator. As Song holds Simon's hand through filming in the streets of Paris and as his piano teacher takes him through his music exercises, Hou guides the viewer through the film—literally explaining the nuances of Vallotton's painting (during the curator's discussion with Simon's class during the field trip), the magic of Lamorisse's special effects (through Song's explanation of the use of digital effects in her own version of *The Red Balloon*) (figure 1.4), and the

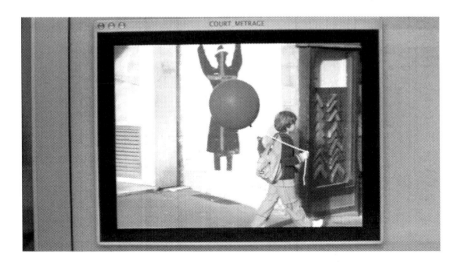

Figure 1.4. Song Fang's Red Balloon. The Flight of the Red Balloon; dir. Hou Hsiao-hsien, 2007.

intricacies of Chinese puppetry (during the seminar), while showcasing Binoche's acting talents and his own authorial signature. Cultural exchange takes place through kids' classics (puppets and children's films), and women's artistic endeavors remain at that level—not as masters of puppetry or the filmmaking craft but as students of Taiwanese traditional theater and European film. Hou maintains his dignity as a filmmaker by standing in as the puppetmaster and absent filmmaker—as Binoche's and Song's off-screen teacher and director. He may not know exactly what is going on, but he ultimately pulls the strings and serves as the master craftsman of the film on screen. He acquires the accolades, and the others accept his tuition.

The film's presentation at the 2007 Locarno International Film Festival—where the director received the Leopard of Honor, the Swiss festival's "life achievement award"—highlights the tensions imbedded in the fiction even more. Edward Yang had passed away a few weeks before the festival began, and the posthumous tribute to his career in Locarno underscored the importance of Taiwan New Cinema to the international film festival circuit and global film culture. (The fact that *Flight of the Red Balloon* includes a version of "Forgotten Times," a song made famous by Yang's ex-wife, Taiwanese chanteuse Tsai Chin, creates an onscreen link to his memory.)[31] As PRC film grows in prestige on world screens, Taiwan's role at the cutting edge of film art changes. As a putative "part" of as well as effectively and affectively quite separate from "China," Taiwanese filmmakers find themselves in a privileged position to observe the "rise of China" on world screens. How Hou launched his *Flight of the Red Balloon*, then, provides a way of understanding the role aesthetics, politics, and film history play in the encounter between China and the West in global cinema. Hou's forays into Japanese and French filmmaking provide only two examples of the ways in which the postmodern realm of global aesthetics encounters what Sheldon Lu has called "transnational Chinese cinema" on increasingly unsettled turf.[32]

Citing China connects close analyses of the motion pictures under consideration to the cultural context, aesthetic legacy, and intellectual history that shaped them. The principal methodology of the study involves textual analysis and ideological critique of individual films coupled with examinations of institutional, political, economic, and social contexts. It takes as its starting point a fundamental commitment to understanding the intricacies of geopolitical encounters mediated through the art of the cinema.

This book looks at very conscious aesthetic and political intertextual encounters in which filmmakers take up positions, aware of the history of the cinematic images that precede them. The book operates with Roland Barthes in mind as he notes the following about intertextuality: "The intertextual in which every text is held, it itself being the text-between of another text, is not to be con-

fused with some origin of the text: to try to find the 'sources,' the 'influences' of a work, is to fall in with the myth of filiation; the citations which go to make up a text are anonymous, untraceable, and yet already read: they are quotations without inverted commas."[33]

As noted above, Barthes developed his ideas about intertextuality at the same time his political thinking was evolving through his encounter with Brecht, modernity, radical politics, and Asian culture. Roland Barthes, Julia Kristeva, Philippe Sollers, and other French literary theorists thought about intertextuality through their interest in Asia generally and Chinese politics more specifically. (I examine French intellectual circles in relation to China and intertextuality in more detail in chapter 5.) Intertextuality presupposes a power differential between those cited and those in possession of the quoted material, particularly when those sources are "untraceable." This intertextuality demands an approach that takes power differentials into consideration but also looks for points of solidarity, creative exchange, and collective critique. A common ground exists, and this aspect of screen history has been truncated, diffused, and dispersed so that the unifying principle at work behind these phenomena has received insufficient attention.

Since Geoffrey Nowell-Smith chronicled the history of world cinema in 1996,[34] the cinematic atlas, as Dudley Andrew notes, has been redrawn,[35] and scholars as diverse as Shohini Chaudhuri; Stephanie Dennison and Song Hwee Lim; Nataša Ďurovičová and Kathleen Newman; and Lúcia Nagib, Chris Perriam, and Rajinder Dudrah have remapped the transnational connections that define the globalized film culture of the twenty-first century.[36] Hamid Naficy hears new "accents" within world cinema, and transnational flows highlight different connections across film texts.[37] As I draw on the work of Ella Shohat and Robert Stam, a method emerges in which films can be analyzed across cultural, economic, and political divisions. Influenced by Russian literary scholar Mikhail Bakhtin, Shohat and Stam demonstrate in their work on cinema and Eurocentrism the complexity of citations, intertextuality, dialogism, and polyphony, which frame any attempt at cross-cultural cinematic exchange. Transnational encounters shape film history, but the intimacy of these contacts, as John Hess and Patricia Zimmermann note, contributes to new types of political practices in contemporary global media.[38] Films navigate a path of resistance as well as influence, and this connection is taken seriously as I explore specific films in this book.

My analyses follow a path charted by Robert Kolker in *The Altering Eye* and John Orr in *Cinema and Modernity*.[39] Kolker and Orr, in their distinct ways, look broadly across the expanse of post–World War II world cinema in order to spotlight the connections between modernist film aesthetics and progressive politics. Although *Citing China* remains more limited in scope since it looks only at films involving China, it attempts to travel a similar route by making clear the links

between politics and world film. Jenny Kwok Wah Lau, in her introduction to *Multiple Modernities: Cinemas and Popular Media in Transcultural East Asia,* poses the following challenge concerning new Asian cultural identities: "If modernity is an attitude rather than an epoch... [the] new Asia that is currently in formation will consist of not one uniform modernity but multiple modernities that defy both the prescriptions of the globalists/universalists and the descriptions of the localists/indigenists. Consequently, it is important to ask what these 'multiple modernities' are and how they may continue to define Asian identities."[40] As this consideration of recent cinema demonstrates, "China" in world film does not attempt to confine modernity to a single defining force. Rather, various approaches to modernity surface in relation to a wide range of political, social, and cultural circumstances.

The films in this book negotiate this contradiction through a common bond that transcends the politics of the nation. They share a critical vision in opposition to capitalism and imperialism; in support of "human rights," feminist, or lesbian, gay, bisexual, transgender, and queer (LGBTQ) causes; or as a counter to global commercial cinema and its deadening impact on the development of film aesthetics. In other words, these filmmakers, in one way or another, see themselves as engaging in a transnational conversation involving a common politics or aesthetic avant-gardism. With the intensification of the mediation of culture and politics through the medium of the motion picture, these films find support at film festivals, on the Internet, on DVDs (legitimate as well as pirated), and within the niche markets associated with art films appealing to specialized audiences with specific interests and tastes.

The films analyzed here liberally draw on past connections between China and the international film community, from the Soviet avant-garde to classical Hollywood cinema. Key historical points of reference haunt these films—namely, the relationship between China's 1911 and Russia's 1917 revolutions; world reaction to Japanese imperialist expansion into Chinese territory through 1945; the establishment of the PRC in 1949 and its place in the Cold War; Hong Kong and Taiwan as imagined "other" Chinas within the legacy of Cold War politics; the Cultural Revolution (1966–1976); the consequences of martial law in Taiwan and British colonial rule in Hong Kong; the legacy of the world's Chinatowns as screen icons and the impact of the emergence of the Chinese diaspora as a global economic, political, and cultural force; the use, reuse, and re-imagination of more recent political events that have left an indelible mark on global Chinese screens, including the end of martial law and the rise of the Democratic Progressive Party in Taiwan, the events of May–June 1989 in Tian'anmen, the change of sovereignty of Hong Kong in 1997, the emergence of the pan-democrats in the Hong Kong Special Administrative Region (HKSAR), including the 2014 Um-

brella Movement, and the consequences of the growth of neoliberalism in the PRC under the auspices of Deng Xiaoping and his successors. The motion picture images associated with all these events continue to be recycled and redeployed in contemporary world cinema. This book looks at only a fraction of these films by bracketing those works that have taken up motion pictures associated with progressive political movements, cultural critique, and aesthetic experimentation. Palimpsests consisting of historical, cultural, and aesthetic layers, these films engage with a global visual culture involving China and things Chinese that evoke radical, revolutionary, or renegade impulses from the common ground of Marxist politics and Popular Front sentiments to New Left, feminist, anti-imperialist, anti-colonial, and LGBTQ transnational movements.

A history of "East is East and West is West" in popular culture looks suspiciously at attempts to construct any sort of constructive bonds (aesthetic or otherwise) across the chasm of "culture," "race," or "civilization." Even politically engaged analyses of these encounters are often highly self-critical and question the value of peering beyond the aesthetics of subversion, antithesis, and mimicry to something that may contain a critical solidarity, a shared aesthetic project, or another sort of political common ground. Without underestimating the very real inequities of Chinese encounters with Euro-American cinematic traditions, not all of these cinematic links can be reduced to ventriloquism, derivative imitation, inferior translation, commercial pressures, or cultural imperialism. Rather, from Marxist attempts at global solidarities (the art of the "workers of the world" in the process of uniting against capitalism) to transcendental spiritual quests that implicitly critique commercial film aesthetics, there has been a consistent and intense conversation among (rather than between) film theorists and practitioners involved in Chinese screen culture and depictions of China on film. Mutual understanding exists, and this aspect of screen history has been truncated, diffused, and dispersed so that the unifying aspect of these connections has received insufficient attention. Within a critical interrogation of film aesthetics, building on what Eisenstein, Pudovkin, Brecht, and Godard have taken from Chinese politics and art, filmmakers inside and outside the Chinese-speaking world continue to contribute to this ongoing cultivation of subversive voices within commercial cinema, as renegades within film culture or as interlocutors of a distinct sensibility that offsets the status quo.

As it is fruitless to look for the "real" East or West in any of these encounters, it is equally fallacious to erase history and politics and take a global, commercial, homogenized, de-territorialized cinema for granted. As transnational political and economic formations proliferate, as awareness of the hybridized nature of culture becomes better understood, and as essentialism bites the dust, the fact of "difference" (along lines however mythic or imaginary of East/West, North/

South, China/the rest) persists. Consequently, these differences are debated, used, abused, and interrogated by filmmakers as the image of "China" emerges in all its impossibility and with all its contradictions on world screens.

The connections among these films and filmmakers, the interrelationships among the textual layers within the films themselves, and the ways in which these films function within current global cinema culture become part of a complex web of associations that needs to be carefully scrutinized to develop a better understanding of contemporary transnational Chinese cinema within world film history. While some of these links have been discussed by other scholars, no study exists that attempts to bring these connections to the forefront and provide the historical depth necessary to reposition contemporary Chinese-language film within the history of global political film culture. This book highlights those neglected links and the impact this history has on contemporary film culture.

Beginning with early Soviet montage filmmaking as a defining moment of world cinema in deep conversation with Asian aesthetics and Chinese theatrical traditions as it shapes Jia Zhangke's film *The World* (2004) the book turns to recent films that cite other major currents in the history of world cinema. Attention turns from Italian Neorealism and its importance to the Chinese Sixth Generation to the French New Wave's ripple effect on filmmakers associated with the Hong Kong New Wave and Taiwan New Cinema. The connections between Brecht's and Godard's interest in China find expression in films by Ann Hui, Evans Chan, and (more obliquely) Tsai Ming-liang and Jia Zhangke. As we turn from global art cinema to popular film, genres such as the martial arts film and the romantic thriller circulate within and beyond the international festival circuit to challenge Hollywood's claims to world dominion. As the PRC tilts the world on its axis with its increased global economic clout, filmmakers draw on Euro-American formulae to attract new viewers and define cinematic pleasures for new audiences on the other side of the globe. The choice of film considered here, however, highlights the geopolitical nature of these transnational citations. While many co-productions attempt to address the "rise" of China as a force in contemporary cinema, not all of them highlight issues of race and migration as clearly as *Unleashed* (a.k.a. *Danny the Dog;* dir. Louis Leterrier, 2005) or the gendered politics of the Chinese diaspora as forcefully as *Like a Dream* (*Ru meng,* 2009). *Citing China* concludes with a consideration of the role film festivals, women filmmakers, and emerging audiences play in the new world of global cinema.

Chapter Outline

Building on this introduction, *Citing China* continues in chapter 2 by exploring Jia Zhangke's *The World* as a site of citations that links it to the roots of modern

film. This analysis highlights the connections between Russian/Soviet film and the way in which contemporary Chinese filmmakers such as Jia situate themselves within the landscape of global film culture. Particular attention is given to silent films set in Central Asia, such as Pudovkin's *Storm over Asia: The Heir to Genghis Khan* (1928), and Eisenstein's use of Chinese art and culture to formulate his theory of montage as a means of investigating Jia's oeuvre. Central Asia as a presence in Chinese filmmaking (particularly within the ethnic minority genre) and Russia as a cinematic and cultural force (both before and after the Sino-Soviet split) pokes through the map of Jia's *The World*. With this in mind, the chapter follows a slightly different map of world cinema by focusing on Ulan Bator rather than Paris, Rome, New York, or Tokyo and linking Mongolia, through the old northern Silk Road and the Mongol empire, from China and Russia to Venice, where the film had its premiere.

Chapter 3 continues this exploration of contemporary Chinese cinema in relation to the "real" by highlighting another way in which a surface "realism" belies other aesthetic antecedents. For example, Italian Neorealism's influence on the Hong Kong New Wave, Taiwan New Cinema, and the films of China's Sixth Generation (e.g., Wang Xiaoshuai's *Beijing Bicycle,* 2001) has been duly noted; however, the impact of other cinematic traditions has not been given the same critical scrutiny. One omission has been Robert Bresson and what Paul Schrader has termed the "transcendental style." By looking at another film by Jia Zhangke, *Xiao Wu* (*Pickpocket,* 1997), and Hong Kong New Wave filmmaker Patrick Tam's *After This Our Exile* (2006), this chapter explores the complex connections among realist aesthetics after Neorealism, the global dimensions of the transcendental style, and the current state of transnational Chinese cinema.

Chapter 4 takes a different turn by looking at the continuing impact Bertolt Brecht's theories of epic theater have had on Chinese-language cinema. This chapter examines two films by Ann Hui and Evans Chan, both of which draw on Augustine Mok's agit-prop street theater performance narrating the life of Hong Kong political radical Wu Zhongxian. Each filmmaker takes a different approach to the Brechtian implications of incorporating political theater within cinematic practice. Given Brecht's interest in Chinese politics and Peking Opera, the ways in which Hui and Chan reconsider Brecht's legacy in Hong Kong cinema provide food for thought on the complex intertextual connections among Chinese culture, Western modernism, and left-wing politics.

Chapter 5 spotlights sexual politics in films dealing with Euro-Chinese subject matter. With Brecht as a starting point again, the focus here moves to Jean-Luc Godard's interest in Brecht and Chinese politics. Since Godard's *La chinoise* (*The Chinese Woman,* 1967) began a political engagement with *la chinoise* during the height of Mao's Cultural Revolution, the French interpretation of Maoism and the visual, visceral impact of the Red Guards on world cinema have been

inextricably linked to Godard; his "surrogate," Jean-Pierre Léaud; and the representation of Chinese women on world screens. This chapter explores Godard's visual and intellectual engagement with Mao within the context of French politics, Pop Art, sexuality, and global film. It analyzes the implications of imagining Chinese Maoism as "feminine" and situates Godard's film within subsequent debates among French intellectuals (e.g., Julia Kristeva and Philippe Sollers) and filmmakers involving Mao's China. This chapter uses this analysis of *La chinoise* as a springboard to explore subsequent representations of the Cultural Revolution and Chinese femininity in transnational cinema. To do so, the analysis draws on a number of films, including Godard's *La chinoise*, Olivier Assayas's *Irma Vep*, and Tsai Ming-liang's *What Time Is It There? (Ni na bian ji dian?*, 2001) and *Visage (Face*, 2009), all starring Jean-Pierre Léaud, against the backdrop of Maoism in France, the evolution of the French New Wave in the 1960s, and subsequent reconsiderations of both in contemporary films.

In chapter 6, the emphasis shifts to questions of race, (post) colonialism, immigration, masculinity, and violence through a consideration of the legacy of Bruce Lee in world cinema. Scholars such as Leon Hunt and Pang Laikwan note that "copies" of Bruce Lee circulate very differently across borders and historical periods.[41] Although Bruce Lee has been claimed as a local Hong Kong star, as a symbol of Chinese nationalism, and as an icon of Asian American masculinity, a case can be made that Lee embodies a particular moment within the Chinese diaspora as a global figure of resistance. The setting of his only completed directorial effort in Rome indicates Lee's perception of himself as a figure who had the potential to transcend the confines of the Chinese nation. This chapter explores the background of *Way of the Dragon (Meng long guo jiang*, 1972) in relation to its Italian setting and looks at a recent transnational reconfiguration of the figure of the Chinese immigrant in global cinema, *Unleashed*. The Jet Li vehicle, set in Glasgow and scripted by French action auteur Luc Besson, takes up themes strikingly similar to the Bruce Lee film and provides a point of comparison to look at changing attitudes toward race and Chinese immigration on screen.

Chapter 7 sheds light on the continuing importance of another seminal figure in world cinema—Alfred Hitchcock—who has anchored so many of the vertiginous citations that characterize postmodern film culture. Although she claims no conscious connection, Hong Kong–Australian filmmaker Clara Law's *Like a Dream* (2009) features a narrative quite similar to Alfred Hitchcock's *Vertigo* (1958). Asian American star Daniel Wu portrays a New York–based computer designer who becomes obsessed with a mainland Chinese woman he knows only from his dreams. Within a postmodern aesthetic, it weaves elements from *Vertigo*, *The Double Life of Veronique (La double vie de Véronique*; dir. Krzysztof Kieślowski, 1991), *La jetée (The pier*; dir. Chris Marker, 1962), and

other classics about obsession, delusions, and dual identities in order to explore the politics of identity constructed between the United States and China. Known for her interest in the Chinese diaspora and melodramas about migration, Clara Law brings her distinctive fascination with subjectivity, the surreal, and the grotesque to this interrogation of the relationship between the American and Chinese dream. Examining this feature alongside its accompanying short, *Red Earth* (*Chidi*, 2010), this chapter shows how global film comments on contemporary tensions between America and China. Ending with Clara Law's contribution to contemporary world film also highlights the way in which cosmopolitan, Chinese-speaking women filmmakers continue to tilt the cinematic globe on its axis in significant ways.[42]

The book concludes with remarks on the rapidly shifting relationship between Chinese-language cinema and global film culture. The economic domination of neoliberalism and the political impotence of the radical tradition, which engendered so much of the aesthetic conversation that took place between China and the West on global screens in the past, indicate that film's place within public debate has also changed. *Citing China* draws to an end by examining whether the aesthetic/political legacy referenced in contemporary postmodern cinema serves only as the residue of a past moment in a history of resistance or remains potent as a visible critique that creates new points of solidarity between filmmakers in China and the rest of the world.

Storms over Asia

Mongolia, Montage Aesthetics,
and Jia Zhangke's The World

Set in a Chinese theme park that replicates major architectural monuments in miniature, Jia Zhangke's *The World* engages with the concept of the "world" in ways that go beyond the film's physical location. Its characters' complex transnational associations, for instance, link them to various provinces of China, as well as Russia, France, and Mongolia. However, the film's title also stakes a claim to the "world" as "world cinema," from the historical roots of its images in the international development of the medium, as well as the institutions that support its circulation, such as film festivals. In this regard, *The World* partakes in a conversation similar to the one taken up by Jia's other films, such as *I Wish I Knew,* discussed in chapter 1, and *Xiao Wu,* the subject of chapter 3. In the case of *The World,* Jia contemplates the way in which screen culture shrinks the globe in the same way that the theme park can bring the Taj Mahal and the Eiffel Tower together physically.

In his monograph *Cartographic Cinema,* Tom Conley argues that certain film auteurs display a "cartographic consciousness" as they map out a world on screen.[1] Taking Jia as its cartographer, *The World* serves as a virtual "map" similar to what Jean Baudrillard, citing Jorge Luis Borges, sees as a blanketing hyperreality. Borges imagines a map the size of the empire it represents, but Baudrillard goes a step further to note that the referent has become redundant:

> Abstraction today is no longer that of the map, the double, the mirror or the concept. Simulation is no longer that of a territory, a referential being or a substance. It is the generation by models of a real without origin or reality: a hyperreal. The territory no longer precedes the map, nor survives it. Henceforth, it is the map that precedes the territory—precession of simulacra—it is the map that engenders the territory and if we were to revive the fable today, it would be the territory whose shreds are slowly rotting across the map. It is the real, and not the map, whose vestiges subsist here and there, in the deserts which are no longer those of the Empire, but our own. The desert of the real itself.[2]

The cinema mirrors the theme park as a place where the references to the "real" no longer carry any weight and a visit to the miniature monuments replaces Chinese tourists' inability to get visas to see them in other countries. Ironically, of course, the migrant workers shown in the film have little time for sightseeing as they travel from Russia to China, from China to Mongolia and Europe, or internally from province to capital.

The park shrinks the "world" so that it can fit within the confines of a metropolitan attraction and provides its own orientation, which has little to do with geographic accuracy. With deliberate disregard for the way his map distorts the globe, Jia questions the coordinates normally used to imagine the "world." Western Europe and Latin America slide off to the side, and Beijing moves to the center of the "middle kingdom," not only as the literal "northern" capital, but also as its earlier incarnation, Dadu, the "big" capital of the Yuan dynasty, which was the eastern edge of the vast expanses of the Mongol Empire. By referring to the Eurasian steppes, Jia also charts a post-socialist politics of globalization after 1989–1991—with respect to the circulation of people and goods—including films. Global film culture can be reoriented to place *The World* aesthetically closer to Soviet and Central Asian film theory and history and shrink the monuments of the West down to size (as they are in the Beijing and Shenzhen theme parks the film uses as shooting locations).

The World and World Cinema

The film's title betrays its globalizing ambitions, and Jia's *The World,* on one level, takes up the vast panoply of issues facing post-Mao China's entry into the World Trade Organization (WTO) in 2001. The allegorical significance of the displaced characters' encounters with the "flat," "small" world of global capitalism and neoliberal deregulation finds its graphic expression in the mise-en-scène (the arrangement of the visual composition). The "great" walls that isolated (and protected) China within its borders crack open to reveal the plight of migrant labor, the degradation of the environment, the overvaluation of consumer goods, and a society under the constant surveillance of the tourist's gaze. In an interview, Jia mentions that the theme park, meant to entertain, actually makes him melancholy:

> I think those sorts of environments, those artificial landscapes, are very significant. The landscape in the World Park includes famous sights from all over the world. They're not real, but still they can satisfy people's longing for the world. They reflect the very strong curiosity of people in this country, and the

interest they have in becoming a part of international culture. At the same time, this is a very strange way to fulfil these demands. To me, it makes for a very sorrowful scene. The World Parks in Shenzhen and Beijing might as well be the same place. Every time I went to one of the parks for the shooting, I saw all the tourists and how overjoyed they were to be there, and for me it was all very sad. How should I put it? This is what Chinese reality is like. And so, in the film, a lot of action takes place under the "Arc de Triomphe," or in front of the "Taj Mahal," or in "London," or in "Manhattan." Of course all of these landscapes are fake. But the problems our society faces are very much Chinese issues, and I think all this is not unrelated to that. We're living in a globalised age, in a world saturated by mass media, in an international city, as it were. But despite all that, the problems we're facing are our own problems. So these landscapes are intimately related to what's going on in the film.[3]

For Jia, the longing to be part of world culture finds satisfaction only in consumer spectacles and inauthentic experiences as social problems multiply.

In *The Communist Manifesto,* Marx and Engels observe a similar phenomenon as "civilization" becomes reduced to the commodity manufactured in the image of global capitalism:

The need of a constantly expanding market for its products chases the bourgeoisie over the entire surface of the globe. It must nestle everywhere, settle everywhere, establish connections everywhere....

The cheap prices of commodities are the heavy artillery with which it batters down all Chinese walls, with which it forces the barbarians' intensely obstinate hatred of foreigners to capitulate. It compels all nations, on pain of extinction, to adopt the bourgeois mode of production; it compels them to introduce what it calls civilisation into their midst, i.e., to become bourgeois themselves. In one word, it creates a world after its own image.[4]

Jia's *The World* pictures a society of the spectacle of consumption in which all the "Chinese walls" have, indeed, come down—even in Beijing. The film makes all this accessible and obvious. As Baudrillard might point out, everything is on display; nothing is hidden or obscure. The spectacle is what you see and what you get. As Godard would say, it is the "reality of the illusion" not the "illusion of reality" that matters.[5] Or, again, as Baudrillard puts it, "The illusion of our history opens onto the greatly more radical illusion of the world."[6]

Turning the map around and letting the ruins poke through reveals the importance of another cinematic tradition and another possible way of seeing *The World*. Much has (and can) be made of the Sixth Generation's return to the "real,"

and connections with Roberto Rossellini, Vittorio De Sica, and André Bazin seem apposite. Jason McGrath, for one, has done a fine job mapping out Jia's engagement with realism, which he sees as "exposing not opposing," by articulating a tension in the director's oeuvre between a "postsocialist critical realism" that attempts to strip away ideology and an "aestheticized long-take realism that became prominent in the global film festival and art house circuit by the late 1990s."[7] However, Jia Zhangke also quotes Jean-Luc Godard, Gus Van Sant, and Lars von Trier with his mobile camera, constructing a self-conscious vision, exploring the reality of the illusion through stories that revolve around performance spectacles. Jia addresses "the world" as "world cinema," and the film is littered with references to film history—some direct, some subtle, many as "structuring absences."

As *The World* is a Chinese (Xstream, Xinghui–Hong Kong, Shanghai Film Group), French (Lumen), and Japanese (Office Kitano) co-production, the use of the ersatz Eiffel Tower as a visual anchor within compositions that resemble Yasujirō Ozu's still, empty long shots comes as no surprise. (figure 2.1). However, Jia also includes whimsical animated segments that resemble Japanese popular anime, and the Eiffel Tower against the Beijing skyline becomes part of this flight of fancy through another cinematic idiom as well (figure 2.2). Jia makes it clear that he is putting on a "show" for his backers and for the international audiences who may see his film.

The Eiffel Tower, Arc de Triomphe, and Notre Dame look "real" because the characters have seen them all in the movies, and world film audiences can appreciate the cosmopolitan charm of Jia's cinematic citations. In fact, Jia makes self-critical connections between himself as a transnational filmmaker and the

Figure 2.1. Reference to Yasujirō Ozu's *Tokyo Story* (1953) in *The World*; dir. Jia Zhangke, 2004.

Figure 2.2. Flight of animated fancy in The World; dir. Jia Zhangke, 2004.

characters in his film. The Louis Vuitton brand-name goods come from a Chinese sweatshop devoted to knockoffs, while the garments in *Gomorrah* (dir. Matteo Garrone, 2008) and the tainted milk in *Something Good* (dir. Luca Barbareschi, 2013) function in a similar way in the Italian iteration of this theme, which links Europe to China through the excesses of capitalism. Jia's film self-reflexively comments on its own status as a commodity that circulates in the global marketplace as another version of the type of "art film" found on the international film festival circuit. *The World* hints at the fear that no matter how accomplished, the Chinese director remains relegated to the realm of the "copy," working on the "cheap" to supply global screens with dubious goods. As a response to this anxiety, *The World* self-consciously weds film clichés with national stereotypes in a story that narrates both China's desire to position itself in the global economy and Jia's attempt to find his place in the world of cinema for the first time as an "above-ground," licensed filmmaker given official approval to (re)present China to the world. Like the characters who work in the theme park in the film, he must create a "world" that the domestic audiences want to see; however, he also offers insight into the "world" of China for the edification of his Western audiences as the film circulates internationally as a "festival" film.

As Dina Iordanova, Bill Nichols, Thomas Elsaesser, Marijke de Valck, Cindy Wong, and Felicia Chan (among others) have pointed out, the changing dynamics of international film festivals have changed the nature of "art film" production.[8] Elsaesser summarizes this as follows:

> For these films, international (i.e., European) festivals are the markets that can fix and assign different kinds of value, from touristic, politico-voyeuristic

curiosity to auteur status conferred on directors. Festivals such as Berlin and Rotterdam set in motion the circulation of new cultural capital, even beyond the prospect of economic circulation (art cinema distribution, television sale) by motivating critics to write about them and young audiences to study them in university seminars.[9]

Jia Zhangke's *The World* exhibits the traces of the need to circulate in this environment. To this end, on and off screen, Jia manages to acknowledge all his mentors and connect himself to many of the major filmmaking centers on the cutting edge of cinema as art and industry today. Jia, a known admirer of Vittorio De Sica's Neorealist classic *Bicycle Thieves* (1948), pits Hollywood glamour (*Roman Holiday*, 1953) against Cinecittà and the Italian art film by including the theme park copy of Rome's "Mouth of Truth" in his film. As an homage to Martin Scorsese (who has praised the Chinese director's work on a number of occasions),[10] Jia has his security guard protagonist, Taisheng (Chen Taisheng), sporting a leather jacket that would make him as much at home on the "mean streets" of New York as in the sweatshops of China, meet his hometown pals against the backdrop of the park's Manhattan—the Twin Towers unmolested in Beijing after 9/11 (figure 2.3).

Jia's aesthetic sampling and his own transnational connections parallel the movements of *The World*'s fictional characters. With musical compositions by Taiwan's Lim Giong, "Flathead" in Hou Hsiao-hsien's *Goodbye South Goodbye* (1996), and visions shaped by Hong Kong cinematographer Yu Lik-wai and producer Li Kit Ming, Jia Zhangke builds a transnational Chinese team to add aes-

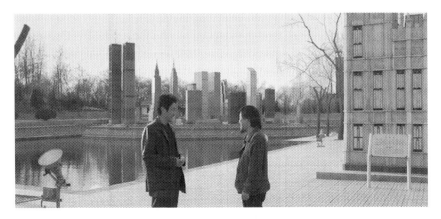

Figure 2.3. Taisheng (Cheng Taisheng) and Sanlai (Wang Hong-wei) in homage to Martin Scorsese's "mean streets" of New York City. The World; dir. Jia Zhangke, 2004.

thetic gravitas in his story about migrant labor in mainland China. In this globalized environment, the image of China as unified dissolves, and the provincial asserts itself against the nation as an imagined entity. Such an image often puts the domestic audience in the same position as the international viewer. As Sheldon Lu notes, Jia sticks with a polyglot approach to dialogue, and the characters (mis)communicate with one another in Shanxi and Wenzhou dialects, as well as in Russian and English.[11] Characters take up Mandarin by necessity in Beijing; however, the seats of power seem vacant, and the people have vanished from the "real" tourist destinations in the capital. Tian'anmen Square is empty in *The World,* while theme parks, sweatshops, and backroom mahjong parlors are booming. Beijing *hutongs* (narrow residential alleys) have been bulldozed to accommodate the ruins of Western civilization from Stonehenge to New York City's Twin Towers, and Jia's camera moves freely among the copies of the world's mausoleums—from the Pyramids to the Taj Mahal.

If Jia covers all the cinematic bases (Paris, Tokyo, New York, Rome), he also depicts all the requisite spaces and policies associated with Chinese neoliberalism—from the rise of consumerism and the service sector (the leisure industries of tourism, entertainment, and prostitution) to the reorganization of manufacturing (toward consumer goods, as seen in the garment business) and real estate (construction sites), privatization (private real estate holdings rather than communes, unlicensed sweatshops rather than state-owned factories, private security guards rather than the public police), new labor relations and the emergence of new class hierarchies (the managerial class over the workers, documented over "unofficial" migrant labor), and the re-gendering of the work force (reemergence of male privilege, availability of prostitutes, and workplace sexual harassment). New mobility marks the new economy. Jia travels with *The World* around the globe, brands come from the West and travel back as pirated commodities, and his characters travel across China to Mongolia and from Russia to the PRC.

The characters all come from elsewhere, and the theme park provides the space for the drama of their lives to play out. Taisheng hails from Shanxi and helps the male newcomer, nicknamed "Little Sister," Chen Zhijun, land a job in construction through his hometown connections. Taisheng's girlfriend Tao (Zhao Tao) serves as the center of another set of diasporic relationships, with an old flame passing through on his way to Mongolia and a friendship with fellow entertainer, Anna (Alla Shcherbakova), from Russia. As a side job, Taisheng agrees to help Qun (Huang Yiqun), a Wenzhou merchant involved in the manufacture of knockoff garments and subsequently has an affair with the woman, who has a long-distance marriage to a husband working in France. Although Tao's former boyfriend, Liangzi (Liang Jingdong), and Qun get their visas to go to Mongolia and France respectively, the Russian émigré Anna surrenders her

passport to a labor trafficker, and she struggles before she can leave China. However, Little Sister, Tao, and Taisheng, who are migrants within China, reach literal dead ends as their encounter with the world stops in Beijing.

As the characters perform their parts in the theme park and as migrants in the city, national identities empty out, and spectacle takes center stage as a consumer product. Tao, for example, performs in the park as a Japanese geisha, Western bride, and "harem" girl. China and India may be political adversaries, but Indian films have enjoyed popularity in the PRC, and Bollywood pops up in Jia's film as Tao dances in front of the Taj Mahal. However, her self-Orientalizing "harem" costume (nose ring, bare midriff, veil) signifies "Indian," "Muslim," or "Las Vegas showgirl" equally effectively, and specific identities melt into clichés. In this costume, Tao also "looks" like she could be a woman from the Uighur ethnic group or one of the other minorities of Xinjiang (China's Central Asia), and by playing these domestic others, she seems to hold up a mirror to a divided China. In fact, as they dress up to perform the roles of foreign nationals, the actors and actresses in the park look suspiciously like China's major ethnic minority groups—from the Uighur/Hui to the Dai/Thai and Koreans and even, of course, ethnic Russians, who are on parade in theme parks as one of China's smallest minorities. Jing Nie calls this "an ironic mimicry of misplaced minority shows which lack any specific cultural and historical depth or sincerity."[12] The Taj Mahal as a physical monument also conjures up connections with the Moguls of India, the descendants of the Mongols who converted to Islam and headed the dynasty that built the Taj Mahal and who are part of the vast empire that connected China (Yuan dynasty), India, Russia, and a large portion of the Eurasian continent during the late-thirteenth and fourteenth centuries. The ancient routes of the Silk Road and the Mongol Empire forge a link connecting China, Russia, and Mongolia, countries that formed the heart of the Eastern bloc during the Cold War.

Cinematic Silk Roads

Throughout most of the twentieth century, Mongolia has served as a buffer between Russia and China—Inner Mongolia, an "autonomous region" (like Xinjiang or Tibet) of the PRC, and the Mongolian People's Republic (established in 1924 on the Soviet model). With the dissolution of the USSR in 1991 and the acceleration of neoliberal market reforms in the PRC signaled by Deng Xiaoping's southern tour in 1992, Mongolia's place on the world map has changed economically and geopolitically as well as culturally. In *The World,* the Mongolian capital, Ulan Bator, is an imagined place that links Tao's old boyfriend, Liangzi, with

her new Russian friend Anna; Liangzi is on his way to Mongolia to work, and Anna is trying to get there to visit her sister. Presumably, Anna's sister and Liangzi are there for the same reasons—looking for opportunities to make money from Mongolia's natural resources, hoping perhaps for a bit of adventure, maybe feeling a sense of entitlement because Mongolia was part of China in the Qing dynasty and a client state of Russia during the Soviet era. "Ulan Bator," in fact, means "red hero," and they may also be looking for something else in the form of nostalgia for their Communist past.

Coincidentally, Jiang Rong published *Wolf Totem,* his semi-autobiographical Cultural Revolution memoir about his sojourn in Inner Mongolia, in 2004, the same year that Jia's *The World* had its premiere. As an indictment of Han Chinese chauvinism, a warning against ecological exploitation, and a romantic celebration of nomadic culture, the novel proved to be controversial on several levels and became a celebrated bestseller in China. In 2015, Jean-Jacques Annaud directed the Sino-French adaptation of the novel on location in Inner Mongolia, even though the director's *Seven Years in Tibet* (1997), starring Brad Pitt, remains banned, because of its sympathetic treatment of the Dalai Lama. Mongolia, then, seems to be on the minds of Chinese artists and intellectuals as a border zone occupied by ambivalent feelings involving political ideologies, national sovereignty, ethnic rights, environmental crises, economic exploitation, and Han Chinese identity.

On Chinese screens, both Inner Mongolia and the country of Mongolia represent the primitive other, the ancient conqueror and the romantic nomad, but the place also signals a range of contradictory sentiments related to questions of borders, cosmopolitan hybridity, and cultural frontiers. In fact, in recent years, not only have Mongolian productions and co-productions increased (especially in 2007, around the eight hundredth anniversary of Genghis Khan's conquests), but, specifically, Chinese films set in Mongolia (or near it in the Gobi Desert) have also been coming out at a steady pace, including Ning Hao's *Mongolian Ping Pong* (2005), Wang Quan'an's *Tuya's Marriage* (2006), Jiang Wen's *The Sun Also Rises* (2007), Zhuo Gehe's *Nima's Women* (2008), Tian Zhuangzhuang's *The Warrior and the Wolf* (2009)—a far cry from his earlier Mongolian-set feature *On the Hunting Ground* (1984)—and, of course, Zhang Yimou's *A Simple Noodle Story* (2009). Inner Mongolian filmmaker Wuershan also sets his transnational Chinese action-adventure fantasy, *Mojin: The Lost Legend* (2015), in his home province, featuring Angelababy as the ghost of "sent down" Red Guard youth and Taiwanese actress Shu Qi as a tomb raider.

Jia Zhangke has taken up Mongolia as a motif on several occasions as well. In *Platform* (2000), the song "Genghis Khan" can be heard on the soundtrack, and in *Unknown Pleasures* (2002), Qiao Qiao (Zhao Tao, who plays Tao in *The*

World) works for the Mongolian King Liquor Company. Given Jia's self-consciousness as a film "auteur" on the international film festival circuit, the links among the actress, the self-reflexive presentation of her role as a "performer" within the fiction in all three films, and the abstruse references to Mongolia may be seen as simply directorial conceits rather than substantive engagements with Mongolia as a specific place. In the case of *The World,* Mongolia appears only indirectly as a title over the night sky, an unseen visa in Liangzi's passport, the weather report on the news, and as a melancholy Russian ballad that Anna fails to teach to Tao. Like the locations in the park, Ulan Bator remains "invisible" but virtually present through these auditory traces and mass-mediated snippets of information.

However, Mongolia functions in another way as well in *The World.* Montage techniques connect Mongolia to Soviet cinema—albeit obliquely—and open up another circuit of cinematic citations for Jia. Russian cinema does not get the direct homage given to Ozu's *Tokyo Story* (1953), but it remains an insistent (present) absence. Jia, as a student of film theory at the Beijing Film Academy, learned the basics of Soviet montage, developed from the creative encounter between Russia and Asia. Traces can be seen, then, of Eisenstein's theory of montage (based on his understanding of Chinese ideograms, traditional painting, and Asian theater traditions like Noh and Peking Opera), as well as of Pudovkin's film practice (as seen in *Storm over Asia: The Heir to Genghis Khan*) and Dziga Vertov's Kino-Eye on Soviet Central Asia (e.g., *Three Songs for Lenin,* 1934). Alexander Dovzhenko also made a film in Siberia, and Eisenstein planned but did not complete Asian projects (including one called "China"). Although the relationship may have been more abstract and intellectual for Eisenstein and more visceral and pictorial for Pudovkin and Vertov, the encounter defines not only Soviet montage aesthetics, but also a particular way of thinking about the politics of the visual beyond national borders with a larger political project in mind.

These early Soviet filmmakers were all looking for a way out of the aesthetic straitjacket of European realism without falling back on modernist primitivism. Many of them found a solution in East Asian aesthetic traditions. Eisenstein and the left-wing German playwright Bertolt Brecht (who will be discussed in chapter 4) both met the cross-dressing performer Mei Lanfang, known for specializing in female roles, during the singer's Moscow tour, and the European dramatists were captivated by the promise of Peking Opera as a potential break with so-called "bourgeois" realism. Orientalism may have motivated some of the Russian interest since the Soviets needed to win the hearts and minds of Asians in their central and eastern provinces as part of their national push against the tsarist forces. Undoubtedly, the Soviet montage theorists wanted very much to "see" through Asian eyes as well, to get away from the aesthetic and ideological bag-

gage of Western Europe, and to construct a revolutionary way of picturing the world based on an aesthetic conversation between Russian film and Asian arts. Marrying Marxist notions of the "dialectic" to Asian language and aesthetics, Eisenstein created a theory of montage as conflict. For him, the juxtaposition of images, as the combination of pictographs in the Chinese ideogram, held the promise of new meaning and the key to socialist progress and modernity through the mass medium of the motion picture.

Although montage fell in and out of favor in practice, in theory it proved resilient and amazingly flexible—staying on the syllabus in the USSR, promoted in Europe and America, and translated and taught in Chinese at the Beijing Film Academy, where many of the teachers were Soviet- or East European–trained or instructed by those who had that kind of film education. Jay Leyda saw these connections firsthand and chronicled them in his books on Soviet and Chinese cinema, *Kino* and *Dianying*.[13] Like many other PRC filmmakers, artists, and intellectuals, Jia acknowledges this common history by allowing it to poke through the map of global film aesthetics in *The World*. Taisheng's white horse, for example, distantly echoes Russian films like Andrei Tarkovsky's *Andrei Rublev* (1969), with its leitmotif of horses and its depiction of the Mongol conquest of Russia. Taisheng's patrol through the ruins of Europe (Stonehenge) resonates with the horse walking through the ruins of the church in Tarkovsky's film, for example. China also has a tradition of using horses symbolically. *Snow-White Horse* (1979), to cite one instance, narrates the liberation by the People's Liberation Army (PLA) of a Kazakh village in Xinjiang with the help of a majestic white horse and its outlaw rider. In *The World*, the horse moves from the ruins of Europe and a post-socialist present to an animated digital valentine as the earlier associations are drained of their significance and put in the service of youth culture (figure 2.4).

Tarkovsky's transcendental style—his disembodied eye and contemplative gaze—links *Andrei Rublev* to many of the filmmakers Jia clearly admires, including Robert Bresson, Yasujirō Ozu, and Hou Hsiao-hsien. (This connection will be examined in greater detail in chapter 3.) However, Tarkovsky's cinematic sensibility competes with a far more material vision and specifically with *Storm over Asia*, a work that Leyda calls Pudovkin's "most sensuous film."[14] Although separated by more than three-quarters of a century, *The World* and *Storm over Asia* share far more than the notion of Mongolia as a meeting point between Asia and the West.

Like *The World*, Pudovkin's film offers a portrait of global capitalism in action and looks at Central Asia as a battleground of competing economic as well as political interests. This story of the supposed "heir" to Genghis Khan's empire deals with Europeans in Central Asia (although not directly named, likely the

Figure 2.4. The horse in love. The World; dir. Jia Zhangke, 2004.

British, who were occupying part of Tibet at the time) specifically as a force of economic exploitation and political manipulation. The rebellious Russians are allied with a progressive sector of the native population as a force of liberation from Europe's imperial designs. The transformation of the protagonist Bair (Valeri Inkishanov) from a nomadic herdsman to the "heir" of Genghis Khan, to be used as a puppet of imperial interests, becomes manifest by his change in clothing—from ethnic dress to a European tuxedo, the emblem of "bourgeois" elegance and civilized respectability. As a silent Soviet propaganda film, *Storm over Asia* should be worlds apart from Jia's *The World*. However, in terms of narrative, mise-en-scène, and montage, Jia's film echoes Pudovkin's work in several striking ways.

Both films take up the international film aesthetics of their day—Pudovkin working with the legacy of D. W. Griffith and within the orbit of his contemporaries like Eisenstein and Jia positioning himself as heir to the various international "new" cinemas of the post–World War II "art film," from Italian Neorealism to Taiwan New Cinema and New American Cinema. Both films deal with the same subject matter—that is, the exploitation of Asian labor in the international consumer economy, from the fur trade to the garment industry and tourism. While the sweatshop in *The World* trades in pirated brand names and the Mongolians in *Storm over Asia* fuel the demand for luxury consumer goods through Central Asia's natural resources, the link between global capitalism and consumerism remains quite strong. Although the products on the racks at Qun's factory may, like the leather jacket Taisheng wears, end up on the backs of domestic consumers hungry to fit in by slipping into the latest European fashions, the fact that Western capital defines the consumer market and relies on Asian labor—bought cheap—remains the same.

Tourism also plays a part in both films. In *Storm over Asia*, European diplomats visit a Lamaist temple to pay respects to the political power of the Buddhist monks but also to see the sights. Historical clichés act as backdrop—a talisman testifying to direct descent from Genghis Khan in *Storm over Asia* and the Taj Mahal in *The World*—as concrete screen emblems of Mongol history reified to fit the interests of consumer capitalism in the twentieth and twenty-first centuries. The monks in *Storm over Asia* put on a show featuring a toddler as a newly reincarnated spiritual leader, just as Tao and her colleagues play their part in their ersatz Las Vegas routines in *The World*. Although the tables are reversed with Tao performing the "world" for her mainly Chinese clientele and the monks performing the "East" for the wealthy Europeans hungry for Mongolia's natural and human resources, the films meet around the trope of cosmopolitan performance. The Russians and Chinese share a common "stage" of exploitation. Bair enacts a Mongolian identity as the "heir" of Genghis Khan, and in *The World*, Anna, the Russian dancer and KTV hostess, performs an ethnic identity on stage as well as, presumably, in bed. However, in the new labor economy, Anna's value as a woman has depreciated, and she does not get the "choice role" of the "red heroine" featured in *Storm over Asia*. The days of the female revolutionary guerrilla (who saves Bair and fights side by side with her male comrades) appear to be in the past, and Anna, separated from the other Russian women performers, as well as from her passport, must fend for herself. The revolutionary days of the "red hero" of Ulan Bator are long gone.

Anna, Tao, and Bair, along with the other performers in *Storm over Asia* and *The World*, are well aware of being in a fishbowl and constantly under scrutiny. In *Storm over Asia*, Bair, bandaged up nearly beyond recognition after a botched execution attempt, has been placed in a European drawing room. Frustrated by his captivity and in enormous pain, Bair struggles to get up and upsets a fishbowl on a table in front of him. The image (which Dudley Andrew has called both "dramatic" and "ideological") speaks eloquently to Bair's condition and to the plight of all those victimized by imperialism and capitalist expansion.[15] Like a fish in a bowl, he is trapped, on display, exotic, captive. When the bowl breaks, he becomes a fish out of water, gasping for breath in an alien environment. Breaking through the imperialist fishbowl may promise freedom but at a cruel price (figure 2.5). Eventually, Bair takes up arms and fights on the Soviet side at the end of the film; however, the fish out of water can never return to the same life of the steppes. In fact, the idealized life of freedom never existed. Central Asia has always been a meeting ground of competing empires, ethnicities, languages, religions, and settled and nomadic ways of life.

Unlike the principals in *Storm over Asia*, who revolt against their oppressors, the characters in *The World* go with the flow. However, as migrant workers, they

Figure 2.5. Bair (Valéry Inkijinoff) as the fish out of water in *Storm over Asia*; dir. Vsevolod Pudovkin, 1928.

remain fish out of water. A poster for *Titanic* (dir. James Cameron, 1997) in the women's dorm room reminds them that they are on a sinking ship in a movie that may or may not turn out to be a blockbuster. The Soviet and Chinese films are filled with images of aridity and humidity—earth and water—from the swimming fish (in a bowl in *Storm over Asia* and on a cell phone in *The World*) to the bottles of water carried through the park's Egyptian desert in *The World* and the wind-swept landscapes of *Storm over Asia*. The characters in *The World,* in particular, seem to be "at sea"—needing to wear raincoats to bed to escape the mildew, taking water breaks on the Eiffel Tower or at the Taj Mahal, using plastic covers to dodge the rain in the park's version of Venice, or standing in front of fountains that erupt opposite the Arc de Triomphe. For Tao, an animated fish appears when she feels trapped and particularly under water as she reads the text message Qun has sent to Taisheng's cell phone, indicating that they had been "destined" for one another (figure 2.6). In traditional Chinese thought, the fish symbolizes good luck, abundance, and fertility—Tao and Taisheng are at a wedding when the message arrives. The betrayal immediately sinks Tao to the depths, and the image of the fish happily swimming looks more like a shark in treacherous waters.

Figure 2.6. Sharks circle in the animated fishbowl. The World; dir. Jia Zhangke, 2004.

Both Pudovkin and Jia use montage to create these associations in their films. However, while the raw emotions and drama of the two fish scenes are readily apparent, they may be excessive. Bair and Tao are so angry that they become self-destructive (Bair collapses, and Tao later gasses herself). Bair breaks the fishbowl and the fish dies, but the metaphor can only be partial since Bair seeks liberation, not annihilation. Tao's fish—a computer-generated fantasy—swims off with her own dreams of marital bliss. The cell phone, which had been the bone of contention and source of jealousy for the couple at the wedding, becomes the confirmation of the lie of Tao and Taisheng's romance. The montage of associations operates in this way—through emotion and indirection, apparent clarity, and actual ambiguity. The animation connects Tao's imagination via Taisheng's cell phone to the next scene, featuring Taisheng at Boss Song's mahjong parlor, where he first met Qun.

Montage goes beyond the emotional and associative in *The World* and revives the memory of Eisenstein's theories of intellectual abstraction through juxtaposition. The apparently dialectical structure frames the film's broad themes—for example, Mao-era versus Deng-era policies, country versus city, landed peasant versus migrant worker, nationalist construction versus global capitalism, provincialism versus cosmopolitanism, consumerism versus labor exploitation. Montage also connects narrative points as parallel stories revolve around on-stage and off-stage lives, illicit versus sanctioned romances, tourists and performers, exploiters and the exploited. In addition, visual aesthetics take on a dialectical structure of their own in the form of montage versus the long take, animation versus observational realism, and Asian versus European film traditions. Even specific images based on abstract binaries—"real" versus "fake," desert ver-

sus water, high level versus low level, high angle versus low angle, moving versus stagnant framing, strong horizontal versus vertical compositions, and so on—bring *The World* closer to Eisenstein than perhaps to any other filmmaker's oeuvre.

A particular cut between two shots serves to illustrate Jia's debt to the Soviet montage tradition. The first shot features Tao and Little Sister with a plane flying in the background, followed immediately by a second shot of Anna on a plane. In the first shot, Tao and Little Sister chat at the construction site (figure 2.7). Pylons of the unfinished building form a concrete forest in the middle ground. Little Sister, with his bicycle, and Tao, on foot, stand in the foreground. They have their heads turned away from the camera to watch a plane against the horizon in the background as dusk falls. The dynamic between foreground and background, vertical and horizontal, lower and upper parts of the frame, shadow and light, define the graphic dimension of the shot. The bicycle (an old-fashioned mode of locomotion) and the plane (the emblem of global transportation) highlight the differences in temporal as well as class terms. This dialectical relation is reinforced by the dialogue. Belonging to the underclass left behind by Deng's neoliberal reforms, Tao and Little Sister have never been on a plane, and they claim they do not even know anyone who has flown on one.

The next shot rebuts the first by revealing its inaccuracy. Tao knows the Russian Anna, who is shown flying on a plane in the very next shot (figure 2.8), and her appearance conjures up other images from the film. Tao, for example, has been in the cockpit of the grounded jetliner in the theme park (and has flown over the skies of Beijing as an animated avatar and around the park

Figure 2.7. Depth, height, and denial—Tao (Zhao Tao) and Little Sister (Chen Zhi-hua). The *World*; dir. Jia Zhangke, 2004.

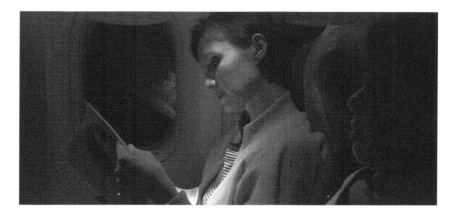

Figure 2.8. Anna (Alla Shcherbakova) in close quarters as the visual contradiction to the previous shot. *The World*; dir. Jia Zhangke, 2004.

on a magic carpet with the help of a blue-screen video setup). The shot of Anna airborne serves as the previous shot's visual "opposite" as well—that is, shallow rather than deep focus, interior rather than exterior, narrow medium close shot rather than a wide long shot, artificial rather than natural light. Anna's head looks down at her magazine rather than up at the sky, profiled with a key light rather than backlit in silhouette. In addition to the cut implying a connection between the ground and the sky, an idea links the two shots and the characters in them—that is, the idea of global flows and the mobility of labor. On the ground or in the air, from Russia to China, or from the countryside to the city, they are connected intellectually by global capitalism. Xiaoling Shi takes the analysis of this sequence of shots one step further by commenting on the following shot in the sequence: "Finally, Anna gets aboard a plane going to Ulan Bator to visit her sister. As she is about to fulfill her dream, the camera cuts to the corridor of a luxury hotel. A cleaner is collecting dirty towels and sheets after the guests leave, implying the cost she pays for the visit."[16]

Along with Pudovkin and Eisenstein, Dziga Vertov makes his presence felt in *The World* as well. Anna and Tao have dinner and bond around their shared connection to Ulan Bator (without actually knowing why). Anna says in Russian, "We don't understand each other, but you're my friend." The two hitch a ride back to the dorm on what appears to be a flatbed tractor. The traveling shot echoes similar shots of horse carts, trams, and automobiles in Vertov's *Man with a Movie Camera* (1929), while the encounter between Russia and Asia evokes the Central Asian segment, "My Face Was in a Dark Prison," from *Three Songs for Lenin*. In the two shot, Anna looks toward the camera at Tao, who

Figure 2.9. Looking like the past or facing the future? Anna (Alla Shcherbakova) and Tao (Zhao Tao). The World; dir. Jia Zhangke, 2004.

looks straight ahead—slightly offscreen left—with a slight smile on her face (figure 2.9). Anna appears to be studying Tao, but she also obliquely confronts the camera, facing the spectator, citing the Kino-Eye. Whether this points to Tao's blithely facing the future while Anna remains thoughtfully confronting the present or whether it invites the spectator—through the camera—to scrutinize Tao as a product of the "new" China or the "new" global economy remains ambiguous. The Kino-Eye can penetrate only so far and see only so much, perhaps illustrating Sebastian Veg's astute observation on the Soviet montage-inspired "aesthetics of contingency" that seems to be operating in this shot: "One might argue that certain works of independent cinema are perhaps more indebted to the formal experiments of the Soviet avant-garde than to Italian Neorealism. In this sense, the accent placed on the aesthetics of contingency is also a radical critique of the linearity of historical development, which is probably not unrelated to China's present situation."[17] As a consequence, this montage residue also connects *The World* in a postmodern, nonlinear fashion to the expanse of world cinema. This puts *The World* in conversation with other postmodern imaginings of Mongolia, such as Ulrike Ottinger's *Johanna d'Arc of Mongolia* (1989), a pastiche of the Orientalist travelogue, ethnographic document, captivity tale, and lesbian romance, set on a Trans-Siberian railway train ambushed by Mongolian women warriors.[18]

Other citations, however, marry *The World* to Jia's contemporaries more specifically. After Anna's plane flies off, the next sequence features a joke about chopping Taisheng up into meat filling for dumplings if he is ever unfaithful to Tao, referencing a film by one of Jia's fellow directors, Hong Kong's Fruit Chan, whose *Dumplings* (2004) was making the festival rounds at the same time. In ad-

dition, Jia casts fellow Sixth Generation director Wang Xiaoshuai as a "boss" in *The World*—again equating film authorship with less than savory associations and with the world of thieves Wang brought to the screen in *Beijing Bicycle*. From the security guard Erxiao (Ji Shuai), who steals from his fellow workers, to Qun, who pilfers designs from Louis Vuitton, Jia's film belies the title of Feng Xiaogang's *World without Thieves* (also produced in 2004). These citations, which take the film away from Soviet montage's commitment to revolutionary dialectics, assert Jia Zhangke's independence from his Russian predecessors. In fact, as he builds on these intertextual references, Jia seems to distance himself further from Eisenstein in particular. Eisenstein famously complained of Pudovkin: "Again, 'bricks.' Bricks, arranged in series to *expound* an idea."[19] Jia builds up his films by using bricks—that is, elements collected from other films. Seen this way, this incorporation of film quotations brings Jia closer to the postmodern *bricoleur,* as a builder from bits and pieces (rubbing shoulders with Quentin Tarantino more than the Soviets), and "dialectical montage" may be the wrong term for his particular style of editing.

The World hints at this bricolage in its opening credits. The title (in English and Chinese), "A film by Jia Zhangke," appears against a long shot of the World Park's Eiffel Tower anchoring the composition (figure 2.10). A trash collector wearing a peasant worker's straw hat appears in silhouette in the foreground with his pack of recyclable materials on his back. Jia seems to be putting his authorship in question by comparing it to the work of a trash collector and a fake monument. Indeed, the shot of the Eiffel Tower conjures up the Parisian New Wave. The trash collector picks up the detritus of global consumerism to make a living, and Jia, like his character Qun, who copies designer fashions, or Tao, who

Figure 2.10. The trash collector of global cinema. *The World*; dir. Jia Zhangke, 2004.

mimics world cultures, may also be recycling bits and pieces of world cinema to make his way in the film world.

Venice and The World

Although Jia may claim to "describe Chinese reality without distortion,"[20] Baudrillard reminds us that the "real is no longer what it used to be."[21] Even the "desert of the real" seems to have a website, and the URL for the park flashing as a title against a shot of the ersatz Egyptian pyramid and Sphinx confirms this. Jia appears to be setting up intellectual coordinates as well as geographical ones, and *The World* alludes not only to Borges and Baudrillard, but also to Italian author Italo Calvino. Unlike Evans Chan, who quotes Calvino directly in his own cartographic feature, *The Map of Sex and Love* (2001), Jia's *The World* hints at Calvino's novel *Invisible Cities* through the connections he makes between Mongolia and Venice in Beijing within the mise-en-scène.[22] Calvino's novel features imaginary conversations between Marco Polo and Kublai Khan about the titular "invisible cities." Many of the passages resonate with *The World*'s interest in exploring the relationship between the real and the imagined, the desired and the actual, the European and the Asian, and the historical and the fictional. One remark echoes with Borges's imperial map as well:

> It is the desperate moment when we discover that this empire, which had seemed to us the sum of all wonders, is an endless, formless ruin, that corruption's gangrene has spread too far to be healed by our sceptre, that the triumph over enemy sovereigns has made us the heirs of their long undoing. Only in Marco Polo's accounts was Kublai Khan able to discern, through the walls and towers destined to crumble, the tracery of a pattern so subtle it could escape the termites' gnawing.[23]

The World also chronicles a society in ruins, and the film visualizes only traces of copies appearing as theme park attractions or animated computer graphics.[24]

The monuments of Marco Polo's hometown of Venice, of course, are clearly visible in *The World,* and Jia takes up Calvino's sense of melancholy by raining on Venice's parade (so to speak), showing his characters in the park's version of St. Mark's Square during a shower (figure 2.11). Still holding the plastic above her head, Tao moves from hyperreal Venice to virtual Beijing—from the theme park to Flash animation. Jia Zhangke moves in the opposite direction as he takes his film from Beijing to Venice for its premiere. From Jia's perspective as cinematic cartographer, the map of the world charts the film festival circuit, and *The*

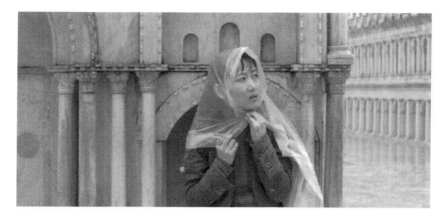

Figure 2.11. Venice rains on Jia Zhangke's parade—Tao (Zhao Tao) in St. Mark's Square. *The World*; dir. Jia Zhangke, 2004.

World's visual design and constellation of citations provide a perfect fit for one of the globe's most prestigious festivals. Leaving Beijing behind, the director takes the film to the 2004 Venice International Film Festival, and the publicity materials for the film feature Tao against the ersatz Doge's Palace as a tribute to the site of both the film and its premiere. This image recognizes the film festival as a vital part of the "location" of the on-screen drama, as well as a guarantor of the quality of the film through its self-conscious association with Italian culture and film history. The oldest continually operating international film festival in the world, the Venice festival has a politically complicated history. However, it has come a long way since Mussolini looked at cinema as a "weapon" of the Fascist state.

China has never been far from Venice as Europe reoriented its political position during the turbulent 1960s, for example. In 1967, the same year Godard produced *La chinoise* (which will be discussed in chapter 5), Marco Bellocchio screened his *La Cina è vicina* (*China Is Near*) at the Venice International Film Festival, winning the Special Jury Prize.[25] Unlike Antonioni's *Chung Kuo Cina*, Bellocchio's feature looks at China through the influence of Mao Zedong on the European Left in the 1960s. Italian interest in the Great Proletarian Cultural Revolution reached its apogee with the publication of Maria Antonietta Macciocchi's *Daily Life in Revolutionary China* in 1971, at a time when the Chinese leadership had repositioned itself vis-à-vis the Western world, and Italy established diplomatic ties with the PRC that same year.[26] This renewed engagement with Europe and America led to Antonioni's invitation to film in the People's Republic, as well as Nixon's trip to China in 1972, and Antonioni screened the controversial *Chung Kuo Cina* in 1974 in Venice, where Italian Maoists picketed

it.[27] The PRC finally lifted the ban on the film in 2004, the same year Jia brought *The World* to Venice as his first "official" film.[28] From this perspective, China draws "near" to Italy as a political idea rather than as an actual location. Undoubtedly over the years, the Venice International Film Festival has shaped "China" on screen, and Jia responds to this as he creates a film specifically for Venice.

Jia's film screened in competition in Venice the same year that Marco Müller took over the directorship of the festival. A China scholar, film programmer, and producer, Müller has helped to champion the cause of Chinese-language cinema in several of Europe's prestigious festivals, including Turin, Locarno, Rotterdam, and, of course, Venice. Early in his career in 1981, Müller introduced festival audiences in Turin to Chinese cinema with "Electric Shadows," the first major retrospective of films from the PRC in Italy after the end of the Cultural Revolution. While in Rotterdam, Müller connected young Asian filmmakers with sponsors, and Jia Zhangke won support through the Hubert Bals Fund there for *Platform*. Before his death in 1988, Hubert Bals had established this fund to support innovative filmmakers coming from developing countries, and given Bals's abiding interest in Asian cinema, films coming from that region have been a priority.[29] Like many of his Sixth Generation contemporaries, as well as Hong Kong New Wave and Taiwan New Cinema directors, Jia has benefitted from growing interest in Chinese-language film within the festival circuit, and his facility with cinematic citations allows his oeuvre to speak to an audience well versed in world cinema history and appreciative of an auteur who understands its aesthetic language.

In her study of the importance of the festival circuit to the international recognition of Chinese cinema, Ma Ran notes that the careers of filmmakers such as Jia Zhangke owe an enormous debt to the evolving tastes of programmers and directors in Cannes, Berlin, Venice, Rotterdam, Toronto, and other major festival locations.[30] As indicated above, Müller, of course, has been instrumental in connecting these savvy filmmakers with festival audiences, critics, distributors, and financiers in several cities. It comes as no surprise then that Müller's career parallels the rise of the filmmakers he champions. As directors such as Jia Zhangke and Zhang Yimou have been able to move closer to sanctioned, "above ground" Chinese cinema, they rely more on domestic audiences and institutions than they did in the past. Müller has gone with them as well, with the announcement in 2015 of his move from the Rome Film Festival to the Beijing International Film Festival.

However, Venice's commitment to Chinese-language cinema does not rely solely on the taste and expertise of a single curator, of course. In fact, another consultant for the festival, Elena Pollacchi, wrote a doctoral dissertation on Chi-

nese cinema at Oxford and holds a teaching post in Chinese at the University of
Venice, Ca' Foscari. Although both Müller and Pollacchi have closer ties to
mainland Chinese cinema, the festival has made an effort to connect with other
Chinese-language film cultures as well, and Hong Kong has emerged as another
prominent point on this map. In 2010, the Clara Law short *Red Earth* (analyzed
in chapter 7) screened at the Sixty-Seventh Venice International Film Festival. In
2003, Ann Hui served on the jury in Venice; her *A Simple Life* (2011) won critical
acclaim and several awards at the sixty-eighth edition of the festival, and her *The
Golden Era* was the closing film for the seventy-first festival. Of course, Hui's in-
volvement with European film festivals goes back decades. *Boat People* screened
out of competition in Cannes in 1983, and *Ordinary Heroes* (1999), the subject of
chapter 4, vied for the Golden Bear at the Berlin International Film Festival.

As with so many of the films analyzed in this book, the festival circuit places
The World in another orbit, and images of Venice that feature so prominently on
posters for the film serve as reminders that international film festivals also en-
hance tourism and the circulation of cultural commodities. Films tend to beget
other films as well, and the leading lady of *The World*, Zhao Tao, appears in the
Italian film *Shun Li and the Poet* (*Io sono Li*, 2011). Given Jia Zhangke's interest in
blending documentary and fiction in his film, the fact that Italian documentarist
Andrea Segre casts Jia's muse in his first fiction feature seems particularly fitting.
This exploration of the meeting of two immigrants in Venice—one from the for-
mer Yugoslavia and the other from China—shares similar thematic concerns
with *The World* as both motion pictures explore globalization in the wake of the
decline of socialism in the "East." Venice again serves as the meeting point of
Europe and Asia.

Although *The World* lost in Venice in 2004, Jia's *Still Life* (2006) won at the
festival two years later, and this win gave rise to some controversy when Zhang
Yimou's producer accused Jia of a conflict of interest because Müller had helped
with the financing for the film. Threatening a law suit, Jia remarked, "This is a
civilized world, please do not say vulgar words."[31] Of course, the "civilized world"
of the international art film contains ironies, and Jia found himself in the news
again when he withdrew his *Cry Me a River* (2008) from the 2009 Melbourne
International Film Festival because Uighur activist Rebiya Kadeer was scheduled
to appear at a screening of a documentary about her family, Jeff Daniels's *The 10
Conditions of Love* (2009). The Australian festival coincided with ethnic unrest in
Xinjiang (including the notorious hypodermic needle incidents), and Xstream,
the Hong Kong–based production company, withdrew both Jia's film and Emily
Tang's entries in protest. Chow Keung of Xstream explained the withdrawal as
follows: "We are independent filmmakers. This response is by consensus, and it is
very personal."[32]

Such a comment seems to beg the question of how "personal" the politics of world cinema is. *The World* stages globalization as a personal issue of performing an identity (or identities) on the world stage, and this personal identity appears to be quite clearly inflected by ethnicity as well as gender. Unhappy with Taisheng's sexual advances, Tao, at one point, takes a bus back to the theme park and passes by Tian'anmen Square—the symbolic seat of Chinese politics and the 1989 demonstrations. The bus window frames Mao's portrait in the background, and the issue of what women specifically can expect or desire from Mao's recognition of their "holding up half the sky" surfaces.

China does have a long tradition of using women to allegorize politics, and *The World* uses Tao as a way of looking at a range of issues from gender inequalities to consumerism and labor relations. However, the "personal" nature of this political picture is not quite clear. The gendered nature of postsocialism and neoliberalism remains vague. It is hard to say precisely, for instance, what Anna and Tao's tearful embrace signifies when they meet in the KTV ladies' room—where Anna works as a prostitute. It may be a leftist critique of neoliberal capitalism out of control, or it may gesture toward the need for more "humanitarian" reforms and legal constraints against sexual slavery and labor rackets. Given that Tao dresses up as a Central/South Asian and the Mongolian steppes connect the two women to the Sino-Russian border through Anna's Ulan Bator ballad, the embrace may be commiseration over the PRC's troubles in Xinjiang and Tibet that parallel past Soviet fiascos in Afghanistan and Russia's Chechnya problems. Or Tao and Anna may simply be performing the roles given them—and resistance proves futile. As Tao plays harem girls, Japanese geishas, and fluffy white European brides on stage, her off-stage identity mutates from country migrant to cosmopolitan sophisticate, from ambitious show girl to sexually harassed, expendable service worker, from reluctant lover to the "woman scorned."

Valerie Jaffee notes, "It is not so much that performance conveys the world as that the world is nothing but a performance."[33] However, this thought goes back to Shakespeare's "all the world's a stage," and the way it is evoked here merits some further attention. Maybe Jia's *The World* is "nothing but a performance" and the director fears playing to an empty house (figure 2.12). Jia, like his protagonist Tao, must perform a variety of roles for domestic and international audiences, and the construction of the "person" he embodies as an auteur on the world stage must be taken into consideration. As the "personal" becomes a "performance," the scene moves to what Baudrillard calls the "obscene"; nothing can be hidden or allegorized because everything has come to the surface; no righteous anger is left to explode, as in Bair's case on the steppes of Mongolia, since meaning has imploded. As Esther Cheung points out, Jia's characters often "swim with the tide of globalization"—even if that may mean going upstream:

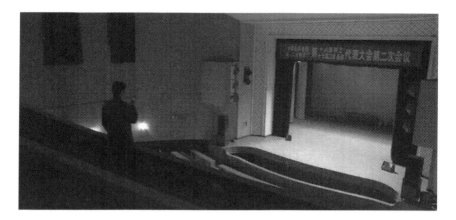

Figure 2.12. Fear of playing to empty house in *The World*; dir. Jia Zhangke, 2004.

Unlike some types of realist works, Jia's films do not articulate explicit anti-Western, nationalistic sentiments as counter-discourses to the waves of post/modernisation. Instead, they adapt a more self-reflective stance toward such "encroachment," at times revealing the insiders as complicit, docile, and helpless. Many of his characters have no choice but to swim with the tide of globalisation, consuming commodities and "benefiting" from global capitalism while at the same time suffering from its uneven development.[34]

The World's ending makes Cheung's observation concrete. In answer to Taisheng's query as to whether they are dead yet, Tao responds, "No, this is only the beginning." She rewrites Taisheng's dead "end" as only the "beginning," but it is difficult to say of what. This may be a Brechtian gesture toward breaking down the illusions of bourgeois theater to stimulate critical consciousness, or it may simply be another citation of a self-reflexive technique recognized as a marker of artistic quality of the festival film. The apparent murder-suicide that concludes *The World* remains part of the story on stage and on screen; however, it also references a panoply of other cultural texts from Greek drama to Shakespearean tragedy to Japanese bunraku puppet productions such as "Double Suicide" or Ozu's *Floating Weeds* (1959), set in the world of the theater.[35] Rey Chow eloquently describes this dark quality of Jia's aesthetic as inextricably linked to "hypermediality":

The acute senses of ephemerality, loss and ultimately melancholy which characterize many a moment in Jia's films are the results of this deeply-felt sensation of hypermediality—indeed, of the composite material, tracks and

symptoms left on human perceptions and interactions by media forms such as print photography, film, newsreel images, historical reportage, popular songs, interviews and, most importantly, storytelling. Rather than a unified reality, it is these motley tracks and symptoms, with their ever unfolding, ever multiplying questions about origins and destinations as well as identities, that Jia's documentary approach invites us to contemplate....

Jia's works showcase the cultural politics of a new kind of conceptual project: a project of imagining modern China not simply as a land, a nation or a people, but first and foremost as medial information.[36]

Within this fabric of hypermediality and the postmodern hyperreal, *The World* places the "real" in relation to another set of aesthetic concerns, and Andrei Tarkovsky's legacy comes to the forefront once again in these moments that transcend his "documentary" tendencies with other intertextual associations. Although Jia's allusions to epic theater, Italian Neorealism, and Soviet montage cannot be denied, his aesthetic breadth goes beyond these styles and draws, as well, on the so-called "transcendental" qualities of Robert Bresson, Yasujirō Ozu, and a later generation of Soviet filmmakers such as Tarkovsky. This stylistic debt and its implication for the way in which Jia's works circulate within global cinema culture provide the subject for the following chapter.

CHAPTER 3

Bicycle Thieves and Pickpockets

Jia Zhangke's Xiao Wu and
Patrick Tam's After This Our Exile

As discussed in the previous chapters, Jia Zhangke engages with the "real" as mediated event in *I Wish I Knew* and as a stylistic sampling of world cinema in *The World*. Jia's first feature, *Xiao Wu*, highlights the tension in his oeuvre among various approaches to realism even more clearly. Reconsidering the "real" and the realist aesthetic has a particular urgency in contemporary film culture. André Bazin, Siegfried Kracauer, John Grierson, and even "formalists" such as Sergei Eisenstein and Dziga Vertov all put forward theories of film's relation to the "real" that now must be reconsidered in light of cinematic postmodernism. In addition to Fredric Jameson's "false realisms" and Jean Baudrillard's "desert of the real," mentioned in chapters 1 and 2, questions of the "real" haunt theorists as diverse as Slavoj Žižek and Gilles Deleuze. Žižek, for example, revivifies Lacan's notion of the "real," while Deleuze looks for "reasons to believe in this world."[1] The relationship of the "real" to the postmodern culture of the spectacle characteristic of late capitalism continues to be a central concern of contemporary philosophy and critical cultural theory.

Within this "desert of the real," various styles of film realism have taken international film festivals by storm and have helped to define the "look" of art cinema at the millennium. Some scholars have pointed to the digital revolution and the celebration of a "century of cinema" as creating a suitable environment for this resurgence of film realism by encouraging filmmakers to go back to the roots of the medium in the *actualities* of the Lumière brothers. Others link current trends in film realism to a desire to develop a style as diametrically opposed to Hollywood commercial homogenization as possible, to insist on the specificity of the local against the global, of the immediate against the computer-generated, and to provide some access to the screen for the marginalized. Celebrating the long shot and the long take (sometimes enhanced by DV's ability to push celluloid's limits on the duration of the shot) has become common within international art cinema from Greece to Iran. The impact of Dogme 95's "Vow of Chastity" as an attempt to redefine world cinema through a type of reinvigorated

realism also should not be underestimated.[2] However, other types of realism have also been lauded (e.g., Michael Moore's winning of the Palme d'Or at Cannes for *Fahrenheit 9/11* in 2004 immediately comes to mind). Far from being buried in the "desert of the real," film realism, in many forms, continues to dominate many aspects of world film culture.

While there may be important international reasons for the dominance of film realism (ranging from a reaction against the artificiality of global consumer culture to the cultivation of a style that is cost effective, accessible, and sometimes provocative), the specific face of film realism in contemporary Chinese cinema needs to be examined in relation to the global dynamics of international cinema and the regional market for motion pictures, as well as the specifically local dimension of films shot in small towns in Shanxi, rural Malaysia, and the mean streets of urban Hong Kong and Taipei.

Drawing on forms as diverse as classical Hollywood's social problem film and the domestic melodrama, Soviet socialist realism, and Popular Front humanism, Shanghai "left-wing" filmmakers of the 1930s and 1940s developed a style of cinematic realism that created the cornerstone for post-1949 Chinese cinema. After 1949, Chinese-language cinema moved in very different aesthetic directions that ranged from socialist realism (often countered by "revolutionary romanticism") in the PRC, social realism (exemplified by genres like the tenement film) in Hong Kong, and "healthy realism" as the KMT's propagandistic reaction to critical realism in Taiwan.

As it did in many places, Italian Neorealism had an enormous impact on not only the evolution of film aesthetics in the PRC, but also the continuing development of various realist aesthetics throughout the Chinese-speaking world. One of the first foreign films shown after the establishment of the PRC in 1949, Vittorio De Sica's *Bicycle Thieves* inspired directors such as Xie Jin, for example.[3] Hong Kong's melodramas of the 1950s (e.g., *The Kid,* 1950), as well as New Wave features such as Allen Fong's *Father and Son* (1981), indicate a familiarity with this seminal work,[4] and scholars have commented on Fruit Chan's debt to Italian Neorealism in films such as *Little Cheung* (1999).[5]

Shades of Italian Neorealism also seem evident in the inaugural works of Taiwan New Cinema, particularly in Hou Hsiao-hsien's contribution to *The Sandwich Man* (1983), "The Son's Big Doll," in subject matter as well as film style. Because of its transnational visibility, it comes as no surprise that PRC filmmaker Wang Xiaoshuai's *Beijing Bicycle* should use *Bicycle Thieves* as the basis for this French-Taiwanese-PRC co-production, co-scripted with Peggy Chiao and Hsu Hsiao-Ming from the Republic of China (ROC).[6] Citing *Bicycle Thieves* precipitates a transnational wave of recognition that links the film to a local and global cinematic history.

Just as the French New Wave grew out of Italian Neorealism as both a continuation and a critique of that particular film aesthetic, filmmakers associated with New Chinese Cinema, from the Fourth (Xie Fei), Fifth (Tian Zhuang-zhuang), and Sixth Generations (Jia Zhangke) in the PRC to the Hong Kong New Wave (Allen Fong) and "indies" (Fruit Chan), as well as Taiwan New Cinema (Hou Hsiao-hsien), reacted against these earlier types of cinematic realism. For them, Italian Neorealism became a stepping stone for cinematic styles that evolved in different directions. They pursued (as the French New Wave had) a modernist aesthetic while maintaining many important links to earlier realist forms. In the move through modernism into the postmodern, the status of cinematic realism has become even more complicated. Transnational co-productions and increased contact across the Chinese diaspora have put these various traditions of realism—and the specificity of their historical, political, and cultural roots—into direct contact. However, the question remains as to why Chinese filmmakers working across national borders should gravitate toward realism in any form within the postmodern cinema's "desert of the real."

From the "Real" to the "Transcendental"

Although Neorealism's influence on the Hong Kong New Wave, Taiwan New Cinema, and the films of China's Sixth Generation has been duly noted by scholars, the impact of other realist aesthetic traditions has not been given the same critical scrutiny. One omission has been the influence of Robert Bresson and what Paul Schrader has termed the "transcendental style" on contemporary Chinese cinema. Even Johnnie To's *The Sparrow* (2008) cites Bresson's *Pickpocket* (1959) in its choice of subject matter and some shot compositions. Several Chinese-speaking directors have noted their debt to Bresson, and the two directors under consideration in this chapter, Jia Zhangke and Patrick Tam, have made their connection to Bresson explicit. As the term "transcendental" implies, this style uses the mimetic properties of the film image to point beyond the "real."

Jia Zhangke self-consciously expresses this debt to Bresson by giving *Xiao Wu* the English title *Pickpocket* in honor of Bresson's seminal feature. Internationally, Jia is in very good company since Martin Scorsese, who has collaborated with Schrader and has spoken about the importance of Bresson to his own filmmaking, points to *Xiao Wu* as outstanding among recent Chinese-language films. The Italian American director has been quoted as saying *Xiao Wu* "was true guerrilla filmmaking, in 16-millimeter format, and it reminded me of the spirit in which my friends and I had begun, back in the 1960s."[7]

In his book on the transcendental style, Scorsese collaborator Paul Schrader

focuses on three filmmakers: Robert Bresson, Yasujirō Ozu, and Carl Theodor Dreyer. The relationship between Hou and Ozu has been widely discussed, and Bresson has been mentioned in some scholarly exchanges regarding Hou's oeuvre. Given the fondness of Hou's early collaborator, Edward Yang, for Bresson, the connection seems valid. Although Schrader's linking of these three very different directors through a common transcultural, ahistorical, spiritual bond has been critiqued, the fact that this style continues to find its way into contemporary cinema worldwide attests to its power. However, the question remains as to why particular Chinese-speaking directors should be attracted to Bresson. Given the spectrum of realist styles available to contemporary filmmakers, the visual austerity, spiritual asceticism, and moral complexity of Bresson may not be an obvious choice.

If observational style, improvisational freedom, and stylistic exuberance might be expected to attract Hong Kong New Wave filmmakers such as Patrick Tam or Sixth Generation filmmakers such as Jia Zhangke, Bresson does not seem to fit the bill. The transcendental requires patience. The cinema's realist tendencies would seem to make the medium a perfect vehicle for narratives about the external world and human beings in society or within the natural environment. These sorts of films might serve as the impetus for political or social reform in that world. However, transcendental filmmakers go against the grain of the medium to craft a style that uses the material to access the spiritual. As Schrader puts it, these films "describe the immanent and the manner in which it is transcended."[8] Realism remains on the visual surface as a conduit for another type of experience. For Schrader, filmmakers such as Bresson, Ozu, and Dreyer use the mimetic properties of film to point toward what cannot be depicted—the spiritual, the otherworldly, the holy. These filmmakers achieve the transcendent through a style that favors stasis over action, quietude over drama, the repetition of the details of quotidian life over the celebration of the spectacle of the extraordinary. In so doing, the films point toward what cannot be depicted in images— much as Byzantine icons gesture toward a spiritual realm beyond the frame.

This type of realism would appear to be diametrically opposed to Italian Neorealism's social engagement and its critical perspective on the legacy of fascism in post–World War II Italy. However, Schrader mentions Roberto Rossellini as on the edge of the style, and many other Neorealists, including Vittorio De Sica, may also be on that frontier. This type of realism may explain why a Catholic scholar such as André Bazin would praise what he calls a "Communist" film such as *Bicycle Thieves*:

> [It is] the only valid Communist film of the whole past decade precisely because it still has meaning even when you have abstracted its social signifi-

cance. Its social message is not detached, it remains immanent in the event, but it is so clear that nobody can overlook it, still less take exception to it, since it is never made explicitly a message....In the world where this workman lives, the poor must steal from each other in order to survive. But this thesis is never stated as such, it is just that events are so linked together that they have the appearance of a formal truth while retaining an anecdotal quality.[9]

Jia Zhangke also admires *Bicycle Thieves:*

Sometimes I have been termed a neo-realist filmmaker, and there is some truth to this, since I admire *Ladri di biciclette* (*Bicycle Thieves,* 1948) by Vittorio de Sica. It's a simple story about a man who is beset by problems in the impoverished environs of postwar Rome. But the film is essentially about the beauty of life, which is reflected in De Sica's assiduous observation of the surroundings: the sun, the light, the city. He has a marvellous [*sic*] way of dealing with objects.[10]

Jia praises De Sica's observation of inanimate objects rather than people, and this may be linked to Bazin's interest in "formal truth" over "social message." Bazin praises Neorealism's "supreme naturalness," and he welcomes, in particular, the "disappearance" of ideology that it implies: "Not one gesture, not one incident, not a single object in the film is given a prior significance derived from the ideology of the director."[11] Jason McGrath sees this same movement away from the ideological in Jia's approach to realism: "Rather than professing to show an ideological truth that underlies apparent reality, it seeks to reveal a raw, underlying reality by stripping away the ideological representations that distort it."[12] As the human hand and the political consequences of the human element disappear, the "raw, underlying reality" can transcend the ideological and take its place—or appear to take its place.

Like Schrader, Bazin looks for the transcendent within the immanent—for the abstract formal truth within the everyday. As John Hess points out in his work on Personalism (a type of existential Catholicism) and the auteur theory, Bazin views film realism with an eye to another spiritual dimension. Hess sees this as having three important consequences that seem to be quite similar to key aspects of the "transcendental style":

1. that films should be as realistic as possible because the more closely the images on the screen correspond to the real world, the more clearly the images will reveal the human being's relation to the infinite;

2. that the mise-en-scène (the composition of the visual image) be constructed in such a way as to include those parts of the real world which most directly reveal "soul through appearance";

3. that the actors must, through identification with the roles and through the gestures they develop to express both themselves and the character they represent, reveal their spiritual dimension.[13]

The "transcendental style" displays these elements. As Schrader points out in his discussion of Bresson, the use of non-actors (emphasizing a non-expressive other-worldliness rather than psychological depth), natural sounds (music not used for dramatic impact), and location filming (with an emphasis on the ordinary object) contribute to the transcendental experience. Schrader quotes Bresson: "The supernatural in film is only the real rendered more precise."[14]

Martin Scorsese, who directed a number of projects with Schrader as scriptwriter, including *Taxi Driver* (1976), which borrows liberally from *Pickpocket*, admires Jia's take on the Bresson classic:

The remarkable eye and ear for detail grabbed me immediately: every scene was so rich, so perfectly balanced between storytelling and documentary observation. And as a character study, and a film about community, *Xiao Wu* is extraordinary. There's nothing sentimental about Wang Hongwei's performance or about Jia's approach to him, and somehow that makes the end of the film, where the protagonist is arrested, chained, and exposed to ridicule, all the more devastating.[15]

Not surprisingly, Jia claims Bresson as his favorite European filmmaker: "My favourite European filmmaker is Robert Bresson. He has the ability to show states of mind on film, which is an extremely difficult thing to pull off."[16] When Jia first met his future collaborator, Nelson Yu Lik-wai, in Hong Kong, the pair immediately bonded because of their mutual regard for Robert Bresson.[17]

Hong Kong filmmaker Patrick Tam also greatly admires Bresson:

As for Bresson, he was a very unique film auteur, his cinematic language and instinct are very different from others. He liked to use the most simple story and minimalistic details to tell the most fruitful message, and to utilize the most superficial action in order to convey the inmost feeling. In addition, his film is also different from traditional drama in a way that he treated the actor as a model. He didn't want any dramatic performance from the actors. I think it is very original and focused.[18]

Many critics see a close connection between Tam's *After This Our Exile* and *Bicycle Thieves*. The Chinese title of the film (translated, meaning father and son) immediately conjures up the father/son duo in *Bicycle Thieves,* as well as Allen Fong's film *Father and Son,* with a very similar title. However, Tam insists his film owes a far greater debt to Bresson. Again, given the subject matter, *Pickpocket* comes immediately to mind.

"What a Strange Road I Took to Find You"

At the end of *Pickpocket,* Michel (Martin LaSalle), the eponymous thief, utters the words in the heading above in a voice-over from his prison cell as he embraces his love, Jeanne (Marika Green). Given that both *Xiao Wu* and *After This Our Exile* reference Bresson's *Pickpocket,* the question arises as to why two very different Chinese-speaking filmmakers should turn to this particular French film for inspiration. The Sixth Generation in the PRC and Hong Kong's New Wave/Malaysian independent filmmaking come together through the legacy of Bresson in these films, and the reasons behind this *Pickpocket* connection need to be explored. In some way, Bresson must answer aesthetic, ideological, philosophical, moral and/or spiritual questions for these two very different filmmakers.

Moreover, both films cite *Bicycle Thieves* as well as *Pickpocket*—from their Neorealist stylistic choices to attention to particular objects in the mise-en-scène (e.g., bicycles play a prominent visual role in each film) and implicit social critiques. While Jia accepts these connections to De Sica's film, Tam downplays them. However, the fact remains that two distinct styles of realism—stemming from Italian Neorealism as well as from the observation of the physical world in the "transcendental style"—come into play in both *Xiao Wu* and *After This Our Exile.* Although Neorealism may point to the transcendent in certain cases, Bazin clearly states it deals with the "immanent." Both styles move away from the ideological into a type of social observation that contrasts sharply with more didactic forms such as socialist realism. Bresson moves toward the spiritual, the redemptive, the transcendental, while De Sica tends to accept the human scale and dramatize the pathos of the individual's moral plight within a society at a loss to help him.

For Bazin, as noted above, *Bicycle Thieves* is that rare example of a "Communist" film that is not didactic. However, although it deals with moral complexity, *Bicycle Thieves* does not take its protagonists to the same spiritual plane as Michel achieves in *Pickpocket.* Caught and imprisoned, Michel finds redemption through grace in the form of Jeanne. However, in *Bicycle Thieves,* when Antonio (Lamberto Maggiorani) is caught trying to pilfer a bicycle to replace his

own stolen one, the humiliation he suffers in front of his son Bruno (Enzo Staiola) does not seem to lead to any transcendental moment of salvation. Rather, the two walk off to continue their struggle to survive.

Perhaps in the meeting ground between *Bicycle Thieves* and *Pickpocket* another type of film realism emerges—somewhere on a sliding scale between Bresson's transcendental style and Italian Neorealism. In assessing the career of another Neorealist, Roberto Rossellini, Gilles Deleuze remarked that he "showed us the link between man and the world. Hence it developed either in the direction of a transformation of the world by man, or in the discovery of an internal and higher world that man himself was."[19] Deleuze astutely pinpoints the commonality of two different approaches to two types of film realism that appear to be diametrically opposed. One form (critical realism, social realism) favors "a transformation of the world by man," while the other (the "transcendental" style) looks toward the "internal and higher world that man himself was." The "internal" may point to humanism and psychological realism, but the "higher world" implies the transcendental.

Deleuze, of course, puts Bresson in the spiritual realm (while Dreyer, for him, remains preoccupied with the moral/ethical). The link between existentialism (a strong dose of Jean-Paul Sartre) and Christian redemptive transcendence seems quite clear in the character of Michel in Bresson's *Pickpocket,* particularly in the way the character resembles Raskolnikov in Dostoyevsky's *Crime and Punishment.* However, the legacy of Neorealism—for example, the use of non-actors, city locations, emphasis on the lower classes, a "gritty" sense of urban life, with links to moral, social, and political issues—can also be felt. Michel's embrace of Jeanne through his prison bars at the film's conclusion represents spiritual redemption more than erotic fulfillment, and any social commentary on the plight of the poor man driven to crime is virtually absent from the plot.

Both Jia and Tam seem preoccupied with both aspects of realism—with Tam perhaps closer to the "transcendental" than Jia. Like Bresson, Jia and Tam are drawn to "sinners" (anti-heroes). Unlike De Sica's protagonist, who gave in to his impulse to steal only after being abused at virtually every level of postwar Italian society (from the trade unions to the police to the church), Jia's Xiao Wu (and virtually all the other characters in the film) and Tam's central Chow family (Chow Cheong-shing, played by Aaron Kwok; Lin, played by Charlie Yeung; and Ah Boy, played by Gouw Ian Iskandar) are all morally flawed in some way. Like Bresson's Michel, Jia's Xiao Wu starts off as a thief. Although Cheong-shing and Ah Boy turn to thievery only later in the film, they do so independently of each other, and Tam does not portray Ah Boy as a complete "innocent." Likewise, Lin may be driven to abandon her family by her husband's abusive ways; however, she still runs off with another man and leaves her son in the questionable "care" of his father.

As Schrader sees Bresson's oeuvre, the flawed protagonist goes on a spiritual journey that leads to a miraculous or redemptive moment that points to the transcendental. The film depicts this journey through a buildup of repeated events emphasizing the details of everyday life—often fragments of objects or parts of the body. Unlike the long shot/long take style (often with deep focus cinematography and a mobile camera) favored by Bazin, Bresson tends to fragment time, space, and the body with an eye beyond the human dimensions of the "democratic" style Bazin prefers.

For Schrader's Bresson, the protagonist mirrors an ironic detachment that the observational style of the film also provides. For example, the camera's scrutiny of events is doubled by Michel's diary entries, which make the same observations in voice-over. The events, in turn, are contrasted with a spiritual passion that erupts unexpectedly in a soulful glance or through the Jean-Baptiste Lully score. This passion leads to a "decisive" action and to a transformative moment that appears to be miraculous. After this redemption, stasis creates a near mystical experience—for example, the impact of the close-up with Michel's eye peering out from behind the prison bars and Jeanne's head to look beyond the camera at the end of *Pickpocket*.

Neither *Xiao Wu* nor *After This Our Exile* evidences the stylistic purity of *Pickpocket*. However, both follow the same narrative pattern—at least to a certain degree. *Xiao Wu* parallels *Pickpocket*'s plot more closely, but *After This Our Exile* appears to be more concerned with questions of redemption. All three films deal with the issue of what has been called a "spiritual malaise" characteristic of postwar Europe in *Pickpocket,* post-Mao China in *Xiao Wu,* and postcolonial Hong Kong displaced onto the Chinese diaspora in Malaysia in *After This Our Exile.* This malaise could be translated into dissatisfaction with the social and philosophical climate in France in the 1950s, Communist reform under Deng Xiaoping in China in the 1990s, and Hong Kong's transition from a colony to a Special Administrative Region after 1997, as well as Malaysia's political and economic vicissitudes at the millennium. All three films owe a debt to the realist traditions that predated them—particularly Italian Neorealism in Europe, critical realism in pre-1949 Chinese cinema, the socialist realism of the international Communist movement, and the social problem film associated with the commercial melodrama in Hollywood and Hong Kong. However, they also break dramatically from these earlier forms. Jia and Tam look to Bresson as the trailblazer to take them in a direction that transcends these other incarnations of realism. However, the question remains as to whether these three filmmakers take up the transcendental style for the same reasons or whether each has taken a different path on his "strange road" to find an appropriate cinematic aesthetic.

Thieves on the Road

Looking at what the three films have in common may help to shed some light on how and why they differ. Like *Pickpocket, Xiao Wu* focuses on its titular thief, and the parallels continue with the main characters surrounding him. With glasses obscuring his face and an air of philosophical detachment, Xiao Wu seems a lot like Michel, holed up in his Parisian garret surrounded by stacks of books. Like Michel, Xiao Wu maintains close contact with the police, and Wu even does his civic duty by returning the identification cards he filched directly to the police by mail. Both work with a gang, although Wu's connections are more juvenile, à la Dickens's *Oliver Twist* or the father-son team in *After This Our Exile*. Both have strained relationships with their families and trouble with the women in their lives.

In *Xiao Wu, Pickpocket*'s Jeanne is divided in two—Xiao Yong's fiancée and the KTV hostess Mei Mei (Hao Hong-jian). In *Pickpocket,* Michel wins Jeanne as the symbol of his redemption when she refuses to marry their mutual (and honest) friend Jacques, the father of her child, because she loves Michel. In *Xiao Wu,* Xiao Yong wants to put his past behind him, so he decides not to invite Xiao Wu to his wedding and refuses his wedding gift by returning his *hong bao* (lucky red envelope containing money) to him. In a parallel plot point, Wu purchases a gold ring for his girlfriend Mei Mei; however, she disappears and leaves him in the lurch before he can even offer her the ring. When he gives the ring to his mother instead, she passes it along as a gift for his brother's fiancée. While Jacques, Jeanne, and Michel's mother always seem to be there for Michel, Xiao Wu is shunned by all. They symbolically refuse to be connected with him (*guanxi*) by refusing his gifts, and he becomes increasingly isolated. The beeper that connects Xiao Wu with Mei Mei, which he foolishly, sentimentally, or self-destructively leaves on even after Mei Mei abandons him, goes off during a robbery, and he is caught. Needless to say, unlike Jeanne, Mei Mei does not appear after Xiao Wu's incarceration.

After This Our Exile also has quite a lot in common with *Pickpocket.* In this case, though, Michel's role manifests in two separate characters. Both father Sheng and son Ah Boy are thieves—cat burglars rather than pickpockets. However, while Michel and Xiao Wu have some skill, Sheng and his son seem doomed to failure from the very beginning. As indicated in the scene in which Sheng lays out a variety of objects to train Ah Boy to look for the most valuable items in a mark's house, neither has any idea of how to be a thief. In fact, the scene plays more like the ritual some Chinese families use to predict their child's future profession by putting out a display of attractive objects for a toddler to pick from at

will (figure 3.1). The perversion of the ritual here indicates how far Sheng has strayed from the Confucian ideal.

Only when completely on his own does Ah Boy manage to steal a watch from his friend's house and a piggybank from his neighbor. The theft of the watch is particularly telling since the scene contrasts Ah Boy's nobler feelings, as indicated by his reaction to his friend's mother's piano playing, and his impulse to steal. Like Michel and Xiao Wu, Ah Boy is a divided character who struggles with his own feelings, desires, and familial circumstances. When he teams up with his father, disaster, of course, ensues. However, no feminine force represents salvation for the duo. Father and son are both estranged from the women in their lives—that is, Ah Boy's mother Lin and Fong (Kelly Lin), a prostitute Sheng pimps out. Both father and son find redemption away from these women—the father through a fresh start with a new wife and family and the son by repaying his debts, forgiving his father, and finding peace with himself.

All three films follow the basic narrative pattern Schrader associates with the transcendental style. Close attention to the repetitive details of daily existence alternates with occasional moments of emotional insight; ironic detachment vies with spiritual passion. The details of Xiao Wu's cold life as a pickpocket meet with unexpected emotional warmth in his dealings with the policeman and his toddler when he first returns a stolen ID or his courtship of Mei Mei in her sickbed. The domestic routine of ironing shirts, fixing meals, organizing bus fares for school, planning family trips, or celebrating birthdays has an emotional

Figure 3.1. The education of a thief—Ah Boy (Gouw Ian Iskandar) and Sheng (Aaron Kwok) in *After This Our Exile*; dir. Patrick Tam, 2006.

dark side as Lin prepares to abandon her family; quotidian details hide the pain of the disintegrating family.

Both *Xiao Wu* and *After This Our Exile* open with journeys. Xiao Wu starts with a bus trip and moves on to a bicycle ride; Ah Boy dreams about riding a bicycle with his father, and the initial sequence ends with his aborted bus ride to school. In many ways, these opening journeys encapsulate the plot of each film. Just as Bresson's *Pickpocket* opens with Michel deciding to steal, stealing, and getting caught (a pattern repeated until the final shot), the openings of *Xiao Wu* and *After This Our Exile* parallel the overall plotline of each film.

The opening of *Xiao Wu* depicts its protagonist in his environment—the struggling hinterland of post-Mao China. Xiao Wu waits on a country road for the bus, and similar scenes dot the film. He is shown sitting by the side of roads as an onlooker, waiting to zero in on his mark or simply killing time throughout the film and watching life pass him by. As he gets on the bus, he is being watched, and he remains under surveillance at various points throughout the film.

A contradictory figure, Xiao Wu dons a shabby suit that does not sit well with his thick, nerdy eyeglasses, while the tattoo exposed when he lifts his arm to steady himself on the bus indicates that the criminal clashes with both the peasant and the student in this single character. He does not pay and attracts the notice of the bus attendant, who leaves him alone when he says he is a cop. His fellow passenger/first mark in the film gives him a quizzical gaze, and the picture of Chairman Mao hanging from the rearview mirror of the bus seems to indicate disapproval. Xiaoping Lin talks about the journey in terms of a "pilgrimage" with Xiao Wu "under the shadow of Mao/Holy Ghost."[20]

The tensions underlying the journey find visual expression in a cutaway to the bus's side-view mirror. As the bus moves forward, the road behind appears moving backward. This forward/backward tension defines Xiao Wu's journey and his predicament. When he appears to make some progress in his life toward romantic love, friendship, reconciliation with his family, and attempt to get "right" with the law, he takes a giant leap backward, losing Mei Mei, his friendship with Xiao Yong, his welcome at his parental home in the countryside, and his détente with the police authorities. A close-up of his shirtsleeve as he gets ready to strike is juxtaposed with the portrait of Mao—an icon of the past, of a different political/moral value system, with the residue of its symbolic power as the "Holy Ghost" of the PRC circa 1997.

After This Our Exile begins with shots of the Malaysian landscape. Evidence of a dock indicates a human presence. Like Ozu, Bresson, Hou, and Jia, Patrick Tam appreciates closely observed details. A shot of a bicycle wheel on a country road opens the plot. A close-up of a foot in a sandal pedaling a bicycle follows. The circular movement of the bicycle wheel is picked up by a twirling pinwheel.

A close-up of Ah Boy's cheek on his father's back looking at the pinwheel is followed by a shot of the bicycle within the green landscape as it moves away from the camera (figure 3.2). Jump cuts of the boy's fall literally disrupt this reverie, and a shot of Ah Boy's eyes opening indicates it was all a dream. Following Bresson, this could be read as a religious allegory—keep in mind, for example, that the pinwheel acts as a prayer wheel in certain Chinese funerary rituals and other religious practices. Ah Boy is taken for a ride by his father, at the mercy of forces beyond his control like the pinwheel, and inevitably falls from grace, only to wake up to the nature of life in order to transcend it (and overcome the sins of his father). However, Ah Boy wakes up in the world of his dysfunctional family. The mattress on the floor and broken electric fan not only pay homage to Ozu's tatami shots, but also closely reflect *Bicycle Thieves* by placing the child Ah Boy in an adult world filled with poverty and pain.

Again, the immanent (the bedroom) and the transcendent (the field of dreams) form a dialectical unit. However, whereas De Sica clearly places the blame on postwar Italian society for the moral emptiness in his film, Patrick Tam, like Bresson, keeps the story on a spiritual plane. Ah Boy's father has a job as a cook, but he squanders his money gambling. His mother faces temptation at her workplace, where she is a bar hostess. In this moral vacuum, Ah Boy steals from his friends who are better off—either materially or emotionally. Although life within the Chinese diaspora in Malaysia may not be ideal, other working-class families similar to Ah Boy's do well, and many in the diaspora, including

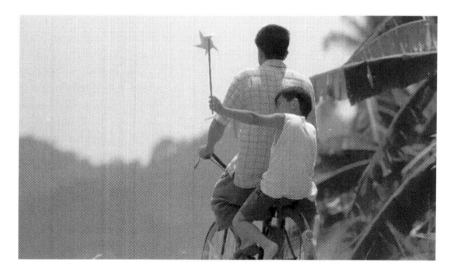

Figure 3.2. Bicycle dreams in *After This Our Exile*; dir. Patrick Tam, 2006.

Lin, find a way to become upwardly mobile. As in Bresson's *Pickpocket,* social, political, and economic circumstances really do not come into play. While Sheng's and Lin's dreams for a better life may be misguided, leading one to gamble and the other to abandon her family, their failings are presented as individual moral flaws, evidence of a spiritual malaise linked to an increasingly materialistic society, to be sure, but still not rooted in the political system, the failings of capitalism, or even the social ills of gambling and prostitution.

After This Our Exile is not a social problem film, a political tract, or even a Neorealist indictment of a heartless political or economic system. Rather—as the Catholic prayer used for the film's English title indicates—it is about what exists "after this our exile" within the human body and during our time on earth. It points to a spiritual transcendence that calls for a change involving moral and spiritual values—a change in the orientation of the society, to be sure, a movement away from personal ambition, avarice, and selfish disregard for the feelings of others.

When compared to *After This Our Exile, Xiao Wu,* then, seems closer to *Bicycle Thieves* than to Bresson's *Pickpocket.* Rather than pinpointing a particular moral weakness, like gambling or an impulse to steal, as the moral flaw at the center of the protagonist's spiritual malaise, Jia keeps his critical options open. Mao may continue to observe Deng's reforms from the dashboard, but he has left more than a moral vacuum behind. The appearance of law and order broadcast on the radio and television takes the place of any sense of social justice in the film. Xiao Wu may be a little (*xiao*) pickpocket, but he is surrounded by thieves even bigger than his old friend Xiao Yong (who now trades in illegal cigarettes and call girls).

The village has deteriorated into a patriarchal enclave where women again demand a bride price, and the town is perpetually threatened with demolition. As many scholars have pointed out, Xiao Wu is one of the "losers" under Deng's reforms—his ability to work with his hands (a working-class skill prized by Mao) no longer makes him fit to succeed under Deng's "socialism with Chinese characteristics." Xiao Wu says so explicitly; he works with his hands but is "too dumb" to be an entrepreneur. With no place in the town or countryside for him, he becomes a bystander, a thief fated to be captured during a publicized crackdown on crime (which leaves "entrepreneurs" like Xiao Yong not only unscathed, but also celebrated as "heroes" who manage to show that getting rich can be glorious).

Although there is no hint of any Maoist nostalgia, no call for Communist political purity or anything close to that in *Xiao Wu,* Jia maintains a link between the spiritual malaise experienced by his protagonist and the economic/ political changes precipitated by Deng's neoliberal reforms. The film carefully

delineates a particular temporal period from 1982 to 1997. The year 1982 appears on a wall featured prominently in the mise-en-scène of several shots in the film. In that year, the Fifth National People's Congress put forward a new constitution that paved the way for the economic changes that followed.[21] At another point, 1993 is mentioned; it is the year after Deng Xiaoping's famous southern tour that accelerated market reforms. In 1997 (the year of the film's premiere), Deng Xiaoping, the mastermind behind those changes, died, just a few months before Hong Kong's return to the PRC. Xiao Wu functions as a contradictory creature of this "reform" era—drawn to steal but happy to support the police who arrest him. In fact, he can be seen allegorically as a Reform Era Everyman who believes in the state and an economic system that has set him up for failure in order to enrich a new elite.

After This Our Exile engages with historical time quite differently. Roger Garcia, for example, sees the film as taking up issues of Hong Kong's past more than the present circumstances of the Chinese community in Malaysia:

> It remains one of the few Hong Kong films in the late 20th century to capture the mood, spirit and feel of growing up in Hong Kong as Hong Kong itself grew up into an integral part of the global economy.
>
> And in its profundity it transmits not only the energy of the image, but also a dialectical current—a melancholic treatise on the author's control or otherwise, of his creation. It is a process that was nascent in the Hong Kong New Wave as filmmakers inflected the identity of a new Hong Kong and its relationship to a patriarchal Mainland China, but a consciousness which has been vapidly absent from much of recent Hong Kong cinema.[22]

Here Garcia places the film within Hong Kong's postcolonial temporal frame, and a different understanding of it emerges. As a political allegory of the encounter between the destructive patriarch and the vulnerable son, it sits within the ranks of the many fathers and sons that have peopled the Hong Kong New Wave since the signing of the Joint Declaration in 1984. Sheng and Ah Boy become stand-ins for the PRC and Hong Kong, and this story of a journey toward acceptance and reconciliation seems to have its own political dimension.

However, Tam prefers Bresson to De Sica, and the theme of redemption and spiritual transcendence may indicate a desire to get beyond the political economy of human existence. Going away from contemporary Hong Kong to Malaysia and back in the past to a way of life that resembles Hong Kong during the postwar colonial era takes *After This Our Exile* away from the direct engagement with politics that *Xiao Wu* does not evade. As the two films drift apart, they again come

closer together since both go to the margins of the Chinese experience—the "primitive" hinterland in and around the small town of Fenyang in *Xiao Wu* and the Chinese-speaking communities of small-town Malaysia (where Johor Bahru, the border town across from "modern" Singapore, functions as the big city). Moving away from Beijing or Hong Kong, the films appear to go back in time to contrast the present with the past and to highlight the impact of change. However, going away from the urban and the modern also opens the films up to an experience outside normal expectations.

The Decisive Action and Stasis

According to Paul Schrader, transcendental films establish narrative patterns that alternate between ironic detachment and spiritual passion expressed through the details of daily life. These patterns build to a decisive action that is transformative and appears to be miraculous. In all three of the films under discussion, the protagonists make decisions that lead directly to their arrests. These decisive actions may or may not be consciously executed. The actions may be fated, inspired by a higher power, or be part of what Deleuze calls "the discovery of an internal and higher world that man himself was."

In *After This Our Exile,* the decisive moment and its transformative power seem clear. For Ah Boy, his role as observer transforms him. After breaking into a house in which a young boy hovers on the verge of death from cancer, Ah Boy begins to cry from his hiding place inside a closet. Of course, he is caught, but Sheng steps in to claim that his son is mentally ill and begs for clemency. After this incident, Ah Boy tells his father he no longer wants to steal, and Sheng agrees to get a job. Given Sheng's problems with the triads because of his gambling debts, the idea of being able to find a job undetected seems remote, as he hobbles along still suffering from the effects of a gang beating. Indeed, after affirming his promise to his son, Sheng still pushes Ah Boy into a house to steal when the opportunity presents itself. Ah Boy drops some of the loot and gets caught again. This time, however, the homeowner has no mercy and begins to beat the boy severely. As the neighbors come out to witness the commotion, Sheng abandons his son.

Father and son meet again during Sheng's visit to the juvenile prison in which Ah Boy is incarcerated. The boxlike framing Tam uses throughout the film (e.g., frames-within-frames; walls dividing the frame; doorways, mirrors, windows, and closet ventilation slats) reaches its apogee in this scene. The camera follows Ah Boy as a female jailor accompanies him, gazing at him in a narrow

corridor through slats in an interior window, past doorways, pillars, and other objects physically dividing the frame (figure 3.3).

Sheng and Ah Boy sit on opposite sides of a table, a window framing them in the background, the light placing them in partial shadow. The father moves closer and squats in front of his son to ask for another chance. A cut makes a transition that cannot be temporally or spatially pinpointed. In an evening exterior location, the camera follows Sheng as he limps along alone in a shadowy blue streetscape. As he walks toward the camera, a bandage on his ear becomes visible. A low angle shot frames him from the chest up against the blue sky. The camera tilts down, the sound of insects can be heard, and Sheng stands silhouetted against an abandoned colonial-style building. He limps over to a bench and sits down. Only then does the connection between this scene and the jailhouse confrontation become clear. Quick cuts reveal two very brief shots of Ah Boy biting Sheng's ear (figure 3.4). After an inserted shot on the bench, the film returns to a longer take showing Ah Boy ripping the ear away from his father's head. While Sheng sits quietly on the bench, the displaced voice of Ah Boy demands an answer to his question, "Why did you make me steal? Why?" Over a close-up of Sheng's bandaged face, the off-screen, temporally displaced sound of footsteps and clank of a door slamming shut indicate that Ah Boy has been put away for good.

Biting off his father's ear is a decisive gesture. It forces Sheng to separate from his son and take stock of his own life, and it also allows Ah Boy the sanctuary of prison. Like Michel in Bresson's *Pickpocket,* Ah Boy finds his freedom in jail, away from his father and a life of crime/sin.

As in most examples that Schrader cites of the transcendental style, these decisive moments bring to a head the dialectic between surface realism and spiritual passion. The attention to formal details becomes more intense through framing and camera movement, music and voice-over displace synchronized sound, long takes give rise to jump cuts, and the narrative folds in on itself temporally and spatially. The intensity of the decisive action is juxtaposed with absolute quietude—the blank expression on Sheng's face, his slow movements leading to immobility, and the change from a focus on the human form to images of the water, sky, and trees at the end of the sequence.

As the film's conclusion indicates, both Ah Boy and Sheng appear to have changed their ways. Although there is no scene of father-son reconciliation at the film's conclusion, Ah Boy implicitly forgives his father—the final sign of his spiritual redemption, as indicated by the phrasing of his voice-over. Ah Boy goes to the riverbank, looks across, and sees a man resembling his father. A boy who resembles Ah Boy in his earlier dream passes by on a bicycle holding a pinwheel, providing a prelapsarian vision of his relationship with his father before the sym-

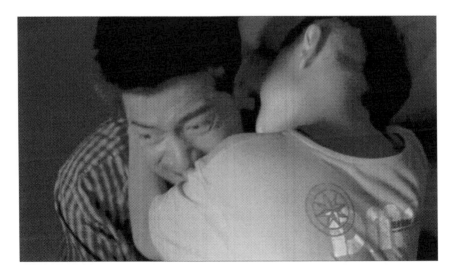

Figure 3.3. Sheng (Aaron Kwok) visits Ah Boy (Gouw Ian Iskandar) in prison in *After This Our Exile*; dir. Patrick Tam, 2006.

Figure 3.4. Ah Boy (Gouw Ian Iskandar) bites Sheng (Aaron Kwok) in *After This Our Exile*; dir. Patrick Tam, 2006.

bolic fall off the bike and away from grace. A concluding flashback image of Sheng's hand caressing Ah Boy's head followed by a close-up of Ah Boy looking off indicates not only forgiveness, but also transcendence—just as Jeanne's caress at the end of *Pickpocket* does not indicate a "happy ending" involving romantic love but points to a transcendence of human emotion with Michel's gaze off screen looking into the infinite (figure 3.5). The withholding of the happy father-son reunion at the conclusion of *After This Our Exile* provides a similar gesture; it moves away from the human scale of Oedipal conflicts and toward something deep within the soul or far away in the heavens.

Although the decisive actions in *Xiao Wu* and *After This Our Exile* seem similar, their consequences differ considerably. Following Mei Mei's suggestion, Xiao Wu purchases a beeper so that she can contact him when she is free. However, she runs off before it goes into regular use. In the countryside, the beeper becomes a novelty and a way for Xiao Wu to show his family how he has prospered and progressed in town. Of course, no one seems particularly impressed. Returning to Fenyang, Xiao Wu continues to wear his beeper even while picking pockets. The beeper goes off (with the weather report, not with a message from Mei Mei) while Xiao Wu tries to steal a wallet. The pickpocket attempts to escape,

Figure 3.5. Michel (Martin LaSalle) looks off into infinity in Robert Bresson's Pickpocket, 1959.

but the victim follows, shouting as Xiao Wu runs deep into the background of the shot.

As in the cases of Michel and Ah Boy, the botched robbery leads to Xiao Wu's incarceration. However, rather than being placed behind bars like Michel and Ah Boy, Xiao Wu ends up handcuffed to a motorcycle in what appears to be the recreation room attached to the police station. Although a toddler walking into the frame gives the place a domestic feeling, the crowd gathered outside the window looking in at the prisoner indicates that this is, in fact, a jail with the prisoner on view, publicly humiliated for all to see.

The policeman turns on the television to help his prisoner pass the time. However, Xiao Wu only seems to be mocked by the broadcasts. Beethoven's *Für Elise* (the same tune his lighter plays) comes on to remind him of his own alienation from the forces associated with the market economy and cultural Westernization. The interview that had earlier featured Xiao Yong comes on, and Xiao Wu takes the place of his friend as the subject of the broadcast. However, instead of Xiao Wu's being used as an example of a model entrepreneur, his case testifies to the efficacy of the anti-crime campaign in the province.

Unlike Bresson's *Pickpocket* and Tam's *After This Our Exile*, Jia's *Xiao Wu* does not use any voice-overs. Rather, music, often in the form of KTV favorites, serves the same function. After Xiao Wu's final humiliation of an anonymous message on his beeper telling him to look out for himself, the film shifts to a street scene at night, and a pop song plays with these lyrics: "I'm fighting desperately to put an end to all my suffering. Look at the sky: the clouds are moving too quickly. May I ask you all who's the hero?"

In daylight, one of the police guards takes Xiao Wu out in handcuffs, presumably to court or to another jail. Needing a break, the guard handcuffs Xiao Wu to a wire on the street, and the prisoner squats down to wait. The camera moves from Xiao Wu to show the crowd that has gathered to look at him. The circular movement conjures up a camera style associated with Jean-Luc Godard's fondness for 360-degree pans, while the use of the handheld camera seems to reference Dogme 95 and its "Vow of Chastity," crafted as a clear statement opposed to the French New Wave auteurism associated with filmmakers such as Godard. The film moves away from Bresson's minimalism and any indication of the transcendental as the cinematographer, Yu Lik-wai, stitches together a camera style in synch with Jia's vision, navigating a contradictory course between the French New Wave and Dogme 95.

Women, children, old men, and people on bicycles stop and stare, and the camera takes on the perspective of Xiao Wu—or, in a self-reflexive gesture, the film shifts from a story about a pickpocket to a tale about the transformation of China into a cinematic spectacle. Unlike *Pickpocket* and *After This Our Exile*,

which end with close-ups of their protagonists staring off beyond the camera, *Xiao Wu* ends with the protagonist off screen and with the citizenry of Fenyang staring directly into the camera lens.

Less an evocation of the transcendent and more a commentary on China and the society of the spectacle, *Xiao Wu,* like the Bresson and Tam films, still moves away from surface realism into another type of filmmaking, reflecting on the cinematic apparatus, on the spectacle of existence, and on the complicity of the viewer in the public humiliation of the "hero" Xiao Wu. Again, the decisive action has led to stasis—the handcuffed Xiao Wu cannot move. However, as in *Bicycle Thieves,* which also ends with the public humiliation of its protagonist caught in the act of trying to steal a bicycle, this status does not point to spiritual transcendence, redemption, or quietude.

The gaze back at the camera places *Xiao Wu* into the world of the international film festival and in the company of the self-reflexive ending of Abbas Kiarostami's *Taste of Cherry* (1997), which won the Palme d'Or at Cannes the same year *Xiao Wu* had its premiere. Like *Taste of Cherry, Xiao Wu* blends an apparently realist aesthetic with a pared-down style that pushes it into the realm of formal self-consciousness and self-reflexivity. In both cases, the films are less an engagement with the "real" per se or a meditation on the transcendental (although *Taste of Cherry* can certainly support a claim to the transcendental style in its depiction of a spiritual malaise that leads to a search for meaning in a life on the brink of suicide—the ultimate "stasis"). Rather, the films appear to be engaging with the idea of cinematic realism. To paraphrase Godard, they go beyond the image of reality (realism/Bazin), as well as the reality of the image (modernism/Godard), to an investigation of the collapse of the real into the image (postmodernism/Baudrillard). Jason McGrath astutely points this out with reference to Jia Zhangke's oeuvre: "The question raised by Jia's realism is not whether it divulges an elemental real so much as how it constructs the powerful impression of a confrontation with reality through the rhetoric of the films' narratives and their cinematic style."[23] Jia engages with global conversations regarding cinema aesthetics, and he draws on a common history of film practice. Just as thieves populate *Xiao Wu,* the film's intertextual citations resemble theft. As Kevin Lee notes in his analysis of the film's closing scene,

> The idea of "stealing" informs the work of Jia's camera. It cops a gaze at the crowd, some of whom turn away, while others stand transfixed by what is looking back at them. The power of the camera's gaze brings to mind a variety of gazes in and around Chinese society: those of the government, of neighbors, and of foreigners seeking an inside look at an exotic world. This moment of mutual gazing brings attention sharply towards us, the audience,

locating our own act of spectatorship within the spectacle. We are implicated in a collective urge to look, and are captured in a moment that inverts the positions of spectator and spectacle so that they become one and the same in a panoptic society that describes China, the world, and the cinema.[24]

In fact, in all these films, the thief can stand in for the filmmaker—Bresson "steals" from Samuel Fuller's *Pickup on South Street* (1953); Schrader, Scorsese, Jia, and Tam "steal" from Bresson. Inevitably, the latter four filmmakers engage with film realism, "transcendental style," and the dialectic between the immanent and the transcendent through the postmodern. In advanced capitalism, within the "society of the spectacle," where images circulate like other commodities, the mimetic properties of the cinema—realism's supposed ability to be "democratic" or "transcendental"—take a backseat to an engagement with cinema as a medium of surfaces.

Performance has taken the place of representation as the operative concept in understanding cinema in the age of the digital revolution. The non-actors that people *Xiao Wu* and *After This Our Exile* live in a world of performance. In *Xiao Wu*, Mei Mei sings and dances in a KTV establishment, and she also pretends to be an actress training in Beijing for the benefit of her parents' peace of mind. The gangster Xiao Yong performs the role of the "new" entrepreneur and welcomes the opportunity to display his success on television. Both play their roles convincingly and change their parts appropriately to survive in the new economy. However, Xiao Wu cannot seem to perform adequately as a boyfriend, son, or thief. With his thick glasses, the non-actor does not even seem to look the part of a gangster.

Similarly, much of the critical attention surrounding *After This Our Exile* involves Aaron Kwok's performance as the flawed father; questions of whether the popular Cantopop singer can *act* come up frequently. Many of the other characters in the film play performers—bar hostesses, prostitutes, etc.—and the notion of the "authentic" behind the mask of the performance comes into doubt. Even the newcomer who plays Ah Boy stands out with a style quite different from Aaron Kwok's, and the two sometimes appear to be operating on different emotional registers, performing in different films.

In speaking of the crisis in the "action-image" after World War II, Gilles Deleuze pointed to the rise of the non-actor, associated with Italian Neorealism and the French New Wave but also with individuals such as Bresson, who preferred "models" to dramatic "actors" for his films. Models, of course, can perform a behavior to the director's specification rather than act out a dramatic situation, and this type of performance suits both Jia and Tam. Going back to the spiritual, Deleuze called the non-actors of this type of cinema "seers"—observers

rather than actors—gesturing toward the mystical. If seen with a postmodern slant, they witness the implosion of meaning in the cinema—paralyzed but observant.

Postmodernism and Stasis

All three films revolve around a tension between stasis (observing) and action (stealing), and the final resolution involves accepting stasis, which can be interpreted as spiritual quietude and redemption. As the characters observe their marks, a higher power (God, Mao as the "Holy Ghost," the State, the police authorities, their own consciences) gaze at them, with the camera (and the viewer's perspective) alternating between the two—sometimes involved with the protagonists' point of view, its detachment from the action, and sometimes identifying with the disembodied eye of the camera and its detachment from the protagonists.

To pick up on interpretations of Ozu's so-called "empty shots," seasons change, human beings come and go, evidence of human presence may linger, but eventually everything passes away with the changing seasons and the passing years, and the individual fades into an insignificant speck within the cosmos. Quietude, for Schrader, marks human acceptance of this spiritual fact. However, although *Pickpocket* may take *After This Our Exile* into the realm of redemption and spiritual transcendence, the same style takes *Xiao Wu* in a different direction.

Nevertheless, in both cases, the engagement with the transcendental style and the type of realism it favors brings both films back to Deleuze to provide an answer for this interest in Bresson. As different as Deleuze, Baudrillard, Debord, and Jameson are, they all point to schizophrenia as the common denominator of the postmodern experience. With the schizophrenic's detachment from the anchors of chronological time, sequential space, and linguistic order, time, space, and meaning lose their foundation in the perception of "reality." In his work on cinema, Deleuze asserted, "Whether we are Christians or atheists, in our universal schizophrenia, *we need reasons to believe in this world*."[25] While "belief" may be the operative concept for Bresson, "reasons to believe" trump faith for Jia and Tam. Through citing *Pickpocket* and crafting conflicted, contradictory, arguably "schizophrenic" characters who perform as seers, Jia and Tam engage with these reasons through their postmodern encounter with the "transcendental style."

Within the context of Chinese-language cinema, this also indicates an engagement with a specific history of realist styles and the ideologies to which they have been attached. As a result, *Xiao Wu* and *After This Our Exile* both deal with how China and the Chinese diaspora have been depicted, how they should be

presented, and how a sense of "authenticity" as well as "transcendence" becomes crucial to that portrayal. Engaging with the "authentic" as a consequence of the rise of independent cinema globally, Tam steps away from the commercial artificiality of Hong Kong cinema to nurture the development of New Malaysian Cinema. However, this connection also indicates that established centers like Hong Kong continue to play an important role in East and Southeast Asian film. For example, Jia partners with cinematographer Yu after meeting him at a festival in Hong Kong, and he sets up his production company, Hu Tong Communication (Xstream), in Hong Kong.

However, within the world of Asian independent filmmaking, the nature of the "real" that needs to be transcended varies greatly. Postcolonial Malaysia with its rural/urban divide, ethnic tensions, and economic disparities differs from postcolonial Hong Kong as an international financial center and commercial hub. The "real" demands of the marketplace in post-Deng Fenyang seem a far cry from the glittering consumerism in the urban centers of Beijing and Shanghai. In fact, the "real" changes as the filmmakers position themselves and their cameras within these varying contexts. In each case, though, the weight of global capitalism cannot be avoided. However, the transcendental moves away from politics and elevates the moral, ethical, and spiritual above the material. The style thus promises relief from ideology while insisting on realism—a claim for authenticity when all forms of identity have been placed in doubt within postmodernity. At a time when meaning and the medium itself are in crisis, looking beyond the confines of the frame to another world has its appeal. If filmmakers sit still and look long and hard enough, they may, indeed, see.

Brecht in Hong Kong Cinema

Ann Hui's Ordinary Heroes and Evans Chan's
The Life and Times of Wu Zhongxian

The house where Bertolt Brecht spent the last years of his life (1953–1956) in what was then East Berlin exhibits remnants of his dedication to Chinese arts and culture, including a scroll hung next to his bed. The Berlin Film Museum displays the good luck Buddha charm that Brecht carried with him during his years of exile in Hollywood. For Brecht, however, Chinese aesthetics went far beyond a passing fancy for *chinoiserie*. The playwright gained inspiration for his radical theory of the "alienation effect" from Asian dramatic traditions, most notably Peking Opera. Brecht had a particular interest in male-to-female cross-dresser Mei Lanfang as an opera performer, and Mei's impact on not only Brecht, but other modernist figures such as Sergei Eisenstein (mentioned in chapter 2) is well documented. Brecht's interest in Asia has been reciprocated, and his notion of "epic theater" has been enormously influential throughout the Chinese-speaking world.[1] When Chinese playwrights take up Brecht, then, they in fact amplify the echoes of Chinese opera contained within his own plays. Although many scholars have looked at the China-West dialogue involving Brecht (Antony Tatlow and Sebastian Veg, among others), Brecht's impact on Chinese-language cinema has garnered less attention.[2]

Ann Hui's *Ordinary Heroes* (1999) and Evans Chan's *The Life and Times of Wu Zhongxian* (2003) provide two cases of the influence Brecht has had on Hong Kong cinema. In both films, the directors draw on the street theater performance of Augustine Mok (Mok Chiu-Yu) for the Asian People's Theater narrating the life of Hong Kong political radical Wu Zhongxian (Ng Chung Yin in Cantonese) in *The Life and Times of Wu Zhongxian*. The Brecht-inspired play, first performed in 1997, resonates with the ambivalent sentiments associated with the Handover, including a sigh of relief at the end of British colonialism and a feeling of apprehension associated with reunification (particularly in the wake of the PRC's violent suppression of the protests in Tian'anmen Square on June 4, 1989).

Ordinary Heroes was produced to coincide with the tenth anniversary of the 1989 events in Tian'anmen. *The Life and Times of Wu Zhongxian* appeared in

2003—a year remembered for the SARS epidemic and its political fallout. That same year also saw one of the largest public demonstrations in Hong Kong history on July 1 against Article 23, an anti-sedition/national security provision unpopular with a large segment of the local population because of its potential use as a tool against certain religious, media, and political organizations out of favor in Beijing. Eventually, the article was withdrawn and shelved indefinitely. Although the film changes the play script in places, the importance of making didactic connections between the life of Wu Zhongxian and contemporary Hong Kong politics remains, as Michael Ingham points out: "In order to understand the derivation of popular activism in Hong Kong in the response to the Tiananmen massacre and more recently the July 1st 2003 demonstrations against planned anti-subversion legislation emanating from Beijing, Ng Chung Yin's role and legacy is of crucial significance. Chan captures Mok's personal tribute in the context of the wider political implications of Ng's heroic but doomed campaign of agitation for enlightened change."[3] Wu's first political cause, for example, involved agitating for direct election of student representatives in his school. His efforts echo the student group Scholarism's successful 2012 campaign against "national" education, through CCP-approved textbooks in the territory's primary and secondary schools, as well as the ongoing demand for "true" universal suffrage (with a selection of candidates not prescreened by officials in Beijing) that forms a major plank in the platform of the political opposition in Hong Kong.

The two films stand in direct opposition to commonly held misconceptions about Hong Kong as apolitical, socially conservative, and incontrovertibly pro-capitalist. As Mok narrates the story of his comrade Wu Zhongxian as a reflection of his own life in the movement, the dramatist testifies to the continuing importance of Hong Kong's radical past to his present work as actor, teacher, and activist. Through Mok's portrait of Wu, *Ordinary Heroes* and *The Life and Times of Wu Zhongxian* paint a picture of Hong Kong politics that goes against the putative understanding of the territory as economically vibrant and politically docile.

In both films, when Mok appears on his makeshift stage and introduces himself before launching into his first story about Wu Zhongxian, he melds Brechtian alienation and traditional Chinese storytelling into a single event. Sometimes, Mok is Wu talking about Mok, and at other times, Mok plays Mok interacting with Wu. The fluidity of this movement in and out of character, as well as between the roles of actor and storyteller, highlights Mok's indebtedness to Brecht, just as his Chinese costume and the use of traditional Chinese instruments underscore Brecht's debt to Chinese theater. Mok's storytelling style also resonates with Chinese oral traditions (often allegorical and satiric) that Brecht took up in his so-called "parable" plays such as *The Good Woman of Szechuan*

(1943). Taking Brecht's theory of epic theater, the alienation effect, and political drama as a starting point, this chapter explores the complex interconnection between politics and the fiction as well as the fact of screen, stage, and street performance in presenting the past and present political landscape of Hong Kong.

The Play's the Thing

Augustine Mok's play brings Hong Kong's history to the surface by exposing the radical fringes of the territory's culture and politics. The story of Wu's life calls for a reconsideration of the importance of the legacy of student activism and transnational radical alliances to contemporary calls for political plurality, universal suffrage, and representative democracy. The films place the life of the radical against the backdrop of revolutionary politics, including Marx and Mao, as well as the student/youth movements that more directly fueled Wu's political thinking (e.g., the antiwar movement in the United States, the Black Panthers, and demonstrations associated with the Prague Spring and May 1968, as well as the Japanese student movement).

As the recorded material of the play shows in each film, Wu enters world and local politics in the aftermath of the 1967 Hong Kong riots, as well as in the wake of the massive youth demonstrations in the PRC associated with the Red Guards. However, Wu's political formation seems to owe more to John Lennon, Yoko Ono, and the peace movement than to the Great Proletarian Cultural Revolution, and the split in the Left is made clear from the outset. Wu enters the activist arena in the early 1970s—a time when many of the youth movements had peaked or had been suppressed worldwide. The tanks rolled into Prague, Mao sent the Red Guards off to the countryside, and the British sent Murray MacLehose to govern Hong Kong on a platform of reform (at least partially in response to the riots). As governor, MacLehose, in fact, acceded to one of Wu's anti-colonial demands by recognizing Chinese (along with English) as an official language of the colony.

Hong Kong labor activist Au Loong-Yu describes the political mood of the times as follows:

> The worldwide radicalization of the 1960s was late in coming to Hong Kong—it wasn't till 1970 that young people began to respond to Socialist or Marxist ideas, for instance. Though the CCP had lost much of its base among the Hong Kong workers after 1967, it benefited greatly from the upsurge in national sentiment among students and intellectuals. China, and its Maoist

model, was seen as an alternative to British rule—though during the course of the 1970s the local CCP moved away from advocating the end of colonialism, in the name of stability. In student circles, the Maoists were constantly challenged by liberal currents and the radical left, notably Trotskyists and anarchists....Many of my classmates became Maoists, but despite my youth I felt a strong aversion to the cult of personality. I joined the Young Socialist Group, which moved increasingly in a Trotskyist direction, but disintegrated in the early 1980s.[4]

Wu's activist career reflects this political climate as a mix of anti-colonialism, Marxist humanism, anarchism, and Trotskyism. His role as editor of the *70s Biweekly* put him at the center of anti-colonial, youth, and countercultural currents as they circulated through Hong Kong from around the world. The 1971 Diaoyu Islands protests, for example, provided a very rare occasion in which right- and left-wing political activists found themselves on the same side of an issue. In this case, the PRC's and/or the ROC's (Taiwan's) claims to Chinese sovereignty went against Japanese and American interests since the United States had administered the islands (along with Okinawa) before handing them back to Japan.

For the Hong Kong Left, these protests provided an opportunity to rally against American imperialism in Asia (Okinawa still was a major staging ground for the war in Vietnam) and, implicitly, the continuation of British colonialism in Hong Kong (since sovereignty and self-determination were key to both). While these remote, uninhabited islands may seem marginal, the oil around them and the issue of sovereignty they symbolize have meaning. Of course, questions of sovereignty underpin debates surrounding the Handover as well, and the arrests for "illegal assembly" during the Diaoyu demonstrations echo Hong Kong residents' decision to take to the streets annually during mass rallies in and around Victoria Park commemorating June 4, for July 1 Handover Day protests, and during the 2014 Occupy Central/Umbrella Movement demonstrations.

Wu Zhongxian's commitment to global politics helps to define his identity as an activist. Given the inspiration May 1968 provided for many young intellectuals from outside France, it seems apposite that Wu, apparently trying to meet up with an elusive lover, ends up setting up a conference of the editorial staff of his left-wing magazine *70s Biweekly* in Paris in 1973. This brings Wu into close contact with a range of radical positions and cultural currents that unite as well as divide the young Hong Kong activists.

As narrated in Evans Chan's film, a screening of Bernardo Bertolucci's *Last Tango in Paris* (1972) seems to bring some of these divisions into the open. While a few of the Hong Kong comrades see the film as a meditation on sexual alien-

ation under capitalism, others appear to be more interested in sex, love, and simply being young. Bertolucci's film can be interpreted as a statement on the ultimate failure of the youth movement to achieve "liberation"—either personal or political—and discussion of this screening in Paris in Mok's play also marks the beginning of the dissolution of Wu's group.

France, of course, has served as a haven for exiles from China over the course of several generations of political struggle, and key figures from China's Trotskyite movement settled in Paris. Given Mao's close ties to Stalin, the Chinese Trotskyites never had much of a foothold in their native land.[5] However, they did maintain a base in Paris,[6] and Wu and others in his cohort met up with P'eng Shu-Tse (Peng Shuzhi) and Ch'en Pi-Lan (Chen Bilan) there.[7] Because the French Left in the late 1960s/early 1970s felt an affinity with the Cultural Revolution, *les maoïstes* (examined more closely in chapter 5) eclipsed others in the Communist movement there. However, because of the proximity of Hong Kong to the PRC and Hong Kong's more intimate knowledge of the downside of the Great Proletarian Cultural Revolution, it is not surprising that young radicals like Wu would embrace the Chinese Trotskyites rather than the French Maoists as role models.

After Wu returned to Hong Kong and there was a brief period of accord between the anarchist and Trotskyite factions in *70s Biweekly,* a split occurred, and Wu, hounded by accusations of treachery, left the magazine to help found the Revolutionary Marxist League in 1975 (sanctioned by Ernest Mandel, a revered Trotskyist activist and Marxist theorist). Wu also became editor of the group's publication, *Combat Bulletin.*[8] The Revolutionary Marxist League supported the Chinese Democracy Movement in the late 1970s/early 1980s (particularly the cause of Democracy Wall activist Wei Jingsheng, who had been in prison since 1979 and was finally released and sent into exile in the United States in 1997).

Wu made a trip to the PRC in 1981 as an act of solidarity. That same year Liu Shanqing (Lau San-Ching), another Hong Kong resident activist, also made the trip across the border and was arrested and sentenced to ten years in prison (Liu was released in 1991). Wu, after being detained and coerced into cooperating with the government, did not suffer the same fate as Liu and was set free and sent back to Hong Kong. At that time, Wu agreed to spy on Hong Kong radicals for the PRC government in exchange for his release, and he was ostracized by his Hong Kong comrades when he returned home and they learned about his betrayal of their cause. Mok's performance also chronicles Wu's involvement in the establishment of the Hong Kong Alliance in Support of Patriotic Democratic Movements in China, with Szeto Wah (1931–2011) and Martin Lee, as part of Hong Kong's support for the demonstrations in 1989. A title at the beginning of Chan's film notes that Wu died of cancer in 1994.

Mok's drama maintains an insistent link between Wu as an individual and

Hong Kong as a place committed to political change and democratic action. The dramatist channels Wu's presence and places his cause within the public discourse on Hong Kong's government, political pluralism, and democracy.

Alienation Effects and the Politics of Montage

Bertolt Brecht famously attempted to bring democracy to the theater by empowering performers and audiences with a radical aesthetic that would liberate them from the deadening acceptance of mainstream ideology hiding behind theatrical illusions. He called for the alienation of the spectator from involvement in the theatrical illusion:

> The spectator was no longer in any way allowed to submit to an experience uncritically (and without practical consequences) by means of simple empathy with the characters in a play. The production took the subject-matter and the incidents shown and put them through a process of alienation: the alienation that is necessary to all understanding. When something seems "the most obvious thing in the world" it means that any attempt to understand the world has been given up.... What is "natural" must have the force of what is startling. This is the only way to expose the laws of cause and effect. People's activity must simultaneously be so and be capable of being different.[9]

In his aesthetic theory as well as theatrical practice, Brecht called for the use of montage—the conflict of images in visual or thematic juxtaposition—to create new ideas and fresh perspectives in order to break the illusionism that he saw as maintaining the status quo. The records of Mok's performances in both Hui's and Chan's films operate according to this Brechtian principle, borrowed from early Soviet film theorists like Sergei Eisenstein and returned to the screen here through materials related either to Wu's life or to his times. Evans Chan's *The Life and Times of Wu Zhongxian* also provides reenactments of reminiscences of Wu's girlfriend (played by actress Lindzay Chan), as well as John Woo's experimental film *Deadknot* (1969).[10] These materials, however, are not presented as unaltered, "authentic" documents of the past or as unquestioned representations of a particular point of view or a specific event.

Chan's film also features several performances of traditional Chinese opera, including one outdoor performance involving the Monkey King (from Wu Cheng'en's classic *Journey to the West*) on the lawn of a colonial building. Not only does this footage remind us of the contrast between Chinese and European culture that defines Hong Kong; it also evokes Brecht's admiration for Peking

Opera. The rascal who caused havoc in heaven, the Monkey King Sun Wukong, provides a particularly apropos character in this instance. A Buddhist convert, Sun goes on his journey to the West to recover sacred scriptures (just as Wu Zhongxian goes west to Paris to get to the heart of international youth radicalism). Sun Wukong maintains a wild, iconoclastic streak as well, and the Monkey King would likely be quite at home with the anarchists as they wreak havoc on colonial institutions. The opera represents a specifically Chinese tradition of street theater, performed outdoors for temple festivals or in the marketplace, and, as such, opens up possibilities for popular, carnivalesque subversion at the very steps of the imperial establishment. Likewise, Mok brings his performance out into the open and operates in the dual traditions of Chinese opera and agit-prop street theater.

Mok begins by narrating a fable about colonial history. He tells the tale of the release of "unfulfilled" martyrs from a cave in India, and he evokes the common British colonial history of India and Hong Kong, as well as the legacy of anti-colonial, subversive politics linking the two places: "The story begins with the British occupation of India." Although the 108 heroes released from the cave refer to characters in the literary classic *The Water Margin* (a.k.a. *Outlaws of the Marsh*), the figures that emerge in Mok's version come from the annals of revolutionary history—for example, Marx, Engels, Trotsky, Stalin, Mao, Liu Shaoqi, Zhou Enlai, Hu Yaobang, Jiang Qing, and Yao Wenyuan. When Deng Xiaoping appears in his vision, Mok becomes hysterical and falls back at the mention of his name. The last hero, of course, is Ng Chung Yin (Wu Zhongxian), connecting Wu to other figures associated with 1989 (Hu Yaobang and Deng Xiaoping), underscoring the film's references to June Fourth. Mok's play begins with the British occupation of India. Chan's film, however, begins with the British occupation of Hong Kong. Again, adding an additional layer to Mok's play, Chan strengthens the British imperial connection by using a score with an Irish-Celtic flavor, blended with traditional Chinese musical elements and composed by Australian-born John Huie.

Mok's piece conforms to the spirit of Brecht's vision of an "epic theater" free from the conservative, Aristotelian conventions of the stage productions of his day. As Mok moves among his dramatic roles, he crafts a narrative in which argument takes precedence over plot. Involving the spectator intellectually becomes more important than emotional identification, and lack of dramatic continuity brings issues rather than fiction to the forefront. The emphasis is on fluidity and change—from actor to character, from character to character, from actor to spectator, from the confines of the fictional diegesis to the public display of the street. For Brecht, the Marxist implications of such an emphasis take center stage—people need to change, to think differently, in order to create a new society. The

use of Brecht, then, reflects Wu's commitment to political change through dramatic action and belief in the power of revolutionary transformation.

For Mok, however, this political fervor has been tempered by time and his own involvement in radical causes. For Hong Kong, too, there is the irony of a colonial end coming not from revolutionary praxis but through a negotiated change of sovereignty and the maintenance of a non-democratic system. In fact, Brecht could easily be one of the "unfulfilled martyrs" Mok invokes when he links Wu Zhongxian to Marx, Engels, Mao, Jiang Qing, and even Deng Xiaoping. Mok, then, uses Brecht to evoke a period of time, its mass-mediated as well as countercultural discourses, and he puts his work within a discursive context Brecht likely did not imagine, moving from the revolutionary modern into the critically postmodern performance. In *The Life and Times of Wu Zhongxian,* Mok's postmodern self-awareness finds expression when he addresses the viewers: "Does it sound vaguely 'familiar' to your postmodern ears?"[11]

In Brecht, what seems to be most "familiar" is made "strange" through the creative process. He states the following: "The artist's object is to appear strange and even surprising to the audience. He achieves this by looking strangely at himself and his work."[12] Mok presents an alienated vision of himself as "strange" in the film, and Evans Chan self-reflexively compares his cinematic practice to John Woo's through the inclusion of *Deadknot.* As presented in *The Life and Times of Wu Zhongxian,* Brecht, clearly and carefully cited, also becomes part of the self-reflexive process of de-familiarization—an object of inquiry as well as an aesthetic tool.

The aesthetic as well as political slippage between the modern and the postmodern serves as a defining feature of both the play and the film, and *The Life and Times of Wu Zhongxian* displays a clear awareness of the important implications of postmodernity to contemporary political projects. As Robert Stam and Ella Shohat note, "The important point that postmodernism makes is that virtually all political struggles now take place on the symbolic battleground of the mass media."[13] Postmodernism reminds us that the political sphere is subject to mediation, to the regime of the image, and to the fact of performance. Although political power has always involved the manipulation of images (e.g., the portraits of emperors on coins), ritual (often religiously based), and public performance (from the giving of an audience at court to the making of speeches in congress or parliament), the equation of power with mass-mediated images and public performances involving mass communication has intensified in recent years. However, within the context of post-colonial Hong Kong, the play and the film also go beyond postmodernism. Stam and Shohat continue: "Post-colonial theory builds on the insights of post-structuralism ... but in some ways it has an adversary relation to postmodernism, for which it forms, as it were, a kind of re-

verse field. If postmodernism is Eurocentric, narcissistic, flaunting the West's eternal newness, post-colonial criticism argues that the West's models cannot be generalized, that the East is in the West and vice versa, that we are here because you were there."[14] Foregrounding the "East" of Chinese aesthetics and politics that can be found in the "West" of Brecht's epic theater, *The Life and Times of Wu Zhongxian* exploits this dialectic fully and dramatically.

Politics as Performance

Evans Chan's film operates as an elaborate dialectical exercise that pits different types of documents and discourses against one another. For example, the film begins with a voice-over quotation from a British soldier's eyewitness account of the raising of the Union Jack on Hong Kong Island in 1841 against an image of the harbor. A counter-image of the unidentified Wu Zhongxian, a young man with glasses and a 1960s haircut, follows (figure 4.1). The juxtaposition places the colonial against the anti-colonial, the documentation of the beginning of the

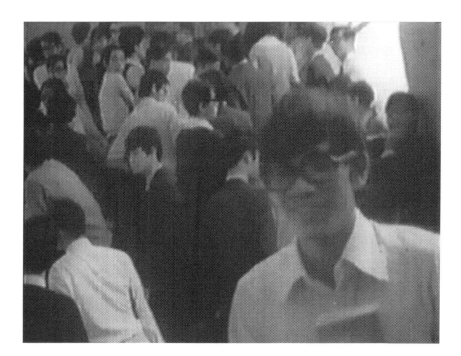

Figure 4.1. Image of Wu Zhongxian from *The Life and Times of Wu Zhongxian*; dir. Evans Chan, 2003.

British colony against the rebellion of youth in the 1960s/1970s, the irony of that rebellion played out within the trappings of a "swinging" English style.

The opening speech of Mok synthesizes these two currents by bringing British colonialism and 1960s counterculture together through performance. Club 64 provides the backdrop. The location is a commercial enterprise, a place of leisure and entertainment within the Hong Kong nightclub district of Lan Kwai Fong (as well as one of Wu's business endeavors), but it also refers to the month and day of the June Fourth crackdown.[15] Here, Mok operates within Brecht's Berlin cabaret tradition, as well as within the Soviet agitprop arena—bringing politics into the streets as well as into the world of leisure and entertainment.

Mok's theatrical vision plays openly with these contradictions. His performance is far from a dramatic monologue or didactic diatribe, and he works closely with the mute Leung Wai-Kit to move lithely among characters and modes of address so that he can openly mock or contradict himself. In a segment setting the stage for Wu's political career, Mok and Leung provide their own versions of the political gestures that defined late-1960s and early-1970s counterculture—the black power salute from the 1968 Mexico City Olympics, the Yippie placing the daisy in the gun of the National Guard at the Pentagon in the 1967 protests against the war in Vietnam, the "snake" dance of the Tokyo student demonstrations of the 1960s, and the confrontation of Soviet tanks in Prague in the spring of 1968. All these gestures found their way into the international mass media, and these very self-conscious and highly photogenic bits of political theatrics help to define the "times" of Wu Zhongxian in Hong Kong as part of a global youth performance—agitprop street theater on a global scale.

Wu's incarceration in Beijing takes place inside the club rather than out on the street backdrop—boxed in rather than out in the open. Mok's narration of Wu's involvement in the mainland democracy movement also finds visual counterpoint in Leung's Butoh-style white mask and marionette prop. A taped "X" over the mouth of the mask and the tangle of the puppet's strings speak to Wu's own silencing and manipulation (figure 4.2). This resonates with Brecht's dictum: "The masks cannot always be stripped off in the same way."[16] The critical tools used to unmask colonial and capitalist iniquities may not necessarily work in the quest for democracy in China. This image clearly goes beyond dramatizing Wu's imprisonment in China, and the taped mouth begs the question of the silencing of the Hong Kong body politic as a consequence of the change in sovereignty. The mask challenges viewers to consider what it conceals and how it may be stripped away.

With the rise of Deng Xiaoping, the suppression of the democracy movement in the PRC, and the deadening impact of Margaret Thatcher and the 1984 Joint Declaration on Hong Kong's political (as well as economic) status, the

Soon I was arrested on the train
by some plainclothesmen...

Figure 4.2. Augustine Mok Chiu-yu and the Masked Man (Leung Wai-kit) with the puppet on a string from The Life and Times of Wu Zhongxian; dir. Evans Chan, 2003.

"times" of Wu's life change beyond recognition. Although removed from direct involvement with the 1989 Tian'anmen protests, Wu witnesses the same contradiction that had been in play during his days in the New Left (as student activist, anarchist, and Trotskyite) between the power of the state and the voice of the people. Mok and Chan, however, take both the "life" and the "times" of Wu and transform them into art, returning to him the public voice that Beijing had taken from him.

The Political Backstory of Ordinary Heroes: Starry Is the Night

Ann Hui's *Ordinary Heroes* has a strong intertextual relationship to her previous feature, *Starry Is the Night* (1988). The Shaw Brothers' production—released the year before the June 4, 1989, crackdown in Beijing dramatically changed the political landscape of Hong Kong—offers a comparative examination of Hong Kong in the late 1960s and mid-1980s. *Starry Is the Night* references both the Maoist-inspired 1967 riots and the initial Legislative Council elections in 1985.

As in many of her other features, including *Ordinary Heroes,* Hui provides a parallel plot linking two distinct temporal moments through a series of flashbacks. In this case, To Choi-Mei (Brigitte Lin) plays a social worker in the mid-1980s who has a romance with a juvenile client more than twenty years her junior, Cheung Tin-On (David Wu). Flashbacks to the 1960s feature Choi-Mei as an undergraduate at the University of Hong Kong (where Ann Hui went to college) involved in an affair with her married professor, Dr. Cheung Yin-Chuen (George Lam). Poon Chung-Lung (Derek Yee) carries the torch for her from their college days and hires her to help with his 1980s political campaign for the legislature when she loses her job because of her inappropriate relationship with her young client. The two temporal periods come together dramatically when Choi-Mei discovers that she has been having an affair with her former lover's teenage son.

Starry Is the Night begins in 1966 with Dr. Cheung conducting a small tutorial session in English in his office in the University of Hong Kong's historic Main Building. Cheung gives a mini-lecture praising the CCP's Long March, noting its indelible mark on history. He admires the "simplicity, power, and strength" of the Communists, which his postwar generation could not match. Channeling Mao Zedong's 1957 youth address, "China's Future Belongs to You," Cheung lays down the gauntlet for his students by saying that they may be able to do what his generation could not. Cheung's armchair Marxism quickly becomes obvious, however, when the professor dismisses young activist Poon's efforts to get students to come to political rallies. Hui adroitly cuts to students rehearsing the balcony scene from *Romeo and Juliet* in the outside courtyard in contrast to Cheung's remarks. Romeo says, "It is the east and Juliet is the Sun," replacing, of course, Mao as the sun in "The East Is Red." Choi-Mei dreamily looks up at the colonial Main Building's distinctive clock tower, clutching her copy of Shakespeare's tragedy, counting down the "borrowed time" of the British colony. Love and left-wing politics come together poetically on campus in English rather than Chinese in this pre-credit sequence, and Hui sets the stage for the conflation of activism and romantic tragedy that follows.

Dr. Cheung and Choi-Mei's relationship consumes them, and they become political spectators, hiding out from student demonstrators in the professor's parked car and watching the riots on television rather than actively participating in the spillover from the Great Proletarian Cultural Revolution, which so dramatically splintered the colony's population. Hui intercuts news footage from the period—burning city buses, empty streets, gasoline bombs, a mass demonstration of protestors waving Mao's *Little Red Book,* and police assaults on young protestors. In fact, Hui brings Dr. Cheung's and Choi-Mei's love affair to its dramatic climax during the 1967 bombings when Cheung's pregnant wife discovers the couple having sex in his campus office. Later in the film, Hui turns again to

politics, and Tien-On proposes marriage to Choi-Mei in the middle of a demonstration calling for direct elections in 1988, in which Choi-Mei, as a woman, simply follows in the footsteps of Poon, the male politician who takes the lead.

Dr. Cheung and Choi-Mei meet again during Poon's political campaign. On the night of his defeat in the election, Poon, still pining for Choi-Mei, delivers a telling speech. The two look out over an empty campaign arena as the camera moves rapidly over discarded papers and along the walls and ceiling of the cavernous space, and Poon laments:

> Outwardly I've had some success, but in fact I'm a flop. I've never succeeded. Dr. Cheung used to say there is no future in political involvement in Hong Kong. I did not believe him. Now I know it's true. I am not saying this because I lost the election. We're doomed even if we go on. I've been involved for over twenty years, since the riots. First, student movements, the defense of the Diaoyu Islands, and now the District voting. I can't help knowing what they'll lead to. But having chosen my ideal, I must dedicate myself to it, insist to the end. There must be fools left to do meaningful but futile things. We plan to continue until 2047.

The camera settles on a low-angle shot of Poon at the end of the speech. Poon mentions the Diaoyu Islands protests specifically in his lament, and this brief remark adds yet another political dimension to the film.

After Poon's monologue, the film's female protagonist, Choi-Mei, comes into frame to interpret his words as a personal rather than political call for action, and she decides to bring her young lover, Tien-On, to visit her former lover, his dying, suicidal father, Dr. Cheung, in the hospital. Romance eclipses activism, and *Starry Is the Night* looks back to the 1967 riots, the Diaoyu Islands protests, anti-colonial intellectuals, and fascination with Mao Zedong's Great Proletarian Cultural Revolution against the backdrop of uncertainty precipitated by the Joint Declaration and prospect of the 1997 Handover.

Made before June 4, 1989, *Starry Is the Night* takes a less acerbic view of Hong Kong's political climate and process of decolonization after the signing of the 1984 Joint Declaration, while *Ordinary Heroes* focuses on the devastating impact of Tian'anmen on local politics and the hope for democratic advances at a time when Hong Kong was grappling with post-1997 angst. The conspicuous absence of the 1967 riots in *Ordinary Heroes,* in fact, may owe something to the fact that Hui covered the period in such similar fashion in her earlier film. The lives of the characters in *Starry Is the Night* seem to tell the backstory of the main figures in *Ordinary Heroes,* picking up politically as well as dramatically where the earlier narrative leaves off historically.

Extraordinary Times of Ordinary Heroes

Much like Chan's *The Life and Times of Wu Zhongxian*, *Ordinary Heroes* journeys through the vicissitudes of the Hong Kong Left—from anti-colonial actions and anti-imperial demonstrations, debates between anarchists and Trotskyites, and support for several waves of the reform movement in the PRC from the Democracy Wall protests of 1978–1979 to the Tian'anmen demonstrations in the spring of 1989. Ann Hui describes her inspiration for the film as follows:

> After the events of June 4th, 1989, and in the wake of the 1997 handover, I feel a great necessity to express my feelings about Hong Kong and its people....I could not find a suitable story until I read one day in the papers an article about a young bum who was killed in a drunken brawl under one of the flyovers in the city. According to his brother, he was an intellectual and a dissident, and had gone to seed because of "disillusionment with China." I set about interviewing a lot of people who knew him. Most of these people were of course activists themselves but they were not exactly like their counterparts in the West. They were mostly just practical do-gooders who were either social workers, journalists, priests or teachers with a handful of "Trotskyites" and "anarchists" thrown in. But many of them impressed me deeply because, just as they were nowhere near the political mainstream, they were also a minority in the money-grabbing and materialist society of Hong Kong.[17]

Hui's film dramatizes the complexities of this political environment from the highest ranks of Hong Kong's legislature to the bottom rungs of its homeless population.

The structure of the narrative of *Ordinary Heroes* involves two overlapping histories of Hong Kong politics. Hui intercuts Mok's street drama with the film's main plotline, which chronicles events beginning with the 1979 Boat People incident, in which the floating population of Hong Kong's harbors demanded the right to settle on land. Her film starts this part of the story by showing the mobilization that took place to protest the colonial government's treatment of the segment of Hong Kong's population that traditionally lived on the water. This section of the film commences *in medias res* with Sow Fung (Rachel Lee), who has amnesia, returning to the typhoon shelter where she grew up, accompanied by Lee Siu-tung (Lee Kang-sheng), a childhood friend. A flashback shows her involvement with the 1979 campaign to resettle her family in public housing after

she is orphaned by a fire that devastated the community. Many political figures, including Lee Cheuk-yan—who gained international attention when he brought money collected in Hong Kong to Beijing to help support the demonstrators in 1989 and now serves as a member of LegCo—got their start through involvement with this anti-government campaign.

The April Fifth Action Group contributed considerable energy to this campaign. The history of its establishment, however, remains unstated. This particular group formed in support of the April 5, 1976, Tian'anmen demonstrations, which sprang up as a spontaneous commemoration of Zhou Enlai's death, which had occurred earlier in the year. This show of support for Zhou (and, perhaps, his ally Deng Xiaoping) set the stage for the eventual end of the Cultural Revolution and fall of the Gang of Four after Mao's death in September. The April Fifth Action Group formed in Hong Kong as part of a Trotskyite critique of both the CCP and the British colonial government. While Wu Zhongxian focused his attention on the Democracy Wall Movement on the mainland, the April Fifth Action Group, headed by "Long Hair" Leung Kwok-Hung and Leung Yiu-Chung, took up local concerns. Their website describes their involvement in the 1979 campaign for the rights of Hong Kong's floating population as follows: "The colonial police made use of the draconian Public Order Ordinance to arrest and prosecute demonstrators from the Revolutionary Marxist League [as well as] social workers and boat people fighting for resettlement."[18] Although Leung Kwok-Hung has long been a fixture in Hong Kong politics and a member of the Legislative Council since 2004, few in Hong Kong know much about the radical politics that shape his current position toward the PRC (into which he is repeatedly denied entry).[19] With his refusal to cut his hair until Beijing apologies for 1989 as testimony to his pro-democracy sentiments and his Che Guevara T-shirt marking his public image as undeniably linked to the world Communist movement, Leung Kwok-Hung brings the political contradictions of the Hong Kong Left into the HKSAR's legislative establishment.[20] Although Leung now operates under the aegis of the League of Social Democrats and sports slightly shorter hair after a stint in jail, he remains one of the most visible and vocal members of the opposition in Hong Kong politics.

Ann Hui includes a thinner, younger version of the LegCo representative, known simply as "Long Hair" (Lee Chi-Man), in the film. *Ordinary Heroes* also fictionalizes other Hong Kong radicals, including Father Francis (Franco) Mella, an Italian Catholic priest influenced by Maoism as well as Liberation Theology, portrayed in the film as Father Kam (Anthony Wong). Perhaps best known for his support for the jailed activist Lau San Ching (Liu Shanqing), Mella went on an annual hunger strike to petition for Lau's release from a Chinese prison, where he was incarcerated between 1981 and 1991 because of his support for the

Democracy Wall activists. Banners supporting Lau's cause surround the fictional Kam during one of his hunger strikes. Illuminated by candlelight, Kam says his evening prayers, and the camera lingers on his hands, holding his Bible as the voice over continues: "Szeto Wah called the young man a trouble maker, Martin Lee said.... He won't be released unless he confesses. Why do you fast for him? Lau San Ching is a practical man. He's not a politician or theorist. He couldn't enter the political mainstream. And no one cared despite a ten-year sentence." While Hong Kong's most visible liberal democrats, Martin Lee and Szeto Wah, remain out of the picture, Hui does not hesitate to show others who have entered Hong Kong's political mainstream.

Yau Ming-Foon (Tse Kwan-Ho), for example, serves as the villain of the film—a radical community organizer who becomes an elected councilman. Getting his political start in the movement to resettle the boat population, Yau parlays that into a lucrative career by exploiting the volunteer labor and free affections of working-class Sow, who sticks with him through his engagement and marriage to another woman, as well as the birth of his son. Yau hooks Sow as a young girl when he shows his solidarity by saying, "Why are rich men's toilets better than your house? You're Hong Kong's original residents." After a frustrating attempt to improve their lot, he tells Sow he wants to run for the legislature at the same time he breaks the news that he is engaged to another woman, and his appraisal of his situation seems to apply to his personal as well as professional life: "Before joining the establishment, you're just a dog. You can bark but no one cares."

Because the film begins this part of the story in 1979, an earlier moment in Hong Kong radical politics stays out of the picture, and Yau's impetus for becoming an activist remains murky. However, Yau seems to share a history with actual political figures at the opposite extreme of Martin Lee and Szeto Wah, including the brothers Tsang Tak-Sing and Jasper Tsang. As students, they became active during the 1967 anti-colonial riots, and Tsang Tak-Sing spent two years in a Hong Kong jail on a charge of inciting violence. Tsang Tak-Sing has served as secretary for home affairs, and Jasper Tsang was the president of LegCo. Both brothers enjoy the support of Beijing, sticking with the movement of the CCP away from Maoism into the current Reform Era. They represent a segment of Hong Kong's student radicals who moved from street activism to successful political careers during the course of the territory's change in sovereignty.

Mok's play and Hui's film gloss over the events surrounding Thatcher's negotiations with Deng Xiaoping about the Handover, as well as the signing of the Joint Declaration in 1984. However, both sides of the political Left come into dramatic conflict during the spring of 1989, and here Wu Zhongxian's story overlaps with the fictional world of Sow, Tung, Yau, and Father Kam. Sidelined be-

cause of his denunciation as a spy, Mok resumes Wu's story when he portrays the drunken, aging activist complaining that he has not been recognized for his involvement in the Democratic Alliance in 1989. As part of this tirade, he calls Leung Yiu-Chung, the co-founder of the April Fifth Group, a "fool." At this point in the film, the camera pulls back, cranes up, and shows that Mok occupies the same space on the street as Tung. Fiction and nonfiction merge as the principles of Brecht's epic theater take center stage on screen.

Ordinary Heroes as Epic Theater

Ordinary Heroes presents Brecht, clearly and carefully cited, as part of the self-reflexive process of de-familiarization. This is not the first film in which Ann Hui draws on Brechtian techniques to enrich her cinematic aesthetic. In fact, like Evans Chan, Hui routinely refers to Brecht and his most famous motion picture interlocutor, Jean-Luc Godard.[21] As Godard states, "A movie is not reality, it is only a reflection. Bourgeois film-makers focus on the reflections of reality. We are concerned with the reality of that reflection."[22] Peter Wollen calls Godard's films "counter-cinema" and lists his debt to Brecht in the form of such characteristics as "narrative intransitivity," "estrangement," "foregrounding," "multiple diegesis," "aperture," "unpleasure," and "reality."[23] Hui's New Wave style owes a debt to these techniques, and Cheuk Pak-tong notes Hui's insistence on "narrative structures that evolve from multiple points of view to multiple layers of time and space intertwining with each other."[24] *Ordinary Heroes* falls squarely within this aesthetic framework.

The dialectical play at the heart of the film begins with the division between its Chinese and English titles. The Chinese title refers to Teresa Tang's song "Thousands of Words," a ballad about a woman abandoned by her lover, and it can refer to the unfaithful manipulator Yau or to the emptiness of his political position. However, Tung also plays the tune on his harmonica when Sow is recovering from amnesia, linking the song to a longing for a change of heart that enables Sow to move beyond her emotional pain. Moreover, Tang's song also conjures up the decade in general, with a nostalgic feeling of lost youth and missed opportunities. The English title, *Ordinary Heroes,* is really an oxymoron since a "hero" by definition is "extraordinary." In Hui's film, the title refers to those people who stand up to the established powers—colonial British as well as Communist Chinese—to agitate for the rights of people treated unjustly by their governments.

The "unfulfilled" revolutionaries of Mok's play do not qualify as "ordinary heroes" in the same way Wu Zhongxian does, and Hui gives a heroic dimension

to all of her activist characters who take to the streets to demand change. Waving banners, playing revolutionary anthems, tearing down the Union Jack, and going on hunger strikes may not be "heroic" in the traditional sense of heroism on the battlefield, but these are not "ordinary" actions either. Thus it may be more appropriate to see the unnamed Hong Kong people in Victoria Park for the June Fourth candlelight vigil as the real "ordinary heroes" of the title. The film ends with images of families in a somber mood lighting candles—ordinary people honoring those who gave their lives in a similar gathering across the border. A tinge of irony clings to the singing of the protestors' anthem, "Bloodstained Glory," originally composed in 1987 to mourn losses from the 1979 Sino-Vietnamese border war. In this instance, the "bloodstained glory" refers to the Chinese protestors slain around Tian'anmen in 1989 rather than People's Liberation Army casualties. Hui's "ordinary heroes," then, may not be in the film at all but simply the evocation of the memory of their actions in and around Tian'anmen Square in 1989. Vivian Lee interprets these "ordinary heroes" as "post-nostalgic" in the following way: "Ann Hui's treatment of history and memory points to the silent margin of society, where she encounters 'ordinary heroes' whose stories are quietly sliding into oblivion in the mainstream historical and social discourse. This mode of remembering is post-nostalgic because the past is evoked to interrogate what *is,* and what will become."[25] The two titles of the film provide no definite interpretation and open the text up to the dialectical play of possible meanings.

As in Ann Hui's other films, the fragmented narrative of *Ordinary Heroes* allows for the juxtaposition of various events in the story for maximum effect. The film jumps from a post-1989 present tense, in which Sow gradually regains her memory through a series of flashbacks, to her childhood, the affair with Yau, and Tung's involvement in her life, to come back to the commemoration of the June Fourth crackdown at its conclusion. The past and present link the personal and the political. In 1989, upset by the violent suppression of the demonstrators in Tian'anmen, Yau returns to his office and sexually assaults Sow. In a daze, she wanders out into the street where a car runs her over and she develops amnesia. Vivian Lee articulates the connection in her analysis as follows:

> The parallel between the June 4th military crackdown in Tiananmen and sexual violence throws as much light on Yau's character as his complicity with the patriarchy of power that characterizes both the colonial and communist regimes. . . . The film's "political meanings" are to be found in the private realm of individual experience. . . . Sow is a victim of both sexual and social violence, but she is also the agent through whom the repressed truths of the past are recalled.[26]

Sow's story serves as a political allegory, and the character becomes part of a wider trend in Chinese-language cinema to use the sexual oppression of women as a metaphor for the rape of the nation.

As Robert Kolker points out in *The Altering Eye,* Godard, drawing on Brecht, masterfully uses the character Nana in *Vivre sa vie* (1962) as an emblem of capitalism as prostitution—as a representative of the social circumstances under critical scrutiny in the film.[27] Sow serves a similar function in *Ordinary Heroes.* Ann Hui first introduces her protagonist running down a long tunnel in her hospital pajamas. Midway, she turns and looks behind her. Like Walter Benjamin's "Angel of History," her feet may carry her forward, but her gaze remains on the past—even if she has no recollection of where she has been or little understanding of where she is going. In this case, the official denial of the June Fourth massacre matches Sow's amnesia, as her restored memory finds a visual parallel in documentary footage of the June Fourth candlelight vigil in Victoria Park. Moreover, as one of the stateless boat dwellers from the activists' initial campaign, she represents a wider Chinese community at the borders of uncertain national affiliations and state allegiances, exemplified by Hong Kong's rocky change in sovereignty and establishment of a local government.

Estrangement from the characters goes beyond Mok's theatrical presentation of Wu's biography. Several of the characters embody political contradictions that threaten to tear the fiction apart. Father Kam provides one particularly telling example. In one scene, the priest scolds Tung for neglecting his babysitting duties. Tung has agreed to help one of the workers who needs someone to look after his son because his wife has been deported. However, Tung does not turn up, the toddler gets caught in a folding chair, and Kam tears into Tung. Afterward, the priest feels guilty. He writes his confession that evening sitting alone on his boat: "May I find my humility again to 'serve the people.' Forgive me, Lord." Combining Catholic theology with Mao's directive to "serve the people," Father Kam's confession resembles Maoist "self-criticism" documents as well. Dueling ideologies speak through the radical cleric, and when Kam leaves for the mainland near the film's conclusion, the film does not clarify whether he goes there to support the outlawed Catholic Church or to devote himself to the revival of Mao's "continuing revolution." Although China has its own version of Catholicism not recognized by the Vatican and Mao Zedong continues to occupy a favorable position as a "father" of the nation (if a somewhat flawed political theorist), the incoherence of Kam's position and the impossible attempt to reconcile these extremes provide no clear guideposts to political change within the film's discourse.

The casting of Anthony Wong for the role of Father Kam brings a wealth of other associations as well (figure 4.3). Known as a rebel and a bit of a "hippie,"

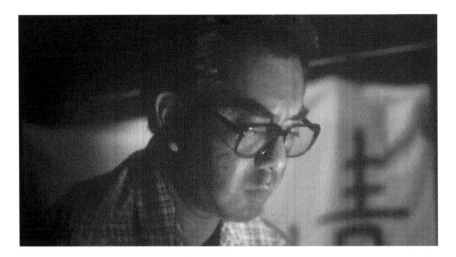

Figure 4.3. Father Kam (Anthony Wong) in *Ordinary Heroes*; dir. Ann Hui, 1999.

Wong often plays character roles that highlight these qualities—from murderous maniacs, at one extreme, to heroes who resist the status quo in the name of justice (such as Yip Man). As a biracial actor, Wong also occasionally portrays characters at the edges of the ethnic Chinese world, as in this case. He functions in a similar way to the biracial actress Lindzay Chan, who provides an additional layer of commentary on Wu Zhongxian's life in Evans Chan's film. In addition, Anthony Wong serves as the face of a generation for Hong Kong film—divided between Western colonialism and an uncertain Chinese future. In this sort of casting, Wong functions in many of the same ways as Jean-Pierre Léaud did within the French New Wave, an aspect of Léaud's career that will be explored in chapter 5.

The casting of Tsai Ming-liang regular Lee Kang-sheng as Lee Siu-tung ("Little East")provides another case in point (figure 4.4). As a "non-actor" from Taiwan New Cinema, Lee stands out as a passive witness to the drama that unfolds on the Hong Kong streets, as well as between Yau and Sow.[28] His unrequited love for Sow keeps him away from the romance, and his background as a Mandarin speaker marks him as outside of local politics. Introduced as a victim of the juvenile thief Sow, Lee's character remains on the periphery throughout the film. He begins by running after the young robber and spends most of the film following Sow into politics, accompanying her to Shenzhen for an abortion, and trying to rewrite her memories during her recovery. Under the shadow of his alcoholic mainland mother, who had been an abortionist in the PRC, Tung cannot seem to escape the violence associated with the nation—or with women—as he hides the sharp objects in the house from his bloodthirsty mother when she is

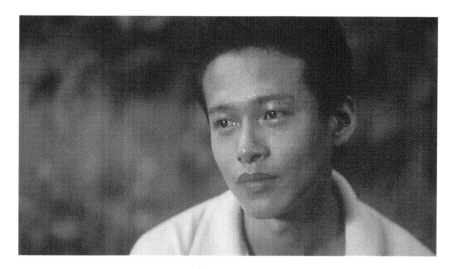

Figure 4.4. "Little East" (Lee Kang-sheng) in *Ordinary Heroes*; dir. Ann Hui, 1999.

on a bender. Lee plays Tung as numb, and the character drifts from ambitious student to harmonica-playing street musician, spiritual seeker in Tibet, and, finally, social worker in an institution for the developmentally disabled. The film shows the plot point in which Tung gives Sow a pack of cigarettes and walks out of her life twice—doubling the narrative import of the image in order to underscore Tung's marginal position at the door, on his way out of Sow's story. Tung (representing Taiwan as the "Little East") may be sympathetic, but no man (or political entity) can effectively come to Sow's (Hong Kong's) rescue.

Hui borrows many of Godard's techniques for foregrounding the motion picture medium in the film. She draws on written titles to divide the film into segments—for instance, "To Forget," "Ten Years of Revolution," "No Card Mothers June 10, 1987," and "Not to Forget." Video, too, plays a role in the juxtaposition of media. Television interviews, for example, allow the characters to address the camera directly—breaking the theatrical film's illusion of an invisible fourth wall onto the world on screen. Talking head footage of Yau, wearing a suit and tie, illustrates his identification with the political mainstream when he says that he wants to be an "insider" since the walls of power are "soundproof." Long Hair, in contrast, takes a more militant stand: "The whole thing is a plot of the colonial government.... [Continuing later in voice-over] I think Trotskyism is more practical. It seeks putting theory into practice. Not like Marxism, which remains theoretical. Say the capitalist class." Father Kam plays the "Internationale" on his acoustic guitar and responds to questions about his Maoist sympathies and desire to go to the PRC.

Hui never loses sight of the fact that political positions are constructed, and she includes a scene of a news conference shot using a handheld video camera; it displays a distraught man slashing his hand in order to sign a petition in blood. The next scene shows the demonstrators and activists sharing a meal at a local *cha chan teng* (restaurant). Yau criticizes the man who bloodied his hand for taking charge of the event and deviating from the agenda set by the political activists. Yau, Sow, and Long Hair clearly feel threatened by the direct action of the people, whom they feel should be indebted to them for granting them any political agency at all. The use of the televisual medium works in tandem with the film's alienation effect, creating an emotional distance from the screen characters in order to highlight the film's critique of local politics.

Hui often isolates her characters within frames—the confines of the television frame; the borders of still photographs; the arches of doorways, windows, tunnels, and corridors. The entire weight of the colonial establishment, for example, appears to bear down on Father Kam when Tung accompanies him to a public toilet by walking down one of the long exterior corridors that frame the government building's neoclassical façade. Harsh neon lighting drains the screen of all color except institutional blue-green. In fact, Hui favors blue filters and a somber palette throughout the film, foregrounding lighting as a visual technique.

Wollen's notion of "aperture" refers to Brecht's references to the world beyond the fiction, and he describes the ensuing polyphony as follows: "The text/film can only be understood as an arena, a meeting-place in which different discourses encounter each other and struggle for supremacy."[29] The open quality of the film allows for links between the present and the past within the diegesis to parallel events after 1989. The "Ten Years of Revolution," which introduces one segment of the film, for example, refers to the ten years of the Cultural Revolution (1966–1976) that shaped the ten years of the Hong Kong activists' agitation against the colonial government (1979–1989), shown in the story of Sow, Yau, Tung, and Kam. The cinematic revolution that inaugurated the Hong Kong New Wave also began in 1979 with first feature films by Tsui Hark as well as Ann Hui (*The Secret*). However, the ten years go beyond the diegesis in another way to memorialize the decade after the suppression of the movement in Tian'anmen (1989–1999), opening the narrative up to other political interpretations. Actual footage of the memorials in Victoria Park and the news reportage woven throughout the film open it up in other ways as well. The mention of incidents not developed in the narrative (e.g., the Golden Jubilee Movement; the strike against the Japanese construction company Kumagai Gumi, which built Hong Kong's cross-harbor tunnels; the Diaoyu Islands demonstrations) points to other debates and issues that may take the film's audience in directions that would not be available in conventional narrative features.

For Wollen, "unpleasure" disrupts the film's circulation as a consumer commodity within the entertainment marketplace. This factor has less to do with actual box office returns than with the film's address to the spectator as a collaborator or co-conspirator. Many of the details in the film related to local politics likely exclude some in the audience but may provoke others into heated debates. Again, the importance of going beyond the film itself to issues of wider concern becomes paramount, and the sense of a "reality" beyond the fiction that works in concert with the "reality of the fiction" that breaks down the ideological effects of classical cinematic representation takes over. Brecht defined this type of "realism" as follows: "*Realist* means: laying bare society's causal network/ showing up the dominant viewpoint as the viewpoint of the dominators/writing from the standpoint of the class which has prepared the broadest solutions for the most pressing problems afflicting human society/emphasizing the dynamics of development/concrete and so as to encourage abstraction."[30] Since her start in television, Hui has displayed a keen interest in the way politics shapes the lives of ordinary people. In 1997, Hui made the documentary *As Time Goes By,* part of a Taiwan-produced series dealing with the Handover; it includes footage of a reunion Hui stages with some of her former classmates. This film provides another point of reference for *Ordinary Heroes,* offering a nonfiction forum for the informal discussion of Hong Kong's sovereignty, local politics, and social change.

In fact, the documentary impulse at the heart of *Ordinary Heroes* remains strong throughout. The film ends with the handheld camera moving among the people gathered for the June Fourth commemoration and pausing, finally, on the face of a small boy lighting candles in the drizzle. The boy looks at the camera, holding flowers, and the freeze frame captures the moment, citing the freeze frame at the end of François Truffaut's *The 400 Blows* and paying tribute to the French New Wave. *Ordinary Heroes* presents modernist cinematic provocation as well as left-wing politics as a quotation of an earlier period, thereby removing it from Hong Kong's current position as a Special Administrative Region. At the same time, this self-reflexive homage to global film takes *Ordinary Heroes* away from the earlier era of counter-cinema and brings it closer to a postmodern aesthetic sensibility.

The aesthetic as well as political slippage between the modern and the postmodern, in fact, serves as a defining feature of both Mok's play and Hui's film, and *Ordinary Heroes* displays a clear awareness of the important implications of postmodernity to contemporary political projects. During her convalescence in the New Territories, Sow mentions that she went to see a Stephen Chow comedy, and the reference takes note of the wide gap between films such as *Ordinary Heroes* and Hong Kong's popular *mou lei tau* (nonsense) comedies. The citation serves as a reminder that the border between high art and popular culture re-

mains porous, and Chow's brand of humor can be potentially as subversive as art films (such as *Ordinary Heroes*) that have played at the Berlin Film Festival. Bertolt Brecht certainly was prescient when he remarked that "the terms *popular art* and *realism* become natural allies. It is in the interest of the people, of the broad working masses, to receive a faithful image of life from literature, and faithful images of life are actually of service only to the people, the broad working masses, and must therefore be absolutely comprehensible and profitable to them—in other words, popular."[31] An image near the end of the film shows a man performing moves from traditional Chinese opera with a makeshift sword. He claims to have been a famous opera star, but he now lives on the streets. This apparent digression signals a limit to the theatrical in the film—to Brecht's debt to Chinese opera, as well as Mok's tribute to Brecht. Men taking the stage and symbolically wielding the sword can only go so far in understanding the political sphere that encompasses both sexes.

Silent Feminism

Although Ann Hui has been reluctant to see herself or her work as "feminist," her vision of Hong Kong politics through a woman's perspective plays a fundamental role in the structure of the plot of *Ordinary Heroes*.[32] Seen in this light, Sow's tale as a "woman's story" provides a different parallel to Wu's biography, serving a similar function to the inclusion of Lindzay Chan in Evans Chan's *The Life and Times of Wu Zhongxian*. Sow represents the personal, the melodramatic, and the lives of women too often excluded from the public sphere and political participation, while Wu Zhongxian and his interlocutor Mok contribute an exclusively male voice to the body politic.

Ordinary Heroes narrates Sow's story against the backdrop of the activities of the male activists with whom she is involved (figure 4.5). For example, although all of the campaigns taken up by Yau in the film directly impact the lives of women, no feminist voice emerges to discuss gender differences, sexual inequality, or women's rights as political issues. The men take action and sound the call for change; the women serve beer, paint placards, and remain on the sidelines. Sow may function as an allegorical figure of the political underdevelopment of the Hong Kong people, but she also acts, on a more personal as well as political level, as a victim of male domination and sexual violence who never quite finds a political voice. Other women in the film remain isolated as well— the molested woman with Down syndrome; the female social worker unable to help her; Tung's mother (Pau Hei-Ching), the alcoholic abortionist; Yau's pregnant wife, who brings him a change of clothing and food without interrupting

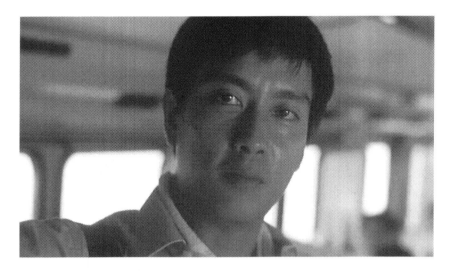

Figure 4.5. Yau (Tse Kwan-ho) in action as a political leader in *Ordinary Heroes*; dir. Ann Hui, 1999.

his meeting to speak with him although he has not been home in days. Issues involving the resettlement of the boat people, the reunion of the boat brides with their families, and the campaign to get official identification cards for the women in the floating population all highlight the fact that the colonial government took a paternalistic attitude toward the issue of the boat families. Although the series of rulings against the women's right of abode in Hong Kong underscored the sexist nature of the government's actions, the men involved in the demonstrations—activists as well as husbands/fathers—never mention these rulings. No women grab the megaphone (as Yau does at one point from one of the fishermen), and none of the oppressed women takes up a knife to sign a petition in blood.

However, Hui creates a feminist space for the contemplation of this absent need in her film by cataloguing these incidents and dramatizing them through Sow's story. Having little to say and no memory throughout much of the film, Sow embodies the irony of the Chinese title of *Ordinary Heroes*. Teresa Tang's "Thousands of Words" plays in the car during the breakup of Yau and Sow, referring to the empty promises of Yau as a married lover as well as the vacuity of his political position as a "sellout," his views fluctuating with the times. Tang's lyrics stand in stark contrast to Sow's inability to articulate her subordinate position from a feminist perspective. Sow remains passive as Yau takes action. He "saves" her during his campaign to get the remnants of her shattered family into public housing with the other resettled boat dwellers; he "gives" her a job as a flunky in his political machine; he "lowers" himself to have an affair with a poor, unedu-

cated woman; and he attempts to "make amends" when he tries to visit her and give her money during her convalescence after her car accident. The power he has over her is undeniable, and her position parallels that of the woman with Down syndrome who is molested in exchange for an apple. In both cases, Tung comes to the aid of the abused women—helping Sow during her recovery and battering the developmentally handicapped woman's abuser. As Tung beats the molester bloody, the low-angle shot of his enraged countenance speaks to Yau, his rival, as the preferred object of the attack. No feminist activists appear, and only the filmmaker Ann Hui connects the dots by juxtaposing the two women's stories in the film.

After the scene in which the young Sow steals Tung's wallet, the character has little agency in the film. She subordinates herself to Yau's needs and uses Tung's romantic attentiveness to help her keep Yau as her lover. Tung plays along, from helping out at the campaign office to buying her a dress that Yau is too cheap to purchase and, indeed, taking her to abort her lover's fetus. One sequence stands out in *Ordinary Heroes* that breaks this pattern. Hui begins with a shot of a woman poling a sampan in one of the typhoon shelters, where the boat brides must stay afloat with their families since they have no right to step on dry land in the colony. Images of silent women rowing the sampans among their floating homes pepper the film, but in this particular case, Hui gives one of these women a voice. Sow visits a pregnant woman doing piecework on one of the houseboats. She assembles plastic flowers while her young son plays nearby (figure 4.6). (Li

Figure 4.6. Sow (Loletta Lee) and Mrs. Yau Hei (Chang Siu-Hung) in Ordinary Heroes; dir. Ann Hui, 1999.

Ka-Shing, the Hong Kong billionaire, famously got his start by cornering the market in artificial flowers, so the irony of seeing how he made millions provides an interpretive context for the scene.) The boy wants to go to McDonald's. Although his mother knows from hearsay that food is served there, she does not dare take the child out to eat. Detention and deportation to mainland China keep her on the boat. Sow, however, takes it upon herself to escort the woman and her child out for fast food. Ducking a policeman on the street, an encounter that sends the boat woman into a fit of hysterics, they make it to McDonald's. In their humble way, these female outlaws defy authorities to get their share of the "good life" promised by global consumerism. The camera frames them first outside the restaurant and then cuts to an interior shot with McDonald's food and wrappers scattered on the table. They have made it "inside" Asia's "world city" to finally enjoy the fruits of their labor as women. This brief sequence of sisterly solidarity speaks volumes to the way in which the male activists ignore the basic needs and reasonable desires of the women they attempt unsuccessfully to help.

The men and women appear to operate in opposing political orbits in *Ordinary Heroes*. This can be seen very clearly in the following scene, in which Tung's mother goes to visit Father Kam on his houseboat. Taking up residence among the people he serves, Kam lives without electricity on the water, and Tung's mother must take a sampan over for the visit. She brings some styrofoam boxes with crab as an offering to establish *guanxi* (personal connections) and pave the way for her request to help her locate her son, whom she has not seen recently. She asks the priest to give him a protective amulet as well as to bring him to Jesus —covering the Taoist as well as the Christian metaphysical domains. Kam agrees to pass along the amulet, but he demurs on Christianity by saying, "He'll believe in God if he thinks it is right."

Opening up to the priest, Tung's mother explains the source of her alcoholism in the nature of her job as an abortionist, complaining about women coming to end their pregnancies in their last trimesters. In the front lines of the Reform Era one-child policy, this midwife-turned-abortionist dramatizes the impact Chinese state policies have on the lives of individual women who bear the brunt of population control. The priest says he did not know about her job, thinking she was a cleaner. Rather than offering her spiritual solace, however, as may be expected of a Roman Catholic priest, he gives her a copy of Mao's *Little Red Book*. Stunned by the gift, she counters, "I fled here from the Mainland, Father," and the priest remains speechless. However insensitive the Maoist priest may be to the fact that this abortionist links her moral dilemma to the way the Communist government has organized her clinical responsibilities, it makes sense that Kam should see more to help her in Mao's dictum that "women hold up half the sky"

than in the Christian New Testament. Unfortunately, the feminist discourse remains between the covers of the *Little Red Book,* and Father Kam cannot articulate even the vaguest of the Communist state's official policies concerning women's rights. He fails to state the need for feminism of any type, and *Ordinary Heroes* leaves women unable to agitate for their own rights even in the presence of committed political activists.

Sow's trip to the mainland abortion clinic in Shenzhen depicts in images what Tung's mother talks about in words. Impregnated by the adulterous Yau, Sow makes the journey across the border with Tung, who may know about the clinic through his mother's former profession. They wait outside the clinic and witness a woman in pain hobbling out on the arm of a man—clearly the procedure is far from simple and painless for women who may or may not be coerced into conforming to the government's one-child program. The caretaker comes up and tries to get them to move so he can sweep the stoop. Tung picks a fight with him after he sweeps away Sow's shoe. A pattern emerges as Tung repeatedly comes to the aid of women in need of rescue. However, in each case, the expression of his anger does little good. Inarticulate and unreliable, Tung's sympathies may be in the right place, but this man fails to give any real support to the women in his life. Throughout the film, he fails to advocate for women's political rights or feminist reforms.

Ordinary Heroes makes this point quite clear in a scene featuring Tung as a silent witness. When Tung and his female colleague show anatomically correct dolls to their developmentally handicapped charges, the young men and women can all give names to the male organ, but none of them knows the word for "vagina." The "thousands of words" of the film's title do not contain the vocabulary necessary for discourse on women's bodies, and it becomes clear that one of the women in the group endured repeated abuse because she could not articulate her suffering. Sow, the silenced amnesiac raped literally by a rising politician and figuratively by oppressive forces linked to the broader crackdown initiated on June 4, 1989, represents both the plight of individual women victimized by male violence and the territory of Hong Kong—frozen in mid-stride like the statue of the Goddess of Democracy. Sex, gender, public voice, democratic process, and sovereignty merge in a single female figure. However, Sow is more than a symbol or a metaphor. Hui makes Sow an engaged political presence. Nonetheless, the activists, elected politicians, social workers, and community volunteers— "ordinary heroes" or "unfulfilled" reformers—in the film remain silent on feminism and its place within Hong Kong's transformation from a colony to a Special Administrative Region with a new political identity. The other side of the dialectic can be seen but not heard in *Ordinary Heroes,* and the silence speaks volumes.

Portraits of Artists in Action

Both *Ordinary Heroes* and *The Life and Times of Wu Zhongxian* remain ambivalent about Hong Kong politics. However, Chan's film provides a wider spectrum of concrete portraits of artistic responses to political activism. These range from Mok's street theater evocation of Wu, to John Woo's experimental homoerotic wet dream *Deadknot,* to Wu Zhongxian himself as an essayist. Wu took up the pen, Woo took up the camera, and Mok takes to the stage. All of these aesthetic positions (and the politics attached to them) coexist in a mosaic that parallels Chan's role as filmmaker/dramaturge/essayist/commentator.

Not only do these artists go to the experimental edges of the stage, magazine, and film media, but they also serve as important exemplars of the transnational culture that shapes their work. Just as Hong Kong politics exists in relation to British colonialism, American global interests, Chinese sovereignty, and international activist movements, Wu Zhongxian, John Woo, Mok Chiu-Yu, and Evans Chan need to be located at the intersection between Hong Kong and global aesthetic currents in order to communicate with their domestic, diasporic, and international audiences. Bernardo Bertolucci and the European New Wave, as well as Chang Cheh, Shaw Brothers, and Hollywood action films, find their way into *The Life and Times of Wu Zhongxian* through references to Wu and Woo, for example. Like Brecht, all of these artists have worked in self-imposed or enforced exile, and they have an intimate feeling for the relationship their work has "between" as well as "within" specific cultural formations.

The film as a whole plays with and against each of its stylistic and political citations to maintain a dialectical tension among them, and it allows no safe haven for complacent spectators. Chan interrupts *The Life and Times of Wu Zhongxian* to include a completely separate film text—John Woo's experimental black-and-white short *Deadknot,* featuring film critic Sek Kei (credited as Wong Chi-keung). The experimental homoerotic trance film serves as a counterpoint to Mok's agitprop theater piece on Wu. It is a jarring turnaround from dramatized fact to dream, from a surreal evocation of politics to an equally surreal depiction of erotic fantasy. It also resonates with Mok's story about the screening of *Last Tango in Paris.* The heterosexual sodomy scene in *Last Tango* connects with the ongoing debates involving Hong Kong's draconian anti-sodomy laws meant to target the gay community. *Deadknot* brings this line of thought full circle by connecting homoeroticism to artistic experimentation, implicit anti-colonialism, and a plea for sexual/personal liberation from all forms of oppression.

In many ways, *Deadknot* resembles what P. Adams Sitney has called the "trance" film[33]—an outgrowth of European surrealist experiments with film and

dream states (e.g., Dali and Buñuel's *Un chien andalou,* 1929) at the intersection of Freud's work on the unconscious and Marx's critique of the oppressiveness of the bourgeoisie. In work by artists as diverse as Maya Deren, Kenneth Anger, and Stan Brakhage, the camera takes on the subjective point of view of the film-maker, who reenacts a dream state and transforms quotidian surroundings through transgressive meanderings.

Unlike Kenneth Anger's *Fireworks* (1947), made over twenty years earlier and to which Woo's black-and-white, trancelike, homosexual psychodrama is clearly indebted, *Deadknot* not only transgresses sexual norms through its de-piction of homoeroticism and sadomasochism, but it also subtly comments on Hong Kong's colonial status. More in keeping with Dali and Buñuel's attack on bourgeois propriety in *Un chien andalou, Deadknot* follows scenes featuring its homosexual couple engaged in sadomasochistic acts with an oneiric encounter with a white plaster reproduction of a headless Venus. As an emblem of Euro-pean civilization, the sculpture goes beyond serving as a visual icon of female perfection out of the reach of the young dreamer, however. Rather, its chalky whiteness points toward an underlying anti-colonial commentary on the ten-sions between the Chinese colonized subject and the funereal and remote culture of the West.

Bisexual expressions of desire become "forbidden fruit" (as a title card notes) within the colonial context and homosexual yearning finds expression through sadomasochistic play rather than officially outlawed sodomy, while interracial heterosexual desire manifests as fetishism and white plaster substitutes for fe-male flesh. The segment ends with a girl covering her eyes with her hands as if shocked by the open display of sexual desire—a vague promise of opposite-sex, same-race "normalcy" that covers up authentic lust. Illicit sex, as defined by the colonial government and British bourgeois norms, serves as a metaphor for the "dead knot" that frustrates Hong Kong's youth and prevents free expression.[34] What ostensibly appears to be a highly subjective, insistently personal trance film has a political component that links it inexorably to Wu's anti-colonial po-litical struggles. Mok criticizes John Woo in retrospect as a different kind of "strange fruit"—that is, a "banana," white on the inside and yellow on the out-side, referring to Woo's identification with Western culture and Hollywood film-making. However, as *Deadknot* indicates, Wu the activist and Woo the film-maker do indeed live in the same "times" and take part in the same struggle for free expression and personal liberation.

Operating dialectically, the depiction of sexuality in *Deadknot* also provides a striking point of contrast with the scenes dramatizing Wu's love affair with a young admirer of *70s Biweekly,* portrayed by Lindzay Chan. While *Deadknot* is raw and favors the handheld point of view shots characteristic of the trance film,

the scenes with Lindzay Chan feature direct address to the camera and reenact-
ments of scenes, with Ellen Leou, Leung, and Mok playing the roles of the young
men and women attracted to the ideals of the magazine. Erotic dream stands in
contrast to romantic reminiscence, direct vision to dramatic reenactment, and
the performance of the camera as a participant in the erotic encounter to the
performance of actors and actresses in front of the camera stands as a dramatiza-
tion of a past romance.

Although seemingly poles apart, the sentiment at the core of *Deadknot*'s
sexual exploration and the romance sparked by a common political cause in the
romantic interlude with Lindzay Chan remain the same. John Woo, in a state-
ment on Wu Zhongxian provided by a title card in *The Life and Times of Wu
Zhongxian,* underscores his feelings of friendship and fraternal respect: "Even
in my fading memories, some names, faces and goings-on between good friends
in the old days have stayed with me. I remember Wu Zhongxian as a courageous
man, who dared take on challenges and speak up to power. He was an ideal-
ist....I had no idea he's been gone for some time."[35] As the inclusion of Woo's
statement indicates, *The Life and Times of Wu Zhongxian* goes beyond Mok's
tribute to Hong Kong's political past to take into consideration the emotional
complexity of Wu, Woo, and their comrades. In an interview with Michael
Berry, Evans Chan also emphasizes the importance of the tenderness at the root
of the two male characters' relationship in *Deadknot:* "The scenes involving the
two men, while featuring S&M elements, also convey a kind of tender camara-
derie. They are tending to each other, they're fellow travelers, they're being
young and crazy together....I also find it quite beautiful and very touching."[36]
Chan's adaptation adds a layer of eroticism and affect that takes *The Life and
Times of Wu Zhongxian* in a different direction and complicates any interpreta-
tion of it as an allegory of Hong Kong's present political environment. The pro-
cess of decolonization includes a personal dimension not suited to street theater
and public demonstrations, an aspect more in keeping with John Woo's *Dead-
knot* than Mok's play.[37] These contradictions among the various pieces that
comprise *The Life and Times of Wu Zhongxian* return, then, to Brecht's celebra-
tion of "montage" as part of epic theater and the way it places fragments of the
social being in "process" and subject to transformation.

Brecht, Wu Zhongxian, the Topical, and the Historical

One of the most striking moments of the Brecht-scripted film *Kuhle Wampe*
(1932) comes at the film's end, when a number of passengers on a tram begin to
talk about the price of coffee in Germany. Rather than wrapping up by offering a

conclusion to the story, Brecht brings in the topical issue of coffee and, with it, the global circulation of commodities, profits, and inflation. In *Ordinary Heroes* and *The Life and Times of Wu Zhongxian,* the activist Wu remains "topical." He becomes a figure at the intersection of different "times" in Hong Kong history, and, fittingly, he appears, disappears, and reappears in other iterations of Mok's play. As Walter Benjamin, renowned essayist and great supporter of Brecht's epic theater, noted, "The chronicler, who recounts events without distinguishing between the great and small, thereby accounts for the truth, that nothing which has ever happened is to be given as lost to history."[38]

Anarchists, Trotskyites, and radical magazine editors remain at the fringes of Hong Kong's history, but Wu Zhongxian emerges from obscurity at what Benjamin might call a "moment of danger": "To articulate what is past does not mean to recognize 'how it really was.' It means to take control of a memory, as it flashes in a moment of danger. For historical materialism it is a question of holding fast to a picture of the past, just as if it had unexpectedly thrust itself, in a moment of danger, on the historical subject."[39] Even though Wu Zhongxian may have been "marginal," his causes become central in relation to Hong Kong's more recent history. The films' picture of Wu thrusts the memory of Hong Kong activism into the present moment, and it shows Wu (and, by extension, Hong Kong) in the process of constant "danger," as well as in a "state of emergency" that serves as an opportunity for change. In fact, Wu Zhongxian acts as an illustration of Brecht's "man as process"—in a position of perpetual redefinition, reinterpretation, and transformation.[40] Both Hui's and Chan's films remain in "process," constantly resituating Wu's life in relation to Hong Kong history and politics. By extension, the films place the act of spectatorship in "process" by redirecting attention to Hong Kong's present as it changes in relation to its contradictory political past.

Ultimately, the films act as documents of transformation. Mok transforms his friend Wu Zhongxian, through the restaging of his life, into a posthumous spokesman for Hong Kong's continuing struggles to find a postcolonial voice. Ann Hui and Evans Chan, in turn, transform Mok's play into films that reconfigure Brecht's epic theater and Godard's counter-cinema in the service of Hong Kong motion picture culture. In this part of the process, the films return to the global context Mok references at the beginning of the play/film—that is, the legacy of British imperialism and the continuing importance of 1960s and 1970s radicalism and international youth culture today. The ways in which global, political, and aesthetic issues shape Wu's life and time remain salient, and Wu is again transformed from a local fringe radical into a global figure of political consequence.

Les Maoïstes, les Chinoises, and Jean-Pierre Léaud

China, France, and the Sexual Politics of the Cultural Revolution

> The Cultural Revolution was wonderful.
> —Rémy in *Barbarian Invasions*

> Everyone talks of the crimes of the Red Guards in the Cultural Revolution.
> —Voice-over, Jean-Luc Godard, *La chinoise*

As the two epigraphs above indicate, there can be a glaring disconnect in how events like the Great Proletarian Cultural Revolution are experienced, understood at the time, and later remembered. Even though the dialogue seems to indicate otherwise, the Francophone Canadian feature *Barbarian Invasions* (*Les invasions barbares;* dir. Denys Arcand, 2003) denounces the Left, while Godard's film highlights the promise of Franco-Chinese political intercourse. Although Mao Zedong was sending the students to the countryside to end their activities in Beijing and other major Chinese cities in 1968, images of the Red Guards in Tian'anmen Square in 1966–1967 lingered and no doubt inspired many who then took to the streets in cities such as Berkeley, Prague, London, Rome, New York, Tokyo, Chicago, and Paris. Opposing Western capitalism as well as Eastern, Soviet-style state communism, the search for a "third" way encompassed a wide range of competing political positions and personal proclivities on the Left. Maoism and its various incarnations provided one model among many.

European New Wave filmmakers took note of this political "wind from the east" in 1966, and directors Marco Bellocchio and Jean-Luc Godard responded in 1967 with *La Cina è vicina* and *La chinoise*.[1] Joris Ivens's epic documentary on Chinese society during the Cultural Revolution, *How Yukong Moved the Mountains* (*Comment Yukong déplaça les montagnes*), had its premiere in Paris in 1976,

marking the end of the era.[2] Looking back on the period in France and Italy, Bernardo Bertolucci's *The Dreamers* (2004) and Olivier Assayas's *Après mai* (*Something in the Air,* 2012) allude to Maoism and the influence of Chinese politics in Europe at the time. Both directors provide sharp critiques of *les maoïstes* in their features.

Assayas directly quotes Simon Leys (Pierre Ryckmans)'s anti-Maoist writings, while Guy Debord's and René Viénet's Situationist films and publications can be felt as an influence in *Après mai* as well.[3] Using the strategy of détournement, in which a common cultural object becomes a vehicle for radical critique, Viénet's *La dialectique peut-elle casser des briques?* (*Can Dialectics Break Bricks?,* 1973) appropriates Tu Guangqi's Hong Kong martial arts film *Crush* (a.k.a. *Kung Fu Fighting; Tang shou tai quan dao,* 1972) for visuals and dubs it in order to reanimate it as an anti-Mao political tract. His *Chinois, encore un effort pour être révolutionnaires* (*Peking Duck Soup,* 1977) continues in a similar vein with a wider range of newsreel and other visual material supplementing kung fu action. In *The Dreamers,* Bertolucci critiques the French infatuation with the Cultural Revolution through the character of Théo (Louis Garrel), whose vision of Mao Zedong as a masterful film director orchestrating the actions of the Red Guards like extras in a revolutionary epic seems as delusional and absurd as the erotic games he plays with his twin sister and their American friend.[4] However, as Bertolucci shows, the relationship between the French Maoists and May 1968 was complicated by other social, cultural, and political factors.

Before his protagonists retreat to their Paris apartment for the preponderance of *The Dreamers,* Bertolucci shows the trio meeting in front of the Cinémathèque Française in the middle of the demonstrations in February 1968 in opposition to the ouster of its director, Henri Langlois. As this scene shows, the film world was intimately involved in the 1968 Paris demonstrations—from protests surrounding Langlois's firing to the successful closure of the Cannes International Film Festival that year. Ironically, in his role as Charles de Gaulle's cultural minister, French Orientalist André Malraux, who had been an early supporter of the Chinese Communists, was the one behind the attempted expulsion of Langlois.[5] Malraux eventually acceded to the demands of the protestors, and Langlois remained in charge at the Cinémathèque Française. As the confrontation between Malraux and the cineastes/students revealed, a younger generation in France had a very different view of political action and the meaning of Sino-French cultural connections than its elders.

Actor Jean-Pierre Léaud took a leading role in the February 1968 demonstrations, and Bertolucci intercuts black-and-white newsreel footage of the young actor making his demands with images of the older Léaud in the same place, recre-

ating his speech as part of the fictional world of *The Dreamers* (figures 5.1 and 5.2). The actor calls for cinephiles to resist the French bureaucracy: "Liberty isn't given; it's taken. All those who love film in France and abroad are with you and with Henri Langlois." Through his association with François Truffaut and Jean-Luc Godard, Jean-Pierre Léaud already represented a generation of French youth on screen. From Truffaut's *The 400 Blows* to Godard's *Masculin féminin* (1966), Léaud had grown up before the French public as the face of the New Wave—rebellious, free-thinking, provocative, and avant-garde.

Taking the spotlight at the Cinémathèque Française seemed a natural next step in Léaud's personal and political development. Revisiting this moment in *The Dreamers,* Bertolucci exploits Léaud as a symbol of his generation. In doing this, the Italian director is not alone, and Léaud serves a similar function in films, such as the episode by Philippe Garrel (Louis Garrel's father) in *Paris vu par…vingt ans après* (*Paris Seen by…20 Years After*) (1984).[6] The actor also figures prominently in films by Olivier Assayas as well as Tsai Ming-liang as a symbol of the French New Wave—its aesthetic promises, radical politics, senescence, and haunting afterlife.

This chapter traces the way in which Jean-Pierre Léaud anchors the political and aesthetic conversations taking place between China and France from the 1960s through the beginning of the new millennium. From Godard's *La chinoise* to Assayas's *Irma Vep* and Tsai Ming-liang's *What Time Is It There?* and *Visage,* Léaud functions as a screen icon able to shoulder a wide range of often contradictory significations involving the legacy of May 1968 and its Chinese connections. His aging face testifies to the complex history of political perspectives, cinematic proclivities, and cross-cultural bonds that provides the foundation for the relationship between France and transnational Chinese film culture. While the Cultural Revolution in *La chinoise* situates French cinema in relation to the PRC, *Irma Vep* looks at Parisian fascination with Hong Kong film, and Tsai Ming-liang's features link Paris to Taipei and Taiwan New Cinema. With each coordinate on the map and temporal moment on the clock, Léaud's image bends to accommodate these three auteurs' understandings of Sino-French cinematic significations.

Les Maoïstes in La Chinoise

A few months before the 1968 demonstrations and following closely after his feature *Week-end* (1967), Jean-Luc Godard created *La chinoise,* a film that chronicled his own intellectual engagement with "les maoïstes" in Paris. Many scholars have pointed to *La chinoise* as eerily prescient regarding the events of May 1968.

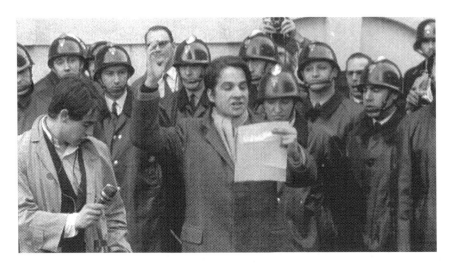

Figure 5.1. Jean-Pierre Léaud in newsreel footage of the February 1968 demonstrations in The Dreamers; dir. Bernardo Bertolucci, 2004.

Figure 5.2. Jean-Pierre Léaud (as himself) recreating his speech in The Dreamers; dir. Bernardo Bertolucci, 2004.

Even the fact that a film—Nicholas Ray's *Johnny Guitar* (1954)—becomes a major bone of contention among the characters presages the centrality of film during the February demonstrations around the Cinémathèque Française. In one scene, one of the characters even talks about the importance of Henri Langlois and Cinémathèque Française to his political development.

Bertolucci makes the link between *The Dreamers* and *La chinoise* clear by hanging a poster of Godard's film in the bedroom of the radical twins, and Léaud, Louis Garrel's actual godfather and family friend, symbolically oversees the revolution happening behind closed doors as well as on the street in front of the Cinémathèque Française. Earlier in his career, Bertolucci had cast Léaud as Tom, the young, aspiring filmmaker in *Ultimo tango a Parigi* (*Last Tango in Paris,* 1972), the foil for Marlon Brando's Paul in a love triangle involving Jeanne (Maria Schneider), in which the May–December couple heated up an empty apartment while Tom/Léaud and the remnants of the student movement remained out in the cold. *Last Tango in Paris,* as seen in chapter 4, became the object of impassioned debates in the expatriate Chinese political circles described by Augustine Mok's performance of Wu Zhongxian's life abroad, and the film spoke to the personal and political turmoil that came in the wake of the May uprisings.[7]

In many respects, while revisiting *Last Tango in Paris, The Dreamers* also retells the story of *La chinoise* as happening in 1968 rather than 1967. As in Godard's film, Bertolucci's narrative confines its youthful characters to rooms inside a comfortable upscale apartment, left to their own devices by their bohemian parents, who have gone off on vacation. Hollywood and New Wave films, such as Godard's *La chinoise* and *Bande à part* (1964), occupy their imaginations. For Bertolucci's teens, freedom has more to do with sexual license than social transformation, and as their relationship implodes, one of the trio instigates a murder-suicide by turning on the gas. An errant brick from the demonstrations crashes through the apartment window, and politics literally saves the lives of the kids inside. Bertolucci moves his characters out into the street to take part in the uprisings, and Godard's young Maoists take timid steps on their own "long march" at the end of *La chinoise.*

As Richard Wolin points out in his book *The Wind from the East,* a small group of students influenced by Maoism emerged from French universities in the mid-1960s; however, they did not play a prominent role in the May 1968 demonstrations.[8] Godard sets *La chinoise* in this rather insular world, and his characters search for a way to make a revolution—cultural or otherwise—from the confines of their Paris apartment. With the adults away for the summer, the kids occupy the apartment and create a mini-commune/Communist cell with other students, activists, and their lovers. The comrades engage in political debates, give formal lectures to one another, listen to Radio Peking, sleep together, sip tea,

take notes, and put on bits of agitprop theater. They enact their ideas using plastic toys (bows and arrows, tanks, machine guns), and sometimes they appear to be children playing games, while at other points they perform the role of earnest students—notebooks in hand, feverishly taking notes. Jean-Pierre Léaud plays a version of himself—a young actor involved in the political debates of the day (figure 5.3).

Godard structures *La chinoise* around a series of interviews (presumably with the director, who remains off screen) in which the answers, but not the questions themselves, are heard. Typical of Godard, it remains unclear during these sessions whether the actors speak on their own behalf or as their characters would be expected to respond. Blurring the line between fiction and fact further, *La chinoise* includes a sequence in which a fictional character has a lengthy conversation with French existentialist philosopher and activist Francis Jeanson.

The film focuses on two couples—Véronique (Anne Wiazemsky) and Guillaume (Jean-Pierre Léaud) and Yvonne (Juliet Berto) and Henri (Michel Seme-

Figure 5.3. Jean-Pierre Léaud (as Guillaume), with PRC blinders on, reading Mao's Little Red Book with the Red Guard broadsheet in the background in *La chinoise*; dir. Jean-Luc Godard, 1967.

niako). Véronique is a teenage philosophy student; her lover, Guillaume, an as-
piring thespian; Yvonne, the housemaid and occasional prostitute; and Henri, a
chemist who is Yvonne's boyfriend. Through the course of the film, this foursome
—along with some others in the cell—drifts further left, purging the more mod-
erate Henri on the way, and Véronique eventually becomes involved in a plot to
assassinate a Soviet diplomat.

In the process, *La chinoise* covers an impressive range of left-wing political
positions, with perhaps the least attention actually given to Maoism and the
Great Proletarian Cultural Revolution. The characters' (and presumably Go-
dard's) critique of the French Communist Party (PCF)'s support for the USSR is
sharp, and the film spares no punches in its characterization of the Left cultural
establishment—including Louis Aragon and, less acerbically, Jean-Paul Sartre,
among others—as intellectually bankrupt. However, the students' articulation of
Mao's ideas says a lot more about their own interests and desires than anything
remotely connected to the mass demonstrations in Tian'anmen Square, struggles
against "rightists" in the CCP establishment, the closure of the universities (as
well as other cultural institutions), or any other aspect of political life in China
circa 1966–1967. Struggle sessions, self-criticisms, party purges, and big charac-
ter posters drift on the edges of the diegesis without really settling in as part of
the students' political life.

The film makes crystal clear the reasons for the split in the Left and the
alienation of French youth from the Communist political establishment. Guil-
laume uses American foreign policy as a yardstick to demarcate "two" types of
communism—the United States goes to war to fight the Asian Communists in
Vietnam but makes peace with the USSR. The Soviet Union, then, gets taken to
task for not adequately fighting the "paper tiger" of US imperialism in Vietnam,
while the PRC's efforts on behalf of the Vietnamese are presumed more reliable.
Soviet premier Alexei Kosygin (who met with Lyndon Johnson in New Jersey
around the time *La chinoise* was being made in 1967) and Leonid Brezhnev, gen-
eral secretary of the Communist Party, bear the brunt of the critique. Dressed in
a conical straw hat like a Vietnamese peasant, assailed by model airplanes and a
giant painted Esso tiger, positioned next to a gas tank labeled "napalm," Yvonne,
during one of the agitprop interludes, cries out to Kosygin for help but, of course,
to no avail.[9]

Although the American and French governments are obviously culpable,
the political contradictions that fuel *La chinoise* remain within the Left. Early in
the film, one of the group staggers into the apartment, beaten and bloody. When
asked if the Fascists bashed him, he says, "No, the Communists." However, no
particular political program sticks, and the characters drift through Maoism
without really absorbing its basic tenets. Parroting the sentiments of propaganda

posters and political slogans, Yvonne finds Mao in the feeling of the brightness of the red sun that remains in her heart after sunset. Ironically, as the others study politics, she placidly continues to wash dishes, clean windows, and shine shoes.

Véronique claims she passes her philosophy examinations because she picked peaches beforehand—feeling that without the experience of manual labor, she was doomed to failure. However, she also insists that the universities need to be shut down—without being able to articulate why or under what circumstances they should reopen. As she sips tea out of china cups in her elegant surroundings, plots violent insurrections, and dreams of bombing the Louvre and the Sorbonne, the film lets stand the contradictions embodied by Véronique as the daughter-of-a-banker-turned-radical: the young have turned against their parents' generation, and the bourgeoisie has turned against itself.[10] The "revolution is not a dinner party," as Mao says, but the students come to the conclusion that "France in 1967 is like dirty dishes."

There are no Chinese characters—male or female—in *La chinoise*. Although a Francophone African student appears and a few of the others may be immigrants, no East Asian characters appear on screen. Radio Peking broadcasts, Mao quotations read by the French students, and still photographs stand in for the Chinese people. Véronique at one point is visually compared to Alice in Wonderland, and China functions as a kind of wonderland for the students throughout the film. As noted, Yvonne dresses as a Vietnamese woman, and both Véronique and Yvonne don Mao jackets and caps, but it remains unclear if either or neither (or both) can be taken for the eponymous "Chinese woman."

No one in the group articulates how the circumstances of the Chinese Cultural Revolution parallel the situation of French youth in any way. Although dissatisfaction with the Soviet Union, the PCF establishment, and France's intimacy with the United States all explain the younger generation's abandonment of the Old Left, it does not explain the appeal of Mao—a champion of the Chinese peasantry—to the privileged, disaffected, but highly idealistic Parisian youth of the late 1960s. In fact, no one in the group bothers to learn much from Yvonne, the farm girl in their midst, and Véronique does not abandon Paris for the countryside, nor does Guillaume last long outside the city.

As the group moves away from Maoism and drifts closer to anarchism, Henri decides he has had enough. Rather than go through a self-criticism session, he agrees to expulsion. Another member commits suicide, and Véronique becomes an assassin. As the film's style drifts between talking-head interviews and Pop Art insertions of comic book images, its turn to violence makes more aesthetic than political sense. Malcolm X, for example, appears briefly in the film as an image pinned to the wall, rather than a source for any political program inspired by "any means necessary." Véronique's violence owes more to comic

book sensationalism than actual political practice. However, the ambiguity and the hybrid constitution of the doctrines presented, as well as the mercurial nature of the characters' political beliefs, practices, and commitments, may more accurately capture the quality of left-wing youth before May 1968 than would straightforward presentations of political dogma.

Véronique's encounter with Francis Jeanson on the train proves to be particularly illuminating in this regard. As a veteran of the resistance against the Algerian War, a supporter of anti-colonial bombers, and an individual very much on the wrong side of French law during that conflict, Jeanson has the Marxist gravitas to expose the holes in Véronique's reasoning.[11] As Jeanson points out, Véronique has no mass popular support, no clear objectives, and only "vague ideas" of what the revolutionary process should look like. He tells her plainly, "You can participate in a revolution, but you cannot invent one." However, Jeanson also fails to articulate his own program of "cultural action" in the film. Just as the opening title claims that La chinoise is a film in "the process of being made," any notion of revolutionary change remains "an idea in progress."

Given Godard's rather caustic treatment of the radical Left in hindsight, the establishment of the Dziga Vertov Group—co-founded with Jean-Pierre Gorin in 1968 and producing the radical feature Wind from the East (Vent d'est, 1969) the following year—shows that his sympathies were not really with Jeanson. The process of making La chinoise strengthened rather than weakened his political resolve. However, La chinoise may be all the more interesting for Godard's political distance, skepticism, and careful dialectical deliberation of the impact of Mao's way on the French radicals of the day. Since this is Godard, his engagement is with la chinoise—the female version—and the film revolves around Véronique (played by Anne Wiazemsky, whom Godard would marry), so his interest in women, at this point, takes precedence over his commitment to Mao. In fact, French intellectual interest in the "Chinese woman" as a political emblem peaked with the publication of Julia Kristeva's About Chinese Women (Des chinoises) in 1974 (translated into English in 1977), and the relationship between a feminized "China" and the European imagination of revolutionary politics lingered on motion picture screens.

Mao in La Chinoise

France officially recognized the PRC and began diplomatic relations in 1964—before the start of the Cultural Revolution in 1966. Before 1949, there had been contacts—at various levels and for very different reasons—between the Chinese Left and the French. Some Chinese Communists had studied or worked in

France (most notably, Zhou Enlai and Deng Xiaoping), and many French intellectuals of various political persuasions had a sustained or passing interest in China as a cultural and/or political force (e.g., André Malraux). China, the French Left, and communism all had made a mark on French artists and intellectuals before 1966. However, the Cultural Revolution was new and in the news, and given the rise of youth movements around the world, it makes sense that students challenging the Communist establishment in Beijing and apparently getting the support of the Chairman for their critique of their red elders should capture the imagination of young leftists in France (and elsewhere).

In one scene in *La chinoise,* Guillaume and Véronique sit across from one another, presumably studying Mao's tract on fighting the Cultural Revolution on "two fronts" (the material and the spiritual); a song plays on the record player in the background between them (figure 5.4). Guillaume suddenly confronts Véronique with the fact she is trying to do two things at once, and he just does not understand how it is possible. Véronique unexpectedly counters with the information that she doesn't love Guillaume any more. After they talk about the sud-

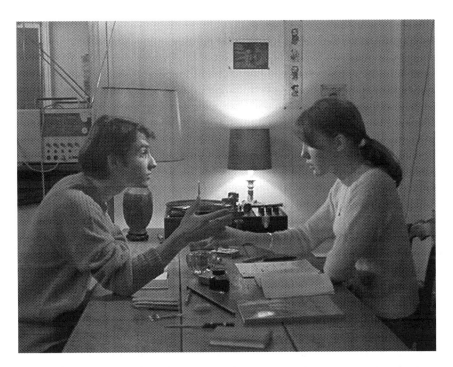

Figure 5.4. Jean-Pierre Léaud (as Guillaume) and Anne Wiazemsky (as Véronique) "struggle on two fronts" in *La chinoise;* dir. Jean-Luc Godard, 1967.

den change in her feelings for a bit, Véronique changes the record (as well as the mood/her feelings), and she tells Guillaume that he has just, in fact, experienced two things at the same time. Guillaume claims now to understand Mao's theory of the struggle on "two fronts," but the lesson is more for the film viewer than for the fictional Guillaume.

La chinoise operates on "two fronts," combining radical film form with revolutionary content as a disjointed story about French youth and as a political essay on Maoism and the French Left. The fickle teenager Véronique may dump Guillaume in this scene, but it may only be an "act" to make a political point. Guillaume may or may not "understand" Mao and/or his girlfriend. Godard challenges viewers to see the difference between a fictional romance and a revolution happening at the same time.

In the film, Godard engages China on these "two" fronts—the political and the cultural. However, without a doubt, China as an aesthetic object wins out over Mao as a political force. Although quotations from the *Little Red Book* (*Mao zhuxi yulu*) form an important component of the soundtrack, Mao's presence asserts itself primarily as an image. Young and old, in glossy magazine photographs as well as highly stylized portraits, Mao's likeness overshadows his ideas. The Chairman's visual traces appear as articles of clothing (cloth caps and button-down dark blue Mao jackets), objects (the ubiquitous *Little Red Book*), and gestures (calisthenics in the morning). Aurally, although Mao's voice is absent, news about the Chairman can be heard broadcast on Radio Peking, as well as issuing from the mouths of his French admirers, and his name booms out from the record player as the popular ditty "Ma-O, Ma-O" (by Claude Channes) vies with the "Internationale" as musical inspiration for the activists.

A slogan written on the apartment wall proclaims, "One must confront vague ideas with clear images," and Godard makes good on this promise. The film's mise-en-scène overflows with photographs, posters, objects, colors, graphic designs, newspaper clippings, and fragments of language directly inspired by images of China in circulation circa 1967. Brightly colored Chinese New Year prints decorate the apartment, and even the Esso tiger ("Put a tiger in your tank") swallows up the film frame in some compositions (playing on the tiger as a Chinese icon, on Mao's characterization of America as a "paper tiger," and on the "society of the spectacle" in which American commercial images take over the contemporary visual landscape, as theorized by Guy Debord in *The Society of the Spectacle,* also written in 1967).[12]

Red (the color of revolutionary China) dominates many compositions and punctuates others in sometimes unexpected ways—for example, the saturated red of the lampshade and the upholstery in the upscale bourgeois Parisian living room occupied by the young Maoists. The *Little Red Book* as an object that dom-

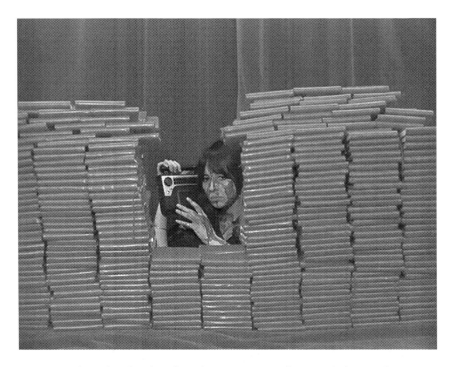

Figure 5.5. The Little Red Book swallows the composition with Yvonne (Juliet Berto) in *La chinoise*; dir. Jean-Luc Godard, 1967.

inates many of the frames (figure 5.5). Serving as a wall to insulate the characters (emphasizing their isolation as well as their embattled status), in addition to providing a visual pun on China's "Great Wall," the red book functions as a synecdoche for the masses in Tian'anmen Square (so obviously absent from the apartment). The deep blue associated with Mao's jacket provides the other principal color used in many shots. Blue doors, blue jackets, and the occasional green or yellow accent round out the palette of predominately bright, saturated, comic-book primary colors (often associated with Pop Art). In fact, Mao's image vies with comic book characters like Captain America and Sergeant Fort within the montage, and the mise-en-scène owes a debt to Andy Warhol and Roy Lichtenstein as well as revolutionary China.

Also, as in comic books/Pop Art, the written word functions as an important visual element in the film. Writing, in fact, vies with the spoken word and the image for attention. Likely inspired by the *da zi bao* (big character posters) of the Cultural Revolution, Godard fills the frame with words, fragments of words, and printed and written texts. The activists paint slogans on the walls, write incessantly on blackboards, and scrawl in notebooks. Godard uses inter-titles

throughout the film to announce breaks, comment ironically on the characters' political positions, and freely play with the slippery signifiers that the word and sentence fragments become.

In many respects, Godard takes up China the way Warhol appropriated Mao's image in 1972 (when Nixon went to China). The French filmmaker sees Mao and the Cultural Revolution as elements of a media spectacle, objects of aesthetic contemplation, sometimes pregnant with meaning and sometimes simply empty outlines filled with color on the screen. Mao becomes part of an elaborate visual collage—changing meaning in relation to the other images present. In the footsteps of Eisenstein and Brecht, Godard takes the dialectical properties of the image seriously, and *La chinoise* comments openly on its own aesthetic strategies. Images of the camera come into view as reverse shots when characters look directly into the lens, clapboards announce the end of takes, and sound technicians appear onscreen. Film as a medium becomes as important a topic as Mao or the lives of the fictional inhabitants of the apartment. The film even references another movie about making movies—Federico Fellini's *Otto e mezzo* (8½, 1963). The banning of Jacques Rivette's *La religieuse* (*The Nun*, 1966) also comes up in conversation in the film.

Guillaume claims an interest in China that is clearly theatrical in nature. Although he mentions the achievements of the model operas in passing, his real fascination with the Cultural Revolution comes through agitprop and street theater. In one scene, Guillaume wraps an ace bandage around his face and tells the story of a Chinese student protesting in Moscow. The activist screams until journalists come over to investigate, and he slowly uncovers his bandaged face. When the journalists see the Chinese protestor has no cuts, they call him a "fake Chinese." However, Guillaume says (as he undoes his own "fake" bandages) that the press misunderstood the theatrical gesture.

Situated somewhere between Antonin Artaud's theater of cruelty and Bertolt Brecht's epic theater, Guillaume draws on both dramaturges' fascination with Asian theatrical forms for inspiration—as does Godard. Brecht serves a particularly important function. In one scene, Guillaume lectures on the differences between the Lumière Brothers and Georges Méliès; he claims that Méliès has more in common with Brecht in his reenactments of the current events of the day than the Lumières' "actualities" (current happenings) did. The Lumières' attitude toward observed phenomena fails to get at the "reality of the image" in the way Méliès gets at the truth of the illusion.[13]

In another scene, a list of famous intellectuals fills the flat's blackboard, and Guillaume systematically erases names one by one. Only "Brecht" never disappears. (Louis Althusser's essay on Brecht becomes a topic of conversation as well and serves as testimony to Brecht's continuing importance to one of the heroes of

French youth at the time.) As mentioned in previous chapters, Brecht, like Go-
dard, was familiar with Chinese politics as well as aesthetics. However, Godard
takes up Mao Zedong using his own cinematic idiom as a range of aesthetic
choices—an image signifying "things Chinese"—going beyond a Eurocentric vi-
sion of art and smashing Western traditions of verisimilitude.

As discussed in chapter 4, for Brecht, Peking Opera's routine breaking of the
"fourth wall" convention of separating the actor from the world of the audience,
its stylized presentation of gestures associated with character types, and its insis-
tence on artifice put it in an enviable position of allowing for emotional distance
and, potentially, critical reflection. In the spirit of Brechtian theater, the inter-
titles and graffiti in *La chinoise* function as much as visual markers of the mate-
riality of the screen to break the illusion of photographic verisimilitude as they
serve as vehicles for a particular political message.

In fact, Jean-Pierre Léaud, as Guillaume, acts as the ventriloquist for Brecht
(and Godard) as often as he spouts Mao. The casting of Léaud in itself implies a
certain attitude toward performance and intertextuality. As a New Wave icon,
Léaud worked on several projects with Godard during this period. In addition to
La chinoise, he starred in *Masculin, féminin, Weekend,* and (later) *Le gai savoir*
(*Joy of Learning,* 1969), as well as making a cameo appearance in several others.
Typically, Léaud plays an actor and/or a cinéaste (as he does later in Truffaut's *La
nuit américaine* [*Day for Night,* 1973] and Bertolucci's *Last Tango in Paris*), and
he serves as a concrete face for a constellation of more abstract ideas—from
Brechtian alienation effects to references to the *bildungsroman.* In the case of *La
chinoise,* for instance, there are direct references to Goethe's *Wilhelm Meister's
Apprenticeship,* a novel in which the young hero also flirts with the idea of a ca-
reer as an actor and ends up in a secret society. Léaud also functions as an inter-
textual bridge (e.g., dressing as an actor playing the French revolutionist Saint-
Just in both *La chinoise* and *Weekend*), another reminder of the constructed
nature of the film fiction and the characters within. The second-in-command of
the Reign of Terror, Saint-Just died at the age of twenty-six, executed with Robes-
pierre, putting an end to that bloody phase of the French Revolution. Léaud im-
personates him, and the youthful fervor of revolutions past and present floats
between history and fiction.

For Brecht and Godard, art means alienation, contradiction, dialectical ex-
changes, confrontation, and struggle. During the Cultural Revolution, Mao's
"revolutionary romanticism" dominated aesthetic theory, and Jiang Qing's
model operas became the norm for artistic practice. Although both approaches
to socialist aesthetics put Soviet socialist realism on the defensive, they are far
from compatible. Godard uses Mao, the Cultural Revolution, and China as aes-
thetic elements rather than as models for artistic practice. His interest is in un-

derstanding the appeal of the Cultural Revolution to the younger generation, to which he is attracted (as represented by his young wife Anne Wiazemsky/Véronique). His attention, then, is as deeply personal as it is political, and Godard employs his own tried-and-true dialectical techniques to uncover the appeal of Mao to the young, as well as to critically examine the fascination the young Maoists hold for him. The closing of the film expresses Godard's ambivalence as the voice-over narration looks forward to "a long march," while some young people throw away Mao's book and close the shutters on the sunlight symbolizing the red sun of the Cultural Revolution.

Old and New Waves in Irma Vep

Jean-Pierre Léaud encounters a very different *"chinoise"* in Olivier Assayas's *Irma Vep.* In this film, Léaud plays a fictional, aging French New Wave director, René Vidal, attempting an ill-conceived and ill-fated remake of a classic French silent serial about the Parisian underworld with Hong Kong film star Maggie Cheung in the title role. Vidal casts "Maggie" (the Hong Kong star plays a version of herself in the film) as the new Asian face of the modern woman, whom the French actress Musidora portrayed in Louis Feuillade's serial *Les vampires* (1915–1916).

As a film about the making of a film, *Irma Vep* resembles Truffaut's *Day for Night,* and Léaud appears to take up the role vacated by François Truffaut in Assayas's fiction. However, as an icon of his generation, Léaud carries the weight of the political as well as the cinematic past, and Léaud's association with Godard (in addition to other directors such as Pier Paolo Pasolini and Jean Eustache) places him at the center of the European New Wave. The actor owes a debt to Truffaut, who shaped his early career through the recurring character of Antoine Doinel, although Vidal cannot easily be equated solely with Léaud's mentor. *Day for Night* provides the clearest parallel, but *La chinoise* lingers as well in Assayas's treatment of the relationship between Léaud and Maggie Cheung in the film.

In *Irma Vep,* Vidal projects the qualities he assumes the Asian woman to possess—"mysterious, beautiful, very strong"—onto his "modern" Irma Vep. He chances upon Maggie Cheung at a screening of Johnnie To's Hong Kong action fantasy *The Heroic Trio* (*Dong fang san xia,* 1992) in the former French colonial outpost of Marrakesh. Thus, Vidal's conception of "Maggie" as the master thief Irma Vep is filtered through a projection of the product of a British colony (Hong Kong) within a former French colony (Morocco) onto the body of a Chinese woman. As Dale Hudson notes, "If Musidora was modern in the sense that Paris was the modern city of the end of the nineteenth century in Vidal's mind, then

Maggie is modern in the sense that Hong Kong was the modern city of the end of the twentieth century."[14]

The West has become postmodern, and Vidal searches for "modernity" elsewhere. "Maggie" must somehow embody mystery, beauty, strength, and modernity on a French cinema screen torn apart by the postmodern crisis in representation, where past images can only be (re)presented and the post-colonial margin holds out the only hope for shoring up the centrality of European cinema. Like the Chinese woman evoked by the title of Godard's film, "Maggie" becomes an icon of "China" as the expression of a hope to reinvent a past moment that the West has ruined. For Godard, China represents youth and radical political change, bounded by a Brechtian aesthetic and Parisian bohemian sexual freedom. Assayas, however, sees Maggie Cheung as an icon of Hong Kong cinematic vitality holding the promise of reinvigorating French cinema with her global connections (figure 5.6).

Vidal may share a similar view, but "Maggie" seems to have a different understanding of her role in the remake of *Les vampires,* which she sees as a tribute to the contributions the New Wave has made to world cinema. While many of the characters in the film voice their disdain for Vidal, Maggie takes the aging director—and the New Wave vision he represents—seriously, and she defends his oeuvre against critical attacks. Likely in reaction to Vidal's exasperation that

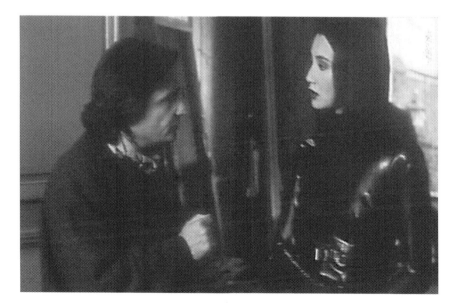

Figure 5.6. Jean-Pierre Léaud (as René Vidal) instructs Maggie Cheung (as herself) in *Irma Vep;* dir. Olivier Assayas, 1996.

there is "nothing for [her] to act" in his version of *Les vampires,* she makes a valiant attempt to improve her performance. To immerse herself in the role, Maggie puts on her latex costume, cases the halls in her hotel, follows a maid into a room with a naked woman (played by Arsinée Khanjian, filmmaker Atom Egoyan's wife) on the phone with her absent lover, steals some jewelry, and sneaks up to the roof to dispose of the ill-gotten goods. In this scene, the mask Vidal has created for her character seems to take over Maggie, and the reasons for her behavior (acting challenge, rehearsal, research, impulse, intoxication, etc.) take a backseat to her embodiment of the underworld figure whom she has been brought to Paris to play. However, when the mask is removed, Vidal must confront the emptiness of his own Orientalist fantasies, and he collapses as a result.

Vidal's creative energies dissipate, and when last seen in the film, he has been drugged to calm his nerves. Literally struck dumb, he falls back in a stupor as if petrified. Vidal is replaced by another fading New Wave director, José Murano (Lou Castel), who has a decidedly more nationalistic vision of *Les vampires.*[15] It is interesting to note that Castel, like Léaud, has been a darling of New Wave directors from an early age. While Léaud played Truffaut's alter-ego Antoine Doinel beginning with *The 400 Blows,* Castel starred as the troubled Alessandro in Marco Bellocchio's *I pugni in tasca* (*Fists in the Pocket,* 1965). Castel also portrayed a director in New German Cinema's Rainer Werner Fassbinder's film about filmmaking *Warnung vor einer heiligen Nutte* (*Beware of a Holy Whore,* 1971).

Léaud and Castel, then, stand in for the leading figures of the new cinemas of France, Italy, and Germany, battling it out over whether a Chinese woman can play an iconic Parisian thief. However, for Assayas, Hong Kong and Hollywood point to the future, while European cinema remains mired in the past. Although Maggie loses her role in the film-within-the-film when Murano replaces her, she goes on to New York, to meet with Ridley Scott, and Los Angeles, to meet with her American agent and, presumably, to satisfy fantasies in Hollywood that she only promised to fulfill in France. A highly mobile "flexible citizen," Maggie leaves both Hong Kong, on the verge of going from a British colony to a Special Administrative Region of the PRC, and Europe behind.[16] While French cinema's past embraced the PRC and the promise of the Cultural Revolution, Assayas, through Maggie, flees it.

Irma Vep, in fact, deals with the cinema as a site of contested fantasies from the start. It begins with a black, blank screen that features the voice-over of the film's producer trying to "close the deal." The empty screen, before the credits roll and the producer's body appears, invites speculation on the blank space as a place for the projection of fantasies. When the voice is given the body of a black man, the connection among the cinema, French culture, and the legacy of French

colonialism in Sub-Saharan Africa sets the stage for the introduction of Maggie Cheung as another "blank" screen for the projection of European desires.

Throughout the film, Maggie struggles with the various images that are projected onto her and with which she is compared. She enters the film greeted by someone wearing an Arnold Schwarzenegger T-shirt and coming from an action adventure film involving Thai drug lords and underwater stunts with frogmen. The Hong Kong star summarizes the film as "too violent," "complicated," and "boring." However, *Irma Vep* makes no reference to Cheung's connection to the Hong Kong New Wave. Given Maggie Cheung's mesmerizing performance as the Chinese silent screen star Ruan Ling-Yu in Stanley Kwan's *Center Stage* (a.k.a. *The Actress; Ruan Lingyu,* 1992), it makes sense to cast "Maggie" as another silent film diva because of her ability to translate silent screen images into a contemporary idiom.[17]

When she meets Vidal, this is not the image that fascinates him as he sits in front of the VCR captivated by Maggie as Chat (French, of course, for "cat"), a.k.a. the Thief Catcher, in *The Heroic Trio.* Within Vidal's fevered imagination, it is all too easy to turn Chat into the cat burglar Irma Vep; the thief catcher into a thief; and the leather clad, motorcycle riding, martial arts adept into a combination of Musidora's original Irma Vep and Michelle Pfeiffer's Catwoman from Tim Burton's *Batman Returns* (1992). For Zoë, the lesbian wardrobe mistress, this all adds up to Vidal's wanting Maggie to look like "a hooker," so she takes the actress to a sex shop, with Maghreb music playing in the background to emphasize the colonial exotic within the locally erotic, to outfit her for the role of Irma Vep. However, the sordid aspect of the latex cat suit does not keep Zoë from projecting her own fantasies onto Maggie when she admits that she would like to play with her like a "big, plastic doll."

Vicki Callahan notes, "Actress Maggie Cheung, who plays herself in the film, becomes a blank screen on which several of the characters project their anxieties and desires."[18] Zoë tries to help Vidal out by facilitating his vision of Irma Vep as a prostitute, while the film's leading man, Ferdinand (Olivier Torres), who plays opposite Maggie's Irma Vep, gives the Chinese actress pointers on his conception of how the role should be played. However, as Olivia Khoo points out, looking at "Maggie" exclusively as a site for the projection of French fantasies misses the point: "Maggie Cheung's own self-transgression in her crossover to the West, and in the 'queering' of her subjectivity and the theft of its codes, indicates her own agency in this latex performance of the exotic."[19] In fact, the power of her physical presence belies any attempt to tame her persona to fit in a nationalist agenda for French film. Vidal's New Wave rival, José Murano, sees Irma Vep as the embodiment of the French working classes, with no place for "*la chinoise*" in the picture. The director refers, of course, to Maggie, but he also

brings in Hollywood with his dismissal of the actress: "Irma Vep is not Fu Man-
chu." A swipe at Godard's *"chinoise"* and the political aesthetic that the film rep-
resents also lingers in his dismissal of the Chinese actress. Although Murano has
high hopes that Maggie's stunt double will be another Arletty and save the film,
the fact that he falls asleep while watching a tape of the Feuillade original does
not bode well for the project.[20]

Murano may have a point nonetheless. Even with white pancake makeup,
her cat suit, and detailed direction from Vidal, Maggie cannot quite squeeze into
the role of Irma Vep in the way she manages to fit into the skintight latex suit.
Rather, she is trapped by the various fantasy projections that attempt to contain
her. Vidal projects onto the Asian "other" what has been lost in the West through
the failure of modernity. Inevitably, Vidal tries to fit his vision of the Asian Irma
Vep into a cinematic history weighed down by Feuillade's silent film serial con-
ception of underworld chaos during World War I, as well as his own generation's
failed efforts to merge the cinematic with the political. This failed impulse is rep-
resented in *Irma Vep* by a clip from *Classe de lutte* (*Class of Struggle*) by the So-
ciété de Lancement des Oeuvres Nouvelles (Society for the Launching of New
Works; SLON, 1967), formed by Chris Marker in the mid-1960s to empower
workers by enabling them to make their own motion pictures.[21] Marker, of
course, had an abiding interest in China, beginning with his trip there in 1955, as
chronicled in the film *Dimanche à Pekin* (*Sunday in Peking*, 1956), and this aspect
of his career adds another layer of meaning to the brief citation in Assayas's film.

In *Irma Vep*, in addition to dealing with the weight of the history of Western
cinema, Vidal must also negotiate Hong Kong screen culture. In an interview
with a journalist (played by Antoine Basler), Maggie deals with an action fan's
projection of the absolute wonder of working with Jackie Chan and John Woo.
Obsessed with the beauty of Hong Kong martial arts cinema, the critic is unable
to process that the joy of working with Jackie Chan lies in the feeling of being
protected as a star and not in doing death-defying stunts and that John Woo
does not thrill Maggie as a director since his films revolve around male, rather
than female, protagonists. Although she tries to defend Vidal, Maggie ends up
being the sounding board for the interviewer's harangue against French cinema:
"It's boring cinema...about your navel...cinema to please yourself not for the
public...only for the intellectuals, for the elite...made with French government
money....You don't think the intellectual film killed the industry of the cin-
ema?" As Grace An notes, "This scene becomes less an interview of Maggie
Cheung and uses her facial image instead as a platform, a screen onto which
French self-deprecation about its own cinema projects itself."[22]

Ultimately, the film refers back to Assayas's own vision of Maggie Cheung as
a projected image and locus of erotic fantasy since he made the film in part to

court his leading lady, whom he later married.[23] Thus, in addition to the Léaud connection, Assayas's romance with Maggie Cheung parallels Godard's relationship with Anne Wiazemsky. Assayas's constantly moving Super-16 camera links the film to *cinéma vérité* and the French documentary tradition of Chris Marker, while his penchant for overexposed shots, ambient noise, and the youth culture of the Parisian streets places him squarely within the tradition of the French New Wave. If Léaud could be Truffaut's alter ego, he could also play Assayas's double. However, having been a critic for *Cahiers du cinéma* and a Hong Kong film "fan boy," like the character played by Antoine Basler, Assayas cannot help but see himself as the "enemy" of the French New Wave tradition as well.

Eventually, through the limitations of both Vidal and Maggie, Assayas confronts his own obsessions with the Hong Kong actress and, by extension, the difficulty of depicting her without projecting an Orientalist fantasy onto her. An exasperated Vidal says, "I am interested in you. You are more important than the character. But in the end, there is nothing for you to act." Assayas seems to agree as he (through Vidal) transforms Maggie into "pure" film by scratching and optically printing the footage until it resembles Stan Brakhage's *Reflections on Black* (1955) with an industrial, electronic music score at the end of the film (figure 5.7). It is difficult to say whether there is a direct connection between Antoine Doinel's drawing a mustache on a pinup girl in *The 400 Blows* and Vidal's desecration of Maggie's image in *Irma Vep;* however, the same impulse to

Figure 5.7. The scratches left on "Maggie"'s face in *Irma Vep;* dir. Olivier Assayas, 1996.

vandalize the outmoded representations of the past seems to be at work through Léaud's characters.

It is equally hard to say whether Vidal's encounter with the American avant-garde has reinvigorated or destroyed French "cinema." The use of the "Ballad of Bonnie and Clyde" (popularized by Serge Gainsbourg and Brigitte Bardot) at the film's conclusion keeps *Irma Vep* within the realm of the scandalous. Assayas, however, does not use the original version of the song; rather, he employs a cover version by the American "new wave" band Luna. In an interview with Brian Price and Meghan Sutherland, Assayas adds a political dimension to all these elements, tying them together in relation to punk rock/new wave music and Bruce Lee:

> Music had become inconsistent. It had all been about virtuoso playing and art rock—bloated, empty and devoid of relevance. Then all of the sudden you had guys playing two-minute songs about guys on the dole, or just rebelling. You had the feeling of not being lost in the failures of '60s politics. What had started in May '68—hope to change the world, hope of the revolution coming —had come to an end, had become an empty shell. But these guys revived the very notion of facing society and expressing themselves in a way that is relevant, radical. It's like within Hong Kong cinema when you had all those period pieces, all those swordplay movies. All of a sudden you have Bruce Lee in the street fighting it out. It's vital. When you're very young, that's what you go for, because it is what's going to drag you wherever you're going.[24]

Reacting against May 1968 and all it represents, Assayas imagines another "China" through Bruce Lee and Hong Kong cinema. Perhaps Assayas sees himself and Maggie as the new "radicals"—the Bonnie and Clyde outlaws of world cinema —and *Irma Vep* brings him full circle at the opposite end of the spectrum from Jean-Luc Godard's *La chinoise*. Arthur Penn drew his inspiration for *Bonnie and Clyde* (1967)—made the same year as Godard's *La chinoise*—from the French New Wave, and Assayas's musical citation makes this connection clear as he transcends May 1968 through Vidal/Léaud. The merger of Hong Kong stardom, the American avant-garde, and the French New Wave, however, also furthered Olivier Assayas's career as an international auteur—a role defined by Truffaut, Godard, and now Assayas, in relation to the changing face of Jean-Pierre Léaud.

The New Wave on Taiwan Time

Tsai Ming-liang's *What Time Is It There?* also uses Jean-Pierre Léaud to explore the ways in which the French New Wave continues to "haunt" world screens.[25] In this

film, populated by ghosts and the afterlife of cinema, Tsai, like Assayas, employs Léaud in order to reposition global cinema and reimagine the encounter of China and France in the post-Mao/post-May 1968 era. Although Alain Resnais's *Hiroshima mon amour* (1959) gets mentioned in passing at a Taipei video store, Tsai's interest in European film does not take him into the realm of politics. Unlike Assayas, who includes references to the Left throughout the film (particularly in the direct citation of Chris Marker's SLON film projects with urban workers), Tsai focuses on Léaud before the "wind from the east" struck Paris in force. Hsiao Kang (played by Tsai's regular lead Lee Kang-sheng) enters a video store searching for a film that will bring him closer to his obsession, a young woman played by Chen Shiang-chyi, who has gone off to Paris wearing Hsiao Kang's dual-time watch, which she insisted on buying off the young man's wrist. Drinking red wine and resetting clocks throughout Taipei to Paris time has not done the trick, so Hsiao Kang looks to French film as a way of becoming synchronized with his dream girl.

The proprietor of the shop, which specializes in film "classics," recommends the seminal masterpieces that had their premieres at the Cannes International Film Festival in 1959—*Hiroshima mon amour* and *The 400 Blows.* Hsiao Kang picks the latter, and Tsai takes his film in the direction of Truffaut's New Wave meditation on youth, cinema, and the suffocating nature of postwar French society. Resnais's film offers a very different trajectory. Based on Marguerite Duras's screenplay, which deals with an adulterous love affair between a French actress and a Japanese architect, it features an antiwar film-within-the-film protesting against nuclear weapons on the site of the first use of the atom bomb in warfare. If Hsiao Kang had taken this French feature, *What Time Is It There?* would have had a very different frame of reference with a more explicitly political plot (perhaps involving the American military presence in Taiwan as well as Japan) and an adult perspective on sexuality, war trauma, existential philosophy, and the impact of the *nouveau roman* on narrative structure in film as well as literature. Resnais, along with Chris Marker, Agnès Varda, and a few others, formed the so-called Left Bank Group at the same time Truffaut, Godard, Rivette, Claude Chabrol, and Éric Rohmer inaugurated the French New Wave. Both groups of filmmakers had much in common, and they occasionally collaborated with one another.[26] However, the New Wave overshadows the Left Bank in most accounts of postwar European cinema, so Hsiao Kang's choice of *The 400 Blows* may reflect this.

Truffaut's *The 400 Blows,* moreover, also speaks to Tsai's interest in reflecting on his relationship to his protégé, and the parallel between Truffaut/Léaud/Antoine Doinel and Tsai/Lee Kang-sheng/Hsiao Kang seems almost inevitable. Truffaut made four films with Jean-Pierre Léaud as Antoine Doinel: *The 400 Blows* (1959); a segment in *Love at Twenty* (*L'amour à vingt ans,* 1962); *Stolen Kisses* (*Baisers volés,* 1968); and *Bed and Board* (*Domicile conjugal,* 1970). Tsai has

made a series of films with Lee as Hsiao Kang, including *Rebels of the Neon God* (*Qingshaonian Nezha,* 1992); *Vive l'amour* (*Aiqing wansui,* 1994); *The River* (*He liu,* 1997);[27] *What Time Is It There?*; its companion, *The Skywalk Is Gone* (*Tianqiao bu jian le,* 2002); *The Wayward Cloud* (*Tianbian yi duo yun,* 2005); *I Don't Want to Sleep Alone* (*Hei yan quan,* 2006); and *Stray Dogs* (2013). In these films, as well as in *Visage,* Lee Kang-sheng appears to play some version of the same character, and his appearance as unnamed characters in other features points to a continuation of the story of Hsiao Kang as well.

These films by Truffaut and Tsai share other similarities as well, including recurring themes (e.g., rebellious youth, sexual experimentation, dysfunctional families, and urban alienation) and cinematic techniques (e.g., observational style, location shooting, use of the long shot/long take, the static frame, and disjointed temporal and spatial relationships). While Léaud's appearance in *What Time Is It There?* cites Truffaut's Antoine Doinel films, it also uses Léaud as an icon of the New Wave, a past moment in film history, and a ghostly presence in postmodern Taiwanese cinema. Like Tsai, who migrated from Malaysia to settle in Taiwan, Léaud's image as Antoine Doinel travels from Europe to Asia to provide a fresh cycle of citations for what Fran Martin calls "a film that is self-consciously about the subject of cinema itself."[28]

The fact that *What Time Is It There?* is a meditation on cinema becomes clear through the choice Tsai makes to include two specific sequences from *The 400 Blows* in his film. In the first, he watches the scene in which Antoine plays hooky at an amusement park and goes for a spin on the Rotor, a large cylinder that acts as a centrifuge and literally takes the floor out from under the feet of the revelers. The ride, particularly in the way Truffaut shoots it, alternating between the perspective of Antoine and the spectators on terra firma (including a cameo of Truffaut), resembles the zoetrope, an optical toy that creates the illusion of movement with pictures spun on a cylinder. Antoine relishes his spin inside this motion (picture) machine, and Truffaut seems to highlight the attraction's connection to the art and technology of cinema. Holding a pillow, cigarette in hand with the sound of the television off, Hsiao Kang sits to the side of the composition as a visual parallel to Léaud as Doinel on the other side. They become two halves of New Wave film history from different continents and different times sharing the same screen space.

The second scene from *The 400 Blows* comes after Hsiao Kang has had an unwelcome homosexual encounter with a plump young moviegoer. He appears to wake up from a dream as the scene of Antoine filching a milk bottle, running with it, and drinking surreptitiously comes on screen. In the earlier scene in the movie theater, Hsiao Kang takes a clock off the wall to reset it, cradling it in his lap as he watches the film. The young man, clearly enamored, sits next to him and picks up the clock when it slides off Hsiao Kang's lap as he moves seats to escape the young man's advances. Picking up the clock and running off, the

young man retreats to the men's room, and he pops out of one of the stalls with the clock over his genitals. Rather than finding out what time it may be "down there," Hsiao Kang leaves, and the nightmare follows. The scene from *The 400 Blows* with Antoine stealing the milk echoes Hsiao Kang's theft of the clock since both share similar patterns of action. However, as Michelle Bloom points out in her insightful analysis of *What Time Is It There?,* the theme of "theft" extends beyond the confines of the film's narrative. Much like *Irma Vep,* when Assayas's pilfering of France's cinematic past finds its parallel in Maggie's theft of the jewelry, Tsai humorously acknowledges his own position as a vandal who appropriates images from another filmmaker's work. Bloom goes on to explain that the scene also fits snugly in Tsai's oeuvre as another instance of his preoccupation with fluids, hunger, and the "consumption" of images as satisfying an existential need. Moreover, she points out that the citation fuses the cinematic worlds of France and Taiwan in a compelling way: "These possible readings seem ultimately less convincing than the more fruitful view of citation as fusion, a blending of images, films and characters. As opposed to cross-cutting between Taipei and Paris, which entails alteration, separation and parallels, Tsai and Truffaut, as well as the French New Wave and the Taiwan New Wave, converge in the Milk Bottle sequence of *What Time?*"[29] Later in the film, Léaud becomes a very physical presence seated on a bench at the Père Lachaise Cemetery in Paris, where he meets the object of Hsiao Kang's obsession and gives her his telephone number. The young boy has become an old man—another monument surrounded by the funerary sculptures in the background of the shot (figure 5.8).

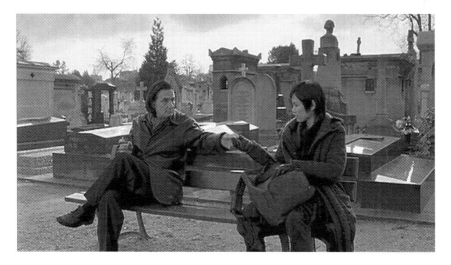

Figure 5.8. Jean-Pierre Léaud (as himself) and Chen Shiang-chyi (as Shiang-chyi) on a bench in Père Lachaise Cemetery in *What Time Is It There?*; dir. Tsai Ming-liang, 2001.

Shiang-chyi's presence on the bench brings a queer connection. Similar to Maggie's uncertain sexuality in *Irma Vep,* where she becomes the object of the erotic attention of both men and women, Shiang-chyi has a liaison with a Hong Kong woman, played by Cecilia Yip. When Hsiao Kang's father's ghost appears to rescue Shiang-chyi's luggage in the Tuileries, Miao Tien, a veteran of Hong Kong martial arts films, fuses film history and queer sexuality. Tsai brings Miao Tien, the gay cruiser of *The River,* to watch over the young lesbian in a French park with a giant Ferris wheel (reminiscent of the amusement park ride in *The 400 Blows*) in the background. The visual connections bring Tsai closer to the New Wave by queering Truffaut's legacy. The questioning of cinematic norms overlaps with challenges to heteronormativity, and Tsai both pays homage to and pushes against international art cinema.

Tsai uses Jean-Pierre Léaud for a second time in a film commissioned by the Louvre and shot there. *Visage* features Lee Kang-sheng as a film director who parallels Léaud mirroring Truffaut, who, of course, serves as Tsai's model film auteur. In this case, Léaud plays an actor, Antoine, who has been commissioned by director Kang (Lee Kang-sheng) to act in a version of Oscar Wilde's *Salome* as King Herod. Wilde's stint in jail for "indecency" because of his homosexuality contributes to the queer dimension of *Visage,* which also includes a scene of Kang kissing another man; in addition, a prominent place is given to the paintings of Leonardo da Vinci, who endured a trial on sodomy charges during the Italian Renaissance. Drawing on the intertextual dimension of his own oeuvre, Tsai brings in song and dance, as he has in earlier films including *The Hole* (1998), as a reference to queer desire and a camp sensibility that breaks down and breaks up film history.[30]

Beginning with *The Hole,* Tsai has worked on a regular basis with various French film companies, so the collaboration between the Louvre Museum and the Malaysian-Taiwanese director for *Visage* solidifies Tsai's long-standing relationship with European cultural brokers. In a striking way, *Visage* illustrates the type of French government-financed film Antoine Basler rails against in *Irma Vep.* Filled with self-absorbed references to the director's own oeuvre, devoid of plot in any conventional sense, and heavy with cultural citations, the film challenges spectators to make connections that only savvy connoisseurs could identify. However, these citations transcend the "navel gazing" of the French critic's complaint. Song Hwee Lim highlights the importance of France as a source of funding for Tsai and links his "cinephilia" to his choice of specific film citations: "One of the ways Tsai has mobilized discourses of cinephilia in his filmmaking is by constructing narratives that offer intertextual reading pleasures that have the potential effect of securing favorable international reception and future investment."[31] Thus, film citations become a bankable part of Tsai's cultural capital in international circles outside of the Sinophone world.

According to Tsai, the invitation from the Louvre's director, Henri Loyrette, coincided with a major retrospective of François Truffaut's films, so he decided to combine the Louvre location with elements from Truffaut's oeuvre.[32] Lim confirms that the casting of Léaud supports Tsai's own claim to "auteur" status on the film festival circuit and beyond: "The French connection with Truffaut and Léaud draws on the legacy of the Nouvelle Vague and the continued currency of the discourse of *la politique des auteurs,* making France the most reliable source of funding for Tsai's films. . . . Tsai's own cinephilia, reimagined as intertextuality in his films, generates further cinephilic discourses that sustain his international profile."[33] In fact, Tsai begins *Visage* with a recreation of the director's own first failed meeting with Léaud for *What Time Is It There?,* which he describes as follows: "My first appointment with Jean-Pierre Léaud in Paris was in a café that he frequents. However, he got the time wrong and thought that I was late. He left without waiting, and I only found his empty cup."[34] *Visage*'s opening empty shot of a reflection in the window of a Paris café with a coffee cup as the sole evidence of Léaud's presence/absence seems a fitting entry point into this feature about the lingering afterlife of the New Wave. The coffee cup, ambient sounds, the use of off-screen voices to convey plot details, and the view of Parisian street life framed by the café window link Tsai's film unmistakably to Truffaut and Godard.[35]

As in *What Time Is It There?,* Léaud as Antoine Doinel in *The 400 Blows* becomes a major point of reference. A flipbook reanimates the famous final sequence of Antoine running along the shore, culminating with a freeze frame of his face, and Tsai cites this as one of the defining moments of his own aesthetic development:

> But I also feel like I am destined to be haunted by *The 400 Blows* ever since I watched it, especially by the face of the boy. The way Truffaut narrates the story of a young adolescent unfolds as a series of distinctive iconographies, particularly the final sequence when Antoine runs to the beach and turns to stare directly at the camera. It is a true confrontation between the screen and the spectator. It feels like the film is talking directly to you, the spectators. It exposes problems, but does not intend to offer any solutions. You might not feel inspired when you watch the film, but the memory of that viewing experience may also haunt you for several days. Why is that? What is the power of imagery (in black and white films in particular)?[36]

Léaud's face dominates Tsai's cinematic imagination, and as Lim points out, Tsai quotes this shot at the conclusion of *Vive l'amour* as well.[37] Fanny Ardant, who starred in several Truffaut films and had a child with him, holds the flipbook in *Visage.* Later in the film, she supports Antoine as he prepares his makeup to play

Figure 5.9. Fanny Ardant (as the producer and Queen Herodias) and Jean-Pierre Léaud (as Antoine and King Herod) in *Visage*; dir. Tsai Ming-liang, 2009.

King Herod and encourages him to wear his scars "like a king" (figure 5.9). These two aging French faces, as well as another New Wave favorite, Jeanne Moreau (star of Truffaut's *Jules and Jim,* 1962), so intimately associated with Truffaut, pay homage to the legacy of the director but also to his mentor, André Bazin, and the "mummified change" that the editor at *Cahiers du cinéma* saw as the defining feature of cinema that distinguishes it from still photography.[38]

Returning to the Tuileries, Tsai creates a wintery forest of his imagination and seats Léaud/Antoine in front of trees replicated through the use of mirrors. A dream sequence featuring French chorines lip-synching to a song by chanteuse Zhang Lu links France, through its colonial Chinese concession, to pre-1949 "old" Shanghai, effectively erasing Léaud's connection to *les maoïstes* and the PRC. Later, Antoine refers directly to Orson Welles's *The Lady from Shanghai* (1947). For Welles, Shanghai functions as a corrupt, exotic, dangerous "present" absence—a place to come "from" that remains off screen in his feature. The mirrors that define the composition in the woods, then, refer to the mirrored funhouse in *The Lady from Shanghai,* and this citation references the nature of the film screen as a distorted reflection of the world—or, at least, the world of motion pictures. With Léaud factored in, the amusement park sequence in *The 400 Blows*

featuring another director and his star also comes to mind. Welles and Rita Hayworth, Truffaut and Léaud, Tsai and Lee Kang-sheng contribute to this *mise-en-abyme* of directors and their muses. When Kang and Antoine list the great auteurs, Pasolini, Fellini, Antonioni, Welles, Murnau, Dreyer, Mizoguchi, Chaplin, and Keaton all make the grade, but Jean-Luc Godard remains absent.

Godard and Truffaut never saw eye to eye after May 1968, and Léaud, in a certain respect, embodies that split. Through Léaud, Godard haunts *Visage,* particularly when Antoine, dressed as Herod, pops up through a hole in the wall of the Louvre directly under da Vinci's portrait of John the Baptist. Léaud was not in *Bande à part,* the Godard film Bertolucci quotes in *The Dreamers.* However, his dashing in and out of frame at the Louvre places him in the same location as the "face" of the New Wave. Godard returns, filtered through Tsai's queer sensibility, which fuses Truffaut, Léaud, Wilde, and da Vinci to the cinematic history of the Louvre in a single long take. Given Tsai's Cold War trajectory from Malaysia to Taiwan to France, the fact that he gravitates toward Truffaut rather than Godard for his inspiration is not surprising. During the "white terror" and decades of martial law, Mao's *Little Red Book* could mean jail time in the Republic of China on Taiwan, and recent films from Malaysia—such a Amir Muhammad's *The Last Communist* (*Lelaki Komunis terakhir,* 2006) and *Village People Radio Show* (*Apa khabar orang kampung,* 2007)—reveal the extent of the anti-Communist violence there. However, Tsai's lack of interest in *les maoïstes* may extend beyond the historical vacuum left in the wake of the "white terror." As seen in the lip-synch dance number around the statue of Chiang Kai-shek in *The Wayward Cloud,* Tsai melds an open contempt for authoritarian figures with a camp sense of humor, and the KMT rather than the CCP figures in his imagination as the butt of the joke.[39]

China Divided

Jean-Pierre Léaud's career has taken him from Truffaut's breakthrough *The 400 Blows* to Tsai's mummification of his image in *Visage.* However, Léaud also represents the changing nature of European-Chinese cinematic connections through his association with May 1968. The actor goes from Godard's radical ruminations on Maoism in *La chinoise* to Assayas's struggle with the eclipse of French cinema occasioned by the rise of Hong Kong in *Irma Vep* and comes full circle as the mirror image of Lee Kang-sheng in Tsai's queer meditations on the nature of life, art, and the cinema. Always the darling of the New Wave, Léaud embodies different political and aesthetic aspects of French cinema in relation to the PRC, Hong Kong, and Taiwan. His image alters in significance as he moves from Godard's counter-cinema to Assayas's and Tsai's postmodern idiom.

In fact, in all the films discussed in this chapter, Jean-Pierre Léaud, Maggie Cheung, and Lee Kang-sheng share a common experience of being the "muses" for acclaimed international "auteurs" but also "blank slates" reflecting the desires, hopes, dreams, and memories of the viewers. Robert Kolker's observations certainly apply to Léaud as well as Cheung and Lee in this regard: "They are the blank slate upon which the viewer may write or not, develop emotions for the character, or simply view that character as part of a pattern, moving through— or, more accurately, being moved through—a network of events."[40] Whether the European Maoists, May 1968, and the political aesthetics associated with Godard's films still cling to Léaud or not remains moot. For some, Léaud's face displays the scars of May 1968 as inextricably linked to the defiance of his direct gaze into the camera at the end of *The 400 Blows*.

In each film, Léaud has a different libidinal relationship to China. In *La chinoise*, Léaud/Guillaume struggles with the tension between sex and revolutionary politics, as the changing dynamics of gender mixed with both the sexual and cultural revolutions in Paris in the 1960s. *Irma Vep* prompts Léaud/Vidal to confront his Orientalist fascination with the Chinese woman in the context of the shifts of power occasioned by globalization and the rise of East Asia. In Taiwan, Tsai Ming-liang infantalizes the aging Léaud and keeps him tied to the boy Antoine Doinel—an emblem of New Wave quality and a tribute to the enduring magic of the cinema—while at the same time "queering" his image through layers of associations with figures such as Oscar Wilde and Leonardo da Vinci. For Godard, PRC politics take center stage; for Assayas, the French Left's Chinese connections move to the background as outmoded; and for Tsai, the Cultural Revolution stays out of the picture.

Even though Tsai has no interest in the French Left and the Cultural Revolution, Léaud's face still bears the "scars" of May 1968 and *les maoïstes* in *Visage*. His screen persona serves as part of global cinema's reexamination of Mao and the Great Proletarian Cultural Revolution in the context of European/North American culture in films as diverse as *M. Butterfly* (1993), *The Red Violin* (1998), *Balzac and the Little Chinese Seamstress* (*Xiao cai feng,* 2002), *Barbarian Invasions,* and *The Last Emperor,* mentioned in chapter 1.[41]

Godard's path has diverged somewhat from this general direction. Controversial "post-Maoist" philosopher Alain Badiou appears in Godard's *Film socialisme* (2010) on a Costa cruise ship.[42] On board Badiou lectures on Husserl and geometry to an empty auditorium. Godard's humorous commentary on the legacy of the French Left does not summarily dismiss Badiou or his links to May 1968 and *les maoïstes*. A collection of Badiou's essays on film, translated into English under the title *Cinema,* indicates that the director and the philosopher both have a stake in the continuing political relevance of the medium.[43] In fact,

Godard quotes one of Badiou's essays on aesthetics in *La chinoise*,[44] and Badiou has long been a supporter of Godard's work, praising him for his "willingness to be truth's traffic cop."[45] The cameo in *Film socialisme* testifies to their mutual admiration. The philosopher appreciates, in particular, the shot in which Godard shows him working at his desk on board as doing "justice" to his presence.[46] Leaving Léaud to Tsai, Godard takes up Badiou to continue his conversation with "China" in the new millennium.

However, the question of the Chinese woman on world screens lingers. In fact, Chinese women haunt Euro-American intellectual and artistic circles more broadly as well. Julia Kristeva's book and the legacy of her encounter with Chinese women during the last phase of the Cultural Revolution, when the Chinese were preoccupied with condemning Lin Biao along with Confucius, continues to provoke debate. In her collection, *In Other Worlds: Essays in Cultural Politics*, Gayatri Chakravorty Spivak criticizes Kristeva for her failure to engage with actual Chinese women living in the PRC.[47] To be fair, Kristeva's interests are theoretical and abstract and not sociological. She makes an attempt to link Mao's critique of Confucianism with Taoist notions of Yin and Yang as well as psychoanalytic theories of language, femininity, and revolutionary social transformation in order to bring Chinese culture in conversation with French feminism. Chinese women disappear in the process. In a similar way, Godard, Assayas, and Tsai take up ideas and images of Chinese women without any women from the PRC actually appearing on screen. The eponymous woman in *La chinoise* is, of course, European. *Irma Vep* features the cosmopolitan Hong Kong actress Maggie Cheung. Tsai's Chinese lesbians come from Taiwan and Hong Kong in *What Time Is It There?* In *Visage,* European chorines lip-synch to songs by a Chinese chanteuse. Léaud, then, encounters China through women but at a distance from mainland Chinese women, and this exoticism has consequences since the political depth of this transnational encounter vanishes along with the Chinese women associated with Mao's revolution.

CHAPTER 6

Dragons in Diaspora

The Politics of Race in Bruce Lee's
Way of the Dragon and Louis Leterrier's Unleashed

Olivier Assayas's fascination with Hong Kong film provides only a single example of a more widespread interest on the part of transnational auteurs in Asian action. Many, including Assayas, also connect popular martial arts cinema with art house fare in their postmodern cinematic explorations. Quentin Tarantino, for example, draws heavily on Hong Kong for inspiration in films such as *Reservoir Dogs* (1992) and the *Kill Bill* series (2003–2004), which teeter between mass entertainment and cinephilic elitism. In his essay, "Asiaphilia, Asianisation and the Gatekeeper Auteur," Leon Hunt points to some of these "gatekeeper" directors who vet Hong Kong action for Western audiences, and French action directors Luc Besson and Louis Leterrier figure prominently within their ranks.[1]

Given his global recognition and the plethora of meanings ascribed to him by fans and scholars around the world, Bruce Lee stands at these filmmakers' gates as the figure most often cited in their encounters with Hong Kong cinema. Lee died in Hong Kong in 1973 at the height of his popularity, and he remains an active force in world cinema through the continuous citation of his films. Maggie's black latex suit in *Irma Vep* resembles the form-hugging jumpsuit of the Bride (Uma Thurman) in *Kill Bill,* a costume that Tarantino pilfers from Bruce Lee's *Game of Death* (*Siwang youxi*) (released posthumously in 1978). Much like Jean-Pierre Léaud, Bruce Lee embodies the aspirations of an entire generation and represents political positions that define as well as transcend his star persona. Like Léaud, Lee was a child actor; however, unlike the French thespian, Lee's continuing cinematic value rests with his mature work, primarily undertaken for Hong Kong's Golden Harvest in the early 1970s, after he returned from a stint in Hollywood working in television and as a martial arts instructor to American stars.

While Léaud serves as the face of May 1968, Lee symbolizes the common ground claimed by working-class and youth upheavals, the American Civil Rights Movement, agitation against the Vietnam War, and the rise of anti-colonial move-

ments in the Third World during the 1960s and 1970s. Lee physically expressed this justified anger against racism and colonialism on screen, and he continues to inspire fans who see him standing up to white, Euro-American oppression—part of what Stuart Kaminsky called a kung fu "ghetto myth."[2] Verina Glaessner sees Lee's films as part of a "cinema of vengeance," which created what David Desser terms the "kung fu craze," which replaced a cycle of Blaxploitation films in inner city theaters in the United States.[3]

Bruce Lee's popularity coincided with the Great Proletarian Cultural Revolution in China, and M. T. Kato makes the connection clear by calling the Bruce Lee phenomenon a "kung fu cultural revolution."[4] However, Lee's Hong Kong martial arts classics did not make the grade as "model" works appropriate for exhibition in the PRC. According to a display at the Shunde Bruce Lee Museum near Foshan in Guangdong, China, Mao Zedong screened Lee's films privately for his own enjoyment and reportedly appreciated the Hong Kong star's anti-colonial, pro-Chinese stance. Bruce Lee played workers and peasants in his films, but he did it outside the boundaries of Mao's understanding of "class struggle" and "continuous revolution." Rather, as an American citizen with a white wife and an interest in Asian mysticism, Lee spoke more to the hippies of his generation than to the Red Guards of China.[5] Nonetheless, other revolutionary movements placed considerable value on Lee's triumphal image. In *Everybody Was Kung Fu Fighting,* Vijay Prashad makes a connection between Lee's star persona and Black Power, the antiwar movement, Indian nationalism, and Third World solidarity.[6]

In 2005, the city of Mostar in Bosnia unveiled a statue of Bruce Lee ten years after the end of the war in the Balkans; the next day, Hong Kong dedicated its own Lee statue to commemorate the sixty-fifth anniversary of the star's birth in San Francisco. The Bosnians erected the statue in the hope of healing the wounds of the Balkan war by providing a symbol of ethnic and racial transcendence—an Asian icon at the service of Europe in ruins. In fact, this did not mark the first time Lee had emerged out of European ashes. In *Way of the Dragon* Lee took on Chuck Norris at the ruins of Rome's ancient Colosseum. For those sidelined by Euro-American prosperity and Cold War military might, Lee's spectacular martial arts "dance" on top of the ruins of Western civilization served as a symbol of the emerging power of Asia, the Third World, and non-white minorities everywhere. For Mostar, Lee promised to rise like a phoenix out of the ashes of its bloody ethnic clashes. However, the tribute to Lee was quickly defaced and removed, and the meaning of his image in relation to European culture remains politically complex. The cinematic gatekeepers who cite Lee in European and American postmodern narratives often strip him of his political significance but leave his connection to the ruins of Western modernity intact.

Like the statues in Mostar and Hong Kong, Louis Leterrier's *Unleashed* (a.k.a. *Danny the Dog*) also marks Lee's sixty-fifth birthday. This Jet Li vehicle bears many similarities to Bruce Lee's kung fu features, including a visual nod to Lee's triumph celebrated through the death of his white American opponent within the ruins of the Colosseum. *Unleashed* plays with a similar vision of Europe in decay as well; however, the attention shifts from anti-colonial celebration to a commentary on the decline of European cinema. In this regard, it has more in common with films such as *Irma Vep* than with Hong Kong kung fu features.

Leterrier's casting of Jet Li, like Assayas's choice of Maggie Cheung, brings other associations. An established figure in Hong Kong cinema, Jet Li came to the territory's screens in co-productions with the PRC featuring his *wu shu* athleticism. His gymnastic approach to the Chinese martial arts differed considerably from Bruce Lee's roots in Wing Chun and his desire to "absorb what is useful" from martial traditions as diverse as Filipino arnis/escrima/kali, French savate, Italian fencing, and Japanese and Korean fighting, as well as Western boxing. Despite their considerable differences, Jet Li has taken on many roles throughout his career that directly or indirectly reference Bruce Lee. *Fist of Legend* (*Jing wu ying xiong;* dir. Gordon Chan, 1994), most notably, is a remake of Bruce Lee's *Fist of Fury* (a.k.a. *Chinese Connection;* [*Jing wu men*]; dir. Lo Wei, 1972); in it Jet Li plays the same character as Bruce Lee played—Chen Zhen.[7] Jet Li also plays Chen Zhen's teacher, Huo Yuanjia, an actual historical figure, in *Fearless* (*Huo yuanjia;* dir. Ronny Yu, 2006).

One of the most memorable scenes in *Fist of Fury* features Bruce Lee's denial of entry into a park in Shanghai's international settlement; a sign reads "No dogs and Chinese allowed." However, the Sikh guard lets in a lady with a dog, and a Japanese passerby suggests that Chen Zhen should try acting like a dog to get in. At that stage, Chen Zhen has had enough and executes a flying kick to destroy the offensive placard. In *Unleashed,* Danny (Jet Li) takes up the suggestion made by the Japanese passerby and becomes a "dog" on screen in order to display his martial prowess. Refusing to act like a dog in *Fist of Legend* as Chen Zhen, Jet Li agrees to put on a dog collar in *Unleashed,* a film about the dehumanization and recovery of a Chinese immigrant to Glasgow who has been trained as an attack animal. The decision to become "Danny the Dog" takes Jet Li's career in a new direction, and the difference between Bruce Lee's violent reaction to the insult of this dehumanization and Jet Li's interpretation of this role testifies to the ways in which this image of Bruce Lee as the hero who stands up to the humiliation of the Chinese by foreign powers continues to circulate globally. However, the political moment has changed, and the anger behind Bruce Lee's kicking of the offensive sign may not be equivalent to Jet Li's struggle against the constraints of the dog collar.

Bruce Lee's star image revolves around the contradictions inherent in the roles he has played on screen and off as the hero beaten down by racism and imperialism who stands up for himself and his community. Although capitalist exploitation and class hierarchies play their roles (particularly in *The Big Boss* [a.k.a. *Fists of Fury; Tang shan da xiong;* dir. Lo Wei, 1971], and *Enter the Dragon* [*Long zheng hu dou;* dir. Robert Clouse, 1973]), race and Chinese ethnicity remain important factors associated with Lee's image. In 1972, Lee seemed to speak to a particular political moment—Nixon in China meeting Mao during the Cultural Revolution; the beginnings of the peace process ending America's war in Vietnam; the height of the Civil Rights Movement; and the student antiwar movements, as well as calls for women's liberation, gay rights, and other attempts to put a collective end to various forms of tyranny.

Bruce Lee as a figure was both very radical and fundamentally conservative—a "nationalist" in bed with the "enemy" (his white American wife); "Chinese" but "made in America" (and even buried in the United States); an exemplar of Chinese kung fu who incorporated more Filipino, Korean, Japanese, and European fighting techniques into his "style without a style" than classic Wing Chun or *taiji chuan,* which he had studied but never mastered. As a star, Lee appealed to fans across borders—a Third World figure who spoke to the American youth; a middle-class, cosmopolitan, college-educated urbanite from a theatrical family who played working-class heroes and appealed to white proletarian ethnics, African Americans, Africans, and Latin Americans, as well as most of Asia and the disenfranchised around the world—including the former Yugoslavia. He was an accomplished, individual hero who saved the day on his own and remained alone—a counter-icon to the "red heroes" across the border from Hong Kong and to activists in other parts of the world.

Way of the Dragon, which is the only completed film Bruce Lee wrote, directed, and starred in, may be the pinnacle of his screen career. The Colosseum scene in *Way of the Dragon* encapsulates all the contradictions that Lee as a star embodies and transcends, and it promises an imaginative antithesis to the white, Western, American, male heroes that had dominated world screens through Hollywood Westerns. With music inspired by Spaghetti Westerns setting the scene, Lee's character Tang Lung (the Dragon from the Tang dynasty—the height of China's historical dominance but also the height of its cosmopolitanism) dares to take on the white Western hero at the center of Europe's martial glory—in the same arena as the Roman gladiators (also the stars of the sword-and-sandal films popular around that time). Lee represents not only China taking on the West, but also Hong Kong cinema taking on its competitors—from Hollywood to Cinecittà, from the classic Western to the costume epic. The stiff, older, hairy, white, American, Western Colt (Chuck Norris), who is a Japanese karate adept (a nod to Hong

Kong's other main competitor, the Japanese samurai film), wears a karate gi to
underscore the point that he represents more than just the West—he embodies
imperial ambitions from ancient Rome to modern Japan (figure 6.1).

Although Lee spends most of the film proclaiming the virtues of Chinese
kung fu over karate, he ends up taking up moves more characteristic of the foot-
work of Muhammed Ali and the kicks of tae kwon do than anything that could
be called Chinese "kung fu" per se. Tang Lung may represent "China" as a
downtrodden minority in Italy, but Bruce Lee remains a cosmopolitan star with
Hollywood as well as Hong Kong connections. The fight provides an excuse for
the display of Lee's martial talents, but it does little to further the drama. Colt is
a hired gun, and he appears only for this one fight; he has little emotional in-
vestment in the battle, just as Tang Lung has no personal sense of revenge at
stake. The fight serves as a spectacular set piece, removed from the plot so that
the fighting can be appreciated more fully—mediated by a kitten as the only
referee—without any narrative entanglements to interfere with Lee's triumph of
the East within the ruins of the West. China also proves its moral superiority
through Lee. Tang Lung gives Colt the respect merited by a "worthy" oppo-
nent—acknowledged with a respectful bow and covering him with his gi before
moving on.

Bruce Lee leaves the world with this provocative image—the death of the
West in its monumental ruins, clearly buried by the swift, light mobility of the
fluid East—just as the Viet Cong were whipping the American GIs in Vietnam.
However, this image of liberty remains inchoate and vague, like Lee himself, who
died in his prime, likely before his peak. No statue in Mostar or Hong Kong can
solidify Lee, who saw himself as "water," a chameleon who shape-shifts to sur-

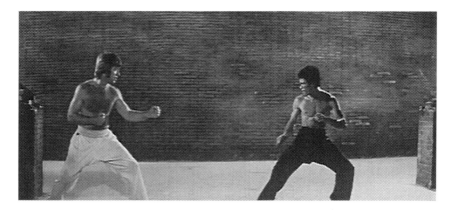

Figure 6.1. Colt (Chuck Norris) and Tang Lung (Bruce Lee) face off in Rome's Colosseum in
Way of the Dragon; dir. Bruce Lee, 1972.

vive rather than as a solid presence with a clear identity or political agenda. Lee kept a miniature tombstone to remind him of this: "In memory of a once fluid man cramped and distorted by the classical mess."

Unleashed differs in several important aspects from *Way of the Dragon*. A French-UK co-production with most of the authorial flourishes associated with Luc Besson and Louis Leterrier quite evident, the film finds Jet Li's own sense of martial artistry held firmly in check by Yuen Woo-ping, whose role may shadow that of Danny's handler/master Bart (played by Bob Hoskins), who controls his minion with a dog collar. However, the similarities between *Unleashed* and *Way of the Dragon* are also quite striking. Both films feature Chinese immigrants in Europe, focusing on young men who are naïve not only within the Western context, but in all respects—neither Danny nor Tang Lung know much about sex, for example; both have led very sheltered lives, to say the least. Tang Lung comes from the rural villages of Hong Kong's New Territories, and Danny grew up in a cage in the bowels of a Glasgow tenement. However, outside of the demands and delights of "civilization," they have both had time to practice martial arts. These ignorant characters impress all who see them with their physical prowess—graceful technique rather than simple brawn. Indeed, Tang Lung and Danny seem "schizophrenic"—cosmopolitan, accomplished, confident in a fight but completely at a loss in "civilized" company, particularly among women. Both films show these martial artists practicing; Tang Lung shadowboxes and stretches his body, while Danny beats a heavy punching bag into submission. However, neither has a kung fu master/*sifu* shown on screen. Like Neo in *The Matrix* (dir. Wachowski Brothers, 1999), they simply "know" kung fu and are able to make deadly use of their skills. Yuen Woo-ping did the martial arts choreography for both *The Matrix* and *Unleashed,* and the fluidity of the action defines Li's character in a similar way as a "natural" fighter in an uncannily familiar but surreal arena of the imagination.

If Bruce Lee plays against the Spaghetti Western, sword-and-sandal, Blaxploitation, and samurai films of his day, Jet Li works within a very different cinematic environment—European neo-noir; the *"cinéma du look";* and the multicultural, multi-ethnic, multiracial melting pot of global action cinema. Luc Besson wrote the screenplay for *Unleashed,* and it includes many elements characteristic of the producer/director/writer's oeuvre. In fact, the plot of *Unleashed* bears a striking resemblance to Besson's *La femme Nikita* (1990), in which he explores the painful process of being stripped of one's identity and rebuilding another in its place, a theme to which Besson returns in *Lucy* (2014). During this period of Jet Li's career, the action star moved beyond the Hong Kong martial arts idiom with French co-productions such as *Kiss of the Dragon* (dir. Chris Nahon, 2001), also written by Luc Besson.

Unleashed tells the story of Danny, who has been taken from his Asian immigrant mother as a child and trained as an attack dog at the bidding of Bart, a petty hood who commands the mean streets of Glasgow, Scotland. The city, however, does not have the same mystique as Rome does in *Way of the Dragon,* and it falls short of providing equal glamor as the ruined heart of an ancient imperium. The post-industrial urban decay of Glasgow serves as a battered reminder of the heights of the British Empire, industrial capitalism, and Scotland as the backbone of the slave trade and the opium trade in earlier centuries. Opium links the Scottish William Jardine and James Matheson of Jardine, Matheson & Co. to Hong Kong, just as Jet Li connects Glasgow to Bruce Lee and Hong Kong cinema. Even before the Treaty of Nanking (Nanjing) made Hong Kong an official colony as spoils of the Opium Wars, Jardine and Matheson laid claim to the deepwater port for the opium/tea trade, and as a consequence the ports of Glasgow and Hong Kong share a history that goes back to the nineteenth century.

Although both *Way of the Dragon* and *Unleashed* hit on the main attractions to satisfy the touristic gaze of the films' spectators (from Rome's Colosseum to Glasgow's Kelvingrove Park), the Scottish city's back alleys, warehouses, gangster haunts, and tenements seem seedier than the comparable locations in Rome. In *Way of the Dragon,* Tang Lung sees the sights with Ching Hua (Nora Miao), the relative he's come to help, and the viewers see a more vulnerable side of the hero while enjoying the tour. Danny also sees another side of Glasgow through his surrogate family. When Danny gives the slip to his handler Bart, blind African American piano tuner Sam (Morgan Freeman) and his ward Victoria (Kerry Condon) take Danny in and "unleash" him in a different way—not to attack, but to taste freedom. Victoria, who studies the piano, parallels Danny's mother, who had come to Glasgow for the same reason. Sam, Victoria, and Danny go sightseeing, and Glasgow shows its other side as an old Victorian and Edwardian center of culture and the arts.

The nod to African American followers and fans in *Way of the Dragon* (the inclusion of one black man among the gangsters in the Italian mafia) becomes a full-blown part of the plot in *Unleashed* through Sam. Li had earlier established a connection with African Americans in *Romeo Must Die* (dir. Andrzej Bartkowiak, 2000) and *Cradle 2 the Grave* (dir. Andrzej Bartkowiak, 2003).[8] *Unleashed* provides another opportunity for Li to develop a relationship with an African American character as part of the action. Locating the film in Glasgow, of course, provides another link to Africa through the city's historical role as a center for the exchange of tobacco through the slave trade. In *Beyond the Chinese Connection,* Crystal S. Anderson notes *Unleashed* functions as an allegory of slavery: "Danny functions as a modern-day Chinese slave in the hands of the British mob boss Bart. His subjugation to Bart re-enacts China's subjugation to

Britain and its subsequent damage to the national psyche of China.... Danny's subjugation by Bart reflects not just the damage of the Chinese national psyche, but also mirrors the psychological damage inflicted on enslaved Africans during the transatlantic slave trade of the eighteenth century."[9] Glasgow as place links the "Black Atlantic" to the Pacific through the trafficking in African slaves and Chinese "coolie" labor. Sam and Danny, through very different diasporic connections, share this historical bond. The fact that Bart tries to pimp Danny's mother and kills her when she resists adds another dimension to the theme of human trafficking. The white mobster enslaves the toddler son when his mother proves unmanageable.

In contrast to Bart's imperious cruelty, Sam embodies the enlightened virtues. As Sam, Morgan Freeman (fresh from *Million Dollar Baby*; dir. Clint Eastwood, 2003) takes up a similar nurturing role in *Unleashed*. For example, Sam tenderly nurses Danny back to health after a particularly vicious mob attack. Literally blind, Sam must also be "color blind," and as a jazz pianist and tuner, he tames Danny the wild child with his music and gets him in tune with the rest of the civilized world. Unlike Tang Lung, who teaches the staff of the Chinese restaurant in Rome how to use kung fu to defend themselves, Danny becomes Sam's pupil in Glasgow, learning to tune pianos rather than improve his fighting techniques.[10] In fact, Sam and Victoria disrupt the martial arts action in the film, and they take *Unleashed* to the thin edge that divides action and melodrama. Questions of family become more important than community (whether racially, ethnically, or economically defined), and the issue of fundamental humanity, including the meaning of humanism within postmodern culture, becomes more pressing than calls for resistance to oppression or personal revenge.

Sam's blindness stands for everything the film seems to show graphically but dramatically ignore—racism, class antagonism, slavery, prostitution, the ravages of neoliberalism, post-industrial decay, and the ruins of imperialism. While *Way of the Dragon* appears to provide some analysis by linking the mafia's racism with its desire to take advantage of a Chinese restaurant weakened by the decline and death of its patriarch, *Unleashed* scurries away from that sort of thinking. The politics poke through visually in Glasgow's industrial ruins—with its Victorian and Edwardian landmarks, its empty warehouses, the rusting shipyard cranes against its skyline, and its decrepit factories. However, Bart taints the city's working-class legacy with his brutality, and music lovers Victoria, Sam, and Danny appear to point to future gentrification of the city. Ironically, they return Glasgow to its class-divided past as a place where the rich can ostentatiously display the fruits of their trade in slaves, opium, tobacco, and other commodities.

Even though Tang Lung's ultimate betrayal comes from one of the kitchen

workers and he has saved the day more for the pretty entrepreneur who runs the Chinese restaurant than for the rights of the Chinese laborers, Bruce Lee still stood for the downtrodden of all races and classes—and, in places like Mostar, at any rate, he can be taken as a beacon of solidarity across ethnic and religious divisions. Jet Li is a different sort of star, and *Unleashed* reconfigures the class dynamics of his star image and his particular position in this narrative.

In fact, Jet Li, through the character of Danny, physically embodies this process of gentrification. Rather than representing the downtrodden working classes in any way, Danny becomes the victim of their excesses as the displaced detritus of neoliberal Britain. Bart, then, functions as the working-class villain (marked by his accent and comportment) who attempts upward mobility by preying on the upper classes as a loan shark. Bart specializes in loans not for the desperate unemployed workers but for the cultural elite of Glasgow—antiques dealers, jewelry store owners, and concert pianists fallen on hard times. He takes particular relish in prostituting and enslaving the cultural elite by trying to get piano students to turn tricks. The story revolves around Danny's return to the cultural elite to which he rightly belongs by his reeducation through gourmet food and classical music.

Although looking at Danny as an allegory for the reemergence of class hierarchies, Westernization, and anti-Mao tendencies in China likely goes too far for its Euro-American audience, the fact that Danny has turned in his dog collar for the more comfortable bow tie and collar at the end of the film visually points to this dynamic.[11] Danny, like Glasgow, has been gentrified, just as the factories have been transformed into upscale apartments and the warehouses into art studios. The monuments to Britain's industrial empire have been spruced up to reflect the new economy; shipyards, heavy industry, and the opium trade may have built up Glasgow, but "music," as Victoria says in the movie, referring to Danny's salvation, will literally save it from complete obsolescence.

In fact, unlike Tang Lung, who makes Rome safe for the Chinese and then goes back to Hong Kong, Danny sticks with his Western family and becomes part of a process of gentrification that seems to be going on all around him. In Glasgow, the ruins do not stay safely confined to the past. Rather, Glasgow has been pockmarked by postmodern developments—the ruins of the past become the stuff out of which the present redefines itself. Jet Li is pushed into an empty, indoor swimming pool that stands as a space of redevelopment (the unruly punks thrown in to challenge him are easily dispatched)—and he, miraculously, survives (figure 6.2). The swimming pool takes the place of *Way of the Dragon*'s Colosseum, serving as the ruins of a different sort of elite culture built on the blood of slaves. With the Electronica band Massive Attack playing on the soundtrack, the punk style of an earlier generation, in which the dog collar defi-

Figure 6.2. Danny (Jet Li) fights the punks in the pool. *Unleashed*; dir. Louis Leterrier, 2005.

antly signified the feeling that Britain's youth had "no future," gets taken out, while the new elite looks down into the empty pit of the swimming pool. While Tang Lung fought Colt in an empty arena, Danny, like the ancient gladiators, fights for the entertainment of the privileged. The film spectators of *Way of the Dragon* have only a feral kitten as a point of identification, and the empty Colosseum offers a surprisingly intimate space for the appreciation of the skills of equally matched rivals. However, Danny's fight in the Glasgow pool does not have the same intimate quality, and the gangsters he faces do not merit the same respect Tang Lung shows to Colt.

Unleashed offers another battle, however, and it may provide a better comparison to Bruce Lee's encounter with Chuck Norris: Jet Li's fight with Michael Ian Lambert (figure 6.3).[12] The character played by veteran Hong Kong–based stuntman and martial artist Mike Lambert is credited only as "the Stranger," and he resembles Colt in many important respects. Both the Stranger and Colt are outsiders brought in by their Euro-trash mafia bosses to deal with unruly Chinese fighters. They are white men who take on the trappings of Eastern martial artistry. Colt wears a white Japanese karate gi and black belt. The Stranger sports a white, ashram-style flowing robe and baggy trousers, and he uses a serrated blade. Neither packs a gun. Lambert's shaved head points to a certain asceticism that Norris always lacked (after all, he came off the plane in *Way of the Dragon* wearing bell bottoms and shades—early 1970s chic). They each appear at the climax of the film to square off in combat that promises to show Lee and Li at their best. Tang Lung/Lee and Danny/Li prove to be faster, lighter, and more fluent in Western techniques than their opponents are in Asian combat styles. However, in *Way of the Dragon*, director/choreographer Bruce Lee picked Norris as a point of contrast—traditional karate versus his unique styleless style with some Chi-

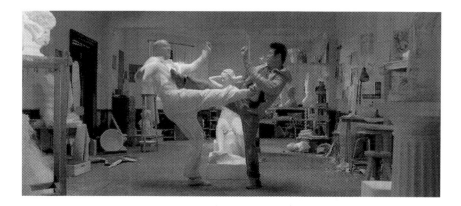

Figure 6.3. Danny (Jet Li) and the Stranger (Mike Ian Lambert) in Unleashed; dir. Louis Leterrier, 2005.

nese characteristics. In *Unleashed,* Yuen Woo-ping likely chose Lambert for the opposite reason—for Lambert's familiarity with Hong Kong martial arts choreography and ability to speak and understand Cantonese.

Differences have been flattened out in *Unleashed.* The raw dialectical tensions and orchestrations of political contradictions operative in the early 1970s disappear in the process of gentrification. The difference between Rome's Colosseum and the Glasgow building undergoing remodeling is telling. Danny slides down what appears to be a coal chute into an abandoned building. He tries to escape Bart's thugs by sliding along an electric wire but is struck down by the Stranger. Danny swings into a converted apartment and lands on a toilet. When he tries to escape, creeping past the female occupant of the flat as she showers, he is interrupted by the arrival of the Stranger in white. They fight as the woman screams, and the combatants end up in the narrow toilet cubicle doing battle. Here, of course, Yuen Woo-ping quotes other well-known martial arts scenes in enclosed spaces (the narrow alley in *The Martial Club* [*Wu guan;* dir. Liu Chia-Liang, 1981] immediately comes to mind). The toilet also alludes to Bruce Lee's difficulties using Western plumbing in the Rome airport in *Way of the Dragon.* Even with the echoes of the fight with Chuck Norris aside, this fight scene serves as a quotation of Hong Kong kung fu cinema. *Unleashed* cites a particular approach to fight choreography. These cinematic techniques and specific martial arts choreography conjure up historical, ideological, and cultural associations, just as the references to Bizet's *Carmen* and Mozart's sonata do in other scenes in the film.

Danny and his opponent fight their way out of the bathroom and end up in the studio area of the loft. The Stranger cracks his neck—much the same way

Chuck Norris and Bruce Lee stretch and crack their joints in the Colosseum to prepare for their fight. However, the ruins of the Colosseum from *Way of the Dragon* become the postmodern works in progress that litter the artist's studio. A white plaster cast of a life-size female nude centers the composition, and nude torsos and sketches fill the space. These postmodern artworks parallel a trend in contemporary sculpture that plays with Britain's neoclassical heritage by reconfiguring the white marble nudes of the past. Bridging Asia and the West, the old and new economies, Jet Li represents process, an "unfinished" human being in the process of becoming the token of a reinvigorated "civilization": representative of a transnational, multicultural middle class, in clear distinction to Bruce Lee's celebration of the non-white, working-class Third World.

Yet both Tang Lung and Danny have reserves of compassion. In the process of living with Sam and Victoria, Danny has learned killing is wrong. When he finishes the fight with the hired assassin, Danny attempts to save the Stranger's life by grabbing at his clothing after he has kicked him through a window. Unfortunately, Danny loses his grip, and his opponent falls to his death on the roof of Bart's white car below. When Danny is placed in the same situation during his final confrontation with Bart, however, his resolve wavers, and Sam steps in to "save" Danny from killing his tormentor. Rather than turning his back on a bankrupt Western civilization, as Bruce Lee does at the end of *Way of the Dragon,* Jet Li embraces his new collar in the form of the formal black tie and sits in the renovated concert hall (an echo of Rome's Colosseum). Danny symbolically fulfills his mother's aspirations to have her talent recognized in the West. A flashback to Danny's mother's face in close-up and a close-up of a tear rolling down his cheek conclude on a sentimental note. Classical music has saved Glasgow from industrial decay, and Jet Li has saved European cinema from atrophy in one fell swoop.

When Bruce Lee conquered world screens, he turned his back on Hollywood and returned only when courted by Warner Brothers through its co-production agreement with Golden Harvest. On screen and off, Lee seemed to turn his back on the West in his triumphal return to Hong Kong. Questions dog the political meaning of Bruce Lee in life and death. As Paul Bowman shows in *Theorizing Bruce Lee,* Lee continues to serve as a "cultural event" and site of contested meanings, which Jet Li as Danny cites but arguably misquotes.[13] It is difficult to discern, for instance, whether Jet Li has turned his back on European *chinoiserie* or has simply become its most recent incarnation (figure 6.4).

Perhaps Jet Li's postmodern portrait of the martial artist as a dog allegorizes a new world order—color blind and with a neoliberal consciousness. *Unleashed,* then, represents a reordering of the cinematic ruin that Bruce Lee left behind. In *Way of the Dragon,* Lee offers a self-portrait in the monumental ruins of the im-

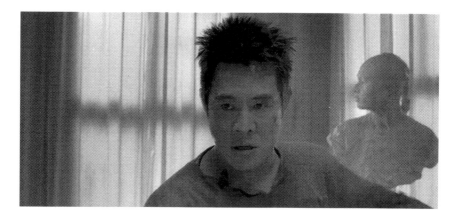

Figure 6.4. Danny (Jet Li) and chinoiserie. *Unleashed*; dir. Louis Leterrier, 2005.

perial West that metamorphoses into a different sort of ruin in Leterrier's portrayal of Jet Li as Danny. In this slippage between memory and monument, Jacques Derrida's remarks on the ruin and the self-portrait in *Memoirs of the Blind* come to mind: "Ruin is the self-portrait, this face looked at in the face as the memory of itself, what remains or returns as a specter from the moment one first looks at oneself and a figuration is eclipsed. The figure, the face, then sees its visibility being eaten away; it loses its integrity without disintegrating."[14] Bruce Lee, here as in Mostar, functions as the "face" of memory, his visibility eroding, eclipsing his earlier significance without completely disintegrating.

Unlike *Way of the Dragon*, *Unleashed* takes a postmodern cinematic turn in its nostalgic flourishes. Girls find a need for a protecting patriarch in a postfeminist understanding of gender relations. The "new" man—African and Asian —lays to rest the excesses of everything the old European man represented. No longer racist, sexist, and avaricious, this new postmodern man manages to hang on to the vestiges of the past (chivalry, gallantry, European classicism, romanticism, and the class distinction) with an "Eastern" Zen compassion for all. If Bruce Lee beats down the old order and violently breaks its chains, Jet Li integrates, works through the high art/pop culture economy, and comes out as a different sort of global icon on the other side.

Citing the American Dream in the People's Republic of China, Taiwan, and Hong Kong

Clara Law's Like a Dream and Red Earth

Cinematic ghosts, such as Bruce Lee and Jean-Pierre Léaud (among other film stars), move across global screens stretching between China and the rest of the world. These revenants embody film "dreams" that continue to circulate and even gain strength through their various iterations. However, dreams have other associations, and Xi Jinping's proclamations on the "Chinese dream" have caused quite a stir. According to the *New York Times*' version of one pronouncement, Xi's Chinese dream has four main components: "Strong China (economically, politically, diplomatically, scientifically, militarily); Civilized China (equity and fairness, rich culture, high morals); Harmonious China (amity among social classes); Beautiful China (healthy environment, low pollution)."[1] While it may be tempting to look at this in primarily material terms as the Chinese version of the "American dream" of upward mobility, independence, and financial security, it also seems appropriate to consider these dreams within the context of Chinese culture and literature.[2] One of the most famous stories associated with Taoist philosopher Zhuangzi (Chuang Tsu) involves his musings on a vivid dream of being a butterfly. If the dream of being a butterfly can be so convincing, he feels that he may, in fact, be a butterfly dreaming of being Zhuangzi.

Clara Law ruminates on the possible connection between Zhuangzi's butterfly and Xi's "Chinese dream" in her film *Like a Dream*. She chooses the romantic melodrama to structure her meditation on the nature of reality and human understanding against the backdrop of contemporary China and the constellation of issues to which Xi points in his discourses on the Chinese dream. Law turns her camera on the themes of growing class divisions, the rural/urban divide, the pace of economic development, the impact of globalization, and China's standing in a geopolitical hierarchy. Although only hinted at on Xi's list, Law also considers women's roles in a changing society. Human

emotion, specifically heterosexual romance, puts in play a dialectical tug-of-war between the material and the ideal, as well as the political and the philosophical in the film.

The simile "like a dream" is incomplete, however, and begs for some connection to other concepts. Philosophers other than Zhuangzi, for instance, have expanded on the metaphor of reality being "like a dream." Plato's allegory of the cave, for another example, in which captives see only shadows of life outside their darkened cave and mistake those apparitions for "reality," is an elaborate metaphor for the possible disconnect between human understanding, physical perception, and "truth." In "White Mythology: Metaphor in the Text of Philosophy," Jacques Derrida warns of the metaphysical quality of metaphor and cautions all to be suspicious of claims to link "truth" and meaning to the slippery, arbitrary signifiers of language.[3] Indeed, "like a dream" offers only a partial meaning that can be completed in any number of ways. Existence is "like a dream," consciousness is "like a dream," love is "like a dream," and, of course, film is "like a dream," a mechanized and now digitized "Plato's cave."

Like a Dream self-consciously reflects on this metaphor. The protagonists, Max (Daniel Wu) and Ailing (Yolanda Yuan), who meet only in the dreamworld, go to a movie theater. Not only does this scene conjure up similar scenes as hallmarks of various international new waves, which routinely send their characters to the cinema (e.g., Hsiao Kang in *What Time Is It There?*, analyzed in chapter 5), but it also allows for a moment of contemplation on the nature of films as dreams and their relation to society as well as individual psychology. In fact, *Like a Dream* does not just reference "movies" in general; it cites very specific films, including *In the Mood for Love* (*Huayang nianhua*, 2010), a film by the most acclaimed director among Clara Law's Second Wave peers, Wong Kar-Wai.

As in Wong Kar-Wai's film, the couple in *Like a Dream* pretends to be another pair of lovers in order to try to figure out the motivation behind certain actions—suicide in the case of *Like a Dream* and an extramarital affair in *In the Mood for Love*. In Wong's feature, Su Li-zhen (Maggie Cheung) is a movie fan who draws on her afternoon matinee knowledge of romance to recreate her husband's infidelity with her rival's spouse. In *Like a Dream,* however, going to the movies to recreate a specific "date" takes on a different significance. In the dead seriousness of an investigation into the unexplained suicide of a lover (a reference, too, to another movie, Hirokazu Kore-eda's *Maborosi* [*Maboroshi no hikari,* 1995], in which a young mother must come to grips with her husband's unexpected suicide), the scene self-reflexively poses a humorous question about the cliché of the "date night" romance.

In his dream, Max tries to help Ailing figure out why her boyfriend committed suicide by recreating their last date, and the couple ends up at the cinema.

They are alone in the auditorium; the reflected light of the film screen illuminating their faces in the dark, their world parallels the viewers' position, and the audience watches the couple in the empty theater—perhaps an ironic comment on the decline in movie attendance. The couple watches what sounds like a war movie. Canned sound effects signal airplanes in a dogfight, and clichéd movie music points to a commercial genre not connected to the "mood for love" associated with romantic comedies or melodramas. Appearing puzzled and perhaps more than a little bored with the film, Max asks if Ailing and her boyfriend watched the movie until the end. Max, the amateur critic, complains that the film is "so trashy" (figure 7.1).

Given the quiet elegance of his dream girl, Max has difficulty connecting her fiancé to the "trashy" movie. It is as if her fiancé suddenly becomes Robert De Niro taking Cybill Shepherd to the porn theater in Scorsese's *Taxi Driver*. The incongruousness of the "trashy" war film also reminds us of Clara Law's oeuvre —her love of seedy urban spaces; grotesque images; horrific mental illnesses; nightmarish situations; gallows humor; and with these darker interests, a propensity to inhabit the same turf as lowbrow B moviemakers who favor a "trash" aesthetic.

In fact, *Like a Dream* begins with a close-up of a dead cat, and images of pickled human brains, kittens in microwaves, and blood on bedroom walls litter the film. Even though she sees herself as an auteur ("not a hired hand"),[4] Law does not disdain the excesses of the Hollywood melodrama, with all of its fantas-

Figure 7.1. Max (Daniel Wu) and Ailing (Yolanda Yuan) watching "trash" in their dream cinema in Like a Dream; dir. Clara Law, 2009.

tic coincidences and fatalistic forebodings involving stories of twins separated at birth, missed romantic connections, abusive parents, fatal illnesses, competition among women for the affections of an undeserving man, female sacrifices, and shattered ambitions. She happily situates her oeuvre between schlock and art, existential ruminations and trash cinema.

Moreover, *Like a Dream* exhibits Law's usual thematic concerns involving the Chinese diaspora, fractured families, mental illness, and the ramifications of the collapse of patriarchal traditions. Specific images create intertextual links. Max's cat echoes the family pet in *Autumn Moon* (*Qiu yue*, 1992).[5] His psychiatric illness parallels the portraits of madness linked to the overseas Chinese experience of migration in *Farewell China* (*Ai zai bie xiang de jijie*, 1990) and *Floating Life* (*Fu sheng*, 1996). Domestic violence plays a role in *The Goddess of '67* (*Yu shang 1967 de naushen*, 2000). Obsessive sexual desire forms the foundation for Law's earlier features, *The Reincarnation of the Golden Lotus* (*Pan jinlian zhi qianshi jinsheng*, 1989) and *Temptation of a Monk* (*You seng*, 1993).[6]

Law never provides a reverse shot of what is on screen in the dream cinema, so viewers must rely on Max's critical assessment. Although not pornography, the war film seems out of synch with what Pierre Bourdieu may call Ailing's *habitus*, which would include a different sort of "cultural capital."[7] Addressing Max, who is standing in for her dead lover, Ailing concurs that the movie was out of character for her fiancé: "You never watched movies; you said they were meaningless and a waste of time." However, somehow the movie moved him, perhaps concretizing his own inner existential battle, and Ailing reports that he began to cry in the middle of the film.

Leaving the cinema, Ailing again addresses Max as her fiancé: "You said it wasn't so bad. We should see more films in future. You said it could remind me how meaningless this world is, how trashy." This begs the question of whether *Like a Dream* should remind its viewers of "how trashy"—clichéd, conventional, unoriginal, and "meaningless"—it is as a cultural commodity designed for the Chinese market. The war movie reminds us that cinema screens are also ideological battlefields. Popular globally, the genre pits pacifism against nationalist xenophobia in films ranging from condemnations of war atrocities to propagandistic calls for national defense. Movies try to cash in on the hopes and dreams of a global audience, dreaming that mainland Chinese viewers, for example, new to many forms of global entertainment, will not dismiss art films such as *Like a Dream* as "trash."

Hollywood is home to the "dream factory," and *Like a Dream* is not dissimilar from another film made the same year, Christopher Nolan's *Inception* (2010), which also takes the viewer on a journey through a fragile, surreal dreamscape on a quest originating in the economic ambitions of an Asian mogul (Ken Wata-

nabe) and the romantic regrets of its protagonist (Leonardo DiCaprio). Similar to *Inception,* Law's film tells a story about America in relation to Asia. A fair portion of the film's plot is devoted to Chinese American Max's life in New York City as a computer software designer obsessed with a mainland Chinese woman he knows only from his dreams. The film moves between China and America, providing a transnational backdrop to this story highlighting Asian American masculinity, Chinese identity, urban angst, and the rapidly changing landscape/dreamscape of the PRC.

Within a postmodern aesthetic, it weaves elements from Hollywood and European films, including *Vertigo, The Double Life of Veronique,* and *La jetée,* as well as other classics about obsession, delusions, and dual identities, in order to explore the politics of identity between the United States and China. Clara Law brings her distinctive fascination with subjectivity, the surreal, and the grotesque to this interrogation of American masculinity and Chinese feminine desire. An examination of this feature along with *Red Earth* highlights the ways in which global film aesthetics and postmodernity combine to comment on contemporary tensions between America and China as seen through the lens of the screen romance.

Dreaming China

Chinese popular culture overflows with romantic tales of dream lovers. Teresa Teng (Deng Lijun)'s "Tian mi mi," for example, provides one case in point:

夢裡夢裡見過你
甜蜜笑得多麼甜蜜
是你~是你~夢見的就是你

(In my dream. In my dream, I caught sight of you.
Honey sweet. Your smile is very sweet.
It is you. It is you. I saw you in my dreams.)[8]

This familiar song pops up in many films, most notably in Peter Chan's *Comrades: Almost a Love Story* (*Tian mi mi,* 1996); note that the Chinese title is *Tian mi mi.* The song appears in films as diverse as *Year of the Dragon* (dir. Michael Cimino, 1985) and *Rush Hour 2* (dir. Brett Ratner, 2001).

Two of China's great traditional love stories, staples of transnational Chinese film and television over the years, grow out of Zhuangzi's butterfly dream. Cao Xueqin's Qing dynasty classic novel *Dream of the Red Chamber* (*Hong lou meng*)

and the story of the "butterfly lovers" Liang Shanbo and Zhu Yingtai both feature love triangles in which an arranged marriage tragically separates the lovers; neither ends happily. *Dream of the Red Chamber,* in particular, has striking plot features paralleling *Like a Dream*'s narrative line. Max, like Baoyu, finds himself smitten by a sickly young woman, Ailing, who bears a resemblance to Lin Daiyu in the novel, a refined, poetic, and very sensitive soul. However, Baoyu ends up marrying Xue Baochai, who, like Yiyi (also played by Yolanda Yuan in a dual role), is more down to earth, practical, and less erotically appealing.

Fairly early in the novel, the naïve Baoyu has a dream in which he explores a palace of wisdom with a goddess as guide. The inscriptions, paintings, and other items he encounters presage events in the story, but they also reflect Taoist thinking on the limitations of conscious knowledge, as well as Buddhist notions of karma, the pain of human desire, and impermanence. One couplet, in fact, seems to summarize the more philosophical dimension of *Like a Dream* as well:

> When the unreal is taken for the real, then the real becomes unreal;
> Where nonexistence is taken for existence, then existence becomes
> nonexistence.[9]

The goddess gives Baoyu her sister as his wife, and he has his first sexual encounter with this dream girl. The metaphysical meditation on existence and the philosophical investigation into the meaning of life turn into a wet dream. The film *Like a Dream* walks a similar line between "trashy" love story and nuanced epistemological exploration of the cinema and reality.

Dream of the Red Chamber has the pulpy kernel of the love triangle at its heart, and Baoyu finds himself flummoxed by the substitution of one woman for the other at his wedding ceremony. Max, too, has difficulty balancing his feelings for Yiyi with his obsession with Ailing, her physical double. In *Like a Dream,* photographic evidence links Max to his Chinese dream girl—giving substance to his romantic obsession. At the end of a business trip to Shanghai, Max discovers the clerk at a photo store has inadvertently given him the wrong envelope. Inside are pictures of the girl of his dreams, posed against various tourist sites in Shanghai. Indeed, these photos also link *Like a Dream* to a constellation of other films in which the protagonist tries to rely on photographic evidence to get to the root of an insoluble mystery. While Hitchcock's photojournalist Jeffries (Jimmy Stewart) has some luck in *Rear Window* (1954), Antonioni's version of the character, fashion photographer Thomas (David Hemmings) in *Blow-Up,* remains mired in an existential crisis in which photographs ultimately refuse to yield evidence of the "truth." (See chapter 1.)

Citing Vertigo: Oedipal Dreams and Asian American Masculinity

Although Law's amateur shutterbug resembles the professional photographers Jeffries and Thomas in the Hitchcock and Antonioni features, Max has more in common with another Hitchcock hero, Scottie (also played by Jimmy Stewart) in *Vertigo*. Embodying post–World War II anxieties revolving around the loss of masculine potency occasioned by the growing independence of women, Scottie stands vertiginously as the cinematic face of Cold War horrors of castration, loss of male identity, and madness. Laura Mulvey explains the way Hitchcock makes this madness appealing through privileging male subjectivity: "In *Vertigo,* subjective camera predominates. Apart from flash-backs from Judy's point of view, the narrative is woven around what Scottie sees or fails to see. The audience follows the growth of his erotic obsession and subsequent despair precisely from his point of view."[10] Max serves as Scottie's Asian American counterpart, with his post–Cold War anxieties stemming from racism, xenophobia, and Hollywood's Orientalist renderings of Asian males as emasculated eunuchs or rapacious perverts.[11]

Like *Dream of the Red Chamber, Vertigo* links philosophical questions of existence, meaning, and knowledge to sexuality and male desire. In *The Women Who Knew Too Much,* Tania Modleski, in fact, sees the film as a meditation on male identity put in crisis by the uncertainty of the existence of femininity: "For if a woman, who is posited as she whom man must know and possess in order to guarantee his truth and his identity, does not exist, then in some important sense he does not exist either, but rather is faced with the possibility of his own nothingness."[12] Like *Vertigo,* Law's film deals with a mystery associated with femininity that revolves around a mentally ill anti-hero and a female doppelgänger.

Both Scottie and Max see psychiatrists for their illnesses, and both suffer serious, debilitating breakdowns. Scottie ends up in a mental asylum, and Max, after wandering the streets of New York City in a daze without eating or sleeping, finally collapses. However, whereas Scottie suffers from vertigo brought on by guilt, Max endures post-traumatic stress from witnessing the murder-suicide of his parents. Max and Scottie both become embroiled in a quest for a "dream girl" who has a double that they manipulate into helping them pursue their obsession. While an unscrupulous couple takes advantage of Scottie's vertigo to cover up a murder by creating a "double," Max really does have a relationship with two identical women, who turn out to be twins separated as infants. Both films involve a past murder, although in Max's case, unlike Scottie's, the women are quite innocent. *Vertigo* and *Like a Dream,* however, each concentrate in unique ways on the malaise at the root of the gender divide—masculinity in crisis, the

ideal woman as a figment of the fevered male imagination, and her copy resigned to a "masquerade" of constructed femininity based on male desire and consumer commodities (high heels and hairdos).[13]

Jean Ma notes that the doppelgänger has become a fixture in contemporary Chinese cinema: "Themes of multiple identity and uncanny repetition pervade contemporary Chinese-language cinema. While the strategy of doubling can take many forms, from doppelgangers to split personalities to sci-fi replicants, these films demonstrate a shared fascination with the idea of a single body inhabited by dual identities, conveyed through the use of a single actor to represent plural characters."[14] Many of these films take up fragmented psyches as allegories of a divided China. Stanley Kwan, for example, gives the tale of two women, played by a single actress (Chingmy Yau Suk-zing), a queer dimension in *Hold You Tight* (*Yu kuaile yu duoluo,* 1998), with a tale of "two Chinas" set in Hong Kong and Taipei.[15] These doppelgängers, duplicates without an original, concretize the "double consciousness" that W. E. B. DuBois theorized as a consequence of racism in America but that also plagues those living throughout the Chinese-speaking world since various nation-states claim to represent the ethnicity as a whole.[16]

Jerome Silbergeld's *Hitchcock with a Chinese Face* takes up the same theme as Jean Ma and analyzes aspects of style, psychology, and allegory in three features from Hong Kong, Taiwan, and the PRC. He notes that these films "impress an American audience as comfortably familiar (or familiarly uncomfortable) and as works of art made in the global here-and-now, even as they sometimes depict the there-and-then."[17] One of them, Lou Ye's *Suzhou River* (*Suzhou he,* 2000), set in Shanghai and featuring a man obsessed with a woman who he thinks is dead, played by an actress (Zhou Xun) in a dual role, bears a strong resemblance to *Like a Dream.* All these films, Silbergeld argues, owe a debt to Hitchcock.

Although Law claims that she has not seen *Vertigo,* she does not discount the fact that she operates in a cinematic environment of postmodern allusions. When asked about the Hitchcock connection, she demurs: "I actually have never watched *Vertigo.* Eddie [Fong, Law's scriptwriter/producer/husband] has watched *Vertigo*—but it really doesn't matter. If you were influenced.... It is [more about] whether the emotions or the experience that the characters were going through was authentic. And if it's true and honest, then it doesn't matter whether it's the shadow of this film or that film."[18] In fact, many of these Hitchcock "shadow" films exist in Hong Kong cinema.

References to film history become part of the story of visual pleasure and desire, and filmmakers interweave the two themes in novel ways. In addition to Clara Law, other Hong Kong women directors have been attracted to *Vertigo*-like

narratives of mistaken identity and women playing dual roles (e.g., Susie Au's *Ming Ming* [2006], also starring Daniel Wu, with Zhou Xun in the dual role of Ming Ming/Nana and partially set in Shanghai; Aubrey Lam's doppelgänger fable *Anna & Anna* [*Anna yu Anna*, 2007], also partially set in Shanghai; Ann Hui's *Visible Secret* [2001] and Carol Lai's *The Second Woman* [2012] both star Shu Qi in dual roles). Silbergeld's project, then, highlights a more general trend in the Chinese-speaking world in which the return to Hitchcock allows Chinese filmmakers to consider issues involving gender, desire, and geopolitical divisions.

Law offers a somewhat different perspective on gender than the male directors in Silbergeld's study, however. It seems important to note that in *Like a Dream,* the most dramatic revelation involves the murder of protagonist Max's mother at the hands of her abusive husband and that the narrative drifts away from Max's dreams and obsessions to reveal the suffering and desires of the women who fuel his fantasies and anxieties. With visual and narrative layers that move between dream and reality, interiority and external action, and slip between female and male perspectives, *Like a Dream* rewrites Hitchcock from a Chinese perspective, with a keen awareness of sexual inequalities, the evils of patriarchal violence, and the male as well as female victims of sexist gender hierarchies.

Law flips *Vertigo* on its head. Instead of being a film about the search for the idealized woman tarnished by her duplicity and murderous past, *Like a Dream* takes its flawed hero on a journey that helps to heal the psychic wounds connected to his childhood trauma by allowing him to embrace the love of two very different but physically identical women. The different depiction of the scene in which the hero sees the woman of his dreams walk through his hotel door is telling. In *Vertigo,* Scottie tries desperately throughout the second part of the film to transform Judy, a working-class, "vulgar" woman resembling his elegant but dead lover Madeleine (both played by Kim Novak), into the woman of his troubled memory. After scenes of clothes and shoe shopping, makeup, and hairstyling, Judy still does not "fit" until she goes into the bathroom and emerges with her dyed hair in a tight bun. Hitchcock films the couple on a revolving platform in soft focus and with filtered lighting in order to give a dreamlike quality to the moment Scottie sees her splendidly and precisely transformed. Soon after, however, Scottie's infatuation turns to hatred when Judy puts on a necklace she kept as a "souvenir" of the murder plot with her lover Elster (Tom Helmore) to kill Madeleine and set up Scottie as a "witness." Scottie realizes he has been duped; he never actually met "Madeleine" but fell in love with her imposter.

Law provides a strikingly similar scene in *Like a Dream.* Max, desperate to transform the working-class Hangzhou factory girl Yiyi into Ailing, the graceful

Shanghai girl of his dreams, encourages the lower-class girl to dress up like the woman in the photos he has in his possession. However, unlike Pygmalion, who can construct his ideal woman, Galatea, Max cannot seem to turn Yiyi into a suitably convincing copy of his dream girl. Hyperactive and nearly hysterical with laughter, Yiyi cannot take Max's dreams seriously, and she undermines his plan at each step with her bizarre, unruly behavior. Max and Yiyi come up with the plan of going to all the places in the photos (the Bund, Yu Gardens, etc.) to see if they can find witnesses who may know the dream girl. (Much in the same way, Scottie and Judy impersonating Madeleine see the sights in San Francisco in order to get to the bottom of her supposed possession by the spirit of a dead San Francisco socialite, Carlotta Valdes, from the early days of the city's history.) Because Yiyi cannot walk in high heels, she literally falls on her face, ruining Max's plans.

On their last evening together in Shanghai, Yiyi refuses dinner with Max and retires to her room. Later, Max's doorbell rings, and the young woman standing in front of him appears to be Ailing. The woman says she traced him through the clerk at the photo shop, who had given her the wrong envelope. She claims to know him from her dreams, in which they watched a trashy war film together. Max scrutinizes her and realizes the sham when he sees her wobble on her high heels (figure 7.2). However, he plays along and grabs her from behind, asking if she remembers what they did in their dreams. She slips away from his embrace and goes into the bathroom for a shower (established as one of Yiyi's favorite activities, representing a luxury she does not enjoy in her humble home

Figure 7.2. The shoes do not fit. Like a Dream; dir. Clara Law, 2009.

in Hangzhou). While Max holds her shoes outside the door, she tells him about her recurring dream of dancing in the rain. She emerges from the bathroom, and Max leads her, as if beginning to dance. She says, "In my dream, the wind dances, the rain danced, we danced....We were very happy. Life is difficult." Max lifts her up and spins her, kisses her forehead, nose, and lips. She leaves the room still wearing the white bathrobe, her dress left on the floor of the shower stall.

While this scene appears to recapitulate the transformation scene in *Vertigo*, it differs in several significant ways that open the film up to radically different interpretations. Although both Judy and Yiyi reluctantly take on the persona of their lovers' dream girls, Judy remains mute during the scene, and her guilt ruins the relationship soon after. Scottie knows that Judy is not Madeleine, but he abandons himself to the illusion he created. In *Like a Dream,* Max momentarily gives in to the illusion that he has found his dream girl. When he embraces Yiyi, he seems genuinely moved by her own dream of dancing in the rain. Yiyi may simply be reiterating the story of the dream Ailing had shared with Max in his dream; however, it becomes her dream as well when the two share this intimate moment. While Scottie seems to love Judy only as Madeleine, Max appears capable of having romantic feelings for Yiyi as well as Ailing. Allowing Yiyi to voice her desires separates Law from Hitchcock. Hitchcock gives Judy only one opportunity to reveal her past in a flashback, whereas Law grants Yiyi ample opportunity to share her past, her dreams, and her emotions with Max. Max may try to fashion Yiyi into Ailing's image, but she resists in a way that the reluctant Judy does not—that is, by voicing her own aspirations.

Despite the differences, neither *Like a Dream* nor *Vertigo* shies away from the relationship between love and death that motivates the melancholia at the heart of each film. The dream girl represents a mysterious phantom associated with suicide, and Max and Scottie both attempt to get to the bottom of deaths that, in fact, have no meaning. In *Vertigo*, the fake Madeleine's suicide is a ruse to cover up a real murder, and in *Like a Dream* Ailing's boyfriend's leap to his death remains unexplained. In fact, these suicidal falls may allude to a fear of "falling in love." However, unlike Hitchcock, who connects mortality to femininity, Law sees the source of danger in the patriarchy.

Whereas the fake Madeleine leads Scottie to an art gallery to see a portrait of Carlotta Valdes, who is her obsession, Yiyi takes Max to visit her father's pickled brain in a museum devoted to medical oddities, and the patriarchs turn out to be the real (although sometimes unwitting) villains of the story (figure 7.3). Yiyi's father had a rare, hereditary brain disease that caused dementia and rapid death. Yiyi bows to the brain in a gesture of reverence, and Max imitates her. However, when she begins to consider how hard it must be to fit everything into his brain—the scent of flowers; the taste of food; memories; all the happy,

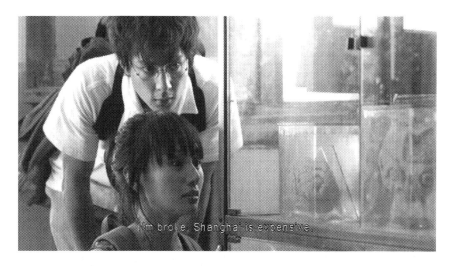

Figure 7.3. Max (Daniel Wu) and Yiyi (Yolanda Yuan) with the pickled brain. *Like a Dream*; dir. Clara Law, 2009.

sad, angry moments—Max barely listens. In his own reverie, he looks out the window at the traffic below and glances over only when Yiyi talks about "his dreams." She asks Max to make software so she can check inside the brain to see if her father really loves her or not. But her mood quickly changes, and she angrily cries, "Thanks, old dad," lamenting that his only legacy is the gene that predisposes her to dementia.

Eventually, Yiyi discovers her twin Ailing, already in the hospital dying from this brain disorder. No explanation is given about the separation, but the film intimates that the poor Hangzhou family could care for only one daughter, and Ailing was adopted by an educated, old-fashioned couple (with books, calligraphy, and a traditional family shrine in their living room). While Yiyi's father may or may not have known about the odds of passing on his disease to his daughters, Ailing's adoptive father, who is frail and powerless, says nothing, remaining as silent as her deceased biological father's brain.

Max, like *Vertigo*'s Scottie, has little power over circumstances as well. He finally meets Ailing too late, and he can only hold her hand as she lies in a coma in the hospital. They meet in a final dream in which it is revealed that she saw him at the Shanghai photo shop before she collapsed into unconsciousness; however, during their final dance the dreamworld disintegrates, and Ailing dies. Later, Max dreams of Yiyi dreaming of him. However, as Ailing's identical twin, she implicitly shares the same fatal gene, and no happy ending awaits any of these dream lovers.

Through these dream girls, Max works through his own inherent fears. He tells the story of his childhood to Yiyi in the third person, calling himself "the boy." Law interrupts the narrative flow involving the quest for the dream girl in order to show a flashback about Max's traumatic past. Hitchcock gives Judy a similarly privileged moment in *Vertigo,* interrupting the story of Scottie's obsession with recreating the dead Madeleine through Judy to allow Judy to reveal to the film viewers that she, indeed, is the Madeleine of Scottie's dreams. In an interview with French auteur/critic François Truffaut, Hitchcock spoke of this flashback: "I put myself in the place of a child whose mother is telling him a story. When there's a pause in her narration, the child always says, 'What comes next, Mommy?' "[19] Max speaks in the voice of a powerless child—in broken Mandarin with Yiyi's help—with an air of nostalgia and deep regret in his voice. In close-up, he tells Yiyi that his mother scooped him up one day when he was only a toddler and drove him to live with a man, away from his father, for two years. Whenever anyone came to the door, the mother and son hid in a closet. A repeated shot of the bedroom from the interior of the closet echoes the opening shot of the film, which shows a mirror above a vanity table, with a vase of white flowers near a window, prefiguring a later shot of blood on the walls of the same room. Max continues, recounting the day his father arrived and shot his mother thirty-two times before killing himself. He went to live with his Mandarin-speaking grandmother, taking his mother's pregnant cat with him. He kept one of the kittens, and *Like a Dream* begins with Max's discovery of the dead cat, the last remaining link to his murdered mother, in his living room.

The death of the cat precipitates Max's dreams, which gradually become nightmares as his dream girl becomes more elusive. He plays hide-and-seek at night with her, just as he had with his mother when they were hiding from his vindictive father and they could leave the house only after dark. The displacement of the emotions surrounding the loss of his mother, recapitulated through the death of the cat, even leads Max to ask the girl if she is really a cat. Eventually, the dream girl turns into a voice on a telephone that laments the coming end of their communication. Max must run to get to the ringing phone before it is too late, and he complains of "running marathons" in his sleep.

Unlike Hitchcock's Scottie, who disentangles himself from "Madeleine" when he realizes Judy's deceit, Max never needs to disassociate himself from the women in his life. He may be powerless to save his mother, Ailing, and Yiyi, but he seems at peace with himself at the film's conclusion. In a voice-over against a calm, dreamy river resembling a Chinese ink painting, Max pensively says, "The dead take part of the living with them—leaving them forever searching because of the loss." It summarizes Sigmund Freud on melancholia quite accurately. Unlike mourning, in which the loss diminishes the world, the loss for the melan-

cholic shrinks the ego itself, reducing the identity of the bereaved. Looking at
Max's situation from a feminist perspective shows this melancholy as more than
mere personal loss. Rather, Max, as a witness to domestic violence, suffers from
the power of the patriarch to take up arms to eliminate his wayward wife. While
the narrative equates the powerlessness Max feels as a child with his inability to
help either Ailing or Yiyi, this equation does not add up. The murder-suicide is
not a force of nature but an act of sexual violence that the film allows to drift
away like the boat on the dream river at the film's conclusion.

The Chinese American Dream

Max also differs from Scottie in another very significant way: Scottie is white,
and Max is Chinese American. *Like a Dream* takes up the masculinity crisis and
theme of fractured identity found in *Vertigo,* but it adds another layer to these
concerns by linking Max's identity crisis to his ethnicity. Martin Luther King,
Jr.'s 1963 "I Have a Dream" speech still rings true, and the American dream of
social equality promised by the "melting pot" remains elusive for those born
outside the Euro-American mainstream. Sociologist Mia Tuan describes the di-
lemma of this split identity eloquently in the title of her book on Asian Ameri-
cans as "forever foreigners" or "honorary whites."[20] In fact, Daniel Wu, the
California-born son of émigrés from Shanghai, has quite a lot in common with
the character Max, whom he plays in Law's film. According to Wu's autobio-
graphical statement posted on the Internet, he describes himself as follows: "I
am what is called an "ABC" (American Born Chinese).... Growing as a Chinese
in America was a very interesting experience because it forced me to live a dual
or double identity. With my friends I walked, talked and acted like an American
but at home I was always a Chinese."[21] Unlike Daniel Wu, who comes to terms
with his ethnicity through the cinema, Max embraces China through the girl of
his dreams. While Max has a lucrative career in America, however, Daniel Wu
turns to Asia, where he enjoys many more opportunities as an actor in Hong
Kong/China than he would likely have in Hollywood. Even though he is not a
native speaker of Cantonese, Wu has a thriving career in Asia, and he exhibits a
particular talent for creating distinctive characters such as the gay policeman in
his debut film *Bishonen*... (*Meishaonian zhi lian;* dir. Yonfan, 1998) and an evil
gang leader in *New Police Story* (*Xin jingcha gushi;* dir. Benny Chan, 2004), as
well as a romantic leading man in films such as *Beyond Our Ken* (*Gongzhu
fuchou ji;* dir. Pang Ho-cheung, 2004), in which he finds himself, a bit like Max,
in an unusual love triangle. Even though Daniel Wu appears to have little in
common with the introverted computer genius Max, the actor and his character

share the feeling of having a "dual or double identity" split between Chinese and American selves.

Max works in a small startup company with two Anglo-American partners —one male and the other female—who seem to accept him as a member of their team, but they always sit across from him, isolating him on the opposite side of their workspace. Max lives alone, rides the subway alone, and must turn to the Internet to ask anonymous strangers about disposing of the body of his dead cat. His white psychiatrist sits above him in his office and offers pills instead of any real counseling when Max tells him about the death of his cat and thoughts of eating the leftover cat food, and he asks whether his reaction is "normal" or not. The doctor replies coolly and inscrutably, "Normal for you." It does not take much imagination to complete his thought as "Normal for you as an Asian." When Max shares his dream about the Chinese woman with his two partners, they speculate that he met the dream girl in a Chinese restaurant or on an Oriental dating website. A figure of isolation, alienation, and the target of not very subtle racist barbs, Max clearly does not feel at home in New York City. A telling scene later in the film confirms that Max has internalized this feeling of being "foreign" in the land of his birth. When Yiyi calls with news of his dream girl, Max responds to her rather than to the African American woman who tries to interrupt the telephone conversation by straddling him on the bed. He can imagine more of a future relationship with a figment of his unconscious fantasy in Asia than he can with a woman from a different racial minority group in America.

Max—mentally ill and close to incapacitated—remains a member of the "model minority," working at his computer into the night and sleeping at his desk. His software company is worth millions, and even though he cannot sign the sales agreement, his partners manage to sell the company and fatten his bank account significantly. In *Like a Dream,* Max serves as a singular example of his ethnic character type. The only other glimpse we have of Asian America in the film comes from a very brief appearance of a figure that seems to be Max's mother; all other Asians in America remain out of the picture, and African Americans function only as images of casual sex.

Perhaps more than the twins Ailing and Yiyi, Max embodies the fragmented identity associated with a postmodern breakdown of a coherent, centered, gendered "self," exacerbated by being Asian in America. Yiyi labels him a "fake," and his own identity as an "American" does not seem quite "genuine" or "authentic." Not only does Max have difficulty being a "man" because he does not want to identify with his murderous father, suicidal rival for Ailing's affections, or Yiyi's brain-damaged father, but he has difficulty being both "Chinese" and "American" as well. In New York, Max plays the role of the taciturn computer nerd—the uptight, somewhat neurotic, celibate Asian American guy, wearing glasses, per-

petually underdressed, and backpack slung over the shoulder. However, the character, like *Vertigo*'s Scottie, has a dark side. Suicidal and bordering on psychotic, he is fully capable of putting a kitten into the microwave, getting drunk on park benches, and having casual sex. In his dreams, he displays yet another incongruent personality as a gregarious young man, clear-eyed with no need of spectacles, who wittily engages Ailing in conversation and happily tries to help her solve the mystery of her fiancé's suicide, mocking her fixation at first but gradually taking her quest seriously (in much the same way Yiyi changes her attitude toward Max's obsession in the second half of the film). In American English, the taciturn Max does not have much to say, but in the Mandarin of his dreamworld, he is a charmer, and in his sleep, Ailing gradually accepts his affection, as celebrated in their dance before the dreamworld implodes and she dies.

Max's identity does not split so neatly in two, however. It is too easy to say that he is at home in a Mandarin-speaking environment and out of place in racist America. Yiyi sees Max as a "fake foreign devil"—trying, but somehow failing, not to be Chinese—but certainly out of place in Shanghai and Hangzhou. Speaking limited Mandarin and unable to read Chinese characters, Max appears to be more "foreign" in China than America and not quite the "flexible citizen" Aihwa Ong sees traversing the globe connecting Asia and the rest of the world.[22] At the end of the film, his dreamworld mixes the languid rivers of the Chinese countryside with the urban traffic of New York and Shanghai. His deracinated, diasporic identity places him beyond borders—foreign everywhere, at home nowhere, still lonely, perhaps, but philosophically enlightened and very rich. Like many cinematic incarnations of diasporic Asian characters, Max embodies ambivalence—reaping the rewards of a Western technical education and economic opportunities while suffering the loss of the mother tongue, the motherland, and a spiritual connection to China. Defining an Asian American dream beyond the limitations of the "model minority" proves difficult, and Max stays trapped in a sort of limbo at the film's conclusion. In transit in a New York taxicab, Max remains on the move in this quintessentially liminal, oneiric non-place.

Chinese Dreams

China and dreams provide another link between *Vertigo* and Law's film. In addition to Scottie's animated nightmare, *Vertigo* takes on an oneiric quality that spills over into other parts of the diegesis, making them "like a dream." Scottie, for instance, may never really awake from his comatose state in the middle of the narrative; filmmaker Chris Marker notes, "There are many arguments in favour of a dream reading of the second part of *Vertigo*."[23] Hitchcock's *Vertigo* also has

its own oblique connection to China. Although Chinatown and San Francisco's Chinese population play no role in the film, Scottie—after supposedly "saving" Madeleine's life by fishing her out of the bay—refers to his own version of ancient Oriental wisdom by attributing to a Chinese aphorism the idea that a person becomes responsible for a life saved. Of course in this case Scottie's Chinese sayings are self-serving since he grasps at any excuse to control the woman with whom he has become infatuated. The visual theme of water, too, connects *Like a Dream* with *Vertigo*. Both take full advantage of their watery locations on rivers and on the bay, and the heroines in each film find themselves soaking wet and toweling off in the protagonists' bedrooms.

However, Hitchcock's vision of femininity and Law's exploration of Chinese women's desires do not mix. As Laura Mulvey points out, *Vertigo* remains rooted in the "male gaze."[24] Unlike Hitchcock, Law provides ample information on the subjective worlds of Ailing and Yiyi. Although Ailing remains comatose throughout the film, the viewer has access to her subjectivity, beyond Max's dreams, in the form of her adoptive mother's flashback based on her daughter's diary. While Hitchcock makes the metaphysical connection between the fake Madeleine and the historical Carlotta part of the plot to entrap Scottie as an unwitting accomplice in a murder, Law allows the paranormal psychic link between Max and Ailing to stand without further rationalization. Hitchcock remains rooted in classical Hollywood conventions of "realism" for suspense, while Law operates with postmodern abandon. Closely collaborating with her cinematographer, Sion Michel, she literally pulls the focus on the hazy world on screen so that a shallow field of vision characterizes both the dreamscape and the waking world in the film.

For example, Ailing and Max share a Hollywood-inspired *pas de deux* in the rain, a clichéd combination of *Singin' in the Rain* (dir. Gene Kelly and Stanley Donen, 1952) and the "king of the world" gesture from *Titanic,* when Max lifts her with arms outstretched, taking the place of her original romantic quest. From an educated and privileged adopted family, Ailing does not need to struggle to be an appropriate object for Max's cosmopolitan romantic desires. However, Yiyi must learn to be like Ailing, and she succeeds only to a degree. Undereducated and working class, she needs to practice walking in high heels, study English, and mimic the gestures of women she sees on the Shanghai streets. Yiyi feels obliged to recreate herself as a different woman—not simply to resemble but to "be" the cosmopolitan and cultured Ailing.

Unhappy with her boring factory job, Yiyi longs to leave Hangzhou and settle in a city, but her version of working-class Chinese femininity holds her back. Ailing already has all that her twin Yiyi desires, so Yiyi knows she can attain this dream of upward mobility. She needs only to fashion herself according to Max's

desires and expectations. As Simone de Beauvoir so aptly stated, "One is not born, but becomes a woman. No biological, psychological, or economic fate determines the figure that the human female presents in society: it is civilization as a whole that produces this creature, intermediate between male and eunuch, which is described as feminine."[25] Max, as the "fake foreign devil," embodies the "good life" of the overseas Chinese—far away from the drudgery of a Chinese sweatshop. He concretizes the Chinese American dream of material success, personal liberty, apparent comfort, and security in the United States.

Yiyi cannot contain her enthusiasm, and after some initial resistance, happily transforms herself. To illustrate this joy, Law provides a reverse shot of Yiyi's delighted face when she thinks she has fooled Max into believing she is the dream girl. The early point-of-view shot of the wobbly high heels lets the viewer know that Max no longer sees the object of his obsessive quest in the flesh before him. Yiyi, however, launches into a conversation she assumes Max expects from Ailing, in which she asks where he plans for them to live as a couple—Shanghai or New York City. The so-called "country girl" from Hangzhou delights in the prospect of her urban dream of upward and outward mobility.

In fact, in the scenes that follow while Max deteriorates in New York City, off screen Yiyi manages to move to Shanghai, get a new wardrobe, and land a well-paying job so lucrative that she can afford to pick up the tab at a fancy restaurant when she reunites with Max. Implicitly, Yiyi's encounter with Max, her trip to Shanghai, and her "success" at being Ailing have given her the confidence to move up in the world independently. Disappointed Max has never dreamed of her, and Yiyi has the dignity to leave him. When she does, she passes him a recording that points the way to the hospitalized Ailing and (except for a momentary appearance in Max's dream after Ailing's death) walks out of the movie's plot.

Yiyi and Ailing represent two competing visions of contemporary Chinese femininity. While Yiyi is ambitious, literally always hungry, carnal, and sensual but uncouth, unpolished, and brash, Ailing embodies the refinement, sensitivity, and ethereal elegance associated with upward mobility. Yiyi devours the local dumpling, *xiao lung bao,* voraciously, while Ailing daintily sips imported coffee in Max's dreams. They represent an East-West divide as well as a class hierarchy —even the photomural in the dreamworld's coffee shop pictures the canals of Venice, Italy, and not Hangzhou, China. Max seems caught in the middle as the "fake foreign devil" trapped between two versions of femininity and two very different visions of China.

The geopolitics of desire depicted in *Like a Dream* does not ring completely true, however. While Max, as an Asian American, may not be able to locate Hangzhou on the map, Yiyi's representation of herself as a country bumpkin is still not convincing. A sense of place becomes garbled in the film. Most of the

exchanges between Max and Yiyi take place in coldly anonymous upscale hotel rooms, restaurants, or corridors. As Max rushes through airports or sits in taxicabs, Hangzhou and Shanghai do not seem that different. Granted, Law makes good use of some of Hangzhou's picturesque waterways, yet the former capital, an important urban center on China's fabled Grand Canal, cannot seriously be considered "rural." Hangzhou and Suzhou are renowned in China for their beautiful, cultured, poetic women, but Yiyi seems more like a Shanghai factory girl than a traditional Hangzhou beauty. While the Hangzhou/Shanghai, rural/urban, poor/rich, traditional/modern split works within the parameters of the diegesis, it fractures when confronted with the realities of contemporary China. Visions of naïve working girls and cosseted urban beauties play into gendered dichotomies that may have more to do with Clara Law's perspective on Chinese femininity, formed from the diasporic vantage point of Hong Kong, Taiwan, Australia, or America, than with mainland Chinese visions of themselves.

At one point, Yiyi angrily confronts Max and protests that he has ruined her life by showing her the photos of her double. She complains that the photos were like an earthquake and she has been cut in half so that she is no longer a complete person. She opines, "I have no control.... My life is on big discount, cheapened by 50 percent. I felt like something is missing, very lonely and painful." Voicing the pain of the loss of the "authentic" self, she articulates a schizophrenic position familiar within postmodern feminist circles. As a cheap copy of another woman, Yiyi feels at a loss. She has what Judith Butler might call some serious "gender trouble," unable to maintain the illusion that she has a coherent, individual, essential gender core: "Acts and gestures, articulated and enacted desires create the illusion of an interior and organizing gender core, an illusion discursively maintained for the purposes of the regulation of sexuality within the obligatory frame of reproductive heterosexuality."[26] Yiyi has lost any illusion, then, of a fixed identity complicated by the changing roles for women in "rising" China.

Max asks Yiyi if money can compensate her for her trouble, and she becomes so offended that she storms out of the room. Understandably, Max sees Yiyi as a worker in the global economy, and indeed he has come to China on a business trip, presumably to find overseas manufacturing venues for his software company. His dealings with Yiyi should be financial—not emotional—in the neoliberal, globalized economy in which he operates. However, if mainland Chinese women have transcended their desire for material success measured in hard cash, the question remains as to what these post-Mao, Reform Era women really desire besides getting away from the "most boring job on earth." A dance in the rain with a handsome Chinese American may be alluring, but it does not complete the picture since Max's Chinese mother found only domestic hell and death in the United States.

Clara Law poses this question of the desires of the post-Mao woman in several of her films, including *The Reincarnation of the Golden Lotus* and *Farewell China*. However, Law is not alone in the ranks of filmmakers from Hong Kong, Taiwan, and beyond the PRC who have depicted mainland women from a cross-border perspective. Shih Shu-mei, K. C. Lo, among other scholars, for example, have looked at Hong Kong films such as the *Her Fatal Ways* series;[27] many others, including Wendy Gan, Lu Tonglin, and Feng Pin-chia, have looked at Hong Kong films featuring mainland brides, prostitutes, and hustlers.[28] In *Like a Dream*, Clara Law offers two versions of mainland femininity subject to the scrutiny of an overseas Chinese male who mediates the border between the PRC and the rest of the Sinophone world for the director.

The Geopolitics of Desire

Filmmakers cite Hitchcock regularly, and traces of his films can be seen throughout the oeuvre of such New Wave filmmakers as Truffaut and Godard and Left Bank filmmakers like Chris Marker, as well as in films paying homage to European art cinema's enthrallment with Hitchcock's Hollywood classics. Indeed, the fascination with *Vertigo* goes beyond film directors' homages and into the realm of philosophical inquiry, with thinkers as diverse as Slavoj Žižek and Gilles Deleuze leading the way.[29]

Given the way in which global filmmakers and European philosophers return to Hitchcock like the guilty to the scene of a crime, Clara Law's *Like a Dream* can be looked at as expanding a conversation about women on screen beyond the parameters of Hitchcock's gaze. Although the centrality of Max cannot be disputed and the film's resemblance to *Vertigo* is obvious, *Like a Dream* also resembles another film, Krzysztof Kieślowski's *The Double Life of Veronique*. This post–Cold War rumination on European identity also features a single actress playing a dual role—Irene Jacob as Polish Weronika and French Véronique; the dual role has been read allegorically as a fable about the post-socialist East and the capitalist West.

Unlike *Vertigo* or *Like a Dream*, *The Double Life of Veronique* has no unifying male perspective on the woman/women to explain away the division as an outgrowth of a masculinity crisis. The women represent the "double life" of Europe at a certain level, and the same could be said of Ailing and Yiyi as embodying two versions of China—one country and two very different "systems" for female desires. As Lisa Rofel notes in *Desiring China*, "Gender and sexual politics served as a central crux of economic reform. In official and popular pronouncements, economic reform was supposed to eradicate what, in a revisionist view,

were represented as the 'unnatural' gender politics of Maoist socialism....If so-cialist power operated on the terrain of 'consciousness,' postsocialist power oper-ates on the site of 'desire.'"³⁰ The question of what women want and what the Chinese want finds expression in what these two women most desire. Looking at the film from this perspective—not as a story of an American man's sexual ob-session but as a fable about the dreams of Chinese women in the new, global cultural economy—shifts the focus away from the American to the Chinese dream.

Clara Law put together a transnational production team to explore this is-sue, and her choices shed some light on the way in which she addresses this ques-tion in the film. The preponderance of the above-the-line talent comes from Hong Kong, Taiwan, and Australia: director Clara Law (born in Macau, estab-lished her career in Hong Kong, now resident in Australia); her husband, script-writer Eddie Fong (born in Hong Kong, resident in Australia); consultant pro-ducer Sylvia Chang (Taiwan/Hong Kong); co-producer Peggy Chiao (Taiwan); director of photography Sion Michel (Australia); and music composer Paul Grabowsky (Australia). Just as the thematic links to films such as *Vertigo* and *The Double Life of Veronique* and the use of Asian and American locations connect *Like a Dream* to world cinema, so does Law's choice of production personnel. Sion Michel's use of the camera (colored filters, variations in aperture, use of lenses, slow motion, step printing, motion blur, dramatic shifts in focus) resem-bles the style of his fellow Australian Christopher Doyle, who also works with ethnic Chinese directors. The Taiwanese producers, who both have very strong ties to the Asian New Waves and are no strangers to co-productions, also bring a cosmopolitan flavor to the film.

Taiwan finds concrete expression in the film in Max's recurrent dreams. Al-though he feels his dream girl lives in Shanghai and he finds her double in Hang-zhou, his nocturnal assignations with her take place in Taipei. To be precise, they have their rendezvous at Taipei 101, one of the tallest skyscrapers in the world. Just as looking at Hangzhou as "rural" does not seem quite right, Max's failure to recognize that his dream setting is not in mainland China may perplex the film's more savvy viewers. The meeting of China and America in Max's dreams seems, however, somehow apropos. Not only does Taiwan's New Cinema serve as an ap-propriate aesthetic backdrop for the work of diasporic Hong Kong filmmakers, but also Taipei's cityscape standing in as the dreamscape for America's encoun-ter with China has a sting to it. A certain irony is inescapable as Ailing com-ments that she and Max search for "home" in their dreams, but neither is in fact connected in any way to the Taipei of their unconscious minds. Written out of its official standing as part of China after the Cold War, Taiwan reemerges in the American subconscious as the container for romantic fantasies about China—a

place to try to solve a mystery and to try to "save" a vulnerable woman—but, of course, without success.

Whereas Hitchcock used green filters to create Scottie's hallucinatory world in *Vertigo,* Law (working with Michel) uses a cool blue to transform Taipei 101 into the empty cityscape of Max's dreams. The building, designed by C. Y. Lee and Partners, boasts a "neo-regionalist modern" style, a term that sounds like shorthand for a postmodern take on corporate glass-and-steel monoliths with Asian characteristics. Law makes good use of the international artworks on display at the base of the structure. Max and his dream girl play hide and seek, for instance, around a version of American artist Robert Indiana's *Love* (1966–1999), and Indiana's *1–0* (2002) is also on display, as is French artist Ariel Moscovici's *Between Earth and Sky* (2002).[31] However, versions of Indiana's *Love* sculpture, with the canted "O" and the cracked-open spheres, exist elsewhere, and Max's dreamscape has the quality of an anonymous non-place; the walls of glass and steel, the minimalist décor, the artwork, the doorways, the plazas, and other public places could be in any modern city. Nothing distinctly ethnically "Chinese" catches the eye. The dream girl, dressed in a neutral-colored trench coat and heels, could be from anywhere, and only her use of Mandarin to communicate places her within the Chinese-speaking world.

Yet Taipei 101 is not really "any place whatever," as Gilles Deleuze might say. Despite its postmodern stylistic anonymity, it represents a distinct location and, more than that, a landmark in the contested place of Taiwan—a territory whose independent existence continues to be assaulted. While Law's use of the location may have been necessitated by funding or other production considerations, placing Max's dreams in Taipei rather than in Shanghai merits some further consideration. His dreams do not revolve around mainland China at all, but the location of his erotic fantasies, as well as the nightmares of loss and visions of decay, turns out to be in Taiwan. Law associates that specific place with suicidal falling bodies; unresolved anxieties; neurotic preoccupations; obsessive desires; emotional descriptions of abandonment; and a nightmarish climax involving the visual destruction of icons of time (a surreal clock with only the number 12 on it) and space (the rupture of floors and cracking of ceilings), orchestrated to a haunting female vocalise (vocal exercise without words) on the soundtrack. Although Ailing's flashback in Max's dream takes them back to Shanghai, it is in the dreamscape of Taipei, with its empty streets and vacant buildings, that she utters her most nihilistic phrases: "All are illusions. Nothing exists. The world is too corrupt. It has no meaning." The wordlessness of the vocalise reinforces the impression of the postmodern implosion of meaning. Associating corruption, meaninglessness, abandonment, and the dissolution of time and space itself with Taipei sends a powerful, visceral message that cannot be fully recuperated by the

couple's pas-de-deux in the plaza that follows. Taipei, oneiric already, dissolves, and Ailing, associated with that city in Max's dreams, dies. Taiwan, already an abstraction, evaporates.

In the coda, Max returns to America, Shanghai pops up in his dreams with a brief appearance from Yiyi, and the existential question of the meaning of existence seems resolved through romantic love. However, the question of the geopolitical identity of the ethnic Chinese world endures. The link between the Asian American Max and the women in a post-Mao, neoliberal China remains tenuous. Ailing, Yiyi, and Max's mother cannot shake the legacy of traditional China, even though Max has found some solace in his own version of Buddhist detachment and acceptance of the inevitability of human suffering, loss, and the transience of life. Ailing and his mother die, and Yiyi seems likely condemned to a premature death as well, so fate continues to have a perplexingly gendered dimension.

Another lingering question remains concerning the address of the film to its viewers in the mainland, within the Sinophone world, as well as within the film festival circuit. *Like a Dream* needs to speak to viewers who may be more familiar with *Dream of the Red Chamber* than *Vertigo* and vice versa. Even though the film's producers and directors come from Hong Kong and Taiwan, the feature focuses on the mainland woman as the object of obsession for the overseas Chinese man. It nods in the direction of the mainland market, with young female viewers interested in a love story starring romantic lead Daniel Wu opposite a mainland starlet comprising a portion of its potential audience. Ailing serves as a source of metaphysical mystery, with her zany double Yiyi acting as an equally mystifying incarnation of the PRC female. They split into two visions of the market—one urbane and sophisticated; the other nouveau riche, unpolished, and with strong proletarian roots. Just as Max romances both Ailing and Yiyi in the film, the producers attempt to attract an audience that can somehow see itself reflected on screen. Ailing and Yiyi, in fact, both "get" the boy, as the shower scene and the dream ballet in the rain both use water as the Chinese metaphor for sex. However, Max's search for the meaning of life through the desires of Ailing and Yiyi only returns him to New York City, perhaps more resigned to the transience of life, but not really any wiser when it comes to women—or mainland China, for that matter.

Max is in good company since several Hong Kong directors have sent their overseas Chinese characters to the mainland for romance. Johnnie To and Wai Ka-Fai's *Don't Go Breaking My Heart* (*Danshen nannu*, 2011), also partially set in Shanghai, has two Hong Kong–based businessmen (one played by Daniel Wu) romancing a girl from the mainland (played by Gao Yuanyuan). Pang Ho-cheung takes his Hong Kong lovers to Beijing in *Love in the Buff* (*Chunjiao yu*

zhiming, 2012), where they find mainland partners. And the list goes on. With the growing importance of the Chinese film market (regionally and internationally), the pecuniary attractions of the Closer Economic Partnership Arrangement (CEPA), and the rise of the Chinese co-production to circumvent quotas, romancing the mainland viewer has become a necessity, and imagining that viewer as an attractive, malleable, romantic young woman has become a bit of a cliché.[32]

Although Hong Kong remains out of the picture in *Like a Dream,* the film seems to be addressing a common preoccupation with mainland romances by filmmakers from outside the PRC. With its complex intertextual citations; the surreal rendering of Taipei; the self-reflexive ruminations on the place of the cinema in the philosophical investigation of existence; and the implicit critique of racism, sexism, and the excesses of capitalism, *Like a Dream* acknowledges a cosmopolitan, art house audience. However, it also does not shy away from the grotesque, the melodramatic, and the excessive, and it welcomes less sophisticated viewers to contemplate the relationship among sex, death, and existence from a working-class perspective. Yiyi literally has a brain—to which she talks in a Shanghai museum—and her story of upward class mobility speaks to a segment of the audience still hoping for Deng Xiaoping's promise of material prosperity after some people "get rich first." The film invites a PRC viewer to "dream" of a life in an Asian American's unconscious in a Taipei setting—Hangzhou dismissed as the rural hinterland and Shanghai associated with the past through images of the Bund and Yu Gardens, Pearl Tower and the new developments in Pudong only vaguely in the distance. The film uses postmodern Taipei as the subconscious repository of the residual fantasy of modernity; it is fancier, as Max observes, than his real office in New York City. In the Taipei dreamworld and in the traffic of Shanghai, the Asian American man seems more awake, while the Chinese in America keep sleeping in the backseat of a taxi, perpetually at a standstill in the congestion of the urban melting pot. The gulf between Xi Jinping's Chinese dream and the American version of the story remains deep, with *Like a Dream* only skimming the surface of the potential nightmares to which it alludes.

Red Earth: Like Chris Marker's *La Jetée*

Clara Law completed a short film in time for the Hong Kong premiere of *Like a Dream;* it was financed by the Hong Kong International Film Festival Society as a companion to the feature. It is what could be called a "festival film," made expressly for exhibition at international festivals. In this case, the Hong Kong International Film Festival "brands" the short, which was picked up and screened

at the Sixty-Seventh Venice International Film Festival and put online as well. Whereas *Like a Dream* avoids Hong Kong as a location, *Red Earth* is set entirely in the HKSAR during an apocalyptic moment when the sun does not set in the city and then fails to rise again after it finally sets for eternity. The dreamscape of *Like a Dream* and the apocalyptic landscape of *Red Earth* resonate to provide a rather dark vision of the future. In *Red Earth,* Daniel Wu plays a character not dissimilar to Max—an unnamed, well-to-do transient who takes pictures of his immediate environment while waiting for a mysterious woman to reappear in his life at the appointed time and place that he has noted in his Blackberry. With the American-accented English in the voice-over, the spectator hears the narrator before seeing his face, which identifies his race and adds the veneer of "model minority" to the neatly attired businessman on screen. Still photographs and their disappointing claims to capture the "truth" of existence link the two films together thematically, and at one point in the voice-over, the narrator explicitly poses the question of whether he is dreaming.

Unlike *Like a Dream,* which does not explicitly acknowledge its debt to Hitchcock, *Red Earth* pays direct homage to Chris Marker's *La jetée,* announced in a title as the film opens, and there is a clear link between Marker's film and *Like a Dream* as well. In fact, the opening title of *La jetée* could describe the story of Max, haunted by the violent image of his parents' deaths; it reads: "This is the story of a man marked by a childhood image." In a nod to Marker's film, most of *Red Earth* relies on still images—with some occasionally coming to life and moving—to tell its futuristic tale. Although *Red Earth* does not propel its protagonist into the past or catapult him into the future in search of an energy source to save the planet, it has the same quality of fractured time that Marker exploits so eloquently in *La jetée.*

In fact, *Like a Dream* stands in relation to *Vertigo* in the same position that *Red Earth* does to *La jetée.* Law's short picks up the themes of voyeurism, obsession, lost love, and mortality from *La jetée* in the same way Marker drew on those same themes from *Vertigo* to make *La jetée.* Emiko Omori points out the connection between Marker's and Hitchcock's films in her documentary *To Chris Marker, an Unsent Letter* (2012), in which she observes that the scene in *La jetée* featuring the time traveler and his lover looking at the rings on a tree trunk pays homage to *Vertigo*'s scene in Muir Woods outside of San Francisco.[33]

While Max pursues his dream girl in Taipei, a city that he does not recognize, *Red Earth*'s protagonist waits for his in a hotel room. In the case of *Red Earth,* the preponderance of the film takes place in the transient non-place of a luxury hotel, specifically the Grand Hyatt.[34] As in most chain hotels around the world, nothing visually specifies Hong Kong as the location for this Hyatt. The unremarkable hotel room, lobby, restaurant, lounge, pool, function rooms, and

grand staircase all share a bland, uniform, international style with their clean lines, neutral tones, and cool lighting. Only the statue of Buddha's head in the hotel room itself situates the interior in a vaguely Asian place. However, the view outside the window tells a very different spatial story. Although the narrator only calls Hong Kong "this city" in the film, the visuals of the IFC tower, the Bank of China, and the dramatic skyline of Victoria Harbor, illuminated by celebratory fireworks when the sun finally sets, place the film quite clearly in Hong Kong as a specific location. At the same time, the hotel setting underscores the narrator's nomadic existence and parallels Law's own feeling of just passing through her former hometown.

All four films rely on water to float the dreams they conjure—Victoria Harbor in Hong Kong, San Francisco Bay, tributaries of the Grand Canal in Hangzhou, the Huangpu River in Shanghai, and the observation pier at Paris's Orly Airport near the Seine. However, in their apocalyptic visions, *La jetée* and *Red Earth* zero in on time, a theme developed differently in *Like a Dream* and *Vertigo* but still critical to their plots, in which characters cannot escape the ramifications of their pasts. Flashbacks in *Like a Dream* merge Max's nightmares and glimpses of his childhood with Yiyi's narration of her discovery of Ailing and the comatose Ailing's memories in a montage that defies any coherent sense of spatial or temporal continuity. Images of clocks punctuate the dreamscape; high angles often dwarf Max and Ailing in compositions in which the back of a single, ominous clock dominates the screen. In Chinese, the word for "clock" (*zhong*) is a phononym with the "end point," connoting "death," so an existential contemplation of the insignificance of a single human life in the vastness of time shadows Max's search for his dream girl.

Law creates *Like a Dream*'s double in *Red Earth*, and the diptych needs to be read together just as Marker envisioned *La jetée* as a philosophical meditation on *Vertigo* (as well as a companion to *Le joli mai* [*The Lovely Month of May*; dir. Chris Marker and Pierre Lhomme, 1963]). In an essay on *Vertigo*, Chris Marker notes that the vertiginous feeling created in Hitchcock's film has a crucial temporal dimension: "The vertigo the film deals with isn't to do with space and falling; it is a clear, understandable and spectacular metaphor for yet another kind of vertigo, much more difficult to represent—the vertigo of time. Elster's 'perfect' crime almost achieves the impossible: reinventing a time when men and women and San Francisco were different to what they are now.... So Elster infuses Scottie with the madness of time."[35] Marker picks up on this "madness of time" in *La jetée* and extends it in his futuristic vision of a cruel world that may not be worth saving, while Law intensifies her philosophical engagement with cinema, meaning, and reality in *Red Earth*. If the dreamscape of Taipei disintegrates in *Like a Dream*, Hong Kong serves as ground zero for the apocalypse in *Red Earth*. The

entire world endures perpetual daylight and then a plunge into darkness, but Daniel Wu's character sees it all from the specific location of the Hong Kong Grand Hyatt hotel near the harbor.

Just as *La jetée* takes up the existential issues of time, death, the meaning of humanity, and the mystery of femininity opened by *Vertigo, Red Earth* turns its attention to several themes on the edges of *Like a Dream*. If Law keeps her former home of Hong Kong out of the picture in the feature, it takes center stage in the short. It concretizes Ackbar Abbas's oft-quoted observation that Hong Kong cinema sees the territory on the verge of the Handover as "déjà disparu."[36] In *Red Earth*, Daniel Wu's unnamed character literally observes the disappearance of Hong Kong as he takes a final self-portrait with the last flash he manages from his digital camera. His anonymous dream girl, Hong Kong, the world itself, and his own narcissistic image all represent a "love at last sight" that functions on several allegorical levels in the film.

Moreover, topics that would perhaps keep the feature off mainland Chinese screens become the source for the drama in *Red Earth*. These include human degradation of the environment, the inadequacy of science to explain the physical world, religion as an alternative source of meaning, prayer as a possible solution to human iniquity, the impotence of politicians to redress the imbalance of nature, and capitalism ("excess") as the cause for the apocalypse. Although, as can be the case in the contradictions of postmodern cinema, the critique of capitalism competes with the product placements in the film—the Blackberry planner and Canon 5D take pride of place in the mise-en-scène. Rather than attempting to romance the mainland Chinese audience through Max's flirtations with Ailing and Yiyi, this film links the end of the world with the "end" of Hong Kong—turning away from God and humanity, grasping at consumer goods, worrying about the consequences of an environmental Armageddon on job prospects, clients, and the value of stocks and bonds.

In *Red Earth*, the mystery represented by the feminine is immediately linked to the fate of the earth, with the narrator remembering the woman with whom he has an assignation in the hotel asking if he knows his "carbon footprint." Camera shy, the woman coyly covers her face with her hand when the narrator tries to photograph her. Moreover, he does not remember her name and knows about their appointment only because of his Blackberry. In this case, rather than an obsessive interest in a memory from childhood, *Red Earth*'s protagonist seems, at first, not that "into" the woman he met casually. He remembers her interest in the environment but not her name or her face. At one point, likely hallucinating during the oppressive days sequestered in the hotel because of the dangers of the sun's radiation, he hears the doorbell and a woman's laughter, glimpsing a red blur in the hotel room's peephole and a running, doubled streak

of a red dress and scarf. Although he seems to see the scarf abandoned at the foot of the lobby's grand staircase, no one else has seen the mysterious woman. Near the end of the film, after the sun no longer rises, he hopes for a glimmer of light to see her face again and imagines, in his cold hotel bed, the warmth of her body next to him. At first quite casual about the relationship, the deepening of his emotions surrounding this woman parallels his own spiritual journey in recognizing his limited but undeniable role in killing the earth and accepting the inevitability of his own mortality and his own relative insignificance in the infinity of time. In *La jetée,* the world survives, but the protagonist dies, but in *Red Earth* the two share the same fate.

The mystery of the woman in *Red Earth* also symbolizes the mystery of the cinema—the impossibility of capturing or "knowing" reality. As the certainty of physics evaporates with the failure of the sun to set, the narrator asks, philosophically, if a "table is a table, a flower a flower." The narrator later laments that the images he captures likely have no meaning or purpose since no future humans will ever see them, but he still feels compelled to take snapshots.

The human dimension remains a compelling element in the film nonetheless. At one point, the protagonist, after losing sight of his hallucinatory dream girl, focuses on an elderly couple standing at the window of the hotel's lounge. They clasp hands and hold them up in a W-shape against the pane of glass as orange light bathes their faces. A poignant close-up of the old woman, her eyes closed, head tilted up to the sun, visualizes an element of hope as well as resignation to fate. This is picked up using Maria Callas's rendition of the Puccini aria *"Vissi d'arte"* as a sound bridge in the following scene, which serves as an epiphany for the narrator.

Step-printed, the character bows down in front of the Buddha's head on the coffee table in his room. In voice-over, the narration continues: "I've never believed in anything, I've never prayed for anything, I've never done anything for this world. I've had a good life, I've been blessed, no wars, no poverty. Living excessively. I've had it all.... Let it end then." As he bows to Buddha, images appear that may or may not be from his digital camera. They show green trees in a park, leafy shadows on a garden fence, and what looks like a suburban home far from the glaring orange light of the Hong Kong skyline. The images share the quality of the time traveler's first encounter with pre-apocalyptic Paris in his journey to find the woman from his memories—lush, alive, ordinary but refreshing. His acceptance of fate has a caveat as the screen flashes images of a little blonde girl and the question "What about them?" comes up. When the sun finally sets, he continues the thought, "What am I waiting for? What else can I do?" The questions remain unanswered as celebratory sounds of horns and fireworks intrude on the soundtrack.

Images of the sun over a bucolic field with leaves and grass and another brief shot of a child after the credits brighten the bleak ending a little. *Red Earth,* ultimately, reflects on the relationship among filmmaking, the meaning of photographic images, and the end of the world (or, at least, the end of Hong Kong). Hong Kong is not the same after 1997; the colony—if not the world—is gone. Asian American Daniel Wu, a fixture in the Chinese diaspora, floating between Asia and the West and most at home in the HKSAR, serves as our guide through both narratives—deracinated, hybridized, perpetually in crisis, shallow, insensitive, materially privileged but oddly suitable for expressing the postmodern predicament and the loss of any stable sense of identity, time, space, or meaning.

Conclusion

Cinematic Citations and the Circulation of Chinese-Language Motion Pictures

Art imitates art, and motion pictures follow suit. For commercial films, in particular, the conventional predictability of a popular genre, familiar star image, respected studio style, valued brand-name director, or proven cultural property for a remake or continuation of a lucrative series speak to the box-office bottom line. For art films on the festival circuit, the obvious recognition of a respected European auteur such as François Truffaut, Robert Bresson, Vsevolod Pudovkin, Chris Marker, or Alfred Hitchcock not only places a film in conversation with the key aesthetic currents of world cinema, but also makes films coming from other locations familiar and accessible to Western audiences. Festival programmers and distributors of "foreign films" in Europe and America may not know *Dream of the Red Chamber,* but they will undoubtedly be familiar with Hitchcock's *Vertigo.* When filmmakers such as Olivier Assayas and Louis Leterrier quote Hong Kong action films, it reinvigorates European screens; when Hou Hsiao-hsien and Tsai Ming-liang cite Lamorisse's *The Red Balloon* and Truffaut's *The 400 Blows* it helps them finance their work by connecting it more directly with sponsors such as the Musée d'Orsay and the Louvre. Jia Zhangke recognizes his debt to European film festivals by giving the ersatz Venice in a Chinese theme park pride of place in *The World* to pay tribute to the site of the film's premiere at the Venice International Film Festival. In popular as well as art house circuits, these citations mean money. Postmodernism has blurred the boundary between film art and commerce, so the difference between blockbusters such as *The Matrix* citing Hong Kong action cinema and transnational Chinese auteurs referencing Hollywood and European classics disintegrates.

As Fredric Jameson shows in his scholarship on postmodern culture, the recycled fantasies that characterize postmodern pastiche and the nostalgia film indicate cultural exhaustion in the late stages of advanced capitalism, but they also point in other possible directions. When European and American filmmakers "cite China," for example, they contribute to a web of images that carry abundant, often contradictory significations. Indeed, the layers of these cinematic

palimpsests obscure as much as they contribute to any particular picture of "China." To complicate matters, the cross-border flow of quotations back and forth between China and the rest of the world blurs the lines between Orientalist exploitation and critical postcolonial commentary in many instances.

Many Chinese filmmakers, for example, refer to the rich history of Chinese cinema in a way that distinguishes them from their Western peers. As noted in chapter 6, Stanley Kwan reinvigorates the image of actress Ruan Lingyu in his film *Center Stage* to comment on similarities between Shanghai before the Japanese occupation and Hong Kong on the verge of the Handover. Tsai Ming-liang turns to King Hu's martial arts classic, *Dragon Gate Inn* (1967), in *Goodbye Dragon Inn* (2003). Raymond Lee's *New Dragon Gate Inn* (1992), produced by Tsui Hark, and *Flying Swords of Dragon Gate* (2011), directed by Tsui Hark, remake the King Hu classic, and other filmmakers such as Ang Lee turn to Hu's *A Touch of Zen* (1971) to recapture the magic of his bamboo forest battle in films such as *Crouching Tiger, Hidden Dragon* (2000). When Hong Kong, Taiwanese, mainland Chinese, and diasporic directors cite "China" through Cold War visionaries such as King Hu, they reference a different catalogue of cinematic conventions. Moreover, King Hu's dynastic China differs from other representations of "China" circulating during the same period. For example, when Tsui Hark reanimates Wong Fei-hung, popularized by the Hong Kong star Kwan Tak-hing beginning in 1949, in the *Once upon a Time in China* series (1991–1997), he cites a specifically Cantonese cultural icon mediating Manchu imperialism and encroaching colonialism through an oxymoronic Confucian modernity. However, when Tsui encounters the "China" of the Cultural Revolution in *The Taking of Tiger Mountain* (2014), the traditional *jiang hu* of martial arts adepts has been transformed by its encounter with the People's Liberation Army. The politics of citing China, then, does not lend itself to easy generalizations.

China has changed dramatically since the end of the Cultural Revolution in 1976 and even more as the nation has emerged as an economic behemoth after the end of the Cold War. Hollywood filmmakers salivate at the prospect of the gargantuan market in the PRC and search for ways around the restrictions of the quota system that keep official commercial releases to a minimum (a modest thirty-nine features annually as of 2016 from all countries, most imports coming from the United States). Co-productions promise special treatment, and Hollywood producers have been scrambling to put more Chinese actors, locations, and various "citations" into popular franchises such as *Iron Man, Transformers, X-Men,* and *Spider-Man*. Wang Jianlin's Dalian Wanda Group has purchased the AMC theater chain, and while China and the United States remain very distinct markets with dissimilar tastes and ideological frameworks, overlaps between the PRC and Hollywood point in the direction of the continuing convergence of

global film culture. Hollywood needs to cite China creatively and expand its repertoire beyond Orientalist clichés in order to maximize profitability.

Hong Kong, of course, has privileged access to mainland markets, but the territory's filmmakers must still navigate the onerous system for the approval of official releases, with no guarantees and many restrictions. Alienated from the PRC by colonialism and the Cold War, Hong Kong and Taiwan cite China by recognizing a shared ethnicity with a dissimilar, largely antagonistic, history. Hong Kong filmmakers Ann Hui, Evans Chan, and Clara Law, for example, tend to look at mainland China from the sidelines, using political dissidents, overseas Chinese, and aesthetic idioms from Europe and America to distinguish their perspective from that of their peers across the border. However, while *Like a Dream* romances its mainland viewers this way, *The Life and Times of Wu Zhongxian* and *Ordinary Heroes* do not expect a warm reception across the border. Narrating the events of June 4, 1989, creates an unbridgeable chasm, and the filmmakers' citations of plays about Chinese dissidents and homoerotic films put Brecht's Chinese-inspired aesthetic techniques to good use as they challenge the accepted limits on film representations. Controversial films such as *Ten Years* (2015) narrate a dystopic future for Hong Kong as it draws closer to the PRC, and the gulf between mainland China and the rest of the Sinophone world widens with the ripple effects of the 2014 Umbrella Movement in Hong Kong and Sunflower Movement in Taiwan felt throughout the Sinosphere.

This book has charted only one avenue through the web of cinematic citations that connect China to the rest of the world's screens. The links between Marxist-aesthetic radicals profoundly influenced by China, such as Sergei Eisenstein, Vsevolod Pudovkin, Bertolt Brecht, Jean-Luc Godard, Chris Marker, and Bernardo Bertolucci, and contemporary transnational Chinese filmmakers such as Jia Zhangke, Ann Hui, and Evans Chan have been highlighted. Godard, in particular, takes up a radical interest in Maoist China that deviates from the Hollywood version and opens up other possibilities for political critique. Chinese filmmakers' interest in Robert Bresson, Vittorio De Sica, Roberto Rossellini, Albert Lamorisse, and François Truffaut takes them in a different direction but also provides an opportunity for critical reflection on the role of filmmakers in contemporary culture as observers who provide a way of transcending what they witness. Hong Kong kung fu continues to inspire filmmakers such as Olivier Assayas and Louis Leterrier, as well as Quentin Tarantino, while Alfred Hitchcock haunts productions that link China to America and beyond.

Hitchcock, of course, had his own Chinese dreams, and the character for "double happiness," used at Chinese weddings, makes its way into the mise-en-scène of *Vertigo* (figure C.1). Orson Welles provides another point of reference with the mirrored funhouse of *The Lady from Shanghai* (figure C.2), reflected in

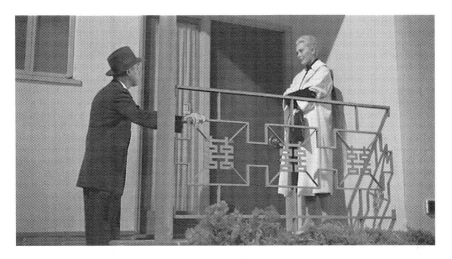

Figure C.1. John "Scottie" Ferguson (James Stewart) and Madeleine Elster/Judy Barton (Kim Novak) with double happiness character in Vertigo; dir. Alfred Hitchcock, 1958.

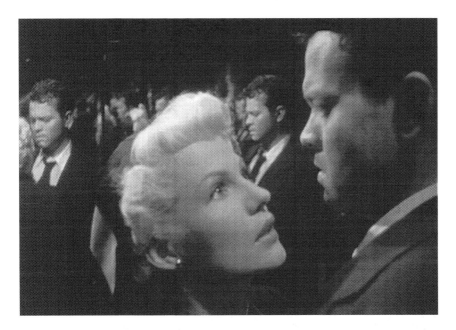

Figure C.2. Elsa Bannister (Rita Hayworth) and Michael O'Hara (Orson Welles) in hall of mirrors in Lady from Shanghai; dir. Orson Welles, 1947.

the Bruce Lee vehicle *Enter the Dragon*, as well as in Tsai Ming-liang's *Visage*. Welles and Hitchcock open up the Hollywood thriller to ruminations on knowledge, illusion, identity, and sexual crisis that take their interest in China beyond the Orientalist surface to provide philosophical substance to their films. The French auteurs also loved Welles and Hitchcock, so the European New Wave tightens the circle as China's Fifth and Sixth Generations, Taiwan New Cinema, and the Hong Kong New Wave all owe a debt to Truffaut, Godard, Bertolucci, and Antonioni as well as Hollywood.

This book underscores the logic behind these currents of inspiration and influence. Superficially, these citations satisfy a desire for a common cinematic lexicon to facilitate foreign funding, festival acquisition, international distribution, and box-office success. While the commercial need for these references seems clear, the intertextual promiscuity seen in films from China as well as Europe and America indicates a depth that goes beyond financial necessity. A political urge to engage with China—as an idea, an aesthetic, and a nation—underpins this cinematic impulse coming from Europe and America, as well as Taiwan, Hong Kong, and the PRC. Just as Jameson's rumination on Perelman's poem "China" provided a key text to illustrate the "postmodern," China continues to function as a metaphor, an allusion, and an illustration as much as a particular location on world screens. These encounters reflect a particular moment in film and world history as directors emerging in the decades around the new millennium, such as Jia Zhangke, Tsai Ming-liang, Evans Chan, Clara Law, and Olivier Assayas, develop cinematic conversations with earlier figures such as Jean-Luc Godard, Bernardo Bertolucci, Michelangelo Antonioni, and King Hu, as well as with the "first" new waves of Chinese cinema in the contributions of figures such as Ann Hui, Patrick Tam, Hou Hsiao-hsien, Edward Yang, Chen Kaige, Tian Zhuangzhuang, and Zhang Yimou.

Chinese filmmakers looking at Europeans such as Bertolucci and Antonioni observing China complicate the circulation of these images with references to Chinese political history. The way in which philosophers such as Alain Badiou; literary scholars such as Roland Barthes, Julia Kristeva, and Philippe Sollers; and filmmakers such as Jean-Luc Godard and Joris Ivens translated the Great Proletarian Cultural Revolution into a political theory for European intellectuals vies with the way the period was experienced in China. When Chinese filmmakers look back at European representations of China (as Feng Xiaogang does in *Big Shot's Funeral* and Jia Zhangke does in *I Wish I Knew*) they turn their cameras on visions of their own past seen by people with a dissimilar experience of "China." Filmmakers from Hong Kong and Taiwan, too, have lived through a very different history of "China," and the complexities of their

postcolonial identities run through their films. *Starry Is the Night,* for instance, considers the Cultural Revolution through Hong Kong's 1967 riots, and Parisian politics of the late 1960s and early 1970s do not get the same treatment in *Ordinary Heroes* and *The Life and Times of Wu Zhongxian* as they do in *The Dreamers* and *Irma Vep.* For Olivier Assayas, for example, Chris Marker's oeuvre serves as shorthand for French radical politics, while for Clara Law, Marker's *La jetée* contributes more aesthetically than politically to her short film *Red Earth.* Tsai Ming-liang strips Jean-Pierre Léaud of his radical past and keeps him "mummified" on screen as the rebellious child of Truffaut's imagination. For Tsai, Antoine Doinel trumps any of Godard's creations, and the New Wave stops before May 1968 truly begins.

Postmodern filmmakers from around the world march through motion picture history by juxtaposing the classics of global cinema (Eisenstein, Pudovkin, Vertov, Bresson, Rossellini, De Sica, Hitchcock, Godard, Bellocchio, Bertolucci, and Bruce Lee) with the geopolitical actualities of contemporary China. Some cinematic quotations drain their sources of meaning, but the vacuum soon fills with new images and ideas. Tsai Ming-liang, for example, decouples Léaud from Godard but reconnects him with a radical interrogation of sexuality through New Queer Cinema. Evans Chan and Ann Hui put Brecht to good use in their post-1989 considerations of political activism in the HKSAR of China. Bringing Brecht to bear on the process of decolonization and the establishment of democratic institutions such as universal suffrage in the former British colony provides a model for dialectical thinking and critical engagement with characters attempting to navigate a treacherous political arena.

The promiscuous use of these quotations impregnates these films with possibilities, and they challenge views that go beyond cinephilic recognition of citations as trivia or a comforting compliment to their own film knowledge. Speaking more generally of East Asian cinema, Song Hwee Lim's remarks on intertextuality resonate with Chinese-language cinema as well: "Intertextuality in contemporary East Asian cinemas demonstrates convincingly that transnational filmmaking is no longer an anomaly within a national cinema's output but is increasingly the norm by which cinema operates today, from production and direction to distribution and reception. Indeed, transnationalism is often woven into the very fabric of a film's narrative, aesthetic, star body, and mode of address."[1] At their best, these cross-cultural, layered motion pictures open up earlier moments for newly imagined webs of citations. For example, in *Like a Dream,* Clara Law puts Hitchcock to task in a critique of the patriarchy and restrictions faced by Chinese women in post-Mao China. Bruce Lee's righteous anger may be dampened, but it still fuels the multiracial vision of *Unleashed.* Even though Law and Leterrier have the com-

mercial market in mind, their choice to revisit familiar territory from a shared motion picture past allows for some progressive currents to blow through their engagement with China.

Unfortunately, this intercourse has its limits, and Mao's dictum to "let a hundred flowers bloom, let a thousand schools of thought contend" has not been fulfilled on Chinese screens. Xi Jinping's Chinese dream of "harmony" dampens debate, and quotations from films from outside of China can prove anodyne (such as the references to the Hollywood romantic comedy *Sleepless in Seattle* [dir. Nora Ephron, 1993] in Xue Xiaolu's *Finding Mr. Right* [*Beijing yu shang xi-yatu*, 2013]). While Xue's film does turn a serious eye on the prevalence of nou-veaux riches Chinese men taking mistresses, consumer narcissism, and the emergence of a new generation of "anchor babies" (born to acquire passports outside of the PRC), it does not offer the same incisive treatment of patriarchal violence as fellow female filmmaker Clara Law does in *Like a Dream*. The shadow of Hitchcock's *Vertigo* provides more room for critical maneuvering than Nora Ephron's *Sleepless in Seattle*, which updates the Hollywood romantic standard *An Affair to Remember* (dir. Leo McCarey, 1957). However, the characters in *Finding Mr. Right*, including the protagonist Jia Jia (Tang Wei emerging from her ban after making Ang Lee's *Lust, Caution*), do find some semblance of their Chi-nese dreams in America (figure C.3). Xi Jinping takes the international ideologi-cal "battlefield" very seriously, and the Chinese president makes every effort to dissociate the Chinese dream from America and so-called Western values. How-ever, as this book has shown, world screens are filled with Chinese films that circulate on the periphery of the PRC—underground in the mainland or exhib-ited only in Hong Kong, Taiwan, or within the international festival circuit.

Figure C.3. "Welcome to the USA" for Jia Jia (Tang Wei) in Finding Mr. Right; dir. Xue Xiaolu, 2013.

Transnational filmmakers, in fact, continue to cite "China" in provocative ways. As co-productions proliferate, as filmmakers liberally quote others, and as political alliances change, global screens will undoubtedly continue to serve as the visible evidence of these struggles over cinematic representation and cultural significance.

Notes

Chapter 1: Introduction

1. Fredric Jameson, "Postmodernism and Consumer Culture," in *The Anti-Aesthetic: Essays in Postmodern Culture,* ed. Hal Foster (Port Townsend, WA: Bay Press, 1983), 111–125. Many of the issues involving Jameson, postmodernism, and China are mapped out in Arif Dirlik and Xudaong Zhang, eds., "Postmodernism and China," special issue, *Boundary 2* 24, no. 3 (1997).

2. Gayatri Chakravorty Spivak, *A Critique of Postcolonial Reason: Toward a History of the Vanishing Present* (Cambridge, MA: Harvard University Press, 1999), 331–336.

3. Jameson, "Postmodernism and Consumer Culture," 123.

4. Law Kar and Frank Bren, *Hong Kong Cinema: A Cross-Cultural View* (Lanham, MD: Scarecrow Press, 2004).; Zhen Zhang, *An Amorous History of the Silver Screen: Shanghai Cinema, 1896–1937* (Chicago: University of Chicago Press, 2005); Jerome Silbergeld, *Hitchcock with a Chinese Face: Cinematic Doubles, Oedipal Triangles, and China's Moral Voice* (Seattle: University of Washington Press, 2004); Rey Chow, *Sentimental Fabulations, Contemporary Chinese Films: Attachment in the Age of Global Visibility* (New York: Columbia University Press, 2007); Shu-mei Shih, *Visuality and Identity: Sinophone Articulations across the Pacific* (Berkeley: University of California Press, 2007).

5. Fredric Jameson, *The Geopolitical Aesthetic: Cinema and Space in the World System* (London: BFI, 1995), 121.

6. Ibid., 151.

7. Ibid., 141.

8. E. H. Gombrich, *Art and Illusion: A Study in the Psychology of Pictorial Representation* (London: Phaidon, 1977); Harold I. Bloom, *The Anxiety of Influence: A Theory of Poetry* (New York: Oxford University Press, 1973).

9. For an appraisal of Jameson on Yang, see Sung-sheng Yvonne Chang, "*The Terrorizers* and the Great Divide in Contemporary Taiwan's Cultural Development," in *Island on the Edge: Taiwan New Cinema and After,* ed. Chris Berry and Feii Lu (Hong Kong: Hong Kong University Press, 2005).

10. Ella Shohat and Robert Stam, *Unthinking Eurocentrism: Multiculturalism and the Media* (London: Routledge, 1994).

11. The film was banned in China until 2004. For a contemporary interpretation of the profound misunderstanding surrounding the screening of the film in Venice, see Umberto Eco and Christine Leefeldt, "De Interpretatione, or the Difficulty of Being Marco Polo [on the Occasion of Antonioni's China Film]," *Film Quarterly* 30, no. 4 (1977).

12. Roland Barthes, *Travels in China* (Cambridge: Polity Press, 2012).

13. Ibid., 195.

14. Another recent documentary goes into greater depth in revisiting Antonioni's *Chung Kuo*. Liu Haiping's *China Is Far Away—Antonioni and China* (2008) includes encounters with the director and his wife before Antonioni passed away in 2007. Given that Antonioni was very frail during the filming, the interviews mainly feature the reminiscences of his wife Enrica Antonioni, as well as excursions to China to find people involved in the 1972 production.

15. For another perspective on the relationship between Antonioni's and Jia's documentaries, see Rey Chow, "China as Documentary: Some Basic Questions (Inspired by Michelangelo Antonioni and Jia Zhangke)," *European Journal of Cultural Studies* 17, no.1 (February 2014): 16–30, doi:10.1177/1367549413501482.

16. For a comparison of the two documentaries, see Hongyun Sun, "Two China? Joris Ivens' Yukong and Antonioni's China," *Studies in Documentary Film* 3, no. 1 (2009): 45–59. For more on Ivens's documentary, see Thomas Waugh, "How Yukong Moved the Mountains: Filming the Cultural Revolution," *Jump Cut: A Review of Contemporary Media* 12/13 (1976), http://www.ejumpcut.org/archive/onlinessays/jc12 -13folder/yukongmovedmt.html. See also Louisa Wei's film dealing with the relationship between Ivens and Chinese filmmaker Situ Zhaodun, *A Piece of Heaven: Preliminary Documents* (2006).

17. Esther C. M. Yau, "Introduction: Hong Kong Cinema in a Borderless World," in *At Full Speed: Hong Kong Cinema in a Borderless World,* ed. Esther C. M. Yau (Minneapolis: University of Minnesota Press, 2001), 8.

18. Chow discusses this in many of her works, including several of the essays anthologized in Rey Chow, *Ethics after Idealism: Theory, Culture, Ethnicity, Reading* (Bloomington: Indiana University Press, 1998).

19. Rey Chow, *Woman and Chinese Modernity: The Politics of Reading between West and East* (Minneapolis: University of Minnesota Press, 1991), 28. Emphasis in original.

20. Jameson, "Postmodernism and Consumer Culture," 116.

21. Ibid., 118.

22. Chris Berry, "East Palace, West Palace: Staging Gay Life in China," *Jump Cut: A Review of Contemporary Media,* no. 42 (1998), http://www.ejumpcut.org /archive/onlinessays/JC42folder/EastWestPalaceGays.html.

23. See my analysis of this connection to Bertolucci: Gina Marchetti, "Eileen

Chang and Ang Lee at the Movies: The Cinematic Politics of *Lust, Caution*," in *Eileen Chang: Romancing Languages, Cultures and Genres,* ed. Louie Kam (Hong Kong: Hong Kong University Press, 2012), 131–154.

24. Yomi Braester, "Chinese Cinema in the Age of Advertisement: The Filmmaker as a Cultural Broker," *China Quarterly,* no. 183 (2005), 549–564, http://www.jstor.org/stable/20192508; Shujen Wang, "*Big Shot's Funeral:* China, Sony, and the WTO," *Asian Cinema* 14, no. 2 (2003), 145–154, doi:10.1386/ac.14.2.145. See also Jason McGrath, "Metacinema for the Masses: Three Films by Feng Xiaogang," *Modern Chinese Literature and Culture* 17, no. 2 (2005): 90–132.

25. In fact, just as Yo Yo is hired to do a "making of" film about the remake of *The Last Emperor,* a documentary does indeed exist about the making of Bertolucci's film—*The Chinese Adventure of Bernardo Bertolucci* (dir. Paolo Brunatto, 1986).

26. For current thinking on global art cinema, see Rosalind Galt and Karl Schoonover, "Introduction: The Impurity of Art Cinema," in *Global Art Cinemas: New Theories and Histories,* ed. Rosalind Galt and Karl Schoonover (Oxford: Oxford University Press, 2010), 3–27.

27. André Bazin, *What Is Cinema?,* trans. Hugh Gray (Berkeley: University of California Press, 1967).

28. Song Fang has gone on to make feature films, including *Memories Look at Me* (*Ji yi wang zhe wo;* dir. Song Fang, 2012).

29. Zhao-fei Zhou, "Wander around Following the Red Balloon: Li Goes to Paris Underplanned," trans. Lin Yiping; *INK Literary Monthly* 58 (2008): 50–52.

30. Citations of Truffaut's film will be discussed in chapter 5.

31. Of course, the song also provides an important element in the soundtrack for Hong Kong *Infernal Affairs* trilogy. See Gina Marchetti, *Andrew Lau and Alan Mak's Infernal Affairs—the Trilogy* (Hong Kong: Hong Kong University Press, 2007), for more on this.

32. See Sheldon Hsiao-peng Lu, "Historical Introduction Chinese Cinemas (1896–1996) and Transnational Film Studies," in *Transnational Chinese Cinemas: Identity, Nationhood, Gender,* ed. Sheldon Hsiao-peng Lu (Honolulu: University of Hawai'i Press, 1997), 1–34.

33. Barthes, *Travels in China,* 194–195.

34. Geoffrey Nowell-Smith, *The Oxford History of World Cinema* (New York: Oxford University Press, 1996).

35. J. Dudley Andrew, "An Atlas of World Cinema," *Framework: The Journal of Cinema and Media* 45, no. 2 (2004): 9–23.

36. Shohini Chaudhuri, *Contemporary World Cinema: Europe, the Middle East, East Asia and South Asia* (Edinburgh: Edinburgh University Press, 2005); Stephanie Dennison and Song Hwee Lim, *Remapping World Cinema: Identity, Culture and Politics in Film* (London: Wallflower, 2006); Nataša Ďurovičová and Kathleen Newman, *World Cinemas, Transnational Perspectives* (New York: Routledge,

2010); Lúcia Nagib, Chris Perriam, and Rajinder Dudrah, *Theorizing World Cinema* (London: I. B. Tauris, 2012).

37. Hamid Naficy, *An Accented Cinema: Exilic and Diasporic Filmmaking* (Princeton, NJ: Princeton University Press, 2001).

38. John Hess and Patricia R. Zimmermann, "Transnational Documentaries: A Manifesto," *Afterimage* 24 (January/February 1997): 10–14.

39. Robert Phillip Kolker, *The Altering Eye: Contemporary International Cinema* (Oxford: Oxford University Press, 1983); John Orr, *Cinema and Modernity* (Cambridge: Polity Press, 1993).

40. Jenny Kwok Wah Lau, *Multiple Modernities: Cinemas and Popular Media in Transcultural East Asia* (Philadelphia: Temple University Press, 2003).

41. Leon Hunt, *Kung Fu Cult Masters: From Bruce Lee to Crouching Tiger* (London: Wallflower, 2003); Laikwan Pang, "Copying Kill Bill," *Social Text* 23, no. 2 (Summer 2005): 133–153, doi:10.1215/01642472-23-2_83–133.

42. See Patricia White, *Women's Cinema, World Cinema: Projecting Contemporary Feminisms* (Durham: Duke University Press, 2015).

Chapter 2: Storms over Asia

1. Tom Conley, *Cartographic Cinema* (Minneapolis: University of Minnesota Press, 2007).

2. Jean Baudrillard, *Jean Baudrillard: Selected Writings* (Stanford, CA: Stanford University Press, 1988), 166–184.

3. Valerie Jaffee, "An Interview with Jia Zhangke," *Senses of Cinema,* no. 32 (2004), http://sensesofcinema.com/2004/feature-articles/jia_zhangke/.

4. Karl Marx and Friedrich Engels, *The Communist Manifesto,* trans. L. M. Findlay (Peterborough, Ontario: Broadview Press, 2004), 65–66.

5. Quoted in Stephen Heath, "Notes on Brecht," *Screen* 15, no. 2 (1974): 103–128.

6. Jean Baudrillard, *The Illusion of the End,* trans. Chris Turner (Stanford, CA: Stanford University Press, 1994), 122.

7. Jason McGrath, "The Independent Cinema of Jia Zhangke: From Postsocialist Realism to a Transnational Aesthetic," in *The Urban Generation: Chinese Cinema and Society at the Turn of the Twenty-First Century,* ed. Zhen Zhang (Durham: Duke University Press, 2007), 82.

8. Dina Iordanova, "The Film Festival Circuit," in *Film Festival Yearbook 1: The Festival Circuit,* ed. Dina Iordanova and Ragan Rhyne (St. Andrews, Scotland: St. Andrews Film Studies, 2009), 23–39; Bill Nichols, "Discovering Form, Inferring Meaning: New Cinemas and the Film Festival Circuit," *Film Quarterly* 47, no. 3 (1994): 16–30; Thomas Elsaesser, "Film Festival Networks: The New Topographies of Cinema in Europe," in Thomas Elsaesser, *European Cinema: Face to Face with Hollywood* (Amsterdam: Amsterdam University Press, 2005), 82–107; Marijke de Valck,

Film Festivals: From European Geopolitics to Global Cinephilia (Amsterdam: Amsterdam University Press, 2007); Cindy Hing-Yuk Wong, *Film Festivals: Culture, People, and Power on the Global Screen* (New Brunswick, NJ: Rutgers University Press, 2011); and Felicia Chan, "The International Film Festival and the Making of a National Cinema," *Screen* 52, no. 2 (2011): 253–260.

9. Elsaesser, "Film Festival Networks," *European Cinema* 46: 82–107.

10. Will Dinovi, "Introducing the Martin Scorsese of China," *Atlantic* (2010), March 11, 2010, http://www.theatlantic.com/entertainment/archive/2010/03/introducing-the-martin-scorsese-of-china/37325/.

11. Sheldon Hsiao-peng Lu, "Dialect and Modernity in 21st Century Sinophone Cinema," *Jump Cut: A Review of Contemporary Media* 49 (2007), http://www.ejumpcut.org/archive/jc49.2007/Lu/index.html.

12. Jing Nie, "A City of Disappearance: Trauma, Displacement, and Spectral Cityscape in Contemporary Chinese Cinema," in *Chinese Ecocinema: In the Age of Environmental Challenge,* ed. Sheldon Lu and Jiayan Mi (Hong Kong: Hong Kong University Press, 2009), 209.

13. Jay Leyda: *Kino: A History of the Russian and Soviet Film* (London: Allen and Unwin, 1960), and *Dianying/Electric Shadows: An Account of Films and Film Audience in China* (Cambridge, MA: MIT Press, 1979).

14. Leyda, *Dianying/Electric Shadows,* 198.

15. J. Dudley Andrew, *The Major Film Theories: An Introduction* (London: Oxford University Press, 1976).

16. Xiaoling Shi, "Between Illusion and Reality: Jia Zhangke's Vision of Present-Day China in *The World,*" *Asian Cinema* 18, no. 2 (2007): 228.

17. Sebastian Veg, "Introduction: Opening Public Spaces," *China Perspectives* 1 (2010), http://chinaperspectives.revues.org/5047.

18. For more on this film, see Brenda Longfellow, "Lesbian Phantasy and the Other Woman in Ottinger's *Johanna d'Arc of Mongolia,*" *Screen* 34, no. 2 (1993), and, Kristen Whissel, "Racialized Spectacle, Exchange Relations, and the Western in Johanna d'Arc of Mongolia," *Screen* 37, no. 1 (1996). Indeed, Ottinger has made other films in China and Mongolia, including several documentaries including *China: The Arts—The People* (1985), *Exile Shanghai* (1997), and *Taiga* (1992).

19. Sergei Eisenstein, *Film Form: Essays in Film Theory,* trans. Jay Leyda (New York: Harcourt, 1949), 37–38.

20. Kevin Lee, "Jia Zhangke," *Senses of Cinema* 25 (2003), http://sensesofcinema.com/2003/great-directors/jia/#b1.

21. Baudrillard, *Jean Baudrillard,* 174.

22. For more on Evans Chan, see chapter 4.

23. Italo Calvino, *Invisible Cities,* trans. William Weaver (New York: Harcourt Brace Jovanovich, 1978), 86–87.

24. Marco Polo continues to contribute to the popular imagination as seen in the 2014–2015 television series by John Fusco.

25. La Biennale di Venezia, "Marco Bellocchio Golden Lion for Lifetime Achievement 2011," http://www.labiennale.org/en/cinema/archive/68th-festival /68miac/bellocchio.html.

26. Maria Antonietta Macciocchi, *Daily Life in Revolutionary China,* trans. Kathy Brown (New York: Monthly Review Press, 1972).

27. For more on *Chung Kuo Cina,* see chapter 1, as well as Chow, "China as Documentary."

28. Geoffrey York, "China Lifts Ban on Film Icon," *Globe and Mail,* (December 2, 2004), http://www.theglobeandmail.com/news/world/china-lifts-ban-on -film-icon/article1144684/.

29. F. Chan, "The International Film Festival."

30. Ma Ran, "Rethinking Festival Film: Urban Generation Chinese Cinema on the Film Festival Circuit," in *Film Festival Yearbook 1: The Festival Circuit,* ed. Dina Iordanova and Ragan Rhyne (St. Andrews, Scotland: St. Andrews Film Studies, 2009), 116–135.

31. CRI English, "Jia Zhangke Considers Suing Zhang Weiping,"December 29, 2006, http://english.cri.cn/3086/2006/12/29/60@178701.htm.

32. Quoted in Bonnie Malkin, "Chinese Directors Boycott Australian Film Festival over Uighur Documentary," *Telegraph,* (July 23, 2009), http://www.telegraph .co.uk/culture/film/5890775/Chinese-directors-boycott-Australian-film-festival -over-Uighur-documentary.html.

33. Valerie Jaffee, "Bringing the World to the Nation: Jia Zhangke and the Legitimation of Chinese Underground Film," *Senses of Cinema,* no. 32 (2004), http:// sensesofcinema.com/2004/feature-articles/chinese_underground_film/.

34. Esther M. K. Cheung, "Realisms within Conundrum: The Personal and Authentic Appeal in Jia Zhangke's Accented Films," *China Perspectives* 1 (April 21, 2010), http://chinaperspectives.revues.org/5048.

35. The Japanese bunraku puppet production "Double Suicide" was made into *Double Suicide* (dir. Masahiro Shinoda, 1969).

36. Chow, "China as Documentary," 27.

Chapter 3: Bicycle Thieves and Pickpockets

I am particularly grateful to Sabrina Baracetti of the Udine Far East Film Festival for her help with my work on Patrick Tam.

1. Slavoj Žižek, "Welcome to the Desert of the Real," *Re: contructions*(2001), September 15, 2001, http://web.mit.edu/cms/reconstructions/interpretations/desertreal .html; Gilles Deleuze, *Cinema 2: The Time-Image,* trans. Hugh Tomlinson and Robert Galeta (Minneapolis: University of Minnesota Press, 1989), 172.

2. Dogme 95 is a filmmaking movement launched by a manifesto written by Danish filmmakers Lars von Trier and Thomas Vinterberg.

3. Alan P. L. Liu, *The Film Industry in Communist China* (Cambridge, MA: Center for International Studies, Massachusetts Institute of Technology, 1965).

4. Cheuk-To Li, "The Return of the Father: Hong Kong New Wave and Its Chinese Context in the 1980s," in *New Chinese Cinemas: Forms, Identities, Politics,* ed. Nick Browne, Paul G. Pickowicz, Vivian Sobchack, and Esther Yau (Cambridge: Cambridge University Press, 1994), 160–179.

5. Natalia Sui-hung Chan, "Cinematic Neorealism: Hong Kong Cinema and Fruit Chan's 1997 Trilogy," in *Italian Neorealism and Global Cinema,* ed. Laura E. Ruberto and Kristi M. Wilson (Detroit: Wayne State University Press, 2007), 207–225.

6. See Huang Zhong, "The Bicycle Towards the Pantheon: A Comparative Analysis of *Beijing Bicycle* and *Bicycle Thieves,*" *Journal of Italian Cinema & Media Studies* 2, no. 3 (2014): 351–362.

7. Quoted in Ru Pravda, "Martin Scorsese's Oscar-Winning Film Inspired by Hong Kong's Crime Thriller," February 27, 2007, http://english.pravda.ru/news /society/27-02-2007/87768-scorsesedeparted-0/.

8. Paul Schrader, *Transcendental Style in Film: Ozu, Bresson, Dreyer* (Berkeley: University of California Press, 1972), 8.

9. André Bazin, *What Is Cinema?,* vol. 2, trans. Hugh Gray (Berkeley: University of California Press, 1971), 51.

10. Jia Zhangke, "Life in Film: Jia Zhangke," *Frieze* 106 (2007): April 15, 2007, http://www.frieze.com/issue/article/life_in_film_jia_zhangke/.

11. Bazin, *What Is Cinema?,* 2: 58, 68.

12. McGrath, "The Independent Cinema of Jia Zhangke," 83–84.

13. John Hess, "La Politique des Auteurs (Part One): World View as Aesthetics," *Jump Cut: A Review of Contemporary Media,* 1974:19–22, http://www.ejumpcut .org/archive/onlinessays/JC01folder/auturism1.html.

14. Bresson quoted in Schrader, *Transcendental Style in Film,* 62.

15. Martin Scorsese, "Foreword," in *Speaking in Images: Interviews with Contemporary Chinese Filmmakers,* ed. Michael Berry (New York: Columbia University Press, 2005), viii.

16. Jia, "Life in Film."

17. Michael Berry, *Speaking in Images: Interviews with Contemporary Chinese Filmmakers* (New York: Columbia University Press, 2005), 22.

18. Quoted in Kantorates, "An Interview with Director Patrick Tam Ka-Ming (Part Ii)," *Cinespot,* May 2007, http://www.cinespot.com/einterviews18b.html. See also Gina Marchetti, David Vivier, and Thomas Podvin, "Interview Patrick Tam: The Exiled Filmmaker," *Hong Kong CineMagic,* June 28, 2007, http://www.hkcinemagic .com/en/page.asp?aid=270.

19. Deleuze, *Cinema 2,* 171.

20. Xiaoping Lin, "Jia Zhangke's Cinematic Trilogy: A Journey across the Ruins of Post-Mao China," in *Chinese-Language Film: Historiography, Poetics, Politics,* ed. Sheldon Hsiao-peng Lu and Emilie Yueh-yu Yeh (Honolulu: University of Hawai'i Press, 2005), 187, 192.

21. Gerhard K. Heilig, "1980, August," http://www.china-profile.com/history/indepth/print/pr_id_95.htm.

22. Roger Garcia, "After This Our Exile," in *Patrick Tam: From the Heart of the New Wave,* ed. Alberto Pezzotta (Udine: Centro Espressioni Cinematografiche, 2007), 135, 137.

23. McGrath, "The Independent Cinema of Jia Zhangke," 84.

24. K. Lee, "Jia Zhangke."

25. Deleuze, *Cinema 2,* 172; emphasis in original.

Chapter 4: Brecht in Hong Kong Cinema

1. Brecht defines "epic theater" in Bertolt Brecht, *Brecht on Theatre: The Development of an Aesthetic,* trans. John Willett (New York: Hill and Wang, 1977).

2. Antony Tatlow and Tak-wai Wong, *Brecht and East Asian Theatre: The Proceedings of a Conference on Brecht in East Asian Theatre* (Hong Kong: Hong Kong University Press, 1982); Sebastian Veg, *Fictions du pouvoir chinois: Littérature, modernisme et démocratie au début du XXe siècle* (Paris: Éditions de l'École des Hautes Études en Sciences Sociales, 2009). See also Sebastian Veg, "Democratic Modernism: Rethinking the Politics of Early Twentieth-Century Fiction in China and Europe," *Boundary 2* 38, no. 3 (2011): 27–65.

3. Michael Ingham, "'Crossings': Documentary Elements and Essayistic Devices in the Fiction and Non-Fiction Films of Evans Chan," *Studies in Documentary Film* 1, no. 1 (2007): 30.

4. Loong-Yu Au, "Alter-Globo in Hong Kong," *New Left Review* 42 (2006), http://newleftreview.org/II/42/loong-yu-au-alter-globo-in-hong-kong.

5. Trotsky opposed the KMT/CCP early alliance, and many Chinese studying in Moscow at the time agreed with him. May Fourth intellectual, editor of *New Youth* magazine, and one of the founding members of the CCP, Chen Duxiu (1879–1942) became the leading voice of the Trotskyite movement in China. See Robert Jackson Alexander, *International Trotskyism, 1929–1985: A Documented Analysis of the Movement* (Durham: Duke University Press, 1991).

6. Trotskyites have made a strong showing in the United Kingdom as well. Although the Paris connection to the Chinese Trotskyites is made in this particular film, others in Hong Kong likely are familiar with the movement through UK connections. Wang Fanxi (1907–2002), for instance, linked the movement with Hong Kong, Macau, and the United Kingdom through his various travels in exile after being expelled from the CCP. See his obituary in Gregor Benton and Pierre Rousset, "Wang Fanxi," *International Viewpoint* 348 (2003), http://www.internationalviewpoint.org/spip.php?article251.

7. For more on Peng's involvement with the Trotskyite opposition in Moscow, see Alexander, *International Trotskyism, 1929–1985.* Chen eventually relocated to Hong Kong and died there in 1987. (Peng died in Los Angeles in 1983.) For

more on their years in Paris, see Yingxiang Cheng and Claude Cadart, "Peng Shu-zhi and Chen Bilan: The Lives and Times of a Revolutionary Couple, Two Leading Figures of the Chinese Trotskyist Movement," *China Perspectives* 17(1998), http://www.cefc.com.hk/article/peng-shuzhi-and-chen-bilan-the-lives-and-times-of-a-revolutionary-coupletwo-leading-figures-of-the-chinese-trotskyist-movement/.

8. The Revolutionary Communist Party also had an active branch in Hong Kong. For more on the Trotskyites in Hong Kong, see Alexander, *International Trotskyism, 1929–1985,* 208–223.

9. Brecht, *Brecht on Theatre,* 71.

10. Lindzay Chan, a retired ballet dancer, performs in many of Evans Chan's films, often serving as the face of Hong Kong's postcolonial identity.

11. Chiu-yu Mok and Evans Chan, *City Stage: Hong Kong Playwriting in English* (Hong Kong: Hong Kong University Press, 2005), 74.

12. Brecht, *Brecht on Theatre,* 92.

13. Robert Stam and Ella Habiba Shohat, "Film Theory and Spectatorship in the Age of the 'Posts,'" in *Reinventing Film Studies,* ed. Christine Gledhill and Linda Williams (London: Arnold, 2000), 390.

14. Ibid., 391.

15. The bar has since been rechristened Club 71, after the annual July 1 protests.

16. Brecht, *Brecht on Theatre,* 110.

17. Quoted in Donato Totaro, "1999 International Festival of New Cinema and New Media," *Offscreen* 3, no. 6 (1999), http://offscreen.com/view/fcmm5.

18. "The April Fifth Action Group," http://wss.hkcampus.net/~wss-6489/en/97/e-colony.htm.

19. See "Long Hair's Website," http://www.longhair.hk/ (in Chinese); http://longhair.hk/en/modules/news/ (in English).

20. Leung has also been involved in Hong Kong Trotskyite circles, including the April Fifth Action group. However, he moved away from the Trotskyites to found the League of Social Democrats in 2006.

21. For more on Godard, Brecht, and Chinese aesthetics, see chapter 5. For more on Evans Chan and counter-cinema, see Gina Marchetti, *From Tian'anmen to Times Square: Transnational China and the Chinese Diaspora on Global Screens, 1989–1997* (Philadelphia: Temple University Press, 2006).

22. Quoted in Sylvia Harvey, *May '68 and Film Culture* (London: British Film Institute, 1978), 66.

23. Peter Wollen, "Godard and Counter Cinema: *Vent d'est,*" in *Film Theory and Criticism: Introductory Readings,* ed. Leo Braudy and Marshall Cohen (New York: Oxford University Press, 1999), 499–507.

24. Pak Tong Cheuk, *Hong Kong New Wave Cinema (1978–2000)* (Bristol: Intellect, 2008), 55.

25. Vivian P. Y. Lee, *Hong Kong Cinema since 1997: The Post-Nostalgic Imagination* (Basingstoke: Palgrave Macmillan, 2009), 282.

26. Ibid., 279–280.

27. Kolker, *The Altering Eye*.

28. Lee's interactions with Léaud in Tsai's oeuvre are examined in chapter 5.

29. Wollen, "Godard and Counter Cinema," 504.

30. Brecht, *Brecht on Theatre*, 109.

31. Ibid., 80.

32. See the discussion of Ann Hui's oeuvre and her ambivalence about her role as a "female" filmmaker in Elaine Y. L. Ho, "Women on the Edges of Hong Kong Modernity: The Films of Ann Hui," in *At Full Speed: Hong Kong Cinema in a Borderless World*, ed. Esther C. M. Yau (Minneapolis: University of Minnesota Press, 2001), 177–207; Patricia Brett, "Crossing Borders: Time, Memory, and the Construction of Identity in *Song of the Exile*," *Cinema Journal* 39, no. 4 (Summer 2000): 43–58; Audrey Yue, *Ann Hui's Song of the Exile* (Hong Kong: Hong Kong University Press, 2010).

33. P. Adams Sitney, *Visionary Film: The American Avant-Garde* (New York: Oxford University Press, 1974).

34. Anti-sodomy laws were finally declared unconstitutional in Hong Kong in 2005.

35. John Woo, November 15, 2001.

36. Quoted in M. Berry, *Speaking in Images*, 536–537.

37. See Gina Marchetti, "Interview: Evans Chan," in Marchetti, *From Tian'anmen to Times Square*, 183–188.

38. Walter Benjamin, "On the Concept of History," https://www.marxists.org/reference/archive/benjamin/1940/history.htm.

39. Ibid.

40. Brecht, *Brecht on Theatre*, 92.

Chapter 5: Les Maoïstes, les Chinoises, and Jean-Pierre Léaud

1. Richard Wolin, *The Wind from the East: French Intellectuals, the Cultural Revolution, and the Legacy of the 1960s* (Princeton: Princeton University Press, 2010). Wolin's book, of course, borrows its title from Godard's and Gorin's 1970 film. For more on the Brechtian nature of this film, see Julia Lesage, "Godard-Gorin's *Wind from the East:* Looking at a Film Politically," *Jump Cut: A Review Of Contemporary Media* 4 (1974): 18–23, http://www.ejumpcut.org/archive/onlinessays/JC04folder/WindfromEast.html.

2. Waugh, "How Yukong Moved the Mountains."

3. Brian Price and Meghan Sutherland, "On Debord, Then and Now: An Interview with Olivier Assayas," *World Picture Journal* 1 (2008), http://www.worldpicturejournal.com/World%20Picture/WP_1.1/Assayas.html.

4. Garrel revisits similar material on May 1968 and its aftermath starring in *Les amants réguliers* (*Regular Lovers*, 2005), a film directed by his father, Philippe Garrel.

5. See André Malraux, *La condition humaine* (*Man's Fate*), trans. Haakon M. Chevalier (New York: Random House, 1934).

6. For more on Léaud's screen persona, see Philippa Hawker, "Jean-Pierre Léaud: Unbearable Lightness," *Senses of Cinema,* no. 8 (2000), http://sensesofcinema .com/2000/jean-pierre-leaud/lightness/.

7. The provocative sadomasochistic sexuality of *Last Tango in Paris* continues to influence Chinese-language cinema. The connection between sadism and politics, of course, goes back to the Marquis de Sade, and the tradition continues through the work of Georges Bataille, Jean Genet, and Jean-Paul Sartre. *Love and Bruises* (dir. Lou Ye, 2011), about the sadomasochistic relationship between a mainland Chinese woman and a Magreb man in Paris, can be seen as part of this tradition, and *Dong gong xi gong* (*East Palace, West Palace;* dir. Zhang Yuan, 1996), smuggled out of China for post-production in France, seems to have a Genet connection in its theatrical presentation of a sadomasochistic homoerotic drama between a policeman and an openly gay man. See C. Berry, "East Palace, West Palace." For a discussion of the relationship between *Lust, Caution* (dir. Ang Lee, 2007) and *Last Tango in Paris,* see Marchetti, "Eileen Chang and Ang Lee at the Movies."

8. Wolin, *The Wind from the East,* 15.

9. The political tides would, of course, turn with Nixon's visit to Beijing in 1972.

10. Keep in mind the film was made seven years before Patty Hearst would be in the news.

11. *La battaglia di Algeri* (*The Battle of Algiers;* dir. Gillo Pontecorvo, 1966) brought the events leading to Algerian independence graphically to the screen the year before Godard's film had its premiere. For more on the Left and the war, see Marie-Pierre Ulloa, *Francis Jeanson: A Dissident Intellectual from the French Resistance to the Algerian War,* trans. Jane Marie Todd (Stanford, CA: Stanford University Press, 2007).

12. Debord was critical of Godard, but their artistic and political sensibilities often overlapped.

13. For more on this aspect of Godard's use of Brecht, see Kolker, *The Altering Eye.*

14. Dale Hudson, "Just Play Yourself, 'Maggie Cheung': Irma Vep, Rethinking Transnational Stardom and Unthinking National Cinemas," *Screen* 47, no. 2 (2006): 222. For more on Maggie Cheung, see Gina Marchetti, "The Hong Kong New Wave," in *A Companion to Chinese Cinema,* ed. Yingjin Zhang (Malden: Wiley-Blackwell, 2012), 95–117.

15. Assayas discusses some of his casting decisions in Steve Erickson, "Making a Connection between the Cinema, Politics and Real Life: An Interview with Olivier Assayas," *Cineaste* 22, no. 4 (1997): 6–9.

16. Aihwa Ong, *Flexible Citizenship: The Cultural Logics of Transnationality* (Durham: Duke University Press, 1999).

17. For more on the connection between *Irma Vep* and *Center Stage,* see Susan Morrison, "Irma Vep," *CineAction* 42 (1997): 63–65.

18. Vicki Callahan, "Detailing the Impossible," *Sight & Sound* 9, no. 4 (1999): 30.

19. Olivia Khoo, *The Chinese Exotic: Modern Diasporic Femininity* (Hong Kong: Hong Kong University Press, 2007), 100.

20. Arletty is perhaps best known as the star of *Les enfants du paradis* (*Children of Paradise;* dir. Marcel Carné, 1945). Because she had a German lover during World War II, she was imprisoned and suspended from film acting for several years, although she eventually returned to the screen. Thus Murano likely identifies her with both the working-class roles she was known for in the 1930s and the political incorrectness of her Nazi liaison.

21. Assayas discusses his use of the SLON material in greater depth in Erickson. *La jetée* (dir. Chris Marker) becomes a point of reference in the context of Clara Law's oeuvre in chapter 7.

22. Grace An, "Par-Asian Screen Women and Film Identities: The Vampiric in Olivier Assayas's *Irma Vep*," *Sites: The Journal of Twentieth-Century* 4, no. 2 (2000): 407.

23. They also divorced but went on to make another feature, *Clean* (dir. Olivier Assayas, 2004), together.

24. Quoted in Price and Sutherland, "On Debord, Then and Now."

25. For more on *What Time Is It There?* in relation to the French New Wave, see Fran Martin, "The European Undead: Tsai Ming-Liang's Temporal Dysphoria," *Senses of Cinema* 27 (2003), http://sensesofcinema.com/2003/feature-articles/tsai_european_undead/; Michelle Bloom, "Contemporary Franco-Chinese Cinema: Translation, Citation and Imitation in Dai Sijie's *Balzac and the Little Chinese Seamstress* and Tsai Ming-Liang's *What Time Is It There?*" *Quarterly Review of Film and Video* 22, no. 4 (2005): 311–325. For a detailed account of the way in which the French New Wave "haunts" Taiwanese cinema, see James Tweedie, *The Age of New Waves: Art Cinema and the Staging of Globalization* (New York: Oxford University Press, 2013).

26. Godard, of course, has a charming cameo in *Cléo de 5 à 7* (*Cléo from 5 to 7;* dir. Agnès Varda, 1962).

27. For more on this film, see Gina Marchetti, "On Tsai Mingliang's *The River*," in *Island on the Edge: Taiwan New Cinema and After,* ed. Chris Berry and Feii Lu (Hong Kong: Hong Kong University Press, 2005), 113–126.

28. Martin, "The European Undead."

29. M. Bloom, "Contemporary Franco-Chinese Cinema," 321.

30. For a rich discussion of intertextuality in *Visage,* see Michelle Bloom, "The Intertextuality of Tsai Ming-Liang's Sinofrench Film, *Face,*" *Journal of Chinese Cinemas* 5, no. 2 (2011): 103–121.

31. Song Hwee Lim, *Tsai Ming-Liang and a Cinema of Slowness* (Honolulu: University of Hawai'i Press, 2014), 62.

32. Erik Bordeleau, "Soulful Sedentarity: Tsai Ming-Liang at Home at the Museum," *Studies in European Cinema* 10, nos. 2–3 (2013): 179–194.

33. Lim, *Tsai Ming-Liang and a Cinema of Slowness,* 149.

34. Quoted in Martin, "The European Undead."

35. Since Godard's *Two or Three Things I Know about Her* (1967), the coffee cup has been inextricably linked to the French New Wave and its aesthetic sensibility.

36. Tsai Ming-liang, "On the Uses and Misuses of Cinema," *Senses of Cinema* 58 (2011), http://sensesofcinema.com/2011/feature-articles/on-the-uses-and-misuses -of-cinema/.

37. Lim, *Tsai Ming-Liang and a Cinema of Slowness,* 129–133.

38. André Bazin, "The Ontology of the Photographic Image," in *Film Theory and Criticism: Introductory Readings,* ed. Leo Braudy and Marshall Cohen (New York: Oxford University Press, 1999), 195–198.

39. I am grateful to Derek Lam for bringing the lip-synch dance scene to my attention. For more on camp and Tsai, see Emilie Yueh-yu Yeh and Darrell William Davis, *Taiwan Film Directors: A Treasure Island* (New York: Columbia University Press, 2005). For a political reading of this scene as queer critique of Chiang Kai-shek, see pp. 146–148.

40. Kolker, *The Altering Eye,* 216.

41. For more on *M. Butterfly,* see Gina Marchetti, "From Fu Manchu to M. Butterfly and Irma Vep: Cinematic Incarnations of Chinese Villainy," in *Bad: Infamy, Darkness, Evil, and Slime on Screen,* ed. Murray Pomerance (Albany: State University of New York Press, 2004), 187–200.

42. Bruno Bosteels, "Post-Maoism: Badiou and Politics," *Positions: East Asia Cultures Critique* 13, no. 3 (2005): 575–634.

43. Alain Badiou, *Cinema,* trans. Susan Spitzer (Cambridge: Polity, 2013).

44. Mentioned in ibid., 112.

45. Ibid., 59.

46. Ibid., 6.

47. Gayatri Chakravorty Spivak, *In Other Worlds: Essays in Cultural Politics* (New York: Methuen, 1987).

Chapter 6: Dragons in Diaspora

1. Leon Hunt, "Asiaphilia, Asianisation and the Gatekeeper Auteur: Quentin Tarantino and Luc Besson," in *East Asian Cinemas: Exploring Transnational Connections on Film,* ed. Leon Hunt and Leung Wing-Fai (London: I. B. Tauris, 2008), 220–236.

2. Stuart M. Kaminsky, "Kung Fu Film as Ghetto Myth," *Journal of Popular Film* 3, no. 2 (1974): 129–138.

3. Verina Glaessner, *Kung Fu: Cinema of Vengeance* (London: Lorrimer, 1974); David Desser, "The Kung Fu Craze: Hong Kong Cinema's First American Reception," in *The Cinema of Hong Kong: History, Arts, Identity,* ed. Poshek Fu and David Desser (Cambridge: Cambridge University Press, 2000), 19–43.

4. M. T. Kato, "Burning Asia: Bruce Lee's Kinetic Narrative of Decolonization," *Modern Chinese Literature and Culture* 17, no. 1 (2005): 87. See also M. T. Kato,

From Kung Fu to Hip Hop: Globalization, Revolution, and Popular Culture (Albany: State University of New York Press, 2007).

5. For more on the contradictory nature of Lee's persona, see Hsiung-Ping Chiao, "Bruce Lee: His Influence on the Evolution of the Kung Fu Genre," *Journal of Popular Film and Television* 9, no. 1 (1981): 30–42.

6. Vijay Prashad, *Everybody Was Kung Fu Fighting: Afro-Asian Connections and the Myth of Cultural Purity* (Boston: Beacon Press, 2001).

7. Donnie Yen takes up the same role in Andrew Lau's *Legend of the Fist: The Return of Chen Zhen* (*Jing wu feng yun—Chen Zhen*, 2010).

8. See Gina Marchetti, *The Chinese Diaspora on American Screens: Race, Sex, and Cinema* (Philadelphia: Temple University Press, 2012).

9. Crystal S. Anderson, *Beyond the Chinese Connection: Contemporary Afro-Asian Cultural Production* (Jackson: University Press of Mississippi, 2013), 83.

10. For an eloquent assessment of Bruce Lee and pedagogy, see Meaghan Elizabeth Morris, "Learning from Bruce Lee: Pedagogy and Political Correctness in Martial Arts Cinema," in *Keyframes: Popular Cinema and Cultural Studies,* ed. Matthew Tinkcom and Amy Villarejo (London: Routledge, 2001), 171–186.

11. For more on the relationship between the piano and class divisions in China, see Richard Curt Kraus, *Pianos and Politics in China: Middle-Class Ambitions and the Struggle over Western Music* (New York: Oxford University Press, 1989).

12. For more on Lambert's career, see Arnaud Lanuque, "Interview Mike Lambert: An English Stuntman in Hong Kong," *Hong Kong CineMagic*, December 27, 2004, http://www.hkcinemagic.com/en/page.asp?aid=70&page=0.

13. Paul Bowman, *Theorizing Bruce Lee: Film-Fantasy-Fighting-Philosophy* (Amsterdam: Rodopi, 2010), 85.

14. Jacques Derrida, *Memoirs of the Blind: The Self-Portrait and Other Ruins,* trans. Pascale-Anne Brault and Michael Naas (Chicago: University of Chicago Press, 1993).

Chapter 7: Citing the American Dream in the People's Republic of China, Taiwan, and Hong Kong

1. Robert Lawrence Kuhn, "Xi Jinping's Chinese Dream," *New York Times,* June 4, 2013, http://www.nytimes.com/2013/06/05/opinion/global/xi-jinpings-chinese-dream.html?pagewanted=2&_r=1.

2. William A. Callahan, *China Dreams: 20 Visions of the Future* (Oxford: Oxford University Press, 2013). For more on the "Chinese dream" in the cinema, see Stacilee Ford, "Blockbuster Dreams: Chimericanization in *American Dreams in China* and *Finding Mr. Right,*" in *The Power of Culture: Encounters between China and the United States,* ed. Priscilla Roberts (Newcastle upon Tyne: Cambridge Scholars, 2016), 409–427.

3. Jacques Derrida and F. C. T. Moore, "White Mythology: Metaphor in the Text of Philosophy," *New Literary History* 6, no. 1 (1974): 5–74.

4. Edmund Lee, "Interview: Clara Law," *Time Out Hong Kong,* May 12, 2010, http://www.timeout.com.hk/film/features/34243/interview-clara-law.html.

5. For an insightful reading of *Autumn Moon,* see Steve Fore, "Time-Traveling under an *Autumn Moon,*" *Post Script* 17, no. 3 (Summer 1998): 34–46.

6. For more on these themes in Law's oeuvre, see Steve Fore, "Tales of Recombinant Femininity: *The Reincarnation of Golden Lotus,* the *Chin P'ing Mei,* and the Politics of Melodrama in Hong Kong," *Journal of Film and Video* 45, no. 4, (1993): 57–70.

7. Pierre Bourdieu, *The Field of Cultural Production: Essays on Art and Literature,* trans. Randal Johnson (Cambridge: Polity Press, 1993).

8. Translation from Icy Teru, "Teresa Teng—Tian Mi Mi Lyrics," http://beautifulsonglyrics.blogspot.com/2012/06/teresa-teng-tian-mi-mi-lyrics.html.

9. Hsueh-chin Tsao, *Dream of the Red Chamber,* trans. Chi-chen Wang (New York: Twayne, 1958), 42.

10. Laura Mulvey, "Visual Pleasure and Narrative Cinema," in *Film Theory and Criticism: Introductory Readings,* ed. Leo Braudy and Marshall Cohen (New York: Oxford University Press, 1999), 842. Reprinted from Laura Mulvey, "Visual Pleasure and Narrative Cinema," *Screen* 16, no. 3 (1975).

11. For more on Asian American men on screen, see Jachinson Chan, *Chinese American Masculinities: From Fu Manchu to Bruce Lee* (New York: Routledge, 2001).

12. Tania Modleski, *The Women Who Knew Too Much: Hitchcock and Feminist Theory* (New York: Methuen, 1988), 91.

13. Joan Riviere, "Womanliness as Masquerade," *International Journal of Psychoanalysis* 10 (1929): 303–313.

14. Jean Y. Ma, "Doubled Lives, Dissimulated History: Hou Hsiao-Hsien's *Good Men, Good Women,*" *Post Script* 22, no. 3 (2003): 21.

15. For an analysis of this film, see Gina Marchetti, "Between Comrade and Queer: Stanley Kwan's *Hold You Tight,*" in *Hong Kong Screenscapes: From the New Wave to the Digital Frontier,* ed. Esther M. K. Cheung, Gina Marchetti, and See-Kam Tan (Hong Kong: Hong Kong University Press, 2011), 197–212.

16. W. E. B. Du Bois, *The Souls of Black Folk* (New York: Penguin Books, 1989).

17. Silbergeld, *Hitchcock with a Chinese Face,* 3.

18. E. Lee, "Interview: Clara Law."

19. Quoted in François Truffaut, *Hitchcock* (New York: Simon and Schuster, 1967), 184.

20. Mia Tuan, *Forever Foreigners, or, Honorary Whites?: The Asian Ethnic Experience Today* (New Brunswick, NJ: Rutgers University Press, 1998).

21. Night Corridor, "Biography Daniel N. Wu," http://www.nightcorridor.com /daniel.html.

22. Aihwa Ong, *Flexible Citizenship.*

23. Chris Marker, "A Free Replay (Notes on Vertigo)," http://chrismarker.org/chris-marker/a-free-replay-notes-on-vertigo/.

24. Mulvey, "Visual Pleasure and Narrative Cinema," 841–842.

25. Simone de Beauvoir, *The Second Sex,* trans. H. M. Parshley (New York: Alfred A. Knopf, 1974), 301.

26. Judith Butler, *Gender Trouble: Feminism and the Subversion of Identity* (New York: Routledge, 1990), 136.

27. Shu-Mei Shih, "Gender and a New Geopolitics of Desire: The Seduction of Mainland Women in Taiwan and Hong Kong Media," *Signs* 23, no. 2 (1998): 287–319; Kwai-Cheung Lo, *Chinese Face/Off : The Transnational Popular Culture of Hong Kong* (Hong Kong: Hong Kong University Press, 2005).

28. Wendy Gan, *Fruit Chan's Durian Durian* (Hong Kong: Hong Kong University Press, 2005); Tonglin Lu, "Fruit Chan's *Dumplings*—New 'Diary of a Madman' in Post-Mao Global Capitalism," *China Review: An Interdisciplinary Journal on Greater China* 10, no. 2 (2010); Pin-chia Feng, "Reimagining the Femme Fatale: Gender and Nation in Fruit Chan's *Hollywood Hong Kong*," in *Hong Kong Screenscapes: From the New Wave to the Digital Frontier,* ed. Esther M. K. Cheung, Gina Marchetti, and See-Kam Tan (Hong Kong: Hong Kong University Press, 2011), 253–262.

29. In addition to *Pervert's Guide to the Cinema,* see Slavoj Žižek, *Looking Awry: An Introduction to Jacques Lacan through Popular Culture* (Cambridge, MA: MIT Press, 1991); Slavoj Žižek, ed., *Everything You Always Wanted to Know about Lacan (but Were Afraid to Ask Hitchcock)* (London: Verso, 1992). For the "real" and the "virtual" dynamic played out in the Judy/Madeleine split, see Gilles Deleuze, *Cinema 1: The Movement Image,* trans. Hugh Tomlinson and Barbara Habberjam (Minneapolis: University of Minnesota Press, 1986). For a critical perspective on the views of Žižek and Deleuze, see Kriss Ravetto-Biagioli, "*Vertigo* and the Vertiginous History of Film Theory," *Camera Obscura* 25, no. 3 (2011): 101–141.

30. Lisa Rofel, *Desiring China: Experiments in Neoliberalism, Sexuality, and Public Culture* (Durham: Duke University Press, 2007), 5–6. For more on women in contemporary China, see Leta Hong Fincher, *Leftover Women: The Resurgence of Gender Inequality in China* (London: Zed Books, 2014).

31. Robert Indiana: *Love,* 1966–1999, polychrome aluminum, 144 in. x 144 in. x 72 in., Avenue of the Americas, New York, and *1/0,* 2002, aluminum, 17.7 in. x 18.1 in. x 10 in. (ten pieces), Taipei 101, Taipei; Ariel Moscovici, *Between Earth and Sky,* 2002, rose de la claret granite, 39 in. x 51 in. (six pieces), Taipei 101, Taipei.

32. See Mirana M. Sze-to and Yun-Chung Chen, "Mainlandization and Neoliberalism with Post-Colonial and Chinese Characteristics: Challenges for the Hong Kong Film Industry," in *Neoliberalism and Global Cinema: Capital, Culture, and Marxist Critique,* ed. Jyotsna Kapur and Keith B. Wagner (New York: Routledge, 2011), 239–260.

33. For more on this, see Alain J.-J. Cohen, "*12 Monkeys, Vertigo* and *La Jetée:* Postmodern Mythologies and Cult Films," *New Review of Film and Television Studies* 1, no. 1 (2010): 149–164.

34. Marc Augé, *Non-Places: Introduction to an Anthropology of Supermodernity*, trans. John Howe (London: Verso, 1995).

35. Marker, "A Free Replay (Notes on Vertigo)."

36. Ackbar Abbas, "The New Hong Kong Cinema and the 'Déjà Disparu,'" *Discourse* 16, no. 3 (1994): 65–77.

Conclusion

1. Song Hwee Lim, "Transnational Trajectories in Contemporary East Asian Cinemas," in *East Asian Cinemas: Regional Flows and Global Transformations*, ed. Vivian P. Y. Lee (New York: Palgrave), 29.

Filmography

Films are presented in their original official titles and dates of release. For films with unofficial English titles, the translations are not italicized.

An Affair to Remember (dir. Leo McCarey, 1957)
After This Our Exile (dir. Patrick Tam, 2006)
Andrei Rublev (dir. Andrei Tarkovsky, 1969)
Anna & Anna (*Anna yu Anna;* dir. Aubrey Lam, 2007)
Après mai (*Something in the Air;* dir. Olivier Assayas, 2012)
Autumn Moon (*Qiu yue;* dir. Clara Law, 1992)
Balzac and the Little Chinese Seamstress (*Xiao cai feng;* dir. Dai Sijie, 2002)
Bande à part (*Band of Outsiders;* dir. Jean-Luc Godard, 1964)
Barbarian Invasions (*Les invasions barbares;* dir. Denys Arcand, 2003)
Batman Returns (dir. Tim Burton, 1992)
Bed and Board (*Domicile conjugal;* dir. François Truffaut, 1970)
Beijing Bicycle (dir. Wang Xiaoshuai, 2001)
Beyond Our Ken (*Gongzhu fuchou ji;* dir. Pang Ho-cheung, 2004)
Bicycle Thieves (dir. Vittorio De Sica, 1948)
The Big Boss (a.k.a. *Fists of Fury; Tang shan da xiong;* dir. Lo Wei, 1971)
Big Shot's Funeral (*Dawan;* dir. Feng Xiaogang, 2001)
Bishonen... (*Meishaonian zhi lian;* dir. Yonfan, 1998)
Blow-Up (*Blowup;* dir. Michelangelo Antonioni, 1966)
Boat People (dir. Ann Hui, 1982)
Bonnie and Clyde (dir. Arthur Penn, 1967)
Café Lumière (dir. Hou Hsiao-hsien, 2003)
Center Stage (a.k.a. *The Actress; Ruan lingyu;* dir. Stanley Kwan, 1992)
China: The Arts—The People (dir. Ulrike Ottinger, 1985)
China Is Far Away—Antonioni and China (dir. Liu Haiping, 2008)
Chinois, encore un effort pour être révolutionnaires (*Peking Duck Soup;* dir. René Viénet, 1977)

Chung Kuo Cina (*China;* dir. Michelangelo Antonioni, 1972)

Classe de lutte (*Class of Struggle;* dir. SLON, 1967)

Clean (dir. Olivier Assayas, 2004)

Cléo de 5 à 7 (Cléo from 5 to 7; dir. Agnès Varda, 1962)

Comrades: Almost a Love Story (*Tian mi mi;* dir. Peter Chan, 1996)

The Conformist (dir. Bernardo Bertolucci, 1970)

Cradle 2 the Grave (dir. Andrzej Bartkowiak, 2003)

Crouching Tiger, Hidden Dragon (*Wo hu cang long;* dir. Ang Lee, 2000)

Crush (a.k.a. *Kung Fu Fighting; Tang shou tai quan dao;* dir. Tu Guangqi, 1972)

Cry Me a River (dir. Jia Zhangke, 2008)

Deadknot (dir. Wong Chi-keung, 1969)

Dimanche à Pekin (*Sunday in Peking;* dir. Chris Marker, 1956)

Dong gong xi gong (East Palace, West Palace; dir. Zhang Yuan, 1996)

Don't Go Breaking My Heart (*Danshen nannu;* dir. Johnnie To and Wai Ka-Fai, 2011)

The Double Life of Veronique (*La double vie de Véronique;* dir. Krzysztof Kieślowski, 1991)

Double Suicide (dir. Masahiro Shinoda, 1969)

Dragon Inn (*Longmen kezhan;* dir. King Hu, 1967)

The Dreamers (dir. Bernardo Bertolucci, 2004)

Dumplings (dir. Fruit Chan, 2004)

Enter the Dragon (*Long zheng hu dou;* dir. Robert Clouse, 1973)

Exile Shanghai (dir. Ulrike Ottinger, 1997)

Fahrenheit 9/11 (dir. Michael Moore, 2004)

Farewell China (*Ai zai bie xiang de jijie;* dir. Clara Law, 1990)

Farewell My Concubine (dir. Chen Kaige, 1993)

Father and Son (dir. Allen Fong, 1981)

Fearless (*Huo yuanjia;* dir. Ronny Yu, 2006)

Film socialisme (*Socialism;* dir. Jean-Luc Godard, 2010)

Finding Mr. Right (*Beijing yu shang xiyatu;* dir. Xue Xiaolu, 2013)

Fireworks (dir. Kenneth Anger, 1947)

Fist of Fury (a.k.a. *Chinese Connection; Jing wu men;* dir. Lo Wei, 1972)

Fist of Legend (*Jing wu ying xiong;* dir. Gordon Chan, 1994)

The Flight of the Red Balloon (dir. Hou Hsiao-hsien, 2007)

Floating Life (*Fu sheng;* dir. Clara Law, 1996)

Floating Weeds (dir. Yasujirō Ozu, 1959)

Flying Swords of Dragon Gate (*Longmen fei jia;* dir. Tsui Hark, 2011)

The 400 Blows (*Les quatre cents coups;* dir. François Truffaut, 1959)

Game of Death (*Siwang youxi;* dir. Bruce Lee, 1978)

The Goddess of '67 (*Yu shang 1967 de naushen;* dir. Clara Law, 2000)

The Golden Era (dir. Ann Hui, 2014)

Gomorrah (dir. Matteo Garrone, 2008)

Goodbye Dragon Inn (*Bu san;* dir. Tsai Ming-liang, 2003)

Goodbye South Goodbye (dir. Hou Hsiao-hsien, 1996)

Her Fatal Ways (*Biaojie, ni hao ye!;* dir. Alfred Cheung, 1990)

Her Fatal Ways 2 (*Biaojie, ni hao ye! xu ji;* dir. Alfred Cheung, 1991)

Her Fatal Ways 3 (*Biaojie, ni hao ye! 3 zhi daren jiadao;* dir. Alfred Cheung, 1993)

Her Fatal Ways 4 (*Biaojie, ni hao ye! 4 zhi qingbuzijin;* dir. Alfred Cheung, 1994)

The Heroic Trio (*Dong fang san xia;* dir. Johnnie To, 1992)

Hiroshima mon amour (dir. Alain Resnais, 1959)

Hold You Tight (*Yu kuaile yu duoluo;* dir. Stanley Kwan, 1998)

The Hole (*Dong;* dir. Tsai Ming-liang, 1998)

How Yukong Moved the Mountains (*Comment Yukong déplaça les montagnes;* dir. Joris Ivens and Marceline Loridan Ivens, 1976)

I Don't Want to Sleep Alone (*Hei yan quan;* dir. Tsai Ming-liang, 2006)

I pugni in tasca (*Fists in the Pocket;* dir. Marco Bellocchio, 1965)

I Wish I Knew (*Hai shang chuan qi;* dir. Jia Zhangke, 2010)

In the Mood for Love (*Huayang nianhua;* dir. Wong Kar-Wai, 2010)

Inception (dir. Christopher Nolan, 2010)

Infernal Affairs I, II, III (dir. Andrew Lau and Alan Mak, 2002, 2003, 2003)

Irma Vep (dir. Olivier Assayas, 1996)

Iron Man (dir. Jon Favreau, 2008)

Johanna d'Arc of Mongolia (dir. Ulrike Ottinger, 1989)

Johnny Guitar (dir. Nicholas Ray, 1954)

Jules and Jim (*Jules et Jim;* dir. François Truffaut, 1962)

The Kid (dir. Feng Feng, 1950)

Kill Bill Volumes 1, 2 (dir. Quentin Tarantino, 2003, 2004)

Kiss of the Dragon (dir. Chris Nahon, 2001)

Kuhle Wampe (*Kuhle Wampe, oder: Wem gehört die Welt?;* dir. Slatan Dudow, 1932)

La battaglia di Algeri (The Battle of Algiers; dir. Gillo Pontecorvo, 1966)

La chinoise (dir. Jean-Luc Godard, 1967)

La Cina è vicina (*China Is Near;* dir. Marco Bellocchio, 1967)

La dialectique peut-elle casser des briques? (Can Dialectics Break Bricks?; dir. René Viénet, 1973)

La femme Nikita (dir. Luc Besson, 1990)

La jetée (*The Pier;* dir. Chris Marker, 1962)

La nuit américaine (dir. François Truffaut, 1973)

La religieuse (*The Nun;* dir. Jacques Rivette, 1966)

The Lady from Shanghai (dir. Orson Welles, 1947)
The Last Communist (*Lelaki Komunis terakhir;* dir. Amir Muhammad, 2006)
The Last Emperor (dir. Bernardo Bertolucci, 1987)
Le gai savoir (*Joy of Learning;* dir. Jean-Luc Godard, 1969)
Le joli mai (*The Lovely Month of May;* dir. Chris Marker and Pierre Lhomme, 1963)
Legend of the Fist: The Return of Chen Zhen (*Jing wu feng yun—Chen Zhen;* dir. Andy Lau, 2010)
Les amants réguliers (Regular Lovers; dir. Philippe Garrel, 2005)
Les enfants du paradis (Children of Paradise; dir. Marcel Carné, 1945)
Les vampires (dir. Louis Feuillade, 1915–1916)
The Life and Times of Wu Zhongxian (*Wuzhongxian de gushi;* dir. Evans Chan, 2003)
Like a Dream (*Ru meng;* dir. Clara Law, 2009)
Little Cheung (dir. Fruit Chan, 1999)
Love and Bruises (dir. Lou Ye, 2011)
Love at Twenty (*L'amour à vingt ans;* dir. François Truffaut, 1962)
Love in the Buff (*Chunjiao yu zhiming;* dir. Pang Ho-cheung, 2012)
Lucy (dir. Luc Besson, 2014)
Lust, Caution (*Se jie;* dir. Ang Lee, 2007)
M. Butterfly (dir. David Cronenberg, 1993)
Maborosi (*Maboroshi no hikari;* dir. Hirokazu Kore-eda, 1995)
Man with a Movie Camera (dir. Dziga Vertov, 1929)
The Map of Sex and Love (dir. Evans Chan, 2001)
The Martial Club (*Wu guan;* dir. Chia-Liang Liu 1981)
Masculin féminin (dir. Jean-Luc Godard, 1966)
The Matrix (dir. Wachowski Brothers, 1999)
Memories Look at Me (*Ji yi wang zhe wo;* dir. Fang Song, 2012)
Menilmontant (dir. Dimitri Kirsanoff, 1924)
Million Dollar Baby (dir. Clint Eastwood, 2003)
Ming Ming (dir. Susie Au, 2006)
Mojin: The Lost Legend (*Gui chuideng zhi xun long jue;* dir. Wuershan, 2015)
Mongolian Ping Pong (dir. Ning Hao, 2005)
New Dragon Gate Inn (*Xin longmen kezhan;* dir. Raymond Lee, 1992)
New Police Story (*Xin jingcha gushi;* dir. Benny Chan, 2004)
Nima's Women (dir. Zhuo Gehe, 2008)
On the Hunting Ground (dir. Tian Zhuangzhuang, 1984)
Ordinary Heroes (*Qianyan wan yu;* dir. Ann Hui, 1999)
Otto e mezzo (8½; dir. Federico Fellini, 1963)
Paris vu par… vingt ans après (*Paris Seen by… 20 Years After;* dir. Philippe Garrel, 1984)

Pickpocket (dir. Robert Bresson, 1959)

Pickup on South Street (dir. Samuel Fuller, 1953)

A Piece of Heaven: Preliminary Documents (dir. Louisa Wei, 2006)

Platform (dir. Jia Zhangke, 2000)

The Puppetmaster (dir. Hou Hsiao-hsien, 1993)

Rear Window (dir. Alfred Hitchcock, 1954)

Rebels of the Neon God (*Qingshaonian Nezha*; dir. Tsai Ming-liang, 1992)

The Red Balloon (*Le ballon rouge*; dir. Albert Lamorisse, 1956)

Red Earth (*Chidi*; dir. Clara Law, 2010)

The Red Violin (dir. François Girard, 1998)

Reflections on Black (dir. Stan Brakhage, 1955)

The Reincarnation of the Golden Lotus (*Pan jinlian zhi qianshi jinsheng*; dir. Clara Law, 1989)

Reservoir Dogs (dir. Quentin Tarantino, 1992)

The River (*He liu*; dir. Tsai Ming-liang, 1997)

Roman Holiday (dir. William Wyler, 1953)

Romeo Must Die (dir. Andrzej Bartkowiak, 2000)

Rush Hour 2 (dir. Brett Ratner, 2001)

The Sandwich Man (dir. Wan Jen, Tseng Chuang-hsiang, and Hou Hsiao-hsien, 1983)

The Second Woman (*Qing mi*; dir. Carol Lai, 2012)

The Secret (dir. Ann Hui, 1979)

Seven Years in Tibet (dir. Jean-Jacques Annaud, 1997)

Shun Li and the Poet (*Io sono Li*; dir. Andrea Segre, 2011)

A Simple Life (dir. Ann Hui, 2011)

A Simple Noodle Story (dir. Zhang Yimou, 2009)

Singin' in the Rain (dir. Gene Kelly and Stanley Donen, 1952)

The Skywalk Is Gone (*Tianqiao bu jian le*; dir. Tsai Ming-liang, 2002)

Sleepless in Seattle (dir. Nora Ephron, 1993)

Snow-White Horse (dir. Yu Zhong Ying, 1979)

Something Good: The Mercury Factor (dir. Luca Barbareschi, 2013)

The Sparrow (dir. Johnnie To, 2008)

Starry Is the Night (*Jinye xingguang canlan*; dir. Ann Hui, 1988)

Still Life (dir. Jia Zhangke, 2006)

Stolen Kisses (*Baisers volés*; dir. François Truffaut, 1968)

Storm over Asia: The Heir to Genghis Khan (dir. Vsevolod Pudovkin, 1928)

Stray Dogs (dir. Tsai Ming-liang, 2013)

The Sun Also Rises (dir. Jiang Wen, 2007)

Suzhou River (*Suzhou he*; dir. Lou Ye, 2000)

Taiga (dir. Ulrike Ottinger, 1992)

Taste of Cherry (dir. Abbas Kiarostami, 1997)

Taxi Driver (dir. Martin Scorsese, 1976)

Temptation of a Monk (*You seng;* dir. Clara Law, 1993)

Ten Years (*Shi nian;* dir. Jevons Au, Ng Ka Leung, Chow Kwun Wai, Fei-Pang Wong, and Kwok Zune, 2015)

The Terrorizers (dir. Edward Yang, 1986)

Three Songs for Lenin (dir. Dziga Vertov, 1934)

Titanic (dir. James Cameron, 1997)

To Chris Marker, an Unsent Letter (dir. Emiko Omori, 2012)

Tokyo Story (dir. Yasujirō Ozu, 1953)

A Touch of Zen (*Xia nu;* dir. King Hu, 1971)

Tuya's Marriage (dir. Wang Quan'an, 2006)

Two or Three Things I Know about Her (*2 ou 3 choses que je sais d'elle;* dir. Jean-Luc Godard, 1967)

Ultimo tango a Parigi (Last Tango in Paris; dir. Bernardo Bertolucci, 1972)

Un chien andalou (dir. Luis Buñuel, 1929)

Unknown Pleasures (dir. Jia Zhangke, 2002)

Unleashed (a.k.a. *Danny the Dog;* dir. Louis Leterrier, 2005)

Vertigo (dir. Alfred Hitchcock, 1958)

Village People Radio Show (*Apa khabar orang kampung;* dir. Amir Muhammad, 2007)

Visage (*Face;* dir. Tsai Ming-liang, 2009)

Visible Secret (*You ling ren jian;* dir. Ann Hui, 2001)

Vive l'amour (*Aiqing wansui;* dir. Tsai Ming-liang, 1994)

Vivre sa vie (dir. Jean-Luc Godard, 1962)

Warnung vor einer heiligen Nutte (*Beware of a Holy Whore;* dir. Rainer Werner Fassbinder, 1971)

The Warrior and the Wolf (dir. Tian Zhuangzhuang, 2009)

Way of the Dragon (*Meng long guo jiang;* dir. Bruce Lee, 1972)

The Wayward Cloud (*Tianbian yi duo yun;* dir. Tsai Ming-liang, 2005)

Week-end (*Weekend;* dir. Jean-Luc Godard, 1967)

What Time Is It There? (a.k.a. *7 to 400 Blows; Ni na bian ji dian;* dir. Tsai Ming-liang, 2001)

Wind from the East (*Vent d'est;* dir. Dziga Vertov Group, 1969)

The World (*Shijie;* dir. Jia Zhangke, 2004)

World without Thieves (dir. Feng Xiaogang, 2004)

Xiao wu (*Pickpocket;* dir. Jia Zhangke, 1997)

Year of the Dragon (dir. Michael Cimino, 1985)

Bibliography

Abbas, Ackbar. "The New Hong Kong Cinema and the 'Déjà Disparu.'" *Discourse* 16, no. 3 (1994): 65–77.

Alexander, Robert Jackson. *International Trotskyism, 1929–1985: A Documented Analysis of the Movement*. Durham: Duke University Press, 1991.

An, Grace. "Par-Asian Screen Women and Film Identities: The Vampiric in Olivier Assayas's *Irma Vep*." *Sites: The Journal of Twentieth-Century* 4, no. 2 (2000): 399–416.

Anderson, Crystal S. *Beyond the Chinese Connection: Contemporary Afro-Asian Cultural Production*. Jackson: University Press of Mississippi, 2013.

Andrew, J. Dudley. "An Atlas of World Cinema." *Framework: The Journal of Cinema and Media* 45, no. 2 (2004): 9–23.

———. *The Major Film Theories: An Introduction*. London: Oxford University Press, 1976.

"The April Fifth Action Group." http://wss.hkcampus.net/~wss-6489/en/97/e-colony.htm. Accessed May 13, 2015.

Au, Loong-Yu. "Alter-Globo in Hong Kong." *New Left Review* 42 (2006). http://newleftreview.org/II/42/loong-yu-au-alter-globo-in-hong-kong. Accessed May 13, 2015.

Augé, Marc. *Non-Places: Introduction to an Anthropology of Supermodernity*. Translated by John Howe. London: Verso, 1995.

Badiou, Alain. *Cinema*. Translated by Susan Spitzer. Cambridge: Polity Press, 2013.

Barthes, Roland. *Travels in China*. Cambridge: Polity Press, 2012.

Baudrillard, Jean. *The Illusion of the End*. Translated by Chris Turner. Stanford, CA: Stanford University Press, 1994.

———. *Jean Baudrillard: Selected Writings*. Stanford, CA: Stanford University Press, 1988.

Bazin, André. "The Ontology of the Photographic Image." In *Film Theory and Criticism: Introductory Readings*. Edited by Leo Braudy and Marshall Cohen, 195–198. New York: Oxford University Press, 1999.

———. *What Is Cinema?* Translated by Hugh Gray. Berkeley: University of California Press, 1967.

———. *What Is Cinema?* Vol. 2. Translated by Hugh Gray. Berkeley: University of California Press, 1971.

Beauvoir, Simone de. *The Second Sex.* Translated by H. M. Parshley. New York: Alfred A. Knopf, 1974.

Benjamin, Walter. "On the Concept of History." https://www.marxists.org/reference/archive/benjamin/1940/history.htm. Accessed May 13, 2015.

Benton, Gregor, and Pierre Rousset. "Wang Fanxi." *International Viewpoint* 348 (2003). http://www.internationalviewpoint.org/spip.php?article251. Accessed May 13, 2015.

Berry, Chris. "*East Palace, West Palace:* Staging Gay Life in China." *Jump Cut: A Review of Contemporary Media,* no. 42 (1998): 84–89. http://www.ejumpcut.org/archive/onlinessays/JC42folder/EastWestPalaceGays.html. Accessed April 30, 2015.

Berry, Michael. *Speaking in Images: Interviews with Contemporary Chinese Filmmakers.* New York: Columbia University Press, 2005.

Bloom, Harold I. *The Anxiety of Influence: A Theory of Poetry.* New York: Oxford University Press, 1973.

Bloom, Michelle. "Contemporary Franco-Chinese Cinema: Translation, Citation and Imitation in Dai Sijie's *Balzac and the Little Chinese Seamstress* and Tsai Ming-Liang's *What Time Is It There?*" *Quarterly Review of Film and Video* 22, no. 4 (2005): 311–325.

———. "The Intertextuality of Tsai Ming-Liang's Sinofrench Film, *Face.*" *Journal of Chinese Cinemas* 5, no. 2 (2011): 103–121.

Bordeleau, Erik. "Soulful Sedentarity: Tsai Ming-Liang at Home at the Museum." *Studies in European Cinema* 10, nos. 2–3 (2013): 179–194.

Bosteels, Bruno. "Post-Maoism: Badiou and Politics." *Positions: East Asia Cultures Critique* 13, no. 3 (2005): 575–634.

Bourdieu, Pierre. *The Field of Cultural Production: Essays on Art and Literature.* Translated by Randal Johnson. Cambridge: Polity Press, 1993.

Bowman, Paul. *Theorizing Bruce Lee: Film-Fantasy-Fighting-Philosophy.* Amsterdam: Rodopi, 2010.

Braester, Yomi. "Chinese Cinema in the Age of Advertisement: The Filmmaker as a Cultural Broker." *China Quarterly,* no. 183 (2005): 549–564. http://www.jstor.org/stable/20192508. Accessed April 30, 2015.

Brecht, Bertolt. *Brecht on Theatre: The Development of an Aesthetic.* Translated by John Willett. New York: Hill and Wang, 1977.

Brett, Patricia. "Crossing Borders: Time, Memory, and the Construction of Identity in *Song of the Exile.*" *Cinema Journal* 39, no. 4 (Summer 2000): 43–58.

Butler, Judith. *Gender Trouble: Feminism and the Subversion of Identity.* New York: Routledge, 1990.

Callahan, Vicki. "Detailing the Impossible." *Sight & Sound* 9, no. 4 (1999): 28–30.

Callahan, William A. *China Dreams: 20 Visions of the Future.* Oxford: Oxford University Press, 2013.

Calvino, Italo. *Invisible Cities.* Translated by William Weaver. New York: Harcourt Brace Jovanovich, 1978.

Chan, Felicia. "The International Film Festival and the Making of a National Cinema." *Screen* 52, no. 2 (2011): 253–260.

Chan, Jachinson. *Chinese American Masculinities: From Fu Manchu to Bruce Lee.* New York: Routledge, 2001.

Chan, Natalia Sui-hung. "Cinematic Neorealism: Hong Kong Cinema and Fruit Chan's 1997 Trilogy." In *Italian Neorealism and Global Cinema*. Edited by Laura E. Ruberto and Kristi M. Wilson, 207–225. Detroit: Wayne State University Press, 2007.

Chang, Sung-sheng Yvonne. "*The Terrorizers* and the Great Divide in Contemporary Taiwan's Cultural Development." In *Island on the Edge: Taiwan New Cinema and After*. Edited by Chris Berry and Feii Lu. Hong Kong: Hong Kong University Press, 2005.

Chaudhuri, Shohini. *Contemporary World Cinema: Europe, the Middle East, East Asia and South Asia*. Edinburgh: Edinburgh University Press, 2005.

Cheng, Yingxiang, and Claude Cadart. "Peng Shuzhi and Chen Bilan: The Lives and Times of a Revolutionary Couple, Two Leading Figures of the Chinese Trotskyist Movement." *China Perspectives* 17 (1998). http://www.cefc.com.hk/article/peng -shuzhi-and-chen-bilan-the-lives-and-times-of-a-revolutionary-coupletwo -leading-figures-of-the-chinese-trotskyist-movement/. Accessed May 13, 2015.

Cheuk, Pak Tong. *Hong Kong New Wave Cinema (1978–2000)*. Bristol: Intellect, 2008.

Cheung, Esther M. K. "Realisms within Conundrum: The Personal and Authentic Appeal in Jia Zhangke's Accented Films." *China Perspectives* 1 (April 21, 2010). http://chinaperspectives.revues.org/5048. Accessed April 30, 2015.

Chiao, Hsiung-Ping. "Bruce Lee: His Influence on the Evolution of the Kung Fu Genre." *Journal of Popular Film and Television* 9, no. 1 (1981): 30–42.

Chow, Rey. "China as Documentary: Some Basic Questions (Inspired by Michelangelo Antonioni and Jia Zhangke)." *European Journal of Cultural Studies* 17, no. 1 (February 2014): 16–30. doi:10.1177/1367549413501482.

———. *Ethics after Idealism: Theory, Culture, Ethnicity, Reading*. Bloomington: Indiana University Press, 1998.

———. *Sentimental Fabulations, Contemporary Chinese Films: Attachment in the Age of Global Visibility*. New York: Columbia University Press, 2007.

———. *Woman and Chinese Modernity: The Politics of Reading between West and East*. Minneapolis: University of Minnesota Press, 1991.

Cohen, Alain J.-J. "*12 Monkeys, Vertigo* and *La Jetée*: Postmodern Mythologies and Cult Films." *New Review of Film and Television Studies* 1, no. 1 (2010): 149–164.

Conley, Tom. *Cartographic Cinema*. Minneapolis: University of Minnesota Press, 2007.

CRI English. "Jia Zhangke Considers Suing Zhang Weiping." December 29, 2006. http://english.cri.cn/3086/2006/12/29/60@178701.htm. Accessed April 30, 2015.

Deleuze, Gilles. *Cinema 1: The Movement Image*. Translated by Hugh Tomlinson and Barbara Habberjam. Minneapolis: University of Minnesota Press, 1986.

———. *Cinema 2: The Time-Image*. Translated by Hugh Tomlinson and Robert Galeta. Minneapolis: University of Minnesota Press, 1989.

Dennison, Stephanie, and Song Hwee Lim. *Remapping World Cinema: Identity, Culture and Politics in Film*. London: Wallflower, 2006.

Derrida, Jacques. *Memoirs of the Blind: The Self-Portrait and Other Ruins*. Translated by Pascale-Anne Brault and Michael Naas. Chicago: University of Chicago Press, 1993.

Derrida, Jacques, and F. C. T. Moore. "White Mythology: Metaphor in the Text of Philosophy." *New Literary History* 6, no. 1 (1974): 5–74.

Desser, David. "The Kung Fu Craze: Hong Kong Cinema's First American Reception." In *The Cinema of Hong Kong: History, Arts, Identity*. Edited by Poshek Fu and David Desser, 19–43. Cambridge: Cambridge University Press, 2000.

Dinovi, Will. "Introducing the Martin Scorsese of China." *Atlantic*, March 11, 2010. http://www.theatlantic.com/entertainment/archive/2010/03/introducing-the-martin-scorsese-of-china/37325/. Accessed April 30, 2015.

Dirlik, Arif, and Xudaong Zhang, eds. "Postmodernism and China." Special issue, *Boundary 2* 24, no. 3 (1997).

Du Bois, W. E. B. *The Souls of Black Folk*. New York: Penguin Books, 1989.

Ďurovičová, Nataša, and Kathleen Newman. *World Cinemas, Transnational Perspectives*. New York: Routledge, 2010.

Eco, Umberto, and Christine Leefeldt. "De Interpretatione, or the Difficulty of Being Marco Polo [on the Occasion of Antonioni's China Film]." *Film Quarterly* 30, no. 4 (1977): 8–12. doi:10.2307/1211577. Accessed April 30, 2015.

Eisenstein, Sergei. *Film Form: Essays in Film Theory*. Translated by Jay Leyda. New York: Harcourt, 1949.

Elsaesser, Thomas. "Film Festival Networks: The New Topographies of Cinema in Europe." In Thomas Elsaesser, *European Cinema: Face to Face with Hollywood*, 82–107. Amsterdam: Amsterdam University Press, 2005.

Erickson, Steve. "Making a Connection between the Cinema, Politics and Real Life: An Interview with Olivier Assayas." *Cineaste* 22, no. 4 (1997): 6–9.

Feng, Pin-chia. "Reimagining the Femme Fatale: Gender and Nation in Fruit Chan's *Hollywood Hong Kong*." In *Hong Kong Screenscapes: From the New Wave to the Digital Frontier*. Edited by Esther M. K. Cheung, Gina Marchetti, and See-Kam Tan, 253–262. Hong Kong: Hong Kong University Press, 2011.

Fincher, Leta Hong. *Leftover Women: The Resurgence of Gender Inequality in China*. London: Zed Books, 2014.

Ford, Stacilee. "Blockbuster Dreams: Chimericanization in *American Dreams in China* and *Finding Mr. Right*." In *The Power of Culture: Encounters between China and the United States*. Edited by Priscilla Roberts, 409–427. Newcastle upon Tyne: Cambridge Scholars, 2016.

Fore, Steve. "Tales of Recombinant Femininity: *The Reincarnation of Golden Lotus*, the *Chin P'ing Mei*, and the Politics of Melodrama in Hong Kong." *Journal of Film and Video* 45, no. 4, (1993): 57–70.

———. "Time-Traveling under an *Autumn Moon*." *Post Script* 17, no. 3 (Summer 1998): 34–46.

Galt, Rosalind, and Karl Schoonover. "Introduction: The Impurity of Art Cinema." In *Global Art Cinemas: New Theories and Histories*. Edited by Rosalind Galt and Karl Schoonover, 3–27. Oxford: Oxford University Press, 2010.

Gan, Wendy. *Fruit Chan's Durian Durian*. Hong Kong: Hong Kong University Press, 2005.

Garcia, Roger. "After This Our Exile." In *Patrick Tam: From the Heart of the New Wave*. Edited by Alberto Pezzotta, 135–137. Udine: Centro Espressioni Cinematografiche, 2007.

Glaessner, Verina. *Kung Fu: Cinema of Vengeance*. London: Lorrimer, 1974.

Gombrich, E. H. *Art and Illusion: A Study in the Psychology of Pictorial Representation*. London: Phaidon, 1977.

Harvey, Sylvia. *May '68 and Film Culture*. London: British Film Institute, 1978.

Hawker, Philippa. "Jean-Pierre Léaud: Unbearable Lightness." *Senses of Cinema*, no. 8 (2000). http://sensesofcinema.com/2000/jean-pierre-leaud/lightness/. Accessed May 15, 2015.

Heath, Stephen. "Notes on Brecht." *Screen* 15, no. 2 (1974): 103–128.

Heilig, Gerhard K. "1980, August." http://www.china-profile.com/history/indepth/print/pr_id_95.htm. Accessed May 13, 2015.

Hess, John. "La Politique des Auteurs (Part One): World View as Aesthetics." *Jump Cut: A Review of Contemporary Media*, 1974: 19–22. http://www.ejumpcut.org/archive/onlinessays/JC01folder/auturism1.html. Accessed May 13, 2015.

Hess, John, and Patricia R. Zimmermann. "Transnational Documentaries: A Manifesto." *Afterimage* 24 (January/February 1997): 10–14.

Ho, Elaine Y. L. "Women on the Edges of Hong Kong Modernity: The Films of Ann Hui." In *At Full Speed: Hong Kong Cinema in a Borderless World*. Edited by Esther C. M. Yau, 177–207. Minneapolis: University of Minnesota Press.

Hudson, Dale. "Just Play Yourself, 'Maggie Cheung': *Irma Vep*, Rethinking Transnational Stardom and Unthinking National Cinemas." *Screen* 47, no. 2 (2006): 213–232.

Hunt, Leon. "Asiaphilia, Asianisation and the Gatekeeper Auteur: Quentin Tarantino and Luc Besson." In *East Asian Cinemas: Exploring Transnational Connections on Film*. Edited by Leon Hunt and Leung Wing-Fai, 220–236. London: I. B. Tauris, 2008.

———. *Kung Fu Cult Masters: From Bruce Lee to Crouching Tiger*. London: Wallflower, 2003.

Indiana, Robert. *Love*. 1966–1999. Polychrome aluminum. 144 in. x 144 in. x 72 in. Avenue of the Americas, New York.

———. *1/0*. 2002. Aluminum. 17.7 in. x 18.1 in. x 10 in. (ten pieces). Taipei 101, Taipei.

Ingham, Michael. "'Crossings': Documentary Elements and Essayistic Devices in the Fiction and Non-Fiction Films of Evans Chan." *Studies in Documentary Film* 1, no. 1 (2007): 21–33. doi:10.1386/sdf.1.1.21_1.

Iordanova, Dina. "The Film Festival Circuit." In *Film Festival Yearbook 1: The Festival Circuit*. Edited by Dina Iordanova and Ragan Rhyne, 23–39. St. Andrews, Scotland: St. Andrews Film Studies, 2009.

Jaffee, Valerie. "Bringing the World to the Nation: Jia Zhangke and the Legitimation of Chinese Underground Film." *Senses of Cinema*, no. 32 (2004). http://sensesofcinema.com/2004/feature-articles/chinese_underground_film/. Accessed April 30, 2015.

———. "An Interview with Jia Zhangke." *Senses of Cinema*, no. 32 (2004). http://sensesofcinema.com/2004/feature-articles/jia_zhangke/. Accessed April 30, 2015.

Jameson, Fredric. *The Geopolitical Aesthetic: Cinema and Space in the World System*. London: BFI, 1995.

———. "Postmodernism and Consumer Culture." In *The Anti-Aesthetic: Essays in Postmodern Culture*. Edited by Hal Foster, 111–125. Port Townsend, WA: Bay Press, 1983.

Jia, Zhangke. "Life in Film: Jia Zhangke." *Frieze* 106 (2007): April 15, 2007. http://www.frieze.com/issue/article/life_in_film_jia_zhangke/. Accessed May 13, 2015.

Kaminsky, Stuart M. "Kung Fu Film as Ghetto Myth." *Journal of Popular Film* 3, no. 2 (1974): 129–138.

Kantorates. "An Interview with Director Patrick Tam Ka-Ming (Part II)." *Cinespot,* May 2007. http://www.cinespot.com/einterviews18b.html. Accessed May 13, 2015.

Kato, M. T. "Burning Asia: Bruce Lee's Kinetic Narrative of Decolonization." *Modern Chinese Literature and Culture* 17, no. 1 (2005): 62–99.

———. *From Kung Fu to Hip Hop: Globalization, Revolution, and Popular Culture.* Albany: State University of New York Press, 2007.

Khoo, Olivia. *The Chinese Exotic: Modern Diasporic Femininity.* Hong Kong: Hong Kong University Press, 2007.

Kolker, Robert Phillip. *The Altering Eye: Contemporary International Cinema.* Oxford: Oxford University Press, 1983.

Kraus, Richard Curt. *Pianos and Politics in China: Middle-Class Ambitions and the Struggle over Western Music.* New York: Oxford University Press, 1989.

Kuhn, Robert Lawrence. "Xi Jinping's Chinese Dream." *New York Times,* June 4, 2013. http://www.nytimes.com/2013/06/05/opinion/global/xi-jinpings-chinese -dream.html?pagewanted=2&_r=1. Accessed May 22, 2015.

La Biennale di Venezia. "Marco Bellocchio Golden Lion for Lifetime Achievement 2011." http://www.labiennale.org/en/cinema/archive/68th-festival/68miac/bellocchio .html. Accessed April 30, 2015.

Lanuque, Arnaud. "Interview Mike Lambert: An English Stuntman in Hong Kong." *Hong Kong CineMagic,* December 27, 2004. http://www.hkcinemagic.com/en /page.asp?aid=70&page=0. Accessed August 2, 2016.

Lau, Jenny Kwok Wah. *Multiple Modernities: Cinemas and Popular Media in Transcultural East Asia.* Philadelphia: Temple University Press, 2003.

Law, Kar, and Frank Bren. *Hong Kong Cinema: A Cross-Cultural View.* Lanham, MD: Scarecrow Press, 2004.

Lee, Edmund. "Interview: Clara Law." *Time Out Hong Kong,* May 12, 2010. http:// www.timeout.com.hk/film/features/34243/interview-clara-law.html. Accessed May 22, 2015.

Lee, Kevin. "Jia Zhangke." *Senses of Cinema* 25 (2003). http://sensesofcinema. com/2003/great-directors/jia/#b1. Accessed April 30, 2015.

Lee, Vivian P. Y. *Hong Kong Cinema since 1997: The Post-Nostalgic Imagination.* Basingstoke: Palgrave Macmillan, 2009.

Lesage, Julia. "Godard-Gorin's *Wind from the East:* Looking at a Film Politically." *Jump Cut: A Review Of Contemporary Media* 4 (1974): 18–23. http://www .ejumpcut.org/archive/onlinessays/JC04folder/WindfromEast.html. Accessed May 15, 2015.

Leyda, Jay. *Dianying/Electric Shadows: An Account of Films and Film Audience in China.* Cambridge, MA: MIT Press, 1979.

———. *Kino: A History of the Russian and Soviet Film.* London: Allen and Unwin, 1960.

Li, Cheuk-To. "The Return of the Father: Hong Kong New Wave and Its Chinese Context in the 1980s." In *New Chinese Cinemas: Forms, Identities, Politics.* Edited by Nick Browne, Paul G. Pickowicz, Vivian Sobchack, and Esther Yau, 160–179. Cambridge: Cambridge University Press, 1994.

Lim, Song Hwee. "Transnational Trajectories in Contemporary East Asian Cine-

mas." In *East Asian Cinemas: Regional Flows and Global Transformations*. Edited by Vivian P. Y. Lee, 15–32. New York: Palgrave, 2011.

———. *Tsai Ming-Liang and a Cinema of Slowness*. Honolulu: University of Hawai'i Press, 2014.

Lin, Xiaoping. "Jia Zhangke's Cinematic Trilogy: A Journey across the Ruins of Post-Mao China." In *Chinese-Language Film: Historiography, Poetics, Politics*. Edited by Sheldon Hsiao-peng Lu and Emilie Yueh-yu Yeh. Honolulu: University of Hawai'i Press, 2005.

Liu, Alan P. L. *The Film Industry in Communist China*. Cambridge, MA: Center for International Studies, Massachusetts Institute of Technology, 1965.

Lo, Kwai-Cheung. *Chinese Face/Off : The Transnational Popular Culture of Hong Kong*. Hong Kong: Hong Kong University Press, 2005.

Longfellow, Brenda. "Lesbian Phantasy and the Other Woman in Ottinger's *Johanna d'Arc of Mongolia*." *Screen* 34, no. 2 (1993): 124–136.

"Long Hair's Website." http://www.longhair.hk/. Accessed May 13, 2015.

Lu, Sheldon Hsiao-peng. "Dialect and Modernity in 21st Century Sinophone Cinema." *Jump Cut: A Review Of Contemporary Media* 49 (2007). http://www.ejumpcut.org/archive/jc49.2007/Lu/index.html. Accessed April 30, 2015.

———. "Historical Introduction Chinese Cinemas (1896–1996) and Transnational Film Studies." In *Transnational Chinese Cinemas: Identity, Nationhood, Gender*. Edited by Sheldon Hsiao-peng Lu, 1–34. Honolulu: University of Hawai'i Press, 1997.

Lu, Tonglin. "Fruit Chan's *Dumplings*—New 'Diary of a Madman' in Post-Mao Global Capitalism." *China Review: An Interdisciplinary Journal on Greater China* 10, no. 2 (2010).

Ma, Jean Y. "Doubled Lives, Dissimulated History: Hou Hsiao-Hsien's *Good Men, Good Women*." *Post Script* 22, no. 3 (2003): 21–33.

Ma, Ran. "Rethinking Festival Film: Urban Generation Chinese Cinema on the Film Festival Circuit." In *Film Festival Yearbook 1: The Festival Circuit*. Edited by Dina Iordanova and Ragan Rhyne, 116–135. St. Andrews, Scotland: St. Andrews Film Studies, 2009.

Macciocchi, Maria Antonietta. *Daily Life in Revolutionary China*. Translated by Kathy Brown. New York: Monthly Review Press, 1972.

Malkin, Bonnie. "Chinese Directors Boycott Australian Film Festival over Uighur Documentary." *Telegraph,* July 23, 2009. http://www.telegraph.co.uk/culture/film/5890775/Chinese-directors-boycott-Australian-film-festival-over-Uighur-documentary.html. Accessed April 30, 2015.

Malraux, André. *La condition humaine* [*Man's Fate*]. Translated by Haakon M. Chevalier. New York: Random House, 1934.

Marchetti, Gina. *Andrew Lau and Alan Mak's Infernal Affairs—the Trilogy*. Hong Kong: Hong Kong University Press, 2007.

———. "Between Comrade and Queer: Stanley Kwan's *Hold You Tight*." In *Hong Kong Screenscapes: From the New Wave to the Digital Frontier*. Edited by Esther M. K. Cheung, Gina Marchetti, and See-Kam Tan, 197–212. Hong Kong: Hong Kong University Press, 2011.

———. *The Chinese Diaspora on American Screens: Race, Sex, and Cinema*. Philadelphia: Temple University Press, 2012.

———. "Eileen Chang and Ang Lee at the Movies: The Cinematic Politics of *Lust,*

Caution." In *Eileen Chang: Romancing Languages, Cultures and Genres.* Edited by Louie Kam, 131–154. Hong Kong: Hong Kong University Press, 2012.

———. "From Fu Manchu to *M. Butterfly* and *Irma Vep:* Cinematic Incarnations of Chinese Villainy." In *Bad: Infamy, Darkness, Evil, and Slime on Screen.* Edited by Murray Pomerance, 187–200. Albany: State University of New York Press, 2004.

———. *From Tian'anmen to Times Square: Transnational China and the Chinese Diaspora on Global Screens, 1989–1997.* Philadelphia: Temple University Press, 2006.

———. "The Hong Kong New Wave." In *A Companion to Chinese Cinema.* Edited by Yingjin Zhang, 95–117. Malden: Wiley-Blackwell, 2012.

———. "Interview : Evans Chan." In Marchetti, *From Tian'anmen to Times Square: Transnational China and the Chinese Diaspora on Global Screens,* 183–188.

———. "On Tsai Mingliang's *The River.*" In *Island on the Edge: Taiwan New Cinema and After.* Edited by Chris Berry and Feii Lu, 113–126. Hong Kong: Hong Kong University Press, 2005.

Marchetti, Gina, David Vivier, and Thomas Podvin. "Interview Patrick Tam: The Exiled Filmmaker." *Hong Kong CineMagic,* June 28, 2007. http://www.hkcinemagic .com/en/page.asp?aid=270. Accessed May 13, 2015.

Marker, Chris. "A Free Replay (Notes on *Vertigo*)." http://chrismarker.org/chris -marker/a-free-replay-notes-on-vertigo/. Accessed May 22, 2015.

Martin, Fran. "The European Undead: Tsai Ming-Liang's Temporal Dysphoria." *Senses of Cinema* 27 (2003). http://sensesofcinema.com/2003/feature-articles /tsai_european_undead/. Accessed 15 May, 2015.

Marx, Karl, and Friedrich Engels. *The Communist Manifesto.* Translated by L. M. Findlay. Peterborough, Ontario: Broadview Press, 2004.

McGrath, Jason. "The Independent Cinema of Jia Zhangke: From Postsocialist Realism to a Transnational Aesthetic." In *The Urban Generation: Chinese Cinema and Society at the Turn of the Twenty-First Century.* Edited by Zhen Zhang, 81–114. Durham: Duke University Press, 2007.

———. "Metacinema for the Masses: Three Films by Feng Xiaogang." *Modern Chinese Literature and Culture* 17, no. 2 (2005): 90–132.

Modleski, Tania. *The Women Who Knew Too Much: Hitchcock and Feminist Theory.* New York: Methuen, 1988.

Mok, Chiu-yu, and Evans Chan. *City Stage: Hong Kong Playwriting in English.* Hong Kong: Hong Kong University Press, 2005.

Morris, Meaghan Elizabeth. "Learning from Bruce Lee: Pedagogy and Political Correctness in Martial Arts Cinema." In *Keyframes: Popular Cinema and Cultural Studies.* Edited by Matthew Tinkcom and Amy Villarejo, 171–186. London: Routledge, 2001.

Morrison, Susan. "*Irma Vep.*" *CineAction* 42 (1997): 63–65.

Moscovici, Ariel. *Between Earth and Sky.* 2002. Rose de la claret granite. 39 in. x 51 in. (six pieces). Taipei 101, Taipei.

Mulvey, Laura. "Visual Pleasure and Narrative Cinema." *In Film Theory and Criticism: Introductory Readings.* Edited by Leo Braudy and Marshall Cohen, 833–844. New York: Oxford University Press, 1999. Originally published in *Screen* 16, no. 3 (1975): 6–18.

Naficy, Hamid. *An Accented Cinema: Exilic and Diasporic Filmmaking.* Princeton, NJ: Princeton University Press, 2001.

Nagib, Lúcia, Chris Perriam, and Rajinder Dudrah. *Theorizing World Cinema*. London: I. B. Tauris, 2012.

Nichols, Bill. "Discovering Form, Inferring Meaning: New Cinemas and the Film Festival Circuit." *Film Quarterly* 47, no. 3 (1994): 16–30.

Nie, Jing. "A City of Disappearance: Trauma, Displacement, and Spectral Cityscape in Contemporary Chinese Cinema." In *Chinese Ecocinema: In the Age of Environmental Challenge*. Edited by Sheldon Lu and Jiayan Mi, 195–214. Hong Kong: Hong Kong University Press, 2009.

Night Corridor. "Biography Daniel N. Wu." http://www.nightcorridor.com/daniel.html. Accessed May 22, 2015.

Nowell-Smith, Geoffrey. *The Oxford History of World Cinema*. New York: Oxford University Press, 1996.

Ong, Aihwa. *Flexible Citizenship: The Cultural Logics of Transnationality*. Durham: Duke University Press, 1999.

Orr, John. *Cinema and Modernity*. Cambridge: Polity Press, 1993.

Pang, Laikwan. "Copying *Kill Bill*." *Social Text* 23, no. 2 (Summer 2005): 133–153. doi:10.1215/01642472-23-2_83–133. Accessed May 23, 2017.

Prashad, Vijay. *Everybody Was Kung Fu Fighting: Afro-Asian Connections and the Myth of Cultural Purity*. Boston: Beacon Press, 2001.

Pravda, Ru. "Martin Scorsese's Oscar-Winning Film Inspired by Hong Kong's Crime Thriller." February 27, 2007. http://english.pravda.ru/news/society/27-02-2007/87768-scorsesedeparted-0/. Accessed May 13, 2015.

Price, Brian, and Meghan Sutherland. "On Debord, Then and Now: An Interview with Olivier Assayas." *World Picture Journal* 1 (2008). http://www.worldpicturejournal.com/World%20Picture/WP_1.1/Assayas.html. Accessed May 15, 2015.

Ravetto-Biagioli, Kriss. "*Vertigo* and the Vertiginous History of Film Theory." *Camera Obscura* 25, no. 3 (2011): 101–141.

Riviere, Joan. "Womanliness as Masquerade." *International Journal of Psychoanalysis* 10 (1929): 303–313.

Rofel, Lisa. *Desiring China: Experiments in Neoliberalism, Sexuality, and Public Culture*. Durham: Duke University Press, 2007.

Schrader, Paul. *Transcendental Style in Film: Ozu, Bresson, Dreyer*. Berkeley: University of California Press, 1972.

Scorsese, Martin. "Foreword." In *Speaking in Images: Interviews with Contemporary Chinese Filmmakers*. Edited by Michael Berry, viii. New York: Columbia University Press, 2005.

Shi, Xiaoling. "Between Illusion and Reality: Jia Zhangke's Vision of Present-Day China in *The World*." *Asian Cinema* 18, no. 2 (2007): 220–231.

Shih, Shu-Mei. "Gender and a New Geopolitics of Desire: The Seduction of Mainland Women in Taiwan and Hong Kong Media." *Signs* 23, no. 2 (1998): 287–319.

———. *Visuality and Identity: Sinophone Articulations across the Pacific*. Berkeley: University of California Press, 2007.

Shohat, Ella, and Robert Stam. *Unthinking Eurocentrism: Multiculturalism and the Media*. London: Routledge, 1994.

Silbergeld, Jerome. *Hitchcock with a Chinese Face: Cinematic Doubles, Oedipal Triangles, and China's Moral Voice*. Seattle: University of Washington Press, 2004.

Sitney, P. Adams. *Visionary Film: The American Avant-Garde*. New York: Oxford University Press, 1974.

Spivak, Gayatri Chakravorty. *A Critique of Postcolonial Reason: Toward a History of the Vanishing Present.* Cambridge, MA: Harvard University Press, 1999.
———. *In Other Worlds: Essays in Cultural Politics.* New York: Methuen, 1987.
Stam, Robert, and Ella Habiba Shohat. "Film Theory and Spectatorship in the Age of the 'Posts.'" In *Reinventing Film Studies.* Edited by Christine Gledhill and Linda Williams, 381–401. London: Arnold, 2000.
Sun, Hongyun. "Two China? Joris Ivens' Yukong and Antonioni's China." *Studies in Documentary Film* 3, no. 1 (2009): 45–59. doi:10.1386/sdf.3.1.45_1. Accessed April 30, 2015.
Sze-to, Mirana M., and Yun-Chung Chen. "Mainlandization and Neoliberalism with Post-Colonial and Chinese Characteristics: Challenges for the Hong Kong Film Industry." In *Neoliberalism and Global Cinema : Capital, Culture, and Marxist Critique.* Edited by Jyotsna Kapur and Keith B. Wagner, 239–260. New York: Routledge, 2011.
Tatlow, Antony, and Tak-wai Wong. *Brecht and East Asian Theatre: The Proceedings of a Conference on Brecht in East Asian Theatre.* Hong Kong: Hong Kong University Press, 1982.
Teru, Icy. "Teresa Teng—*Tian Mi Mi* Lyrics." http://beautifulsonglyrics.blogspot.com/2012/06/teresa-teng-tian-mi-mi-lyrics.html. Accessed May 22, 2015.
Totaro, Donato. "1999 International Festival of New Cinema and New Media" *Offscreen* 3, no. 6 (1999). http://offscreen.com/view/fcmm5. Accessed May 13, 2015.
Truffaut, François. *Hitchcock.* New York: Simon and Schuster, 1967.
Tsai, Ming-liang. "On the Uses and Misuses of Cinema." *Senses of Cinema* 58 (2011). http://sensesofcinema.com/2011/feature-articles/on-the-uses-and-misuses-of-cinema/. Accessed May 15, 2015.
Tsao, Hsueh-chin. *Dream of the Red Chamber.* Translated by Chi-chen Wang. New York: Twayne, 1958.
Tuan, Mia. *Forever Foreigners, or, Honorary Whites?: The Asian Ethnic Experience Today.* New Brunswick, NJ: Rutgers University Press, 1998.
Tweedie, James. *The Age of New Waves: Art Cinema and the Staging of Globalization.* New York: Oxford University Press, 2013.
Ulloa, Marie-Pierre. *Francis Jeanson: A Dissident Intellectual from the French Resistance to the Algerian War.* Translated by Jane Marie Todd. Stanford, CA: Stanford University Press, 2007.
Valck, Marijke de. *Film Festivals: From European Geopolitics to Global Cinephilia.* Amsterdam: Amsterdam University Press, 2007.
Veg, Sebastian. "Democratic Modernism: Rethinking the Politics of Early Twentieth-Century Fiction in China and Europe." *Boundary 2* 38, no. 3 (2011): 27–65.
———. *Fictions du pouvoir chinois: Littérature, modernisme et démocratie au début du XXe siècle.* Paris: Éditions de l'École des hautes études en sciences sociales, 2009.
———. "Introduction: Opening Public Spaces." *China Perspectives* 1 (April 21, 2010). http://chinaperspectives.revues.org/5047. Accessed April 30, 2015.
Wang, Shujen. "*Big Shot's Funeral:* China, Sony, and the WTO." *Asian Cinema* 14, no. 2 (2003): 145–154. doi:10.1386/ac.14.2.145_1. Accessed April 30, 2015.
Waugh, Thomas. "*How Yukong Moved the Mountains:* Filming the Cultural Revolution." *Jump Cut: A Review of Contemporary Media* 12/13 (1976): 3–6. http://www

.ejumpcut.org/archive/onlinessays/jc12–13folder/yukongmovedmt.html. Accessed April 30, 2015.

Whissel, Kristen. "Racialized Spectacle, Exchange Relations, and the Western in *Johanna d'Arc of Mongolia.*" *Screen* 37, no. 1 (1996): 41–67.

White, Patricia. *Women's Cinema, World Cinema: Projecting Contemporary Feminisms.* Durham: Duke University Press, 2015.

Wolin, Richard. *The Wind from the East: French Intellectuals, the Cultural Revolution, and the Legacy of the 1960s.* Princeton: Princeton University Press, 2010.

Wollen, Peter. "Godard and Counter Cinema: *Vent d'Est.*" In *Film Theory and Criticism: Introductory Readings.* Edited by Leo Braudy and Marshall Cohen, 499–507. New York: Oxford University Press, 1999. Originally published in *Afterimage* 4 (1972).

Wong, Cindy Hing-Yuk. *Film Festivals: Culture, People, and Power on the Global Screen.* New Brunswick, NJ: Rutgers University Press, 2011.

Yau, Esther C. M. "Introduction: Hong Kong Cinema in a Borderless World." In *At Full Speed: Hong Kong Cinema in a Borderless World.* Edited by Esther C. M. Yau, 1–28. Minneapolis: University of Minnesota Press, 2001.

Yeh, Emilie Yueh-yu, and Darrell William Davis. *Taiwan Film Directors: A Treasure Island.* New York: Columbia University Press, 2005.

York, Geoffrey. "China Lifts Ban on Film Icon." *Globe and Mail,* December 2, 2004. http://www.theglobeandmail.com/news/world/china-lifts-ban-on-film-icon/article1144684/. Accessed April 30, 2015.

Yue, Audrey. *Ann Hui's Song of the Exile.* Hong Kong: Hong Kong University Press, 2010.

Zhang, Zhen. *An Amorous History of the Silver Screen: Shanghai Cinema, 1896–1937.* Chicago: University of Chicago Press, 2005.

Zhong, Huang. "The Bicycle Towards the Pantheon: A Comparative Analysis of *Beijing Bicycle* and *Bicycle Thieves.*" *Journal of Italian Cinema & Media Studies* 2, no. 3 (2014): 351–362.

Zhou, Zhao-fei. "Wander around Following *The Red Balloon:* Li Goes to Paris Underplanned." Translated by Lin Yiping. *INK Literary Monthly* 58 (2008): 50–52.

Žižek, Slavoj, ed. *Everything You Always Wanted to Know about Lacan (but Were Afraid to Ask Hitchcock).* London: Verso, 1992.

———. *Looking Awry: An Introduction to Jacques Lacan through Popular Culture.* Cambridge, MA: MIT Press, 1991.

———. "Welcome to the Desert of the Real." *Re: contructions,* September 15, 2001. http://web.mit.edu/cms/reconstructions/interpretations/desertreal.html. Accessed May 13, 2015.

Index

About the Author

GINA MARCHETTI teaches film, critical, and cultural studies at the University of Hong Kong. She is the author of *Romance and the "Yellow Peril": Race, Sex and Discursive Strategies in Hollywood Fiction* (University of California, 1993); *From Tian'anmen to Times Square: Transnational China and the Chinese Diaspora on Global Screens* (Philadelphia: Temple University Press, 2006); *The Chinese Diaspora on American Screens: Race, Sex, and Cinema* (Philadelphia: Temple University Press, 2012); and *Andrew Lau and Alan Mak's Infernal Affairs—The Trilogy* (Hong Kong: Hong Kong University Press, 2007). Visit the website https://hkwomenfilmmakers.wordpress.com for more information about her current work on Hong Kong women filmmakers since 1997.